Art of the Hellenistic Kingdoms

From Pergamon to Rome

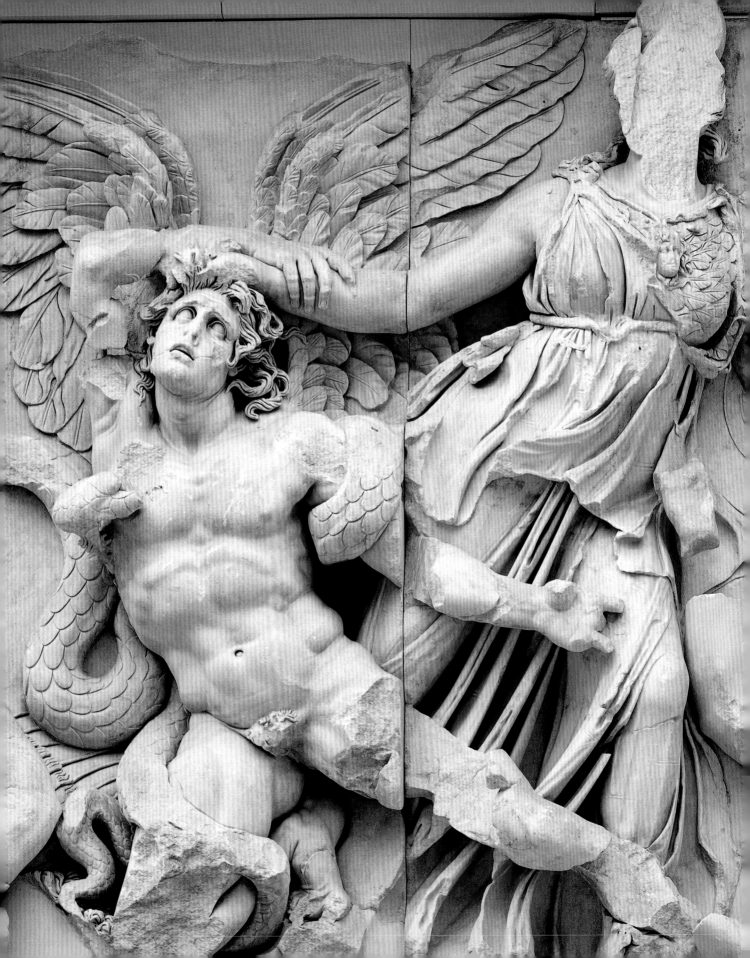

THE METROPOLITAN MUSEUM OF ART
SYMPOSIA

Art of the Hellenistic Kingdoms

From Pergamon to Rome

EDITED BY Seán Hemingway AND Kiki Karoglou

THE
MET

The Metropolitan Museum of Art, New York

Distributed by Yale University Press, New Haven and London

CONTENTS

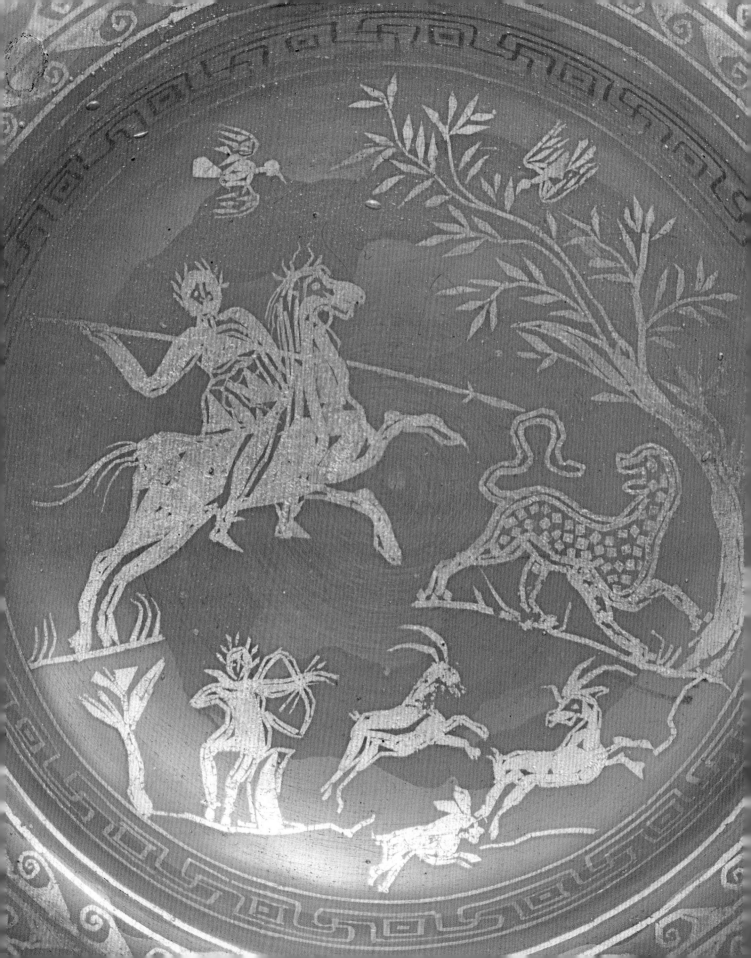

CONTRIBUTORS

Dorothy H. Abramitis

Conservator, Department of Objects Conservation, The Metropolitan Museum of Art, New York

Sophie Descamps-Lequime

Curator, Department of Greek, Etruscan, and Roman Antiquities, Musée du Louvre, Paris

Seán Hemingway

John A. and Carole O. Moran Acting Curator in Charge, Department of Greek and Roman Art, The Metropolitan Museum of Art, New York

Ariel Herrmann

Independent Scholar

Marsha Hill

Curator, Department of Egyptian Art, The Metropolitan Museum of Art, New York

Kiki Karoglou

Associate Curator, Department of Greek and Roman Art, The Metropolitan Museum of Art, New York

Christine Kondoleon

George D. and Margo Behrakis Chair of Greek and Roman Art, Art of Ancient Greece and Rome, Museum of Fine Arts, Boston, MA

Christopher S. Lightfoot

Curator, Department of Greek and Roman Art, The Metropolitan Museum of Art, New York

Carmelo Malacrino

Director, Museo Archeologico Nazionale di Reggio Calabria, Italy

Joan R. Mertens

Curator, Department of Greek and Roman Art, The Metropolitan Museum of Art, New York

Olga Palagia

Professor of Classical Archaeology Emerita, National and Kapodistrian University of Athens, Greece

Dominique Robcis

Chef de travaux d'art (Metal Conservator), Centre de recherche et de restauration des musées de France, Paris

Susan I. Rotroff

Jarvis Thurston and Mona Van Duyn Professor Emerita, Washington University in Saint Louis, MO

Andreas Scholl

Director, Antikensammlung, Staatliche Museen zu Berlin

Agnes Schwarzmaier

Curator, Antikensammlung, Staatliche Museen zu Berlin

R. R. R. Smith

Lincoln Professor of Classical Archaeology and Art, University of Oxford, England

Jeffrey Spier

Senior Curator of Antiquities, J. Paul Getty Museum, Malibu, CA

Karen Stamm

Conservator, Department of Objects Conservation, The Metropolitan Museum of Art, New York

Lillian Bartlett Stoner

Independent Scholar

Alessandro Viscogliosi

Professor, Department of History, Representation and Restoration of Architecture, Sapienza University of Rome, Italy

Ute Wartenberg

Executive Director, American Numismatic Society, New York

Mark Wypyski

Research Scientist, Department of Scientific Research, The Metropolitan Museum of Art, New York

Paul Zanker

Dietrich von Bothmer Distinguished Research Scholar, Department of Greek and Roman Art, The Metropolitan Museum of Art, New York

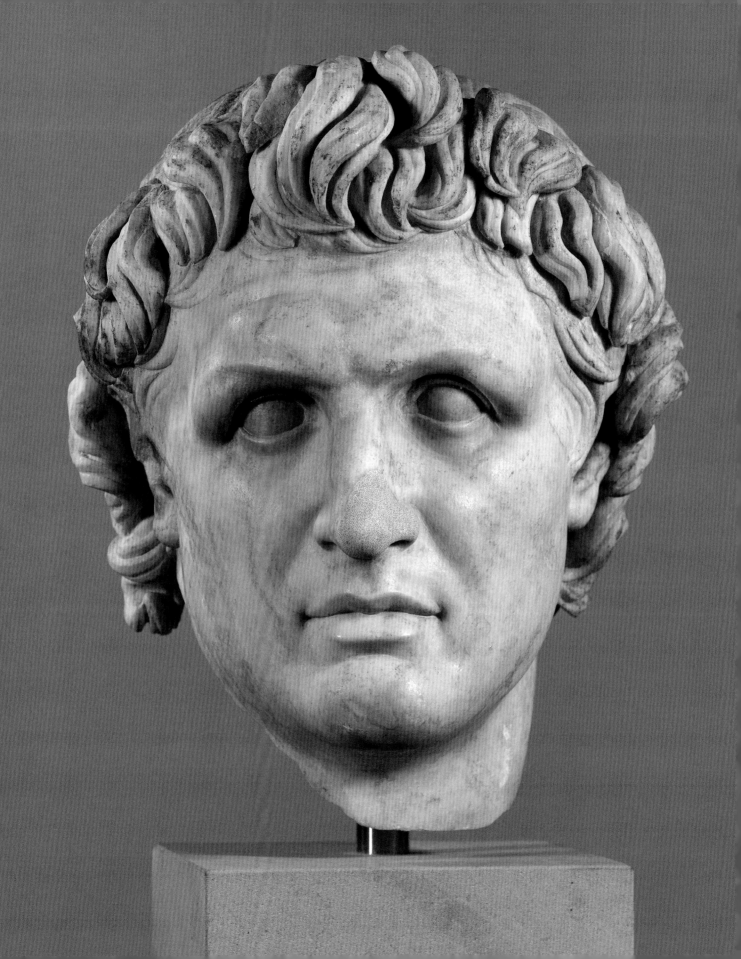

ACKNOWLEDGMENTS

The exhibition "Pergamon and the Hellenistic Kingdoms of the Ancient World" on view at The Met in 2016 was the first major international loan exhibition in the United States devoted to the arts of the Hellenistic Age. The Hellenistic period, the three centuries between the death of Alexander the Great in 323 B.C. and the suicide of the Ptolemaic queen Cleopatra in 30 B.C., was a critical era in the history of Greek art, which traditionally has received less attention than earlier periods. A historic collaboration between the Met and the Berlin State Museums and also with numerous prominent museums in Greece, Italy, other European countries, Morocco, Tunisia, and the United States, this landmark exhibition presented the rich diversity of art forms that arose through the patronage of the royal courts of the Hellenistic Kingdoms, placing a special emphasis on Pergamon, capital of the Attalid dynasty.

We acknowledge Thomas P. Campbell, the former director of The Met, for the opportunity to organize this exhibition and its accompanying main event, the two-day scholar's symposium "Art of the Hellenistic Kingdoms: From Pergamon to Rome" that addressed the wide range and complexity of Hellenistic art. A great debt of gratitude is owed to Carlos A. Picón, former curator in charge of the Department of Greek and Roman Art, who was the driving force of the exhibition.

We recognize the foundations and individual donors whose generosity made possible the realization of the exhibition: the Stavros Niarchos Foundation, Betsy and Edward Cohen/Areté Foundation, Dorothy and Lewis B. Cullman, Renée Belfer, Diane Carol Brandt, Gilbert and Ildiko Butler, Mary and Michael Jaharis, The Vlachos Family Fund, and the Federal Council on the Arts and the Humanities, which provided an important indemnity. The Andrew W. Mellon Foundation, James and Mary Hyde Ottaway, Mary and Michael Jaharis, and the Jenny Boondas Fund provided important backing to produce the exhibition's generously illustrated catalogue.

The symposium was made possible by Mary and Michael Jaharis and the Deutsche Forschungsgemeinschaft (DFG, German Research Foundation), and Prof. Dr. Hermann Parzinger, President, Stiftung Preußischer Kulturbesitz (Prussian Cultural Heritage Foundation), delivered the program's keynote address as part of DFG's Leibniz Lecture series. At the DFG, we would particularly like to thank Prof. Dorothee Dzwonnek, Secretary General; Dr. Hans-Dieter Bienert, Program Director; and at DFG's New York Office, Dr. Annette Doll-Sellen, former Director, and Stefan Altevogt, Senior Program Associate, for their kind collaboration.

Organizing a symposium with international speakers requires planning, and we must acknowledge the preparations made by our Education Department, especially our former colleague Jennifer Mock, associate museum educator, together with the able assistance of the entire staff in the Greek and Roman Department, especially Debbie T. Kuo, senior administrator, and Lillian Bartlett Stoner, former research assistant, as well as Elizabeth Burke, deputy chief development officer for foundation giving, in Development.

We are pleased to contribute to the Museum's symposium series with the publication of this important collection of essays written by distinguished specialists including many curators from The Met, who showcase the Metropolitan's rich holdings of Hellenistic art. We thank all the contributors to *Art of the Hellenistic Kingdoms: From Pergamon to Rome* for their enthusiasm in sharing their expertise, for their close collaboration, and for providing images of works illustrated in their essays. In the Publications and Editorial Department, we wish to acknowledge Mark Polizzotti for embracing this volume, and Michael Sittenfeld, Peter Antony, Gwen Roginsky, and Sally VanDevanter for their assistance in its production. We are especially grateful to Barbara Cavaliere, who devoted much time, energy, and great skill as editor, to Amelia Kutschbach for her meticulous work on the notes and bibliography, to Jennifer Sherman and Josephine Rodriguez-Massop for securing image acquisitions and permissions, to Theresa Huntsman for her careful proofreading, to Pamlyn Smith for the map, and to Briana Parker for helping to move the volume forward. Our special thanks go to Rita Jules of Miko McGinty Inc. for the handsome design.

We are deeply grateful to The BIN Charitable Foundation, Inc., The Adelaide Milton de Groot Fund, in memory of the de Groot and Hawley families, and Mary Jaharis for their commitment in bringing this publication to fruition. Finally, we dedicate this volume to the memory of Michael Jaharis.

Seán Hemingway and Kiki Karoglou

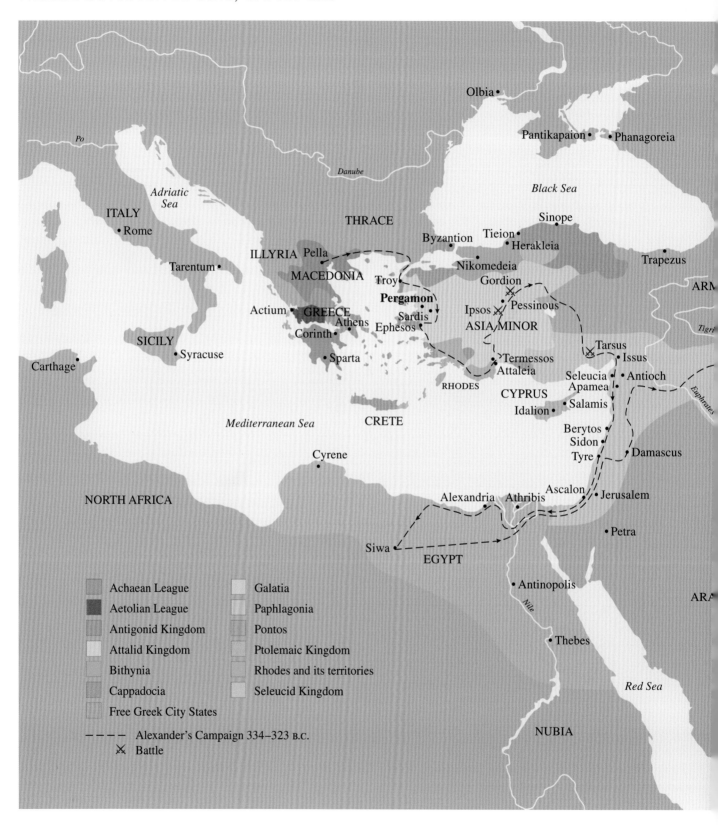

Olbia

Pantikapaion • • Phanagoreia

Po

Danube

Black Sea

Adriatic Sea

ITALY
• Rome

THRACE

Sinope

Tieion

Byzantion • Herakleia

Trapezus

ILLYRIA Pella

Tarentum •

MACEDONIA

Troy

Nikomedeia

Gordion

ARM

Pergamon

Ipsos Pessinous

Actium • GREECE

Sardis

Athens

Ephesos

ASIA MINOR

Tigri

SICILY

Corinth •

• Syracuse

Sparta

Termessos

Tarsus

Issus

Attaleia

Carthage •

RHODES

CYPRUS

Seleucia Antioch

Apamea

Euphrates

Idalion • Salamis

Berytos

Mediterranean Sea

CRETE

Sidon

Tyre • Damascus

Cyrene

Ascalon

Alexandria Athribis

Jerusalem

NORTH AFRICA

• Petra

Siwa

EGYPT

• Antinopolis

ARA

Nile

• Thebes

Red Sea

NUBIA

Legend:

- Achaean League
- Aetolian League
- Antigonid Kingdom
- Attalid Kingdom
- Bithynia
- Cappadocia
- Free Greek City States
- Galatia
- Paphlagonia
- Pontos
- Ptolemaic Kingdom
- Rhodes and its territories
- Seleucid Kingdom
- - - - Alexander's Campaign 334–323 B.C.
- ⚔ Battle

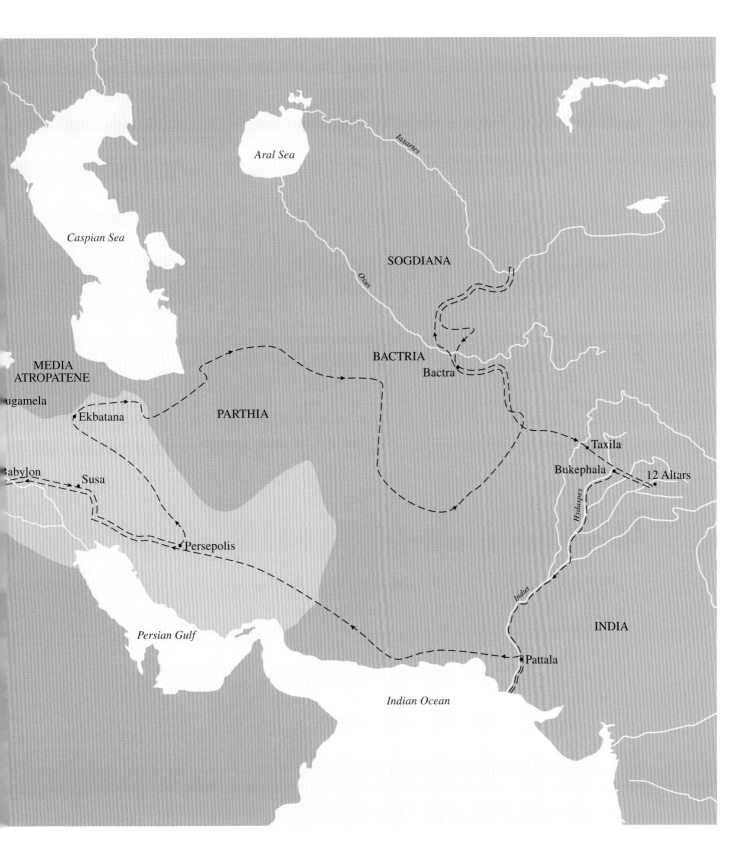

Caspian Sea

Aral Sea

Iaxartes

Oxus

SOGDIANA

BACTRIA

MEDIA
ATROPATENE

ugamela

Ekbatana

PARTHIA

Bactra

Taxila

Bukephala

12 Altars

abylon

Susa

Persepolis

Hydaspes

Indus

Persian Gulf

INDIA

Pattala

Indian Ocean

Seán Hemingway
Introduction

The exhibition "Pergamon and the Hellenistic Kingdoms of the Ancient World" presented an extraordinary opportunity to see a wide selection of artworks from the Hellenistic period, which spanned the nearly three centuries from the death of Alexander the Great in 323 B.C. until the inception of the Roman principate in 28 B.C. The conquests of the Macedonian king Alexander the Great (356–323 B.C.) spread Greek civilization eastward throughout the lands of the former Persian Empire and changed the face of the ancient world forever, opening trade routes and encouraging cultural exchanges with far-reaching implications (see map, pp. 10–11). The Hellenistic Age that followed Alexander's reign witnessed unprecedented cultural exchange and a burst of creative activity. After his death, his generals, known as the Diadochi (Successors), divided his vast empire, which stretched from Greece and Asia Minor through Egypt and the Near East to the Indus River Valley, into multiple new kingdoms. Several dynasties emerged after Alexander's Successors divided his empire: the Seleucids in the Near East, the Ptolemies in Egypt, and the Antigonids in Macedonia. During the first half of the third century B.C., smaller kingdoms—including the Attalid kingdom of Pergamon—broke off from the Seleucid kingdom. Over the next three centuries, the concentration of wealth and power in these kingdoms fostered an unparalleled growth in the arts. Hellenistic royalty were major patrons of the arts and sciences, forming the first great libraries, art collections, and museums. It was primarily through the Hellenistic kingdoms and illustrious city-states such as Athens that Greek art was transmitted to the Romans. During the two-day symposium "Art of the Hellenistic

Kingdoms: From Pergamon to Rome," which took place at The Metropolitan Museum of Art on May 5 and 6, 2016, a group of distinguished scholars convened to present new papers on a variety of subjects related to Hellenistic art, especially in the context of the Museum's exhibition and its significant collection of Hellenistic art.

The exhibition "Pergamon and the Hellenistic Kingdoms of the Ancient World" began with works from the age of Alexander (fig. 1), the foremost model for his Successors, who sought to link themselves to their great leader and conqueror of the world. Alexander's patronage of the arts was especially influential. The first essay in this volume takes a fresh look at some of the earliest preserved portraits of Alexander that exist today. Ute Wartenberg examines two rare series of coins, known as the Manbog coinage and the Elephant coinage, which were probably minted during Alexander's lifetime. These remarkable coins are a physical manifestation of the cultural merging that Alexander championed during his reign. The melding of Classical Greek with Persian cultural traditions evident in this coinage is but one example of the creation of new standards and conventions in taste and style that, in turn, led to new expressions of wealth and power in art during the Hellenistic period.

The Hellenistic era was a time of renewed interest in literature and poetry, fostered by the patronage of Hellenistic royalty. It is the period when art history was first developed and great libraries were formed, such as those at Alexandria in Egypt and at Pergamon. The next two essays in this volume delve into the subject of Hellenistic poetry and its relationship to art. Jeffrey Spier examines epigrams by the

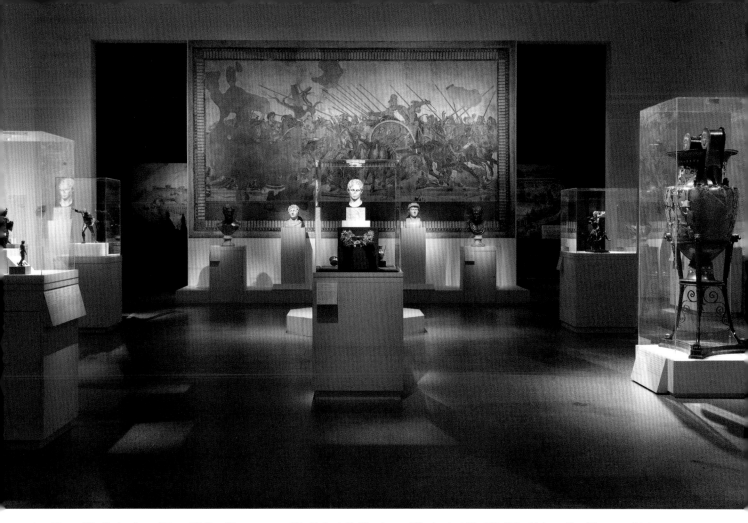

FIG. 1. View of the first gallery of the exhibition "Pergamon and the Hellenistic Kingdoms of the Ancient World," at The Metropolitan Museum of Art, New York, 2016, which presented the Age of Alexander

Macedonian poet Poseidippos of Pella (ca. 310–240 B.C.) written on a newly discovered papyrus, which was recently acquired by the University of Milan. Poseidippos traveled from Pella, seat of the Antigonid royal court, to Alexandria, capital of the Ptolemaic kingdom, where he wrote poetry for the Ptolemaic kings. These poems contain a wealth of references to precious stones and their use in the Ptolemaic court, where poetry and precious engraved gems were used to praise the patron and to serve as reflections of royal power and authority. Christine Kondoleon looks at the interplay between word and image in Hellenistic poetry and its presentation in overlapping imagery shared by mosaics, sculptures, and luxury arts. Visual artists and poets alike valued the rich diversity of mediums available for the artistic expression that flourished in the Hellenistic period. Kondoleon mines the random artistic sampling

preserved today from the archaeological record and offers pairings of Hellenistic poetry and art. A potent theme that Kondoleon explores carefully is love, which can also be traced in later Roman evocations of Hellenistic art and poetry.

The greatly expanded Hellenistic world extended across the Mediterranean Sea to the Pillars of Hercules (the Straits of Gibraltar) in the West and through Asia Minor and the Near East to the Indus River Valley. This is a fascinating period of immense complexity with many kingdoms and shifting alliances. Scholars who study it must always be prepared to reevaluate our understanding of Hellenistic art in light of new discoveries.

Pergamon is perhaps the best example of a Hellenistic kingdom we have today, given that the archaeological remains of its capital city have been so extensively explored

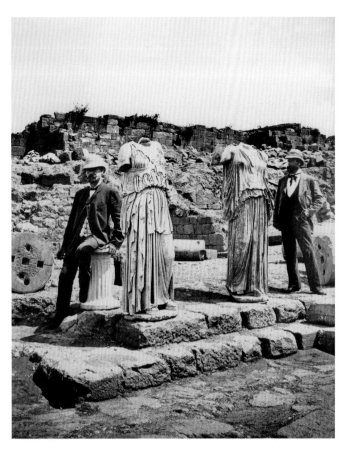

FIG. 2. German archaeologists Carl Humann and Richard Bohn in the sanctuary of Athena at Pergamon with statues of Athena and Hera. Photograph after Grüssinger, U. Kästner, and Scholl 2011, p. 36, fig. 1

a complex that brings the art and architecture of ancient civilizations together in one place like nowhere else in the world. The most impressive architectural monument from the Hellenistic period is the Great Altar of Pergamon, with its monumental frieze depicting the battle between the gods and the giants, which has been so powerfully reconstructed in Berlin (see essay by Scholl, figs. 2 and 7). Because the slabs of the Gigantomachy frieze are built into the walls of the Pergamon Museum, they could not travel to the exhibition, but fragments came, and through creative exhibition design, a selection of the Telephos frieze slabs and the three-dimensional sculpture that adorned the roof, it was possible to convey a sense of the majesty and power of the Great Altar at Pergamon in the exhibition at the Metropolitan.

Susan I. Rotroff is one of the most distinguished scholars of Hellenistic pottery working today. Her essay is concerned with hemispherical moldmade cups, the so-called Megarian bowls that were among the most successful innovations of Hellenistic potters. Such moldmade bowls originated as copies of metalware used by Hellenistic royalty, and they reflect a new trend in dining ware that spread throughout the Hellenistic world. Rotroff concentrates on the Pergamene moldmade bowl industry, how it began, and its influence elsewhere. Although most of the extant bowls from Pergamon are fragmentary, the best are of a very high quality and exhibit distinctive motifs. Interestingly, at present, there is little evidence that Pergamene moldmade bowls were widely exported beyond the range of territories belonging to the Pergamene kingdom.

The incredible wealth of the Hellenistic kingdoms is most evident in the opulence of material goods that were produced for royalty and other elite members of society by artisans skilled in glassmaking, metalworking, and gem engraving. An entire gallery of the Met's Pergamon exhibition was devoted to the luxury arts in its many forms, resulting in one of the most splendid Hellenistic treasuries ever assembled in modern times. In her essay, Agnes Schwarzmaier conveys a sense of the variety of luxury goods that the Attalid kings of Pergamon commissioned with their vast riches, even though very little of these precious portable items remain today. Such finds most often appear among grave goods, but no unplundered royal graves at Pergamon have been identified, like the remarkable royal tombs of the Antigonid dynasty at Vergina.

through excavations conducted primarily by the German Archaeological Institute for nearly 140 years. A large portion of the Metropolitan Museum's exhibition focused on Pergamon through generous loans of major works of art from the Pergamon Museum in Berlin as well as archival materials from the early excavations of the site (fig. 2). It was possible to bring so many treasures from Berlin for the exhibition because of the major renovations currently underway at the Pergamon Museum. The next piece in our proceedings is by Andreas Scholl, Director of the Pergamon Museum. It begins a series of essays on Pergamene studies. Scholl situates the current exciting and ambitious renovation of the Pergamon Museum in the context of that museum's display of its collections and history since its formation in 1901, when it was the newest addition to Museum Island,

Nonetheless, through literary references and careful scholarly inquiry, Schwarzmaier has assembled an impressive array of items, from luxurious textiles known to the Romans as *Attalicae vestae* to fine gilt silver tableware.

The Met's exhibition included stunning examples of Hellenistic sculpture from Pergamon. The largest and most impressive, standing over ten feet tall, was the marble statue of Athena (fig. 3) that was once in the library at Pergamon. It is a one-third-scale replica of the gold and ivory statue of Athena Parthenos by Pheidias that stood in the Parthenon, on the Akropolis of Athens. The contribution by R.R.R. Smith examines another famous sculpture from Pergamon, the twice-life-size portrait head known as the Berlin Attalos, which probably represents Attalos I, the first king of Pergamon, who ruled after its founder, Philetairos. The Berlin Attalos is one of the most powerful Hellenistic ruler portraits to survive (see p. 8). Smith presents in meticulous detail the issues surrounding changes that were made to the sculpture in antiquity. Through careful analysis of the head, Smith argues persuasively against the idea that the portrait originally featured a diadem. What is perhaps most unusual about the sculpture is that the hairstyle was dramatically redone with a thick wreath of wig-like locks on the front that were fitted with mortar. The delicate state of the original mortar, which is still preserved, did not allow the head to travel to the Met for the exhibition. The statue, which would have been set up in a temple, was probably recut with the diadem and more dramatic hairstyle when the dynast became king.

Two essays study the influence of Pergamene sculpture and architecture on ancient Rome. Olga Palagia examines a life-size bust of a bearded god from Nemi, near Rome. Palagia considers this sculpture of about 100 B.C., which is carved in a style reminiscent of the Hellenistic baroque style of the Pergamon Altar, in light of other works created by Greek sculptors in Late Republican Rome. She supports the identification of the god as Asclepius and argues that it was set into a tondo and served as architectural decoration. In his fascinating contribution, Alessandro Viscogliosi traces the influence of Pergamon on Roman architecture after Attalos III bequeathed Pergamon to Rome upon his death and the city became the first capital of the Province of Asia Minor. In time, the Romans would return the gift to Pergamon, most notably through the construction of the Trajaneum on the Pergamene acropolis (fig. 4).

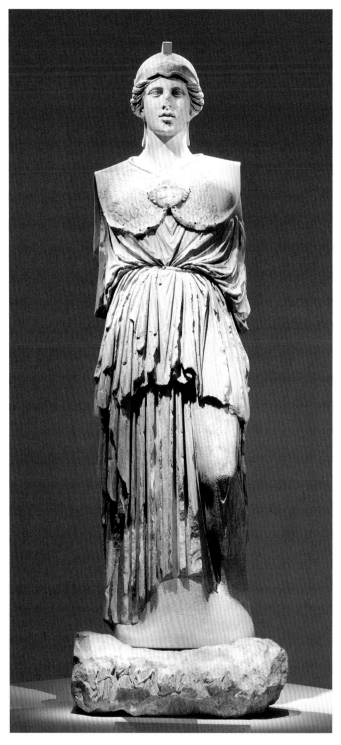

FIG. 3. Athena Parthenos, Greek, Hellenistic, ca. 170 B.C. Marble, overall: 14 ft. 11¹⁵⁄₁₆ in. × 51³⁄₁₆ in. × 37 in. (457 × 130 × 94 cm). Antikensammlung, Staatliche Museen zu Berlin (L.2016.33.1). Featured in the third gallery of the exhibition "Pergamon and the Hellenistic Kingdoms of the Ancient World," at The Metropolitan Museum of Art, New York, 2016, which presented aspects of the Hellenistic city of Pergamon

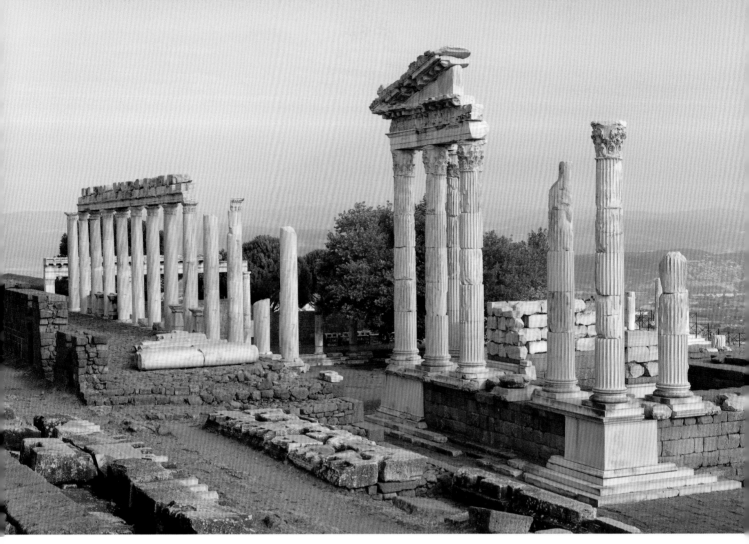

FIG. 4. Temple of Trajan or Trajaneum at Pergamon, Roman, Imperial period, 2nd century A.D. Near modern-day Bergama, Turkey

The Met's encyclopedic collection includes relatively few examples of ancient Greek architecture. Most prominent among them are elements from the monumental Temple of Artemis at Sardis, which was one of the largest temples ever constructed in antiquity (fig. 5). The temple was begun in the late fourth century B.C., and the column capital and base reconstructed at the entrance to the Metropolitan's Hellenistic galleries dates to the Temple's first phase of construction. However, even after five centuries, the Temple of Artemis at Sardis was never completely finished. The Met was fortunate to recently acquire some of the earliest surviving photographs of Greek archaeological sites, which include perhaps the earliest extant photograph of the Temple of Artemis at Sardis (fig. 6), illustrating its

two standing unfinished columns in 1843, well before the American excavations of the temple began in 1910.

The Metropolitan Museum of Art has an important collection of Hellenistic art, which was re-installed as part of the renovation of the Greek and Roman galleries completed in 2007. In planning the Met's Pergamon exhibition, we decided that we would not draw too heavily on the permanent collection, so that the Hellenistic galleries could act as an interesting supplement to the show. The collection features well-known treasures such as the statue of Eros Sleeping (fig. 7), which has been the subject of recent scholarly and scientific examination,[1] the exquisite statuette of a masked and veiled female dancer (fig. 8) as well as more recent additions such as the majestic marble head of Zeus

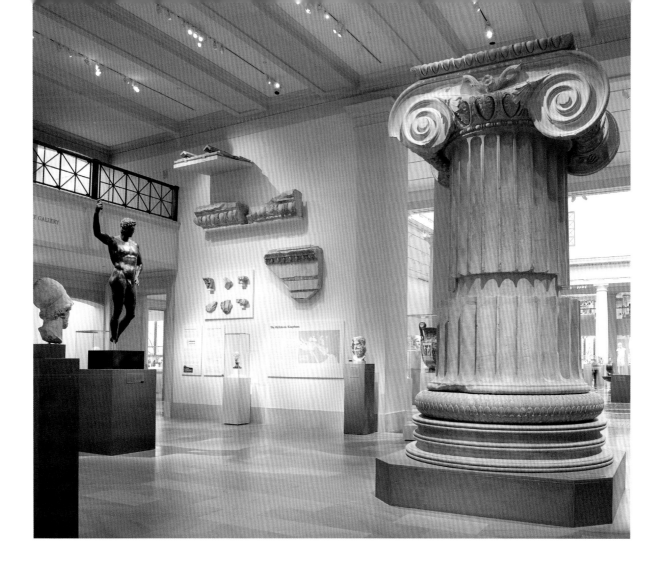

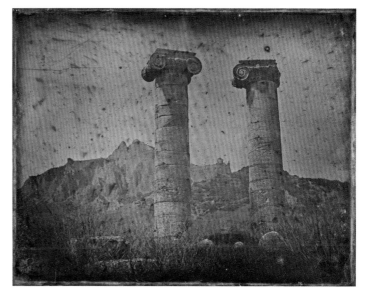

Above: **FIG. 5.** Ionic Column from the Temple of Artemis at Sardis, Greek, Hellenistic, ca. 300 B.C. Marble, h. 142⅛ in. (361 cm). The Metropolitan Museum of Art, New York, Gift of The American Society for the Excavation of Sardis, 1926 (26.59.1)

Right: **FIG. 6.** Joseph-Philibert Girault de Prangey (French, 1804–1892). Sardes. T. de Cybèle (Temple of Artemis at Sardis), 1843. Daguerreotype, 7½ x 9⁷⁄₁₆ in. (19 x 24 cm). The Metropolitan Museum of Art, New York, Purchase, Mr. and Mrs. John A. Moran Gift, in memory of Louise Chisholm Moran, Joyce F. Menschel Gift, Joseph Pulitzer Bequest, 2016 Benefit Fund, and Gift of Dr. Mortimer D. Sackler, Theresa Sackler and Family, 2016 (2016.615)

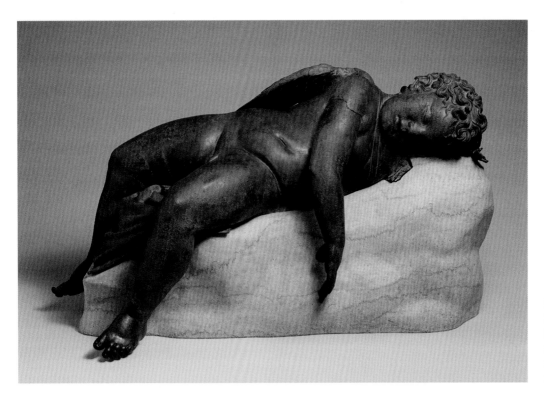

FIG. 7. Eros Sleeping. Greek, Hellenistic, 3rd–2nd century B.C. Bronze. 6½ x 14 x 33⁹⁄₁₆ in. (41.9 x 35.6 x 85.2 cm). The Metropolitan Museum of Art, New York, Rogers Fund, 1943 (43.11.4)

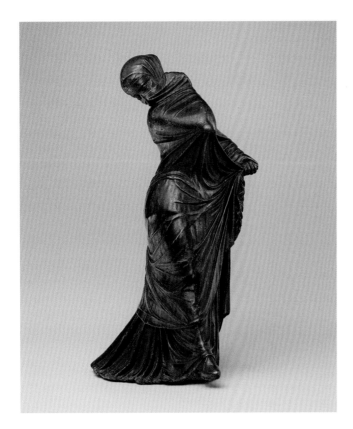

Ammon (fig. 9). The next section of this publication is devoted to Hellenistic sculpture and includes several essays about works of art in the collection of the Metropolitan. Kiki Karoglou offers an illuminating new assessment of an original Early Hellenistic marble votive statuette of Dionysos acquired by the Museum in 1959. The god of wine and theater is represented wearing a sacrificial goatskin. Most likely, this statuette was dedicated at a sanctuary in association with one of the rural Attic festivals of the god, possibly by one of his priests or by a member of an ephebic chorus from a Dionysian play. Lillian Bartlett Stoner's contribution focuses on another important Hellenistic sculpture long in the Met's collection, a bronze statuette of drunken Herakles acquired in 1915. She considers its probable contexts of display in light of other examples of the type as well as possible meanings in antiquity for this provocative image of the great hero. The drunken

Left: FIG. 8. Statuette of a veiled and masked dancer. Greek, Hellenistic, 3rd–2nd century B.C. Bronze. 8¹⁄₁₆ x 3½ x 4½ in. The Metropolitan Museum of Art, New York. Bequest of Walter C. Baker, 1971 (1972.118.95)

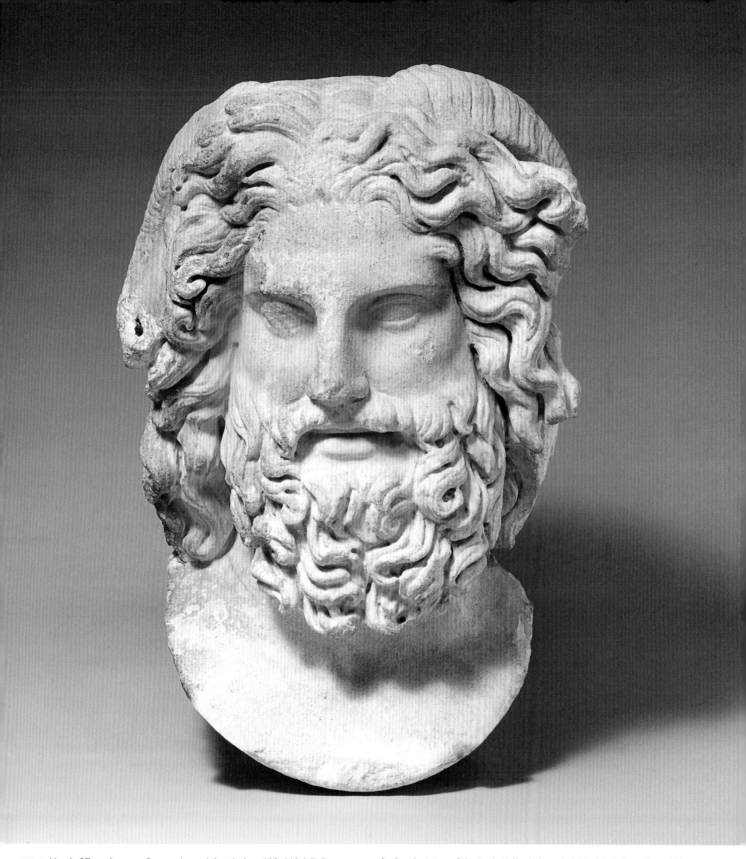

FIG. 9. Head of Zeus Ammon. Roman, Imperial period, ca. 120–160 A.D. Roman copy of a Greek statue of the Early Hellenistic period. Marble, h. from base: 19 in. (48.2 cm.). The Metropolitan Museum of Art, New York, Purchase, Philodoroi Gifts, Acquisitions Fund, Mary and Michael Jaharis Gift, 2011 Benefit Fund, funds from various donors, Mr. and Mrs. John A. Moran, John J. Medveckis, Nicholas S. Zoullas, Mr. and Mrs. Frederick W. Beinecke, Leon Levy Foundation, Jeannette and Jonathan Rosen, Judy and Michael Steinhardt, Malcolm Hewitt Wiener Foundation and Aso O. Tavitian Gifts, 2012 (2012.22)

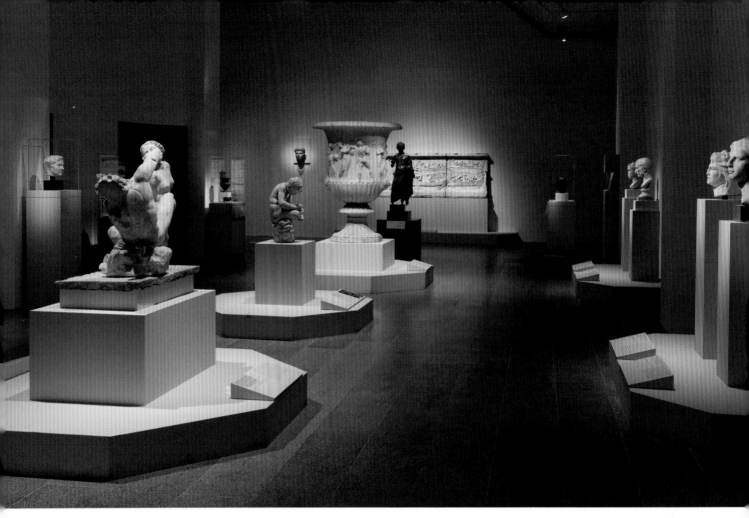

FIG. 10. View of the last gallery in the exhibition "Pergamon and the Hellenistic Kingdoms of the Ancient World," at The Metropolitan Museum of Art, New York, 2016, which presented the Late Hellenistic Age

Herakles is a later, more extreme variant on a theme that likely begins with Lysippos's famous fourth century B.C. sculpture *Herakles Epitrapezios* (see essay by Stoner, fig. 6), which represents the hero indulging in the pleasures of wine and food after his many Herculean labors. My essay, co-authored with Dorothy H. Abramitis and Karen Stamm, looks at another major class of Hellenistic sculpture, the equestrian bronze statue, and its Roman legacy, through a fragmentary example acquired by the Met in 2002 as part of the bequest of the fashion designer Bill Blass. This collaborative study combines a careful technical analysis of the bronze sculpture with art historical and archaeological research. The last study in our Hellenistic sculpture section, by Sophie Descamps-Lequime and Dominique Robcis, also presents fruitful results from combining scientific and scholarly research. Their careful analysis of provincial Roman statuettes and an inkpot from southern France that exhibits finely wrought metallic polychromy adds to our understanding of the Hellenistic legacy of metalworking and the legendary Corinthian bronze alloy that ancient sources report was discovered by accident during a conflagration at the sack of Corinth in 146 B.C.

The final section of our symposium proceedings, which was devoted to Hellenistic decorative arts and their influence on Roman art, is published herein beginning with the contribution by Ariel Herrmann. It is an excellent example of the complex issues that scholars face when trying to interpret fragmentary sculptures and series of works that derive from an earlier, likely famous, sculpture. Herrmann's essay delves into an unusual iconographic type, Athena wearing a Gorgoneion helmet, which is reflected in an exquisite Hellenistic bronze roundel from Thessaloniki that

was featured in the Met's Pergamon exhibition and also in a now-lost marble relief known as the Hamilton fragment as well as a half dozen other versions. The essay by Joan R. Mertens explores the significant transition from painted to relief wares in Hellenistic pottery from Athens and the influence of Athenian moldmade pottery in other regions of the Hellenistic world with particular reference to examples in the Met's collection.

The last Hellenistic kingdom to fall to Rome was the Ptolemaic kingdom of Egypt in 31 B.C. Marsha Hill, curator in the Metropolitan's Department of Egyptian Art, provides a thoughtful overview of the production of faience vessels and statuary in the Hellenistic period. Hellenistic faience evolved out of a long tradition established centuries earlier in Egypt. Ptolemaic faience workshops led to the creation of a number of outstanding new faience works in the Hellenistic era, which meld Greek and Egyptian elements. Christopher S. Lightfoot presents a similarly illuminating overview of Hellenistic glass production, noting its significant debts to Achaemenid Persian predecessors and the extraordinary variety of innovative high quality creations that utilize bold new techniques such as mosaic glass and gold sandwich glass vessels. Two additional essays, one co-authored by Lightfoot and Carmelo Malacrino, Director of the Archaeological Museum in Reggio di Calabria, and the other by the Met's research scientist Mark T. Wypyski, supply new art historical and scientific analysis of the Tresilico gold glass bowl, which is unique for its gold leaf figural decoration.

The final section of the Met's Pergamon exhibition featured the advancing of Rome as a dominant power in the Eastern Mediterranean and its development into a major center for Hellenistic art in the first century B.C. (fig. 10). Portrait sculptures of prominent historical figures and examples of the lavish decorative artworks that were commissioned for Roman private villas, also preserved and illustrated in the cargoes of two Late Hellenistic ships that sunk on their way to Rome, provide an extraordinary array of the artistic accomplishments of this complex period in history. It is fitting that the last essay in this publication is a discerning analysis of one of the finest groups of Roman wall paintings to survive. They come from a villa near Pompeii at Boscoreale and are among the most important frescoes in the Met's collection. Paul Zanker shows how these outstanding examples of second and third style Pompeian painting emulate Greek culture, especially the sumptuous lifestyle of the Hellenistic kings, and how they include careful copies of major Hellenistic paintings that were highly valued by the Roman patrician who commissioned them for the most important rooms of his villa rustica. The deep appreciation that many Romans had for Greek art ensured its influence on Roman Imperial art and its rich legacy in the centuries following the end of the Hellenistic era.

1. Hemingway and Stone 2017.

ART FROM ALEXANDER THE GREAT
TO THE HELLENISTIC KINGDOMS

Ute Wartenberg

Early Portraits of Alexander the Great: The Numismatic Evidence

Portraiture is considered one of the singular artistic achievements of the Hellenistic period, and coinage was one of the first widely available mediums to adopt it. In contrast to Hellenistic coins, earlier Archaic and Classical coins typically display animals, mythical creatures, gods, or sometimes, a victory scene. From the middle of the fourth century B.C. onward, we find portrait-like depictions on the periphery of the Greek world, for instance in Thessaly, Thrace, Macedon, and, primarily, the western Satrapies of the Persian empire. The new empire of Alexander, which expanded to India, resulted in an increasingly global civilization, greatly enriched by the release of massive amounts of gold and silver from the Persian treasuries. This set the stage for a new coinage. Alexander's image became a major factor in justifying the claims of his successors for his empire, and his portrait, usually in the guise of the god Zeus Ammon, was used on coins of Ptolemy I and Lysimachus, and perhaps also Seleukos I.[1] The appearance of images of Alexander the Great on coins is a topic frequently debated by numismatists and others. In this essay, I focus on what are probably the earliest two cases that depict Alexander, coins both probably minted during his lifetime. The first is a rare series from Manbog, a sanctuary in northern Syria, which shows Alexander on horseback attacking a wolf. The second is the famous elephant coinage (sometimes referred to as medallions), which is associated with Alexander's victory over the Indian ruler Porus. Both rare series could be described as one-offs, and minted in unusual circumstances, but they stand at the onset of a visual narrative representing Alexander as conqueror of Persia.

Alexander and the Wolf Hunt on the Coinage of Manbog

Although the coinage of Manbog deserves the credit for carrying the earliest surviving depiction of Alexander the Great, it is rarely mentioned in scholarly debates about his images. The coins were issued at the sanctuary of the Syrian goddess Atargatis at Manbog, where a small series of coins was minted sometime before 333 B.C.[2] The coinage is curious in several respects: all the coins are of the same denomination and weigh around 8.4 grams.[3] The weight standard (Babylonian or Attic) is hard to interpret and is unique for this region. On the coins with Alexander's name (*'Iksndr* in Aramaic), one encounters imitations of types known from the neighboring Cilician mints, and in particular, the seated Baal and the lion attacking animals are well known from the coinage of Tarsos. Although the style of the coinage is largely crude, some are of stunning beauty, especially the second series ascribed to Alexander. His influence on the famous sanctuary of this region must have begun after the battle of Issos, but the exact reason that his name appears on the coins is not entirely clear. Scholars date these coins to after 333–331 B.C.[4]

One of these coins (figs. 1a and b) is remarkable for its depiction of a figure on horseback hunting an animal. The type has long been known from a single specimen in Paris, but a second coin with this imagery, which shows significantly more detail, has come to light in the last decade on the international coin market (figs. 2a and b). The obverse shows the goddess Atargatis seated on a stool. A fire altar is in front of her, and in her right hand, she holds a rose. Normally, this goddess is shown in different poses on the Manbog coinage, but this particular example has a

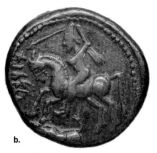

a.　　　　　　　b.

FIG. 1. Stater, Manbog–Hierapolis, ca. 333 B.C. Silver. Bibliothèque Nationale de France, Paris

a.　　　　　　　b.

FIG. 2. Stater, Manbog–Hierapolis, ca. 333 B.C. Silver. *Numismatica Ars Classica* 54, March 24, 2019, no. 875

striking similarity to the coinages of Tarsos and the royal coinage of Alexander himself. In the debate about the dating of the launching of Alexander's coinage, this small series of Manbog in his name adds a tantalizing piece of evidence in support of 333–332 B.C., the later date now accepted by most scholars for the introduction of the royal silver coinage, which Martin Price and some other scholars traditionally dated to the beginning of Alexander's reign in 336 B.C. It seems unlikely that these iconographical similarities on the three coinages are coincidental.[5]

More remarkable for the discussion about portraits is the reverse of the Manbog coin. It shows a classic hunting scene, in which a man on horseback, dressed in a long garment that reaches to his knees (a *kandys*) and wearing some kind of tiara, holds a spear in his raised left hand, which points to the ground; underneath his horse is his prey, which he is trying to kill.[6] The Aramaic inscription (*'Iksndr*) on the left identifies the rider as Alexander.[7] This Achaemenid hunting scene also appears in other mediums during the fourth century B.C.[8] In a recent discussion of the two known coins of Manbog, Helge-H. Nieswandt interprets the scene as a boar hunt.[9] Some iconographical details of the animal, however, such as the long raised tail, the lean body, and the wide mouth, are atypical of a boar, as Nieswandt herself points out, and clearly point toward a different animal, in all likelihood, a wolf.[10] All the main characteristics of that animal are correctly shown. We see a long wiry body, a head with a wide-open mouth, a ridge on the back, and most importantly, the upright tail that is a characteristic feature of a wolf during an attack demonstrating his dominance. Alexander as a hunter is a well-known motif in

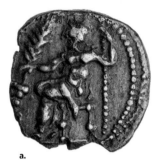

a.　　　　　　　b.

FIG. 3. Obol, Tarsos (?), ca, 340 B.C. Silver. American Numismatic Society, New York, 1954.185.34

the later iconography of the king, but a wolf hunt is, as far as I know, unique. One must therefore ask what prompted the choice of this animal and indeed, the whole scene at the mint of Manbog. The wolf is actually a relatively common motif in this region as well: a large fractional coinage, which shows, on one side, Baal seated, has a forepart of a wolf and above it, a crescent moon (figs. 3a and b). It is often attributed to Tarsos in the second half of the fourth century B.C., but apart from the common obverse, there is no compelling reason for the choice of this mint.[11] The wolf is also commonly found as a countermark on coins of Cilicia and Pamphylia, and possibly on some rare Syrian issues; some of these are accompanied by the Aramaic letter *nun*, and sometimes, a second Aramaic letter (figs. 4a-c). The letter appears also on its own on countermarks, which are often found on coins of early Manbog. It is quite likely that *nun* and wolf indicate the mint, but more research is needed to establish the veracity of that interpretation.[12]

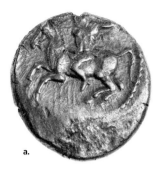
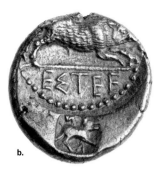

FIG. 4. Stater, Aspendos, ca. 350–340 B.C. Silver. Boar as main type and small countermark with wolf, inscription *N* and another Aramaic letter, 3 images with enlargement of countermark. Private Collection

What the coinage of Manbog in Alexander's name indicates is the willingness of the local authorities to mint coins in his name. The coins of Manbog with Alexander's portrait therefore can be considered the first numismatic depiction of the Macedonian king and probably the earliest surviving depiction of him created during his lifetime in any medium. He is portrayed dressed in Persian garments and engaged in the royal pursuit of a hunt. The local style of the coinage and the wolf, I argue, adds a local element to this scene.[13] The addition of Alexander's name in Aramaic indicates the Macedonian king's control over the sanctuary. In this coinage, we see the shift toward portraying Alexander, which is even more remarkable in a period when the Persian king,

Darius III, was still the ruler of the empire. What the coins of Manbog further illustrate is that authorities felt able to use Alexander's image to promote the sanctuary. If this was done with Alexander's permission or knowledge is uncertain; however, in the eyes of the priests in charge, Alexander had assumed a status identical to that of a satrap, and he was shown with the respect previously reserved on the coinage of Manbog for the Great King.

The Elephant Coinage[14]

One of the undoubtedly most famous scenes on ancient coinage is found on a small series known as *Porus decadrachms*, or elephant coins. On the obverse, we see a view of a rider on a horse setting upon two men on an elephant (fig. 5a). The horseman and one of the elephant riders are attacking each other with lances. The rider on the horse wears a crested helmet and a linothorax, a cuirass made from stiff linen cloth; a small cape is flying behind him. By contrast, the two riders on the elephants wear only a tunic-like garment, which is tied around their waists, whereas their upper bodies appear to be naked or only lightly clothed. Their heads are covered with some sort of high headgear; above the scene, the Greek letter Ξ is visible on some specimens. The reverse (fig. 5b) shows a tall figure holding a thunderbolt and a small flying Victory that is about to put a wreath on his head; the letters AB (in a ligature) are on the left. Although there is almost unanimous agreement that the man being crowned and the man on the horse depict Alexander the Great, the identity of the two men on the elephant is much less clear. The prevailing view is that one is Porus, King of the Pauravas in India, whom

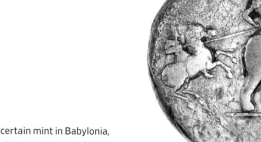

FIG. 5. Decadrachm, uncertain mint in Babylonia, 323–322 B.C. Silver. Manbog–Hierapolis. Silver. American Numismatic Society, 1959.254.86

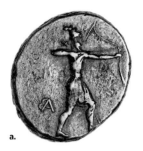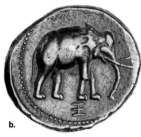

FIG. 6. Tetradrachm, uncertain mint in Babylonia, 323–322 B.C. Silver. American Numismatic Society, 1995.51.68

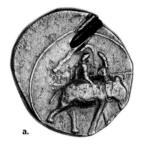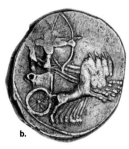

FIG. 7. Tetradrachm, uncertain mint in Babylonia, 323–322 B.C. Silver. American Numismatic Society, 1990.1.1

Alexander fought in the battle on the Hydaspes River in 326 B.C., and the other is an attendant.[15] The battle famously featured war elephants, and the Greek historian Arrian reported that King Porus rode such an elephant.[16] Hence, the identification of this scene appears to be set. To cite John Kroll: "The presentation of Alexander as the conqueror of India is unmistakable."[17] But is it? There are other ways of looking at this unusual coinage.

Most of the known specimens came from a hoard, which was reportedly found in Iraq sometime before 1973.[18] As part of this hoard, two further, smaller coin types appeared, which were linked to the larger decadrachms. On one type, we see an archer who is drawing a large bow and the AB ligature to the left, and on the reverse, an elephant and the letter Ξ (Ksi) are visible (fig. 6). On the second coin, which exists only in three specimens, there is an elephant moving forward, with two men on top (fig. 7). The driver seems to be holding a spear, while the second man is looking back. On the other side is a chariot drawn by four horses with two men, one of whom is driving, while the other is drawing a bow. The hoard, from which over four hundred coins were recorded as photographs or casts before it was dispersed on the antiquities market, is only partially published. So far, the only article about the whole group is an overview of some of the pieces by Martin Price.[19] Price had acquired some 165 or more so-called Athenian imitations for the British Museum's collection, which were published by Peter van Alfen; some of them were minted in Egypt and Babylonia before Alexander's conquest. The second group of coins comprises over one hundred so-called lion staters, minted under Mazaios and his successor in Babylon. Group three is Alexander's new royal coinage, composed of over 115 tetradrachms and perhaps eight decadrachms. Also included were a few miscellaneous Greek coins and, of course, the coinage under discussion here: seven decadrachms, eleven smaller tetradrachms of the first type (elephant/archer), and three of the second type (elephant/chariot).[20] Price believed that all the coins in this hoard were minted before Alexander's death in 323 B.C., but Hyla Troxell, who examined the hoard's records at the American Numismatic Society, thought that a date of about 320 B.C. is more likely and that most of the coins date to Alexander's lifetime.[21]

Regarding the iconography of the elephant coins, most scholars argue that the tetradrachms are all Indian warriors, in their chariots or with their elephants. Frank Holt, who has researched and described these coins at length, has conducted the most extensive analysis of the arguments for the "Indian" interpretation in his well-researched book on the subject, *Alexander the Great and the Mystery of the Elephant Medallions.* In his view, the scene depicted on the decadrachm captures the very moment when Alexander chased Porus from the battlefield: "This numismatic narrative ends, of course, with the large-scale depiction of Porus retreating on his own elephant, relentlessly pursued by Alexander."[22] According to this line of argument, the coins reflect various details from various written sources about Alexander the Great and the battle against Porus. Furthermore, the coins are medallions, which were issued to commemorate the greatest of Alexander's battles.[23]

A few numismatists always doubted the "Indian" interpretation. Hélène Nicolet-Pierre, for example, argued for a reading that sets the elephant coinage in a Persian context. This interpretation was taken up by the Oxford scholar Shailendra Bhandare, who pointed out that the Indian/ Porus interpretation of many British scholars has its roots

in a colonial attitude toward Indians and the role of Alexander the Great in India.[24] By cross-reading Holt's book and Bhandare's extensive article, one realizes that every viewer of these coins interprets them based on their own personal historical contextualizations. Labels like Indian, Persian, and the like say more about modern contexts than the actual ancient reality. If we consider the decadrachm scene with the elephant, it is obvious that the literal interpretation raises significant issues. For example, would the king ride into battle without any armor on an elephant? Arrian describes in some detail the elaborate armor of Porus, on which a gap at the shoulder suggests the possibility of injury. The so-called Indian hairstyle is also questionable, since we know little about Indian hairstyles of the period;[25] Strabo's description states: "all of them wear long hair and long beards, plait their hair, and bind it with a fillet."[26] What one can recognize on most of the poorly struck coins resembles much more some sort of headgear.[27] I argue that we do not know enough about ancient Indian clothing to determine whether this is indeed Indian or Persian. Other such highly literal readings of details of this coinage can be found in Holt's book but also in other interpretations. By trying to combine visual objects and written sources, scholars try to put them in a seemingly well-defined historical context. How questionable such a method is should be obvious, since each interpretation depends on the ideology of the viewer, his or her experiences and assumptions. What is even more troublesome about these various readings of these coins is that they rely on the notion that a historical event known only from a few surviving texts is depicted on a coin. If correct, this would represent the only such known example in ancient coinage before the Roman period. Of course, we have allusions to victories in the Classical and later Hellenistic periods, but nothing that resembles this purported type of snapshot depiction. These interpretations of the elephant coins seem suspiciously modern.

The scenes on the elephant decadrachms instead belong to a different tradition, and I suggest looking for their origins somewhere else. If we abandon the idea that the scene refers to a specific event (such as the battle at the Indian river Hydaspes), a rather different interpretation is possible. Based on the hoard evidence, it is most likely that the elephant coinage was minted around the last few years of Alexander's life. His conquest of Babylonia created a

need for turning vast quantities of silver and gold into coinage, as his soldiers and new allies had to be paid. In other cities of Alexander's new empire, some sort of infrastructure for minting coins was often in place, but Babylon was different; it had no coinage but did have an enormous amount of gold and silver in its treasuries. Considering these circumstances, it is extraordinary to see how swiftly coins began to be minted there. The person responsible for such an efficient introduction is probably Mazaios, Alexander's first Persian satrap of Babylonia.

Mazaios had been a Satrap of Cilicia and other provinces under the Persian kings since the 350s B.C. Cities in Cilicia such as Tarsos, Mallos, or Soloi are known for an extraordinary variety of coin designs, combining Persian and Greek imagery. It was in the western Satrapies of the Persian empire that the first portrait-like profile heads were struck on coins in significant quantities as early as the beginning of the fourth century B.C. Since 361 B.C., a new Satrapal coinage, generally referred to as lion staters, was being minted in a Cilician city, perhaps Myriandros; it shows the Tarsian god Baal seated on a throne, with his name inscribed (fig. 8). The reverse has a lion and the Aramaic inscription MZDI (Mazaios); a similar coinage exists in Tarsos, in which the lion attacks a stag or a bull. It is highly likely that these coinages (issues) were the inspiration for Alexander the Great's royal coinage. The lion staters continued to be struck by Mazaios in Babylon after the battle of Gaugamela on October 1, 331 B.C., although he changed the weight and style: the coins were now minted on the Attic standard, just like the Macedonian coinage of Alexander, and the style is also different from the Cilician issues. This coinage continued after the death of Mazaios in

 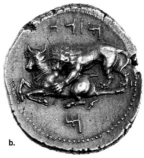

a. b.

FIG. 8. Stater, Mazaios, Myriandros (?), 361–333 B.C. Silver. American Numismatic Society, 1967.152.502

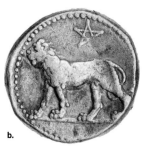

a. b.

FIG. 9. Stater, "Lion stater," Babylon, ca. 321–316 B.C. Silver.
American Numismatic Society, 1944.100.72084

328 B.C. and was taken over later by Seleukos I on a reduced Attic standard (fig. 9).[28] In short, the influence of Mazaios and his Satrapal administration is visible in the coinage of Babylonia, and the elephant coins should be considered a part of this monetary setup. Their large numbers in the Iraq 1973 hoard further illustrate the close connection between these two coinages.

If we compare the elephant coins to the Satrapal coinages of Cilicia, one is struck by the variety of designs that show the Satrap, often with various symbols of power, such as the Satrap Datames seated on his throne closely examining an arrow (fig. 10b) or communicating with a god (fig. 11b).[29] This kind of narrative symbolism is evidenced on the elephant coinages, and a depiction as Alexander with the thunderbolt would have appeared normal to a Persian viewer. The elephant, the chariot, and the archers are basically symbols of power, while reminding viewers of the victory itself. The question of where to locate a mint for this sort of coinage is much more complicated, and a number of mints in Babylonia have been suggested, which previously had no mints at all.[30] Almost immediately after Alexander's arrival at Babylon and most likely because of

Mazaios's involvement, a relatively well-structured and immense series of coins was minted, which fit into the traditional Persian monetary system of a royal coinage (of Alexander) and a Satrapal one (Baal/lion coin). Less well understood are mints such as Susa and various smaller ones, which seem to issue coinage right after Alexander's death and are perhaps the most likely candidates for a mint for the elephant coinage. Yet it is clear that these coins are very close in style and manufacture to a number of later issues of Seleukos I. In particular, a silver coin of Seleukos I with Zeus and an elephant[31] has a similar style of fine bas-relief engraving and thick hammered flans, although it was undoubtedly minted much later, in the 280s B.C. (figs. 12a and b).

How differently the elephant is employed as an emblem on the elephant coins and later on Seleucid coinage is of relevance for our discussion. It has been recognized that Seleukos I used the elephant as an emblem of his new dynasty.[32] Not just on coins but also in other mediums, elephants represent a weapon of mass destruction, to use a modern term, and the power of the new king. They also signal a geopolitical ambition of this new vast empire. For Seleukos, the animal, which was so feared by Alexander and his army, is on his side, and the title *elephantarches* (ruler of the elephants) gives his power full credit. Seleukos's coins reflect the change from an animal that was attacked and chased to one that is being led in a triumphal quadriga. Against this background in which the elephant is an emblem on Seleucid coinage, it is hard to imagine that the elephant coinage was minted much after Alexander's death. On it, the elephant still represents the Eastern hemisphere, which Alexander fought hard to conquer. As the obverse of the elephant decadrachm shows without ambiguity, this is a victory issue, albeit an odd one;

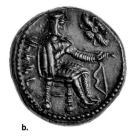

a. b.

FIG. 10. Stater, Datames, Tarsos, ca. 385–362 B.C. Silver.
American Numismatic Society, 1977.158.561

a. b.

FIG. 11. Stater, Datames, Tarsos, ca. 385–362 B.C. Silver.
American Numismatic Society, 1944.100.54388

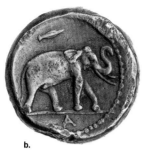

a. b.

FIG. 12. Tetradrachm, Seleukos I, Susa (?), ca. 287–281 B.C. Silver. American Numismatic Society, 1944.100.73359

the discrepancy in size between the small depiction of the victor against the huge elephant has been noted by other scholars. It seems unlikely that the engravers were Greek or indeed part of the entourage of Alexander, who is said to have controlled his image carefully, if we believe Pliny's account.[33] Also unusual on a coin is the military character of this scene, in which an actual confrontation between enemies is shown. While hunting scenes are common in Persian art, military scenes are much less common in Graeco-Persian art altogether.[34] However, the image fits into a wider canon of later depictions of Alexander and his victories, and while one might speculate that the elephant coins are innovative in their design, one always has to keep in mind how radically different our picture would be if more ancient paintings had survived. Apelles's famous painting of Alexander Keraunophoros is close to what we see on the obverse of the elephant coin. As Olga Palagia recently illustrated, the visual narrative of the famed Alexander Mosaic of about 100 B.C. might well have precursors in Macedonia that display battle scenes between Greeks and Persians during the years of Alexander's successors.[35]

To sum up, the seemingly exceptional character of the scenes on the elephant coinage is perhaps mostly the result of our limited comparative evidence, visual or otherwise, from this period. The image of Alexander hunting a wolf on the coinage of Manbog made during his lifetime illustrates the desire of the Persians to incorporate the king into their own tradition of visual representation. If we compare the images of Alexander on the elephant coinage and the Manbog coinage, we can see a similar approach, in which the king becomes more Persian while still being clearly identified, through either the inscription (on the coin of Manbog) or his horse and clothing.[36] Although we will

probably never know the exact circumstances and meaning behind Alexander's earliest images on these two coin series, they fit well into what we know about Persian imagery on coins.

Acknowledgments

I am most grateful to Carlos Picón, Seán Hemingway, and Kiki Karoglou for their invitation to speak at the symposium. A version was also given at the Belgian School of Athens, and I would like to express my gratitude to Dr. Panagiotis Iossif and the attendants at this event for their helpful suggestions and comments. Wolfgang Fischer-Bossert, Oliver Hoover, and Peter van Alfen have also assisted me in various ways.

1. Introductions to coin portraiture are numerous. See Stewart 1993, Arnold-Biucchi 2006, and Dahmen 2007, who discuss Alexander's imagery. For a recent discussion of Hellenistic numismatic portraits, see Kroll 2014.
2. For discussions of this mint, see Seyrig 1971 and Mildenberg 1999; for a full die-study of the ca. 60 B.C. specimens of this mint, see Andrade forthcoming.
3. The few fractions associated with this mint are hard to place and do not alter this picture radically.
4. For a summary of the argument for a date between the battles of Issos and Gaugamela, see Andrade forthcoming.
5. The most detailed account for the various arguments is still Troxell 1997, pp. 86–98.
6. It seems highly unlikely that the animal is a hunting dog accompanying the rider.
7. Andrade forthcoming, series 12 (with the Aramaic inscription IKSANDRE), shows a second horseman probably representing Alexander the Great.
8. See for example the Çan sarcophagus; compare with Sevinç et al. 2001 and Ma 2007.
9. Blömer and Nieswandt 2016, pp. 18–23.
10. Ibid., p. 21. Nieswandt mentions the problem of boar hunting within the religious context of this region where this animal was considered unclean. She assumes that this is an early case of transferring an iconographic motif to this region.
11. See Hill 1900, Tarsus 84–88, pls. XXXII, 8–9.
12. One possibility is that *nun* refers to the Assyrian name of Manbij, Nappigu, which might be the town associated with the sanctuary.
13. Nieswandt's idea that a lion hunt was the Great King's prerogative is, however, an intriguing suggestion as well; compare with Blömer and Nieswandt 2016, pp. 20–21.
14. The literature on this subject is vast and will not be listed here, except when specifically cited. Most of it can be found in publications such as Holt 2003 and Dahmen 2007. In the following, I have only cited recent articles or books for specific references. Like scholars such as Arnold-Biucchi 2006, I also do not wish to discuss the gold piece in trade, published by Osmund Bopearachchi on multiple occasions, which has never been made available to scholars for inspection to verify its authenticity. For the discussion, see

Bopearachchi 2017, pp. 255–56, and the essays in Holt and Bopearachchi 2011; for arguments against the authenticity of the piece, see Fischer-Bossert 2006 and Bracey 2011, among others. Yoon 2012 also rightly points out the criminal activities surrounding the Mir Zakah Hoard and its discovery in Afghanistan, from which this gold object supposedly emerged.

15. For a detailed analysis of the various arguments, see particularly Holt 2003 and more recently Dahmen 2007.

16. Arrian, *Anabasis of Alexander*, 18.5.

17. Kroll 2014, p. 115.

18. See Price et al. 1975–2010, vol. 1, p. 38; ibid., vol. 2, p. 49; ibid., vol. 3, p. 22; ibid., vol. 8, p. 188, for a listing of the various parcels recorded by Price and others; see Price 1991a for a partial publication of the hoard.

19. See note 17 above; van Alfen 2000, p. 9 n. 1; Holt 2003, p. 173, Appendix C, with an overview of published numbers, who cites a letter by Michel Duerr that states the number of coins could have been as high as 1500+. Photos, plaster casts, and notes of this hoard are in the archives of the American Numismatic Society in New York and have been used for this paper.

20. The first part of the hoard appeared in the early 1970s; Price 1991a, p. 66, reported some more pieces from the hoard seen only in 1989.

21. See Price 1991b, p. 51, for his last discussion on the subject; see Troxell 1997, pp. 74, 85, for short discussions.

22. Price 1982, pp. 75–83; Holt 2003, pp. 155, 154, who even argues that the smaller coins show the Indian chariot and elephants in retreat: "The two Indian military units put out of commission by the stormy weather turn out to be the very ones depicted on the smaller medallions."

23. Here I can provide only a highly abbreviated outline of the arguments. For previous scholarship, see Holt 2003, chaps. 5, 6, who provides an excellent overview of all various interpretations by earlier scholars.

24. Nicolet-Pierre 1978; Bhandare 2007.

25. Holt 2003, p. 101: "The die engraver must actually have seen these troops, whose hairstyles, for example, match the descriptions in ancient texts."

26. Strabo, *Geography*, 15.1.71, translated in Strabo 1903.

27. See Bhandare 2007, pp. 224–32, for the various issues of the Indian elements on this coinage.

28. The lion stater coinage continues to be a major gap in our numismatic understanding; for preliminary discussions, see Price 1991b, pp. 66–67; Nicolet-Pierre 1999, with a slightly different arrangement than Iossif and Lorber 2007.

29. On Datames's issues at Tarsos, see Moysey 1986.

30. Price 1991b, pp. 451–53.

31. Houghton, Lorber, and Hoover 2002, no. 187.1a.

32. Iossif and Lorber 2010; Kosmin 2014, pp. 1–7.

33. Pliny the Elder, *Natural History*, 7.125, mentions Pyrgoteles as an engraver of gems; Apelles was the painter and Lysippus the sculptor of the bronze.

34. Ma 2007, pp. 252–53.

35. Palagia 2017.

36. For the Achaemenid empire, this visual assimilation of foreign officials is well attested; see Ma 2007, p. 252, who rightly mentions the statue of Ptah-Hotep, an overseer of the Treasury in Egypt in the XXVIIth dynasty, in Persian and Egyptian garb.

Jeffrey Spier

Precious Gems and Poetry in the Hellenistic Royal Courts

The rediscovery of over a hundred lost epigrams of Poseidippos of Pella (ca. 310–240 B.C.) in a papyrus recently acquired by the University of Milan has provided remarkable evidence for the importance of precious gems in the court of the Ptolemies.[1] The twenty works in the initial section, entitled the *Lithika*, or "poems about stones," are brief, charming epigrams, playful but complex in their imagery, which refers to both the natural world and the society of Hellenistic Egypt. The descriptions of the stones are not purely literary inventions but in fact reflect the fascination within the Ptolemaic court for exotic stones.

Poseidippos, who traveled from Macedonia to Alexandria to serve Ptolemy I and II, wrote numerous poems praising the monarchy, often equating the king— and especially the queen—with deities. Although the poems of the *Lithika* do not explicitly refer to the Ptolemaic rulers, as so many of his other poems do, the importance of gems as marks of status and admired objects within court culture is clear. Surviving engraved gems correspond well with the literary sources. Valuable stones such as peridot, garnet, and amethyst were carved with images of the king or queen, often with attributes of gods. In addition, some of these works were signed by the gem engraver, a rare practice that suggests special value and prestige.

The use of rare gems in Greece, indeed even the knowledge of such stones, changed dramatically following Alexander's conquest of the East and the opening of trade routes to north India (present-day Afghanistan and Pakistan). Previously, stones such as garnet, peridot, emerald, aquamarine, tourmaline, and citrine were hardly known. Other stones, including lapis lazuli and amethyst, were

uncommon and clearly considered exceptionally valuable. Interestingly, many of these gems appear to be little known in pharaonic Egypt. Even peridot and emerald, materials found in Egypt, were not used before Hellenistic times. Garnet, the most popular of Hellenistic stones, hardly appears earlier and then only in the form of small, unengraved beads. Only amethyst, mined in Egypt since Middle Kingdom times, was both a traditional Egyptian material and a popular Hellenistic stone.[2] The taste for unusual gems imported from India and Arabia arose suddenly it seems, a reflection of the new extent of the Greek world.

Although few examples of these rare gems survive, those that do are typically finely engraved, often with portraits of the king or queen, suggesting that they had considerable political significance. The importance of gems to the royal court is already apparent under Alexander the Great, who allowed his portrait on seals to be engraved solely by the artist Pyrgoteles.[3] The only recorded engraved tourmaline, a stone most likely from Afghanistan, displays a superb head of Alexander with the ram's horns of Ammon, datable to around 300 B.C. (fig. 1).[4] Peridot (τόπαζος, in Greek) is also rare. Although the material is not mentioned by Poseidippos, it is discussed by the Roman writer Pliny, who tells of its discovery on an island in the Red Sea off the coast of Egypt, itself called Topazos (the modern names are Zabargad or St. John's Island).[5] The gem was brought to Berenike, the wife of Ptolemy I, and later her son, Ptolemy II, admired the stone and made from it an over-life-size statue of his wife, Arsinoe II, which was dedicated in her shrine, the Arsinoeum in Alexandria. No sculpture of this sort survives, but the story may well be true and in any event,

FIG. 1. Head of Alexander the Great with ram's horns, ca. 300 B.C. Tourmaline. Ashmolean Museum, University of Oxford

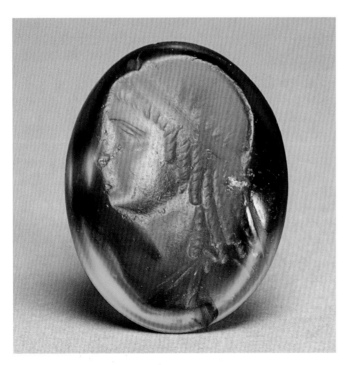

FIG. 2. Head of a Ptolemaic queen as Isis, ca. 200 B.C. Peridot. The Walters Art Museum, Baltimore

attests to the remarkable ambitions of the Ptolemaic gem cutters. Extant engraved peridots are uncommon, but an example in Baltimore with the head of a queen in the guise of Isis is surely of Ptolemaic origin, probably late third or second century B.C. in date (fig. 2).[6]

Returning to the Greek writers and poets with an interest in gems, it should be noted that even a distinguished philosopher-scientist such as Theophrastos (ca. 371–287 B.C.), the successor to Aristotle at the Lyceum in Athens, in his extant book, *On Stones* (Περί Λίθων), appears to have had little actual experience with rare gems. His sources were purely literary, and there is little in his book about the gems that would become popular in the Hellenistic courts a generation or two later. In contrast, the epigrams of Poseidippos show a keen awareness of rare materials in current use. In addition to the foreign origin or unusual nature of the stone, however, these poems also marvel at the engraving, praise the gem engraver, and often conclude with the name of the young woman who received the gem as a gift. Clearly, the erotic significance of both gems and epigrams was of primary importance. Take, for example, Epigram 5:

> Timanthes engraved this star-like lapis lazuli,
> This Persian semi-precious stone containing gold,
> For Demylus; and in exchange for a tender kiss
> the dark-haired Nicaia of Cos [received it as a
> desirable] gift.[7]

The Greek name for the stone is σάπφειρος, but descriptions of the gem by various ancient writers confirm it is not what is known today as sapphire but rather as lapis lazuli. The reference to a Persian stone "containing gold" (that is, gold-colored flecks of pyrite) confirms the identification.[8] Lapis lazuli, from remote mines in Afghanistan, was known in Greece since the Bronze Age but was always a rare and precious material. The poem also mentions the artist, Timanthes, not known otherwise as a gem engraver, although there was a famous painter of that name.

Although lapis lazuli was highly valued in pharaonic Egypt, there are very few surviving examples dating from the Ptolemaic period. A scaraboid in the J. Paul Getty Museum dating from the mid-fourth century B.C. and likely carved in Asia Minor under Persian rule, is the sort of work that influenced the Hellenistic gem carvers (figs. 3a–b).[9]

a. b.

FIG. 3. Scaraboid, mid-4th century B.C. Engraved shown with impressions. Side a: lion and side b: boar.
J. Paul Getty Museum, Malibu, Gift of Damon Mezzacappa and Jonathan H. Kagan

It is wonderfully carved on both sides, one side showing a lion with its head turned to face the viewer, and the other, a boar scratching itself with its hind leg. By the end of the fourth century B.C., fashions for shapes of gems and rings changed, with large scaraboids giving way to thinner gems set into the fixed bezel of a ring. Surely of Ptolemaic origin and dating to the late third century B.C., for example, is a lapis lazuli stone engraved in Greek style with the head of an Egyptian priest, which is set in a gold ring.[10]

Other materials mentioned by Poseidippos include "shining anthrax" (ἄνθραξ αὐγάζων), no doubt garnet; beryl (both emerald and aquamarine);[11] a "honey-colored" yellow gem; carnelian; engraved shells from Persia mounted in gold; an uncertain stone that when anointed with oil shines and makes visible an engraved Persian lion; "clouded" jasper (chalcedony?); "snake stone" (thought to have been found in the skull of a snake and often cited in ancient literature); rock crystal; and magnetite. Here is Poseidippos, Epigram 7:

> Rolling yellow rubble from the Arabian mountains,
> The winter-flowing river quickly carried to the sea
> The honey-coloured gem engraved by the hand of
> Kronios.
> Mounted in gold it lights up sweet Nikonoe's
> Inlaid necklace, as on her breast
> The hue of honey glows with the whiteness of her skin.[12]

It is a lovely poem, again focusing on the erotic—the honey-colored gem on the white neck of Nikonoe. But it also provides the exotic source of Arabia and a reference to the famous artist, Kronios, who is named by Poseidippos in two other epigrams (2 and 6) as an engraver of a beryl and

cited also by the first century Roman writer Pliny.[13] He surely was a historical figure. But what is the unnamed, honey-colored gem? It was likely citrine, chemically identical to amethyst but of different color. It appears to come into use only in the Hellenistic period and is not attested earlier. In early Roman Imperial times, the gem is always very finely engraved, which perhaps suggests it was more valuable than the average seal stone. No engraved Hellenistic citrine survives, but at least two unengraved stones are set in elaborate gold rings of almost architectural shape, with hinged hoops incorporating pillar-like elements, and stepped bezels (fig. 4).[14] Examples of this type of ring from excavated tombs in northern Greece provide a date in the second century B.C., and they may well be Ptolemaic in origin.[15]

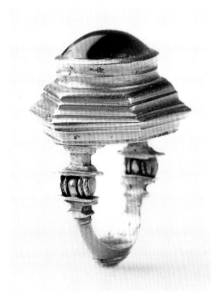

FIG. 4. Ring set with citrines, ca. 200 B.C. Gold. Slava Yevdayev collection

Rings of the same shape are often set with garnet, a stone that may be considered the Hellenistic gem par excellence. Although some modern scholars translate *anthrax* as "ruby," that identification must be incorrect. Ancient descriptions of the gem as red, "gleaming like a burning coal," accord well with garnet, and indeed, many actual examples survive.[16] Garnet was unknown in Greece and rarely used in Egypt until Hellenistic times, but it became immensely popular from the third century B.C. onward. The fragmentary Epigram 3 of Poseidippos mentions an *anthrax* engraved with an image of a bowl with flowers, which "draws at once the eye's swimming glance."[17] Other garnets include a fine portrait of Berenike II in Boston[18] and a cameo probably depicting Arsinoe II in the Getty Museum, which was once set into a gold ring, now lost.[19] Indeed, cameos, carved from both garnet and banded agate, were an innovation of artists in the Ptolemaic court.[20]

A Ptolemaic origin is also likely for some gems engraved with a distinctive royal image known to Poseidippos and described not in the *Lithika* but rather in one of the poems called Dedications (Ἀναθεματικά). Epigram 36 mentions a picture of Arsinoe II in the guise of the goddess Aphrodite holding a spear and shield, which was painted or woven on a linen cloth:

To you, Arsinoe, to provide a cool breeze through
 its folds,
Is dedicated this scarf of fine linen from Naucratis.
With it, beloved one, you wished in a dream to wipe the
 pleasant perspiration after a pause from busy toils.
Thus you appeared, Brother-loving one, holding in your
 hand the point of a spear and on your arm, Lady, a
 hollow shield.
And at your request the strip of white material was dedi-
 cated by the maid Hegeso of Macedonian stock.[21]

Another poet, Apollonios of Rhodes, who was active in the Ptolemaic court at the end of the third century B.C., similarly describes an armed Aphrodite on the decorated mantle of the hero Jason: "Wielding the swift shield of Ares; and from her shoulder / To her left arm the fastening of her tunic was loosed / Beneath her breast."[22]

The image of an arming Aphrodite most likely derives from a cult statue of Arsinoe II that was familiar to the poets and gem carvers. On a garnet signed by the engraver

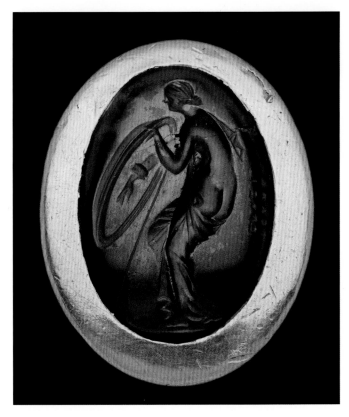

Gelon (fig. 5), the goddess, nude but for the drapery around her legs, is seen from the rear, holding a shield and the tip of a spear, just as the poet describes. The gem, which is set in a gold ring, was found in a tomb at Eretria in Greece and dates to around 200 B.C.[23] Other examples of similar date are known, including an amethyst in a stepped gold ring, now in a private collection.[24] These gems accord remarkably well with the poem and demonstrate the close association between works of art and literature in the Ptolemaic court.

Amethyst was a gem rarely used in Greece before the Hellenistic period, although it had long been popular in pharaonic Egypt. Poseidippos does not mention amethyst in his poetry, but another Hellenistic poet does. An epigram preserved in the *Greek Anthology* is ascribed either to Asklepiades of Samos, who flourished in the late fourth century B.C., or to Antipater of Thessalonica, who lived much later, in the late first century B.C. Similarities to other poems, including those by Poseidippos, make the attribution to Asklepiades more likely.[25] The epigram reads:

I am Drunkenness [*Methe*], the engraving of a skilled
 hand, but I've been engraved in amethyst. The stone
 is in opposition to its emblem.
Yet the holy object belongs to Cleopatra, for on the
 queen's hand even a drunken goddess should
 be sober.[26]

If the poem is by Asklepiades, this Cleopatra (there
are many queens with this name) is likely the sister of
Alexander the Great, who was married to Alexander of
Epiros and continued to rule there after his death in
330 B.C. She did not remarry, although courted by the pow-
erful successors of Alexander, the royal lineage being
important to them. In 308 B.C., when she finally agreed to
marry Ptolemy, she was murdered by order of his rival, the
Macedonian King Antigonos.[27]

The device of Methe drinking from a cup is in fact
popular on gems, although none dates as early as the late
fourth century B.C., which is not to say that one could
not have existed.[28] This particular composition likely
derives from a fourth century B.C. painting by Pausias of
Sikyon, which is described by the Roman writer Pausanias
as being displayed at Epidauros.[29] It has plausibly been
suggested that the use of the image in the epigram by
Asklepiades may refer to the Dionysiac royal cult so import-
ant in Macedonia and thus be appropriate for Cleopatra,
the sister of Alexander. That the gem was amethyst is signif-
icant. It is first of all a pun, for *methe* means drunkenness,
and *a-methe* is literally not-drunk. Because of this, amethyst
was sometimes said to have the power to prevent drunken-
ness. The poem also makes explicit that the stone is "in
opposition to" the image engraved on it, and furthermore
that the goddess Methe must be subservient to the queen,
thus praising and reinforcing royal authority in the manner
of so many of the epigrams composed for the royal courts.

One more unusual stone named by Poseidippos can be
considered. *Magnes*, or magnetite, is an iron oxide that is
attracted by a magnet and can become magnetized itself.
Epigram 17 reads:

Consider the nature of this stone uprooted by Mysian
 Olympus.
Its double power makes it a marvel.
On the one hand it easily attracts iron that stands in
 the way,

Just like a magnet. On the other hand it drives it afar,
 causing, with its side, an opposite effect. It's quite a
 prodigy, how on its own
It can imitate two stones in their forward projections (?).[30]

This is just one of a number of literary descriptions of mag-
netite, which include philosophical speculations about if,
in view of their power of movement, magnets had souls.
No Hellenistic magnetite seal is known, although there are
magical amulets carved from the material dating to Roman
Imperial times. There is, however, a remarkable description
of the use of magnetite by Ptolemy II provided by the
Roman writer Pliny the Elder:

The architect Timochares had begun to use lodestone
[magnetite] for constructing the vaulting in the Temple
of Arsinoe at Alexandria, so that the iron statue con-
tained in it might have the appearance of being sus-
pended in mid air; but the project was interrupted by his
own death and that of King Ptolemy who had ordered
the work to be done in honour of his sister.[31]

Whether a magnetic building could actually enable a statue
to float in the air is doubtful, but it again shows the ambi-
tions of the Ptolemaic court with regard to rare gems.[32]

Aside from literary sources, some other surviving
stones provide additional evidence for the importance
of the medium in furthering royal Hellenistic aims. A chal-
cedony now in Boston shows the head of Isis with cork-
screw curls, a solar disc with cow's horns, and a royal
diadem, identifying the goddess as a Ptolemaic queen,
perhaps Cleopatra II during her period of sole rule
(131–127 B.C.). It is a finely engraved work, signed by the
otherwise unknown artist Lykomedes.[33]

Also reflecting royal cult is the superb group of jewelry
in the Getty Museum, comprised of a diadem, hair net, ear-
rings, snake bracelets, and two very large rings set with car-
nelians.[34] The gems are large and convex, and the style of
engraving is characteristically Ptolemaic of the second cen-
tury B.C., with elegantly elongated figures. One shows the
goddess Artemis, not distinctively Ptolemaic, but the other
is engraved with an image of Tyche, "Good Fortune," hold-
ing a double-cornucopia tied with fillets, a very specific ref-
erence to the cult of Arsinoe II (fig. 6). This must have been
worn by a woman with close ties to the royal court.

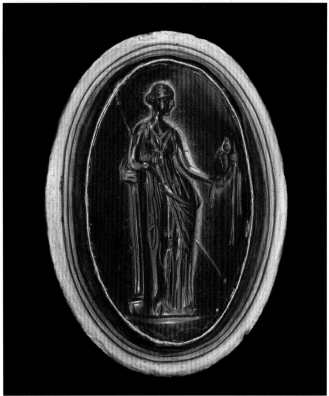

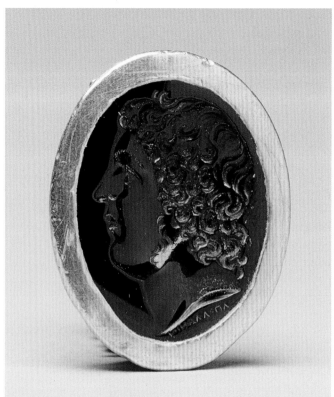

FIG. 6. Tyche holding a double-cornucopia, ca. 200 B.C. Garnet set in a gold ring. J. Paul Getty Museum, Malibu

FIG. 7. Portrait of the Athenian Echedemos, signed by the engraver Apollonios, ca. 200 B.C. Garnet set in a gold ring. The Walters Art Museum, Baltimore

The later years of Ptolemaic rule saw the continued use of seals and rings as emblems of royal authority. Garnets engraved with the portrait of the king were presented as royal gifts that served as markers of status. The Roman historian Plutarch relates that in 87 B.C., Ptolemy IX presented an emerald ring engraved with his portrait to the Roman general Lucullus in a diplomatic attempt to remain a Roman ally without having to contribute to their war effort against Mithridates.[35] Many gems and rings of this type must have existed, but few survive. They are known, however, from clay impressions that once sealed papyrus documents, and often display remarkable compositions.[36]

The Ptolemies no doubt set the fashions for rare stones, but other Hellenistic kings also served as patrons for gem engravers. The gem cutter Apollonios signed a garnet portrait of Antiochos III of Syria early in the second century B.C.,[37] as well as a fine depiction of a curly-haired individual who has very plausibly been identified as

Echedemos, son of Mnesitheos, an Athenian aristocrat and prominent politician, who flourished around 200 B.C. (fig. 7).[38] The latter garnet is set in a ring closely related to the architectural, stepped types with hinged hoop set with citrine and garnet discussed above, which are likely of Ptolemaic origin; fashions spread quickly. Evidence for the identity of the young man comes from a very similar portrait on a clay sealing from Kallipolis in Aetolia, in northern Greece, where Echedemos was active as a diplomat in 190 B.C., negotiating a treaty between the Aetolian League (after the defeat of its ally, Antiochos III) and Rome. Echedemos himself is the subject of an epigram. One does not have to be a king to be praised, it seems, although surely Ptolemaic literary influence is present. In two surviving poems, the Athenian poet Artemon praises the beauty of his patron, whom he compares to the sun god Apollo. It is, unfortunately, an appallingly sycophantic poem:

Child of Leto, son of Zeus the great, who utterest
 oracles to
all men, thou art lord of the sea-girt height of Delos;
 but the lord of the land of Cecrops
is Echedemus, a second Attic Phoebus, whom soft-
 haired Love lit with lovely bloom. And his city Athens,
 once mistress of the sea and land,
now has made all Greece her slave by beauty.[39]

The flattery is overwrought, but it signifies the importance of poetry in Hellenistic aristocratic circles. Gems served a similar purpose, to praise the patron, grant status to those he chose to benefit, and remind all of his power and authority.

1. See Poseidippos of Pella 2001; Austin and Bastianini 2002; and there is now a considerable body of additional scholarly commentary.
2. For a portrait of Ptolemy II carved in amethyst, see Boardman and Vollenweider 1978, p. 80, no. 285; for amethyst mines in Egypt, see Shaw and Jameson 1993.
3. Pliny the Elder, *Natural History*, 37.8; Apuleios, *Florida*, 7.6–7; no work by Pyrgoteles survives.
4. Boardman and Vollenweider 1978, pp. 76–78, no. 280.
5. Pliny, *Natural History*, 37.107–9; Harrell 2014; Thoresen and Harrell 2014.
6. Walters Art Museum, Baltimore, 42.1319; see Reeder 1988, p. 246, no. 141; Spier 1989, pp. 21–22, fig. 2.
7. Poseidippos of Pella 2001, pp. 113–14; Austin and Bastianini 2002, pp. 26–27.
8. See, for example, Theophrastos, *On Stones*, 4.23; Theophrastos 1956, pp. 136–37; Theophrastos 1965, p. 102.
9. J. Paul Getty Museum, Malibu, 83.AN.437.9; see Spier 1992, pp. 57–58, no. 111.
10. Marshall 1907, p. 70, no. 384; Plantzos 1999, pp. 60, 118, no. 141, pl. 25; Walker and Higgs 2001, p. 111, no. 136.
11. For the varieties of beryl, see Pliny the Elder, *Natural History*, 37.76–79; an epigram by Macedonian poet Addaios, who lived during the reign of Alexander the Great, describes an "Indian beryl" engraved by Tryphon, which may have been aquamarine; see Paton 1916–18, vol. 3, p. 301, 9.544.
12. Poseidippos of Pella 2001, pp. 115–16; Austin and Bastianini 2002, pp. 28–29.
13. Pliny the Elder, *Natural History*, 37.8.
14. The first set with citrine and the second with garnet, see Miller 1979, p. 41, pl. 26e; Scarisbrick 2004, p. 22, no. 36; Spier and Ogden 2015, pp. 76–79, nos. 28–29, respectively.
15. Miller 1979, pp. 40–41, 61, pl. 26.
16. Theophrastos, *On Stones*, 3.18; Theophrastos 1956, pp. 89–90. For a survey of the literary and archaeological evidence, see Thoresen 2017, pp. 172–74, 180.
17. Poseidippos of Pella 2001, pp. 111–12; Austin and Bastianini 2002, pp. 24–25.
18. Museum of Fine Arts, Boston, 27.709; Beazley 1920, pp. 80–81, no. 96; Spier 1989, pp. 23, 30, no. 1, fig. 5; Plantzos 1999, pp. 49–50, 114, no. 35, pl. 7 (identified as Arsinoe II in the guise of Aphrodite).
19. J. Paul Getty Museum, Malibu, 81.AN.76.59; see Boardman 1975, pp. 92–93, no. 59; Spier 1989, fig. 36; Plantzos 1996, p. 121, pl. 22a. For gold rings once set with cut-out gems, see Segall 1938, p. 39, no. 32, pl. 13; Amandry 1953, pp. 105–6, fig. 65.
20. See Plantzos 1996.
21. Poseidippos of Pella 2001, pp. 150–52; Austin and Bastianini 2002, pp. 58–59; Fulińska 2012.
22. Apollonios, 1.742–44 .
23. Museum of Fine Arts, Boston, 21.1213, from Eretria, Tomb of the Erotes; see Beazley 1920, pp. 85–86, no. 102; Plantzos 1999, pp. 68, 119, no. 165, suggests an Alexandrian origin; for a recent analysis of the tomb, see Huguenot 2008, vol. 1, pp. 180–82; vol. 2, pp. 2, 18, no. 69, pls. 32, 1–3.
24. Spier and Ogden 2015, pp. 74–75, no. 27, also notes another garnet in Paris.
25. Gutzwiller 1995.
26. *Greek Anthology*, 9.752; Gutzwiller 1995, p. 383.
27. Diodoros of Sicily, *The Library of History*, 20.37.3–6.
28. Spier 1992, pp. 81–82, no. 180, with further literature on gems of this type.
29. Pausanias, *Description of Greece*, 2.27.3.
30. Poseidippos of Pella 2001, pp. 126–128; Austin and Bastianini 2002, pp. 38–39.
31. Pliny 1940–86, vol. 8, p. 235, 31.148–49. See also Ausonius, *Mosella*, 311–17, and Rufinus of Aquileia, *Ecclesiastical History*, 11.23, for an iron statue in the Temple of Serapis in Alexandria.
32. Pfrommer 2004.
33. Museum of Fine Arts, Boston, 27.711; see Beazley 1920, p. 80, no. 95, pl. 6; Kyrieleis 1975, pp. 117, 120, pl. 100, 2 (suggesting the identification as Cleopatra II); Plantzos 1999, pp. 52, 115, no. 48, pl. 9; Phoebe Segal in Picón and Hemingway 2016, p. 212, no. 137.
34. J. Paul Getty Museum, Malibu, 92.AM.8; see Pfrommer 2001; Mary Louise Hart in Picón and Hemingway 2016, pp. 225–27, cat. 159a–k.
35. Plutarch, *Parallel Lives: Lucullus*, 3.1.
36. See Spier 1989, for late Ptolemaic portraits in garnet. For the sealings from Edfu and Nea Paphos, see Milne 1916 and Kyrieleis 2015.
37. Numismatic Museum, Athens, Karapanos Collection, 355; see Plantzos 1999, pp. 54, 115, no. 71.
38. Walters Art Museum, Baltimore, 57.1698; see Reeder 1988, p. 241, no. 136; Pantos 1989; Plantzos 1999, pp. 58, 116, no. 101; Marden Fitzpatrick Nichols in Picón and Hemingway 2016, p. 216, no. 144.
39. Paton 1916–18, 12.55, 12.124 .

Christine Kondoleon
Visual Riddles and Wordplay in Hellenistic Art

The remains of Hellenistic mosaics suggest that the pictorial arts of the period were remarkably rich and varied, with innovative compositions and techniques. More recent archaeological discoveries in Greece (Aigai) and Egypt (Alexandria) and the older recorded mosaics from Pergamon and Pompeii suggest a highly sophisticated audience for these arts, especially in the realm of the royal households. Inventive artists were patronized at the highest levels, and what we glimpse, if only through the serendipity of finds, are hints of a dynamic exchange between performances, poetry, word, and image. There are parallels in the inventiveness of artists and writers at this time who seem in the thrall of the aesthetic of *poikilia*, Greek for versatility and intricacy, namely a diversity in arts, crafts, poetry, music, and rhetoric. This essay explores a few instances of the interplay of images and words, that is, the influence of poetry on image making and its reception. The sequence of such exchanges is difficult to track, but there is enough evidence to point to the primacy of the recited word for some of these examples.

The overlapping imagery shared by some mosaics, sculptures, and luxury arts reflects a Hellenistic visual culture that celebrates variety and invites the viewer to share in learned jokes and wordplays. As Greek literary historian Marco Fantuzzi aptly notes, there was a "competitive flirtation between poetry and the plastic arts."[1] Perhaps, it was the Hellenistic poets who led the trend toward naturalism, toward heightened expressions of emotion and eroticism. Were these word masters the catalysts for the taste for a new cosmopolitan society that privileged virtuosity, elegance, and wit? The very technique of mosaic made of cut cubes

(tesserae) of stone or glass is a Hellenistic invention; the technique developed from the fourth century B.C. and is characterized by the use of light and dark pebbles (as in Pella) and the explosion of colors and painterly effects that emerged in the later Hellenistic period. The introduction of a number of new subjects on mosaics, such as the Asian green parakeet from the east side of Palace V on the Pergamon Acropolis (200–150 B.C.), suggests a keen observation of nature and a fascination with the natural world of the newly conquered territories opened by Alexander's campaigns eastward. No subject was too minor to employ expert craftsmanship in the service of realism. For example, pet animals such as hounds were the subjects of short poems, epigrams, and the visual arts.[2] An arresting image of a Jack Russell-like dog on a mosaic roundel of the second half of the second century B.C., discovered during the construction of the new Library of Alexandria in what was once the Ptolemaic Palace quarters, exemplifies the inventive ingenuity of the Hellenistic mosaicist who captured the moment just after the hound kicks over a metal pitcher.[3] The image is so fresh and appealing that it seems to be a poem "in stone" in the spirit of the third-century B.C. poet Callimachus of Cyrene: "poetry should aim at small-scale perfection."[4]

The focus on the less grand, one might say the intimate, is a characteristic of the expanded repertoire of the Hellenistic poets who took the epigram inherited from their Attic forebears and used it as a format to explore love (Eros) and nature, the sensual and the pastoral. Meditations on beloved pets and the noises of the cicada or shrill-voiced mosquitoes are among the topics found in the

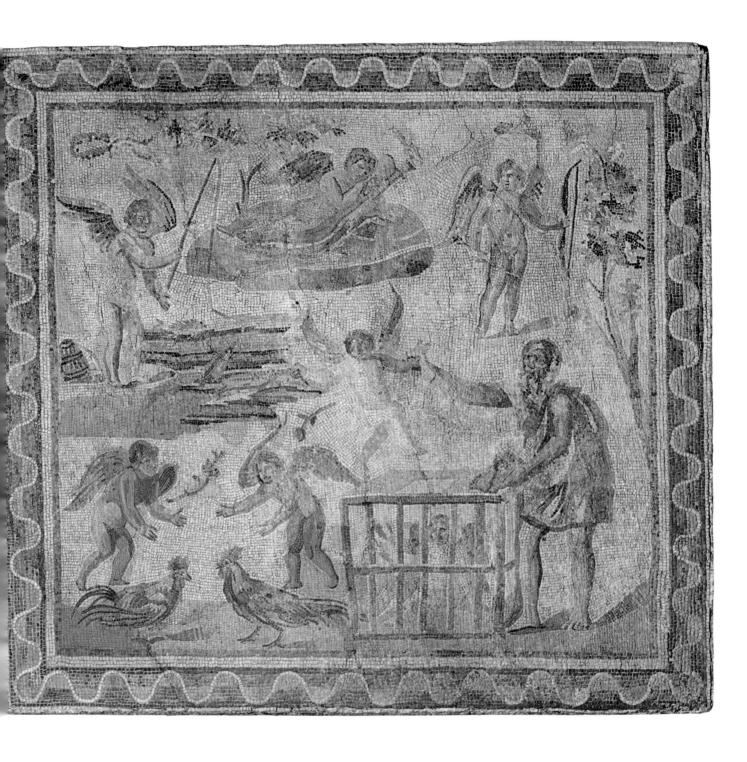

FIG. 1. Mosaic with Peddlar of Erotes, Roman, Syria (present day Turkey), 3rd century A.D. Stone, glass, and lime mortar, 87 x 97½ x 2 in. (221 x 247.7 x 5.1 cm). The Baltimore Museum of Art, Antioch Subscription Fund, BMA 1937.128

first anthology of short poems titled *Garland* (*Stephanus*) by Meleager of Gadara.[5] And while this first century B.C. collection includes poems dating back to the sixth century B.C., there is a clear preference for themes of love and wine in works from the later periods. Eros, child of Aphrodite, was the most appealing subject for Hellenistic poets, who explored the many facets of his childishness through their words. At the same time, Hellenistic artists were equally drawn to depict Eros as both a charming and a dangerous child. Theocritus, who was from Sicily and traveled about to Alexandria and Kos, initiated the pastoral tradition in the fourth century B.C., but he also wrote love epigrams. In one, he likens Eros to a minor irritation such as a sting by a bee and in another, to the prick of a thorn.[6] The visualization of these words by artists of the period suggests an interplay between description or *ekphrasis* and invention, but which came first, the poem or the image? When a Hellenistic viewer gazed upon the gorgeous sleeping bronze Eros (see p. 18),[7] it is more than likely that their viewing was conditioned by words such as these, from a Hellenistic epigram: "I fear, ambitious boy, / That even as you slumber, you might see a dream piercing to me."[8] Behind the innocence lurks an image of Eros that is all-powerful. This is also brilliantly expressed in a first century B.C. terracotta statuette representing Eros wearing the Nemean lion skin of Herakles over his head and shoulders.[9] Eros seems to smirk as he holds his hands behind his back, perhaps to hide the apples of the Hesperides. This pose functions as a humorous sendup of the famed fourth century B.C. masterwork *Eros Stringing the Bow* by Lysippos in the Capitoline Museum. The sculpture must have been understood as a visual message professing that "love conquers all," as stated in an epigram by Geminus (who was a Roman Consul in Moesia in A.D. 46 and one of the epigrammatists named in the Greek Anthology) entitled "On a Statue of Heracles," that "Heracles, where is your great club, your Nemean cloak and your quiver full of arrows. . . . you are in distress, stripped of your arms. Who was it that laid you low? Winged Love, of a truth one of your heavy labors."[10]

The conceit that love is tricky and needs to be caught and tamed by punishment was popular in the Hellenistic era. Moschus, a second century B.C. Greek bucolic poet of Sicily, wrote a poem titled "Eros the Runaway" (ΕΡΩΣ ΔΡΑΠΕΤΗΣ), wherein he describes a little boy slave who is sought by his mother, who goes about warning of his tricks and to keep him tightly chained.[11] While only three scenes survive, two wall paintings from Stabiae and a Roman third century A.D. mosaic from Antioch (fig. 1), they tell the same story and must be based on a lost Hellenistic pictorial model.[12] The mosaic features an old man called a peddler by several scholars who grabs an Eros by his arm and pulls him into a cage where there is another Eros already caught. In the Stabian painting, a seated older female pulls out of the cage a winged Eros, seeming to offer it to a seated wealthy matron whose attendant appears to discuss his merits. In the *Garland* of Meleager, there is a poem (poem 3) that provides the "sound track" of the scene and underscores the Hellenistic origins of the visual composition: "Let him be sold, though still he sleeps upon his mother's breast! Let him be sold! Why should I keep so turbulent a pest? For winged he was born, he leers, sharply with his nails he scratches . . . an utter monster: and for that reason sold shall he be today: if any trader would buy a boy, this way!"[13] The words of these Hellenistic poets provide a way to understand the Roman compositions, which in turn might be traceable to a lost Hellenistic model in painting or mosaic.

In order to best understand the aesthetic of Hellenistic culture, it is vital to draw on variations in different media, as it is this very diversity (*poikilia*) that was valued and sought by poets and artists alike. Toward that end, precious jewelry offers many intimate and inventive images. The struggles of the lovelorn in the grip of desire, those seeking the help of the gods to secure reciprocation and satisfaction, are invoked in a group of gold rings, intaglios, and cameos of the Hellenistic age. Undoubtedly, these were worn as talismans, and their subject matter reflects the interplay between what is held and what is seen, what is used or worn, and what is felt or recited. A sampling of a group of gems in the Farnese Collection in Naples reveals a range of Eros imagery that exemplifies the imaginative ways in which Eros was depicted—bound in chains, punished, fighting with cocks.[14] Sometimes, such items were given as gifts to the beloved and as such carried special messages, but deciphering their meaning can pose challenges to the contemporary mind. On an exceptionally fine gold ring of the late Classical period, Aphrodite is balancing two Erotes on a scale, with a third at her feet (fig. 2).[15] The weighing of love (*Erotostasia*) is a rare image, and while

FIG. 2. Ring with Aphrodite weighing Two Erotes, Greek, Classical, late 5th century B.C. Gold. Bezel, 11/16 in. (1.8 cm). Museum of Fine Arts, Boston, Francis Bartlett Donation of 1912 (23.594)

we cannot be certain, perhaps it was a visual pun on the age-old theme of she/he loves me, she/he loves me not. It clearly is some sort of playful variant on the more serious iconographic theme of the weighing of souls (*Psychostasia*).

Aphrodite can be seen meting out punishments to her naughty boys on a gilt silver mirror, on which she sits at the edge of her chair about to strike the wrong boy for dropping her perfume bottle that is shown broken at her feet, while the guilty Eros hides under her seat (fig. 3).[16] A date in the later Hellenistic period seems likely, and given this charming vignette, it may well be inspired by a now-lost epigram. In fact, the Boston mirror can be compared to a scene found on the medallion of a gilded silver dish from Seleucid Bactria dated to the third or second century B.C., on which a seated Aphrodite casts her head downward toward an Eros whom she holds by one wing as he looks pleading up at her. Most likely, he is being punished for

FIG. 3. Mirror with Seated Aphrodite and Erotes, Greek, late Hellenistic, 2nd–1st century B.C. Gilt silver, 6 5/16 in. (16.1 cm). Private Collection, Boston

FIG. 4. Plate with Erotes struggling with a lion, Greek, late Hellenistic, 200–100 B.C. Gilt silver. Al-Sabah Collection, Kuwait (LNS 1269M)

the spilled contents of her perfume flask set at the bottom of the medallion.[17] Variations on the theme of Aphrodite punishing her boy are found on Hellenistic and Roman mirrors, which fittingly provide their owners with an intimate connection to the feminine, the beautiful, and the sensual.[18] A similarly posed Aphrodite sits holding up a box mirror to her winged son, who points to his own reflection on a plaster cast found in ancient Kapisi (now Begram, Afghanistan).[19] The cast most likely belongs to a group of about fifty plaster medallions found in the Begram hoard in rooms thought to be part of the royal workshops; the casts must have served as workshop models for merchants to sell and for clients to select precious metal wares from the Hellenistic West.[20] Several of these casts have scenes that are found on carved stone reliefs and on the central medallions of silver wares (such as plates and deep bowls) and mirrors, suggesting that a great variety of compositions entered the artistic repertoire with little regional differentiation to satisfy an elite from across the Hellenistic world reaching to what is now Afghanistan.[21]

The mischief of multiple Erotes forms the center of yet another remarkable gilded silver plate from Seleucid Bactria and now in the Al-Sabah Collection in Kuwait (fig. 4).[22] In a rustic sanctuary setting demarcated as Dionysiac by the thyrsoi, four Erotes struggle to put slippers on a sleeping pantheress. The plate dates to the third or second century B.C. and establishes the formulation of the composition by this time. Because the scene is also the subject of three mosaics, the series offers important evidence for the currency of Hellenistic style and iconography in a widespread region and its legacy in Roman art. The mosaics feature various numbers of Erotes tormenting a lion with ropes in a similar rustic Dionysiac setting, but the mosaicists make more of it by including maenads, and even Dionysos himself (fig. 5).[23] As amusingly portrayed on these mosaics, the power of Eros, especially when

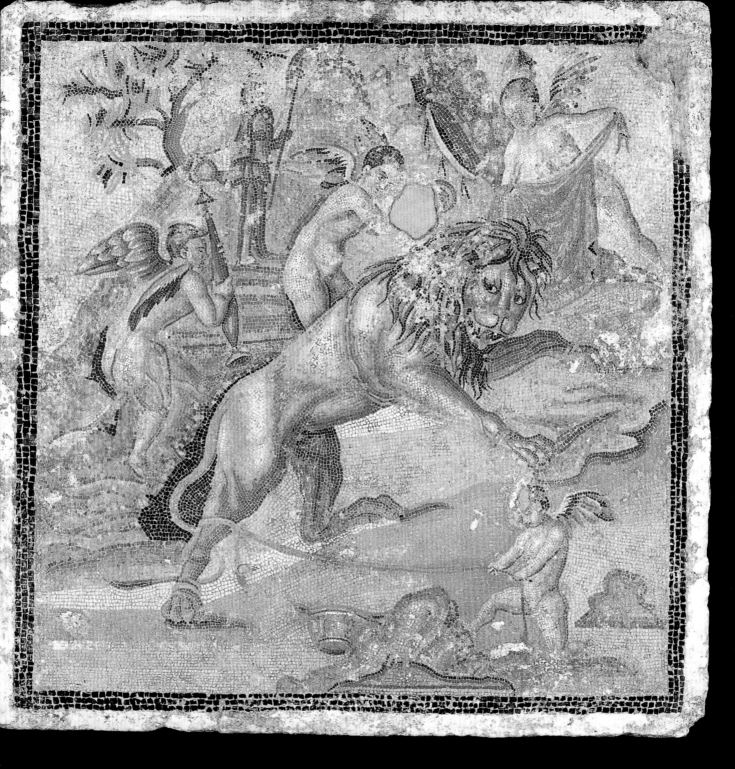

FIG. 5. Mosaic with Erotes tormenting a lion, Greek, late Hellenistic, from Capua, 2nd century B.C. British Museum, London (inv. M1)

multiplied as Erotes, is such that even the most ferocious of creatures—the lion, the panther, or the tiger—can be tamed.

This conceit is close in spirit to a multifigured marble sculpture described by Pliny as the work of the early first century B.C. sculptor Arkesilaos.[24] It was carved from a single piece of marble and included winged Erotes with a lioness. According to Pliny, some of the Erotes tie up the lioness; others hold her down; others compel her to drink; and others try to put slippers on her. The sculpture seems to encapsulate in the humor of the winged little boys taming a lion, the type of overblown parody that appealed to Hellenistic tastes. On the gilded silver plate, the slippers mentioned by Pliny as part of the marble sculpture group are featured, but they are not present on the mosaics. Piecing these variants together gives a fairly accurate idea of the elements of the original composition. The fact that the theme is explored in marble, mosaic, and silver suggests the far flung mobility of visual formulas and their adaptability.

The attraction to the miniature, the childish, and the playful has long been recognized as an innovation of Hellenistic art, but the multiplication of Erotes may in fact have a more serious cast and one directed to an audience schooled in the poetic language of the period.[25] Viewers and users of the precious objects and spaces decorated with such scenes were meant to interact with these works, to understand their performative dimensions. For example, a literary scene composed by the Syrian Lucian, a writer associated with the Second Sophistic, a period (second century A.D.) steeped in the revival of Greek culture, offers dramatic commentary on Erotes and lions. In his *Dialogues of the Gods*, Aphrodite and Eros exchange words. Aphrodite warns her son that he has gone too far in his mischief in making Rhea fall for Attis and that her lions have disheveled hair, and are blowing horns, clashing cymbals, and beating their drums. She expresses her concern that the lions will tear him to pieces, to which Eros replies: "Be under no alarm, mother; I understand lions perfectly by this time. I get on to their backs every now and then, and take hold of their manes, and ride them about; and when I put my hand into their mouths, they only lick it, and let me take it out again. Besides, how is Rhea going to have time to attend to me? She is too busy with Attis. And I see no harm in just pointing out beautiful things to people; they can leave them alone;—it is nothing to do with me. And how would you like it if Ares were not in love with you, or you with him?"[26]

Further confirmation of the popularity and understanding of this imagery is found in the far reaches of the Hellenistic world, where two bronze wall decorations of Erotes riding a lioness were found in a house in Yemen dated to the late first century B.C.[27] One of these Love boys smiles and the other does not, as they ride full-maned lions and tame them with whips and chains. Whether these were imported or cast in a local foundry, they speak to a language of humor shared throughout the Hellenistic world. Similar messages come through on Hellenistic mosaics from Pompeii and Delos with the child Dionysos as the Tiger Rider, as they alert the visitors to these receptions to beware of the power and pitfalls of the magic poison of desire, especially when drinking.[28]

Several gold medallion plaques from Amarit, Syria, dated to the third century B.C. bear the device of Aphrodite riding lions, and in one case, Eros is tied up while walking by her side.[29] Again, it is the precious intimate objects that tell the bigger story—namely that rather early in the Hellenistic age, artists and poets adopted motifs that were widely appealing and even powerful, as such gold plaques could have been worn as talismans to either protect or invoke the power of Aphrodite/Eros. The ability of ancient artists to capture the emotion, the humor, and the subtleties of ancient poets is impressive and should alert us to a very fluid exchange among artists and writers and the sophistication of ancient viewers who were clued in to the culture.

1. See Fantuzzi 2009, p. 294, in his review of the far-reaching and insightful study of word-image ensembles in the Hellenistic and Roman period that focuses especially on the Poseidippos of Pella epigrams on the precious stones (*Lithika*) by Prioux 2008; and Kuttner 2005 who reviews how the gem-poems of Poseidippos set up a gallery of art and poetry that informs us about "the cultured Hellenistic eye" and how it plays out in the royal courts.

2. B. Fowler 1989, pp. 127–31, figs. 87–91.

3. Lightfoot 2016b, p. 82, fig. 107.

4. Howatson 2013, p. 126, who reports that Callimachus of Cyrene reputedly stated this.

5. Paton 1916–18, vols. 1, 2: for the mosquito, see 5.151; for the cicada, see 7.196.

6. See Peter Higgs in Picón and Hemingway 2016, pp. 277–78, no. 221. The thorn wound is described in Theocritus, *Idylls*, 4.50–57; see Theocritus 2015, pp. 78–79. On the thorn puller sculpture group type, see the recent article Meinecke 2016.

7. The Metropolitan Museum of Art, New York, 43.11.4; see Hemingway and Stone 2017. Picón and Hemingway 2016, pp. 274–75, no. 218.

8. *Greek Anthology*, 16.211; Sorabella 2007, p. 355.

9. Museum of Fine Arts, Boston, 00.321; See Christine Kondoleon in Picón and Hemingway 2016, p. 168, no. 81.

10. *Greek Anthology*, 16.103; Gow and Page, 1968, vol. 2, p. 295.

11. Moschus, "Eros the Runaway," 2. 24–28; see Theocritus 2015, pp. 443–47.

12. See Levi 1947, vol. 1, pp. 191–95, for the fullest discussion of these scenes and the citation of the epigram of Meleager of Gadara as an explanation for the Antioch mosaic from the "House of the Peddlar of Erotes," now in the Baltimore Museum of Art, 1937.128; and the "Seller of Cupids" fresco, Villa Arianna, Castellammare di Stabia, ca. 50 A.D., 9180; see Pescei and Freed 2004, p. 113, no. 7; and Levi 1947, vol. 1, p. 194, which cites two frescoes from Pompeii with the scene; the other is from the Casa dei Capitelli Colorati.

13. Levi 1947, vol. 1, p. 147.

14. In the Museo Archeologico Nazionale, Naples, Farnese Collection, sardonyx, 25858, with the capture of Eros; onyx cameo, 26027, with Eros bound; Eros as Herakles, 6718; Erotes with cocks fighting, 25849; and Eros punishing Psyche, 25912. Also to consider with these is the group of intaglios with the subject of Eros kneeling beside a wounded lion who extends his forepaw; see Bonner 1944, especially p. 443, n. 12, in which the author cites Lucian, *Dialogues of the Gods*, 12.2, and notes that several gems show Eros riding a lion.

15. There are two gold Late Classical rings, one at the Museum of Fine Arts, Boston, 23.594, and the other at the J. Paul Getty Museum, Malibu, 85.AM.277.

16. From the collection of George and Lizbeth Krupp, Boston, and displayed in the 2011–12 "Aphrodite and the Gods of Love" exhibition.

17. Carter 2015, pp. 154–55, no. 31.

18. Taylor 2008, pp. 47–55.

19. The Metropolitan Museum of Art, New York, 1996.472; see John Guy in Picón and Hemingway 2016, pp. 250–51, no. 188; and Picón 2014, especially p. 452.

20. On possible functions of the Begram plaster reliefs, see Boardman 2015, p. 162.

21. For example, the hitherto unparalleled Museum of Fine Arts, Boston, RES.0834C, relief of an older man asleep on the ground beside a rustic sanctuary who is portrayed in a dreamlike sexual union with a winged female; see Kondoleon and Segal 2011, pp. 126–27, 202, no. 107, shares the same composition with a plaster cast from Begram from the National Museum of Afghanistan, Kabul; see Hiebert and Cambon 2008, pp. 184–85, no. 190.

22. See Carter 2015, pp. 156–58, no. 32. Another very similar gilt silver medallion was recently on the European art market, but this version does not include the slippers; I thank Jeff Spier for bringing it to my attention.

23. The earliest of the three mosaics is Erotes tormenting a lion, Capua, 2nd century B.C., now at the British Museum, London, MI; for another from the House of the Centaur (VI 9,3), Pompeii, now in Museo Archeologico Nazionale, Naples, 10019, see Andreae 2003, pp. 190–201, fig. 192; for the Mosaic of Erotes Tormenting a Lion, Anzio, ca. 50 A.D., now in Antiquarium Comunale, Rome, see Salvetti 2013, pp. 227–30, fig. 84. The motif of the lion tamed by love as represented in this group of mosaics is reviewed by Prioux and Trinquier 2016, pp. 45–46, who add the interesting suggestion that the cloth held by the erotes in several of the mosaics is meant to blind the lion whose power resides in the eyes. These mosaics are discussed in reference to the symbol of the lion in royal iconography and its appropriation by the Ptolemaic Queen Berenike II.

24. Pliny the Elder, *Natural History*, 36.41.

25. See especially Onians 1979, pp. 126–33; Gutzwiller 1995, warns not to take the epigrams of Poseidippos seriously, as in the case of an amethyst gem engraved with the image of *Methe* (Drunkenness) that turns out to be a clever rhetorical device for praising Cleopatra, sister of Alexander the Great.

26. Lucian, *Dialogues of the Gods*, 20.12; Lucian 1961, pp. 331–33.

27. The lion riders are from the House of Yafash, Yemen, Freer Sackler, Smithsonian Institution, Washington, D.C., LTS1992.6.87, LTS1992.6.88; see Daehner and Lapatin 2015, pp. 240–41, no. 26.

28. See, for example, the House of the Faun, Pompeii; Andreae 2003, pp. 188–92, figs. 188, 189.

29. From Amarit, Syria, third century B.C., now in the Musée du Louvre, Paris, BJ2242-2243-2244; originally in the De Clercq De Boiseglin Collection; see Ridder 1911, p. 248, nos. 1371, 1372, pl. V.

PERGAMENE STUDIES

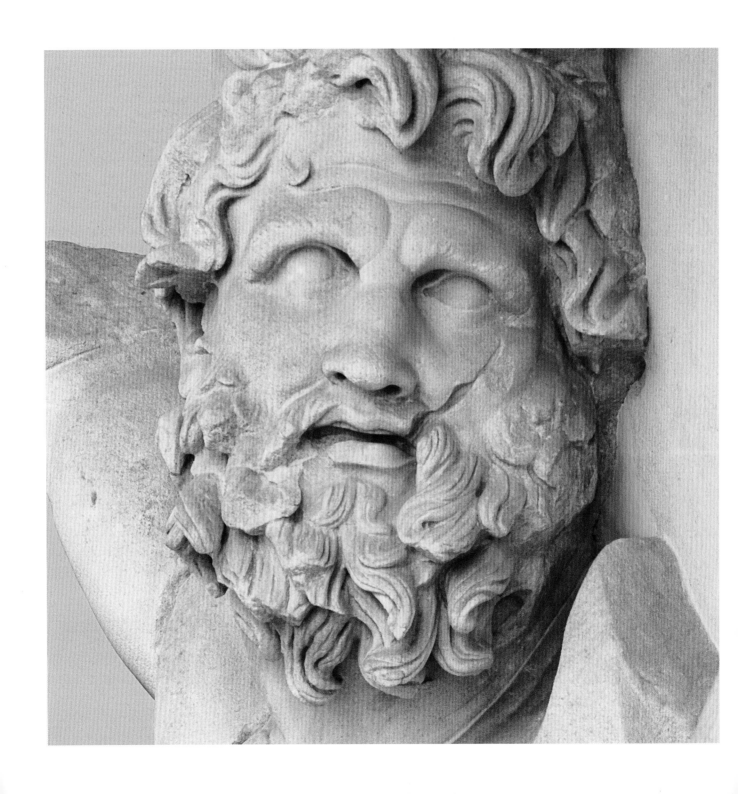

Andreas Scholl

Monumental, Impressive, Unique: Hellenistic Art and Architecture in the Restored Pergamon Museum

History of the Pergamon Museum

Construction of the Pergamon Museum, until quite recently the youngest structure on Berlin's Museum Island, took many years. From 1830 to 1876, three Neoclassical museum buildings were erected on the island in the Spree: the Altes Museum, the Neues Museum, and the Alte Nationalgalerie. But in the late nineteenth century, there was absolutely no room for the display of the large numbers of works of art including architectural elements that found their way to Berlin thanks to new purchases and above all, from the division of finds after large-scale excavations mainly undertaken in the Ottoman empire—foremost of course at Pergamon, but one might also think of Miletus, Didyma, Priene, or Myus.

In 1881, the Berlin Architects' Association was commissioned to design structures to house the finds from Olympia and Pergamon, as well as an extension for the enormous collection of plaster casts. According to a major competition announced in 1884, a "Renaissance museum" for the art historical holdings was meant to be erected at the northern tip of the island, and another for the ancient originals south of the urban railway viaduct, still in existence today. Then in 1896, the famous director general Wilhelm von Bode convinced German emperor Wilhelm II to build the Kaiser Friedrich Museum (since 1960 named the Bode Museum). The new museum for the finds from Asia Minor planned by the architect Fritz Wolff was thereupon reduced to a pavilion-like structure to house the Pergamon Altar. This first Pergamon Museum presenting finds from Pergamon, Magnesia on the Maeander, and Priene was inaugurated in December 1901 (fig. 1). A full-scale reconstruction of the Pergamon Altar that could be viewed from all sides served as the museum's centerpiece (fig. 2). Fragments of ancient buildings were to be found in a courtyard. This building, with galleries filled with natural light, was a groundbreaking innovation, but it survived for only a few years; structural damage and plans for an expansion of the museum led to its being razed in the spring of 1909.

Following Wilhelm von Bode's concept, in 1907, the Berlin architect Alfred Messel began planning a monumental new museum building with three wings. In addition to the Pergamon Altar at the very center, other reconstructions of ancient architecture were to be displayed in the south wing, where the Museum of the Ancient Near East (Vorderasiatisches Museum) found its new home. The north wing, the so called German Museum (Deutsches Museum), with central European art from the Middle Ages to the Baroque, combined a badly misconceived exhibition of original art works and casts mixed at random. A colonnade was to close off the courtyard on the Kupfergraben side, but it was never erected.

After Messel's death in 1909, the project was entrusted to Ludwig Hoffmann, who realized the original plan by 1930. The site posed and still poses very special problems. A mud-filled pit 50 meters deep known as the Kolk, a leftover from the last Ice Age, had to be bridged over with a concrete vault beneath the south wing. Work was suspended during World War I and resumed only after 1924. The planned colonnade, the entrance structure, and all the sculptural ornamentation were abandoned in order to reduce the building costs. The design of the interiors reflected the architectural notions of the 1920s, especially

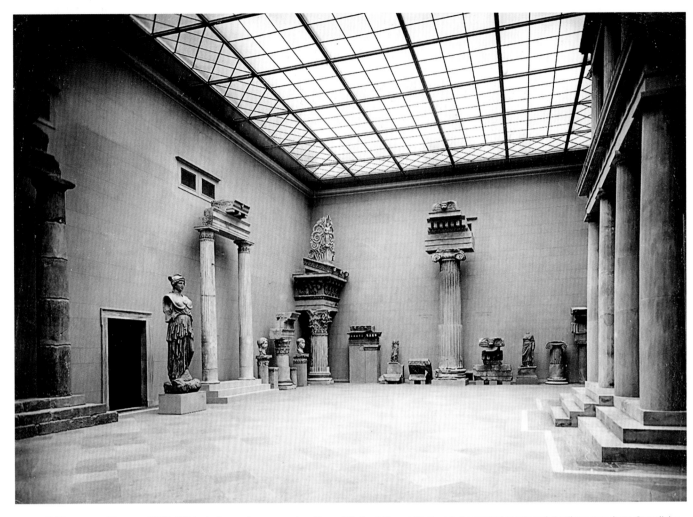

FIG. 1. Old Pergamon Museum (1901–08), including various reconstructions of Hellenistic architecture in its central courtyard. Antikensammlung, Staatliche Museen zu Berlin

the ceilings, which were inspired by the Bauhaus and Neue Sachlichkeit movements. In 1926, the planned Olympia Room was abandoned in favor of the Ishtar Gate and the reconstruction of the Processional Street from Babylon.

For the Berlin state museums' centennial in 1930, the new structure was inaugurated, with the German Museum (Deutsches Museum), the ancient architecture galleries, the Pergamon Altar, and the Babylonian structures in the south wing. Pedestrian bridges connected the main floor to the Neues Museum and to the Bode Museum on the other side of the urban railway viaduct, but the entry situation has remained provisional until the present day.

At the beginning of World War II, the museums were closed and their holdings placed in storage. Bombing at the end of the war heavily damaged mainly the Mshatta Façade and the Market Gate from Miletus. After repairs, the Museum of the Ancient Near East (Vorderasiatisches Museum) was reopened to visitors in 1953, and the rebuilt Market Gate opened a year later. The hall containing the Pergamon Altar had to wait until 1959, that is, until after the return from the Soviet Union the year before, of important museum collections, such as the slabs of the altar frieze.

War damage and the political division of Berlin during the Cold War period occasioned a redistribution

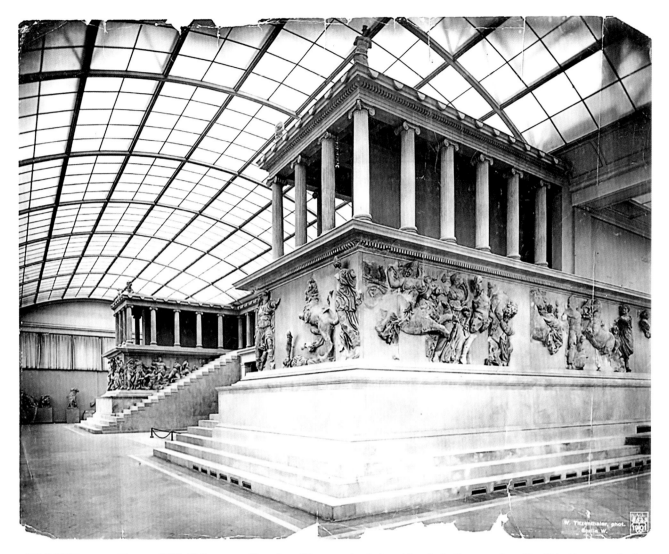

FIG. 2. Old Pergamon Museum (1901–8), Pergamon Altar, view of the reconstructed west facade. Antikensammlung, Staatliche Museen zu Berlin

of the collections between the island's museums and the new museums in West Berlin. The returned holdings from the Collection of Classical Antiquities (Antikensammlung) were placed in the galleries of the former German Museum (Deutsches Museum), in the north wing. The main floor served primarily for the display of ancient sculptures, while smaller works were accommodated in a portion of the second floor. From 1980 to 1982, a central entrance structure with space for service facilities was erected. It was required to adhere to the dimensions of the entrance structure as planned by Messel. The courtyard was redesigned, and a new bridge built across the Kupfergraben. At last, the Pergamon Museum was given a suitable entrance.

The reunification of Germany and, subsequently, of the State Museums under the aegis of the Prussian Cultural Heritage Foundation (Stiftung Preussischer Kulturbesitz) meant that new planning for the Pergamon Museum was initiated. Once its overall refurbishment and completion is finished (hopefully by 2030, the centennial of the Pergamon Museum), the Museum of the Ancient Near East (Vorderasiatisches Museum) is to take over the entire south wing, and the Museum of Islamic Art (Museum für Islamische Kunst), with the Mshatta Facade, (fig. 3), is to be assigned

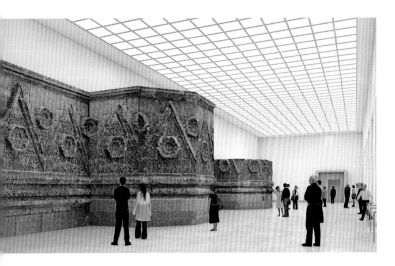

FIG. 3. Pergamon Museum, north wing, computer rendering of the main floor with the full scale reconstruction of the Ummayad Mshatta Facade

to the north wing. The historic galleries with Classical and ancient Near Eastern architectural monuments are to remain largely unchanged. A planned connecting passageway, the Archaeological Promenade, partially underground, will serve to tie together the buildings with archaeological holdings (fig. 4). In addition, a new central entry structure named James-Simon-Gallery to the south of the Pergamon Museum, designed by David Chipperfield, will assume general service functions from early 2019 onward.

In 2000, following an international competition, Oswald Mathias Ungers from Cologne was awarded the commission for the general refurbishing and completion of the Pergamon Museum. In order to establish for the very first time a logical and self-explaining guidance system including a central entrance structure, his design calls for a fourth wing along the Kupfergraben, connecting as a

FIG. 4. Museum Island Berlin after completion in 2030, computer rendering of the archaeological promenade indicated in gray shading, 2015

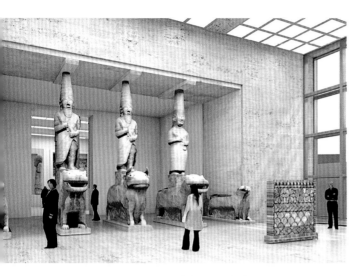

FIG. 5. Pergamon Museum, view south from inside the new west wing, with a full scale reconstruction of the monumental entrance to the Aramean royal palace of King Kapara at Guzana (Tell Halaf) in northern Syria, 9th century B.C., 2015

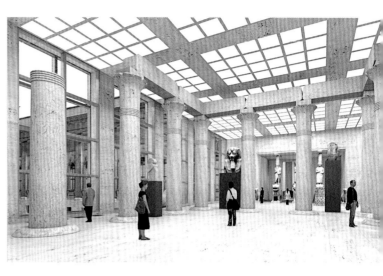

FIG. 6. Pergamon Museum, view south from inside the new west wing, with a partial reconstruction of the funeral temple of Pharaoh Sahure, 5th dynasty, ca. 2440 B.C., from Memphis/Abusir, 2015

bridge both wings, which have been dead ends since 1930. The new fourth wing will accommodate Egyptian architecture as well as the ancient Near Eastern Tell Halaf Facade, thereby completing the circuit on the main-floor level (figs. 5 and 6). Once it is completed, the Pergamon Museum will be fully functional for the first time in its history, forming the centerpiece of the entire Museum Island, a UNESCO World Heritage Site since 1999.

The Collection of Classical Antiquities (Antikensammlung)

Berlin's Collection of Classical Antiquities dates back more than three hundred years. In 1698, antiquities from the G. P. Bellori Collection arrived from Rome and henceforth were added to the Elector's Kunstkammer in the Stadtschloss (Berlin City Palace). A first museum building, the Altes Museum, was built after plans by Karl Friedrich Schinkel and opened in 1830. All the antiquities were housed there until portions of the later structures on Museum Island could be utilized. The collection of ancient vases was moved to the Neues Museum in 1879, and in 1930, the Pergamon Museum opened with its reconstructions of the Pergamon Altar and the Market Gate from Miletus.

With the beginning of World War II, the art objects were stored in bunkers in and around Berlin. Large parts of the collection were taken by the Red Army to the Soviet Union in 1945, but the majority of them, including the Pergamon Altar friezes, were restituted to East Germany in 1958. The partitioning of Germany also divided the collection, part of which was displayed in the East in the north wing of the Pergamon Museum and part in the West in the Stüler Building opposite Charlottenburg Palace. In 1998, a reunified display opened on the main floor of the Old Museum. Ambitious restoration work on the Pergamon Altar (1994–2004) and the other architectural holdings heralded the comprehensive reconstruction and refurbishing of the Pergamon Museum, which began in 2013. Once this is finished, the Collection of Classical Antiquities (Antikensammlung) will be displayed in the three large halls containing Hellenistic and Roman architecture as well as the Pergamon Altar (fig. 7). Classical antiquities are also exhibited in the Neues Museum. In 2010/11, the Collection of Classical Antiquities took over the entire Altes Museum, where Etruscan and Roman works are exhibited on the upper floor and Greek art on the main floor.

Excavations

After the museum's founding, its holdings rapidly expanded, especially in the nineteenth century, by way of gifts and purchases. Schliemann's excavations in Troy in 1871 opened up a new field of research, the scholarly

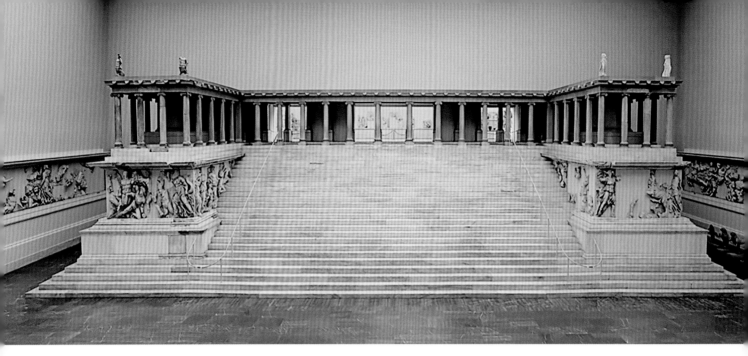

FIG. 7. Pergamon Museum, Pergamon Altar, reconstruction of the west facade. Antikensammlung, Staatliche Museen zu Berlin

excavation of ancient sites. Museum directors such as Alexander Conze, Theodor Wiegand, and Richard Schöne were instrumental in securing funds for such expensive digs. At the beginning, the primary focus was on the acquisition of new artworks for the museums, but increasingly, these endeavors fostered the scholarly study of ancient sanctuaries, settlements, and landscapes.[1]

Pergamon

Whereas Olympia was abandoned in late antiquity, Pergamon, modern-day Bergama in Turkey, is still inhabited. The German engineer Carl Humann arrived there in the 1860s to build roads. He saw that local lime burners were destroying the ancient ruins on the acropolis and urged the Berlin State Museums to undertake proper excavations. After a division of finds was agreed upon, from 1878 to 1886, the foundations of the Pergamon Altar were discovered and many slabs of the Giant and Telephus friezes unearthed. In addition, the upper city with its palaces, the Athena sanctuary, the Roman Trajaneum temple complex, a monumental theater, and a huge market were researched, along with the surroundings. Initially, the excavators were awarded a third of all finds, subsequently a second third, then in 1879, the Turkish government offered to sell to the museums the remaining share. As a result, all the frieze fragments discovered at Pergamon came to Berlin.

Numerous architects and archaeologists worked on this project under the direction of Alexander Conze and Carl Humann. The German Archaeological Institute continues excavations in Pergamon, which are administered to this day by its branch in Istanbul.[2]

Hall of Hellenistic Architecture

In the Hall of Hellenistic Architecture, architectural fragments are presented in partial reconstructions in such a way as to illustrate their function and effect. In the context of the didactic presentation as conceived by Theodor Wiegand and others, various models of ancient sites were created, and those of Pergamon's acropolis and the city center of Miletus are still displayed in the adjacent galleries. New tactile models for the restored and completed museum are currently in the making.

The hall, 30 meters long, 20 meters wide, and 17.20 meters high, combines reconstructions and original fragments from important Hellenistic buildings discovered at Miletus, Priene, Magnesia on the Maeander, and Pergamon (fig. 8).

Opposite the doorway leading from the center hall with the Pergamon Altar is the facade from the Temple of Zeus Sosipolis. This temple stood in the agora at Magnesia, surrounded by columned halls (*stoai*), and is a typical example of Hellenistic architecture in Asia Minor from the

second century B.C. In the corner to the right is a reconstruction of the Doric Temple of Athena, and to the left the graceful Temple of Zeus from the upper market at Pergamon. Also from Pergamon is the entrance gate (*propylon*), through which one enters the hall. It was part of a complex of colonnaded halls, also two-storeyed, that enclosed the precinct with the Temple of Athena in the east and north. According to the inscription above the passageway, in the second century B.C., Pergamon's King Eumenes II consecrated the complex to Athena, bringer of victory. On the side of the courtyard, the balustrades between the upper-story columns were decorated with reliefs of weapons; a few of the originals are mounted on the wall next to the gate. Depictions of trophies such as these were typical features of ancient victory monuments. In the center of the hall stands a colossal Hellenistic copy of the Athena Parthenos from the Acropolis in Athens that was found in Pergamon's Athena sanctuary. This impressive sculpture is now on long term loan to The Metropolitan Museum of Art (see p. 15, fig. 3).

To the left of the gate is a corner column with Corinthian capitals from the entrance to the courtyard of the Miletus town hall (*bouleuterion*). In the opposite corner, a portion of the *bouleuterion* has been reconstructed. The half-column order of the upper floor with windows and

relief shields is particularly notable. The hall's long walls feature sections of two famous large temple structures in their full original height. The Temple of Athena from Priene, begun in the fourth century B.C., is considered a classic example of Ionic architecture in Asia Minor (fig. 9). According to the Roman architect Vitruvius, it was the work of Pytheos, who also designed the tomb of the Carian ruler Mausolus of Halikarnassus, one of the Seven Wonders of the Ancient World. The opposite pair of columns stems from the Temple of Artemis in Magnesia, a key example of Hellenistic architecture from around 200 B.C. Vitruvius attributes it to the architect Hermogenes of Alabanda, who also composed a theoretical treatise about this temple.[3]

The Pergamon Altar

The Great Altar of Pergamon, excavated in the nineteenth century and partially reconstructed in its original size in the Pergamon Museum opened in 1930, is the most famous monument on Berlin's Museum Island (fig. 7). Because of the special importance of this unique ensemble from the Hellenistic period, the architect Alfred Messel planned the museum's main hall around it, and the museum itself ultimately came to be known simply as the Pergamon Museum.

Pergamon first took on political significance under the successors of Alexander the Great. King Lysimachus (360–281 B.C.), who ruled Thrace and Mysia, assigned a follower named Philetaerus as commander of the city to guard his large treasure there. Philetaerus rebelled against his master and established his own rule. By means of shrewd diplomacy and successful military campaigns, and with the assistance of Rome, he and his successors, who are known as the Attalids after his father Attalus, managed to establish an important empire in western Asia Minor. After defeating a band of marauding Celts, Attalus I (r. 241–197 B.C.) adopted the title of king. Under his sons Eumenes II (r. 197–159 B.C.) and Attalus II (r. 159–138 B.C.), Pergamon became a splendid royal residence. The most important monument in this redesigned city, visible from afar, was the Pergamon Altar, built on a terrace of the acropolis under Eumenes II around 170 B.C.

In early Byzantine times, the altar, along with other ancient buildings, was demolished and their materials incorporated into a massive fortification wall. Scholarly excavations were undertaken in the second half of the nineteenth century, by which time the early Byzantine walls

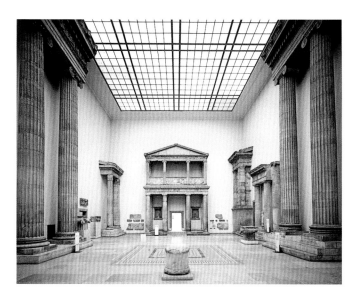

FIG. 8. Pergamon Museum, Hall of Hellenistic architecture, ca. 1990, with the facade of the propypylon to the Sanctuary of Athena at Pergamon at the center. Antikensammlung, Staatliche Museen zu Berlin

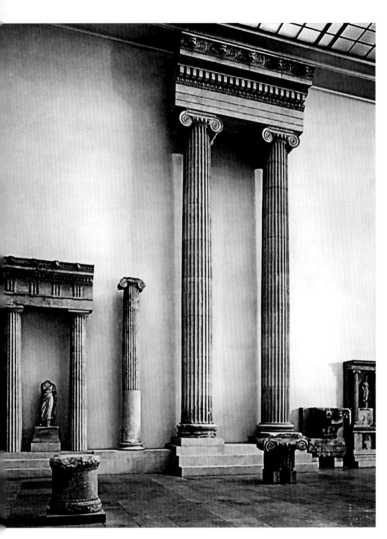

FIG. 9. Pergamon Museum, Hall of Hellenistic architecture, ca. 1930, with two reconstructed columns from the Temple of Athena at Priene in Asia Minor. Antikensammlung, Staatliche Museen zu Berlin

The altar, nearly square (36.8 x 34.2 meters), stood atop a base surrounded by a frieze 113 meters long and 2.3 meters high. Above this stood a portico whose back wall enclosed a courtyard containing the actual altar. The courtyard wall was faced on the inside with an additional smaller frieze picturing the Telephus myth. Atop the stone roofs of the colonnades stood so-called acroteria, statues of deities grouped together with flanking quadrigas, griffins, centaurs, and tritons. The altar's base frieze with its large number of figures in almost fully three-dimensional relief represents the Gigantomachy, the struggle between the Olympian gods and the Giants, the rebellious sons of Gaia, the personification of Earth. According to ancient Greek myth, the Giants hoped to plunge the divine order into chaos, and the Olympian gods managed to prevent them only with the help of the mortal hero Heracles. With regard to artistry, the Gigantomachy frieze is the most important part of the altar structure. The turmoil of battle is impressively evoked in overlapping, richly varied sculptures of pairs of combatants, with the menace of the Giants emphasized by their serpentine legs and animal attributes.

The altar's west facade, with its 20-meter-wide staircase leading up to the altar courtyard and flanked by projecting wings, has been completely reconstructed utilizing fragments from the original architecture. The friezes from the north, south, and east sides of the base are displayed against the room's walls. The original sculptures themselves have not been amended; only the backgrounds of fragmentary slabs are completed.

The central event of the Gigantomachy is found in the right half of the east frieze. Here, Zeus, the father of the gods, and his daughter Athena are seen in combat with several Giants, and the earth mother, Gaia, is begging for the life of her son Alcyoneus, who has been subdued by Athena.

The Telephus Frieze

After climbing the altar's tall stairs, one enters the Telephus Hall, where offerings were actually made. The fire altar, of which only a few exquisitely decorated marble cornices survive, stood in a courtyard. In its place, in the middle of the floor, there is a mosaic from the small altar chamber of Palace V in Pergamon. At the bottom of it is a frieze with garlands of fruit enlivened by birds that can be clearly identified. Of the two upper panels, only the left one survives. It pictures an Alexandrine parakeet; the one on view is a copy.

were being dismantled by lime burners for their fragments of ancient marble. Carl Humann, a German engineer employed by the Turkish government as supervisor of road-building projects, visited Bergama in 1864. He managed to stop the lime burning on the acropolis and convinced the Berlin museums to initiate excavations at the site. In the course of three campaigns (1878–1886), the altar and other important structures were excavated. By contract, the finds were to be divided with the Turkish government, and as a result, the fragments of the altar frieze found their way to Berlin, where over a period of twenty years, scholars and restorers fitted them together again.

A frieze that narrates the life of Telephus circles the walls of the hall, just as it originally appeared in the altar courtyard. This mythical hero was thought to be a son of Heracles, and Pergamon's founder. By celebrating this mythical precursor, the Attalids hoped to lend legitimacy to their only recently established ruling dynasty. A colonnade was planned to extend in front of the frieze, but it was never built. Unfinished details on the frieze also indicate that it was among the last additions to the altar. Perhaps work on the monument was prematurely suspended following the death of its builder, King Eumenes II, in 159 B.C.

The Pergamon Museum in the Future

The Pergamon Museum faces the Kupfergraben, and a fourth wing will be added on that side (fig. 10). As a result of this new connection, visitors will be able to take a complete uninterrupted tour through the architecture of classical antiquity. That floor of the museum will be directly accessible from the James-Simon-Galerie. In the course of the complete renovation, both the bridge over the Kupfergraben and the tempietto entrance in the Court of Honor will be rebuilt. The Court of Honor, which is enclosed by the four wings of the building, will become a hub with passages that allow visitors to access the entire Museum Island, even outside the opening hours.

FIG. 10. Museum Island Berlin after completion in 2030, computer rendering with the restored Pergamon Museum in the center, 2015

Complete Renovation and Extension

The complete extensive renovation of the Pergamon Museum is being carried out without interrupting the overall operation of the museum. In fall 2012, the north wing was closed and the basement under the Court of Honor cleared. The heart of the museum, the Hall of the Pergamon Altar located in the central structure of the building, has been closed to the public since fall 2014. The entire south wing, featuring, among other things, the Market Gate of Miletus, the Ishtar Gate, and the Processional Way of Babylon, is open to the public during that first phase of the renovation. The plan is to reopen the north wing and the Hall of the Pergamon Altar in 2024. After that, in a second building phase, the south wing will be renovated and the fourth wing built. Prior to starting the complete renovation, urgent measures for danger prevention had already been undertaken at the Pergamon Museum, and the cornice was renovated between 2007 and 2009.

Collections in the Pergamon Museum

The Pergamon Museum houses the architectural exhibits of the Collection of Classical Antiquities, the Museum of Islamic Art, and the Museum of the Ancient Near East. As soon as the renovation is completed, the museum will additionally present the monumental architecture of the Egyptian Museum, and it will have a clear structure with regard to content: each collection, including the architectural exhibits associated with it, will be presented in one of the four wings. That way, the Ancient Architectures Tour will be created on one exhibition level (fig. 11).

A New Direct Entrance to the Pergamon Museum

The entrance situation of the Pergamon Museum will significantly improve in the future. A new tempietto entrance in the Court of Honor will replace the pavilion, which was built between 1980 and 1982 (fig. 12). From there, visitors will be able to either reach the main exhibition level or directly access the Archaeological Promenade. The north and south wings will be directly accessible from the Court of Honor via two new entrances. Visitors will reach the Court of Honor over a barrier-free bridge. In addition, there will be a direct access from the James-Simon-Galerie to the main exhibition level of the Pergamon Museum featuring the Ancient Architectures Tour.

The Museum Island Welcomes the World

Given the large number of visitors to the Museum Island, the James-Simon-Galerie is of crucial importance for the infrastructure of the whole museum complex. It will serve as the new entrance building, offering the visitors guidance, information, and hospitality. It will assume central service functions for the Museum Island and thus relieve the strain on the historical exhibition venues.

In his design of the new building, architect David Chipperfield draws on the historical theme of Stüler's colonnades. The sixth building on the Museum Island will thereby harmoniously blend in with the historical ensemble and at the same time represent a very significant contribution of contemporary twenty-first century architecture on the Museum Island. The foundation stone for the James-Simon-Galerie was laid in fall 2013. The topping out ceremony was held in April 2016, and we hope to inaugurate this marvelous new facility that also contains spaces for temporary exhibitions early in 2019.

A New Entrance Building for the Entire Museum Island: The James-Simon-Galerie

Aligned in a north-south direction, the James-Simon-Galerie is located between the Kupfergraben and the Neues Museum. In the future, visitors will be welcomed by a large open flight of stairs, which will be visible from the Lustgarten. With regard to architecture, the building alludes to the immediately adjoining Pergamon Museum and the colonnades enclosing the Neues Museum and the Alte Nationalgalerie. Between the Neues Museum and the James-Simon-Galerie, the New Courtyard is being created. The terrace of the James-Simon-Galerie, which faces southwest and offers a view over the Kupfergraben, will be another new open space accessible to the public. The James-Simon-Galerie is the future visitors' center of the Museum Island. It will be the central reception area and meet the modern expectations of the public toward one of the largest museum complexes in the world. In addition to a large area for ticket sales and information, it will feature checkrooms, a museum shop, a cafe, and a restaurant, as well as an auditorium and space for special exhibitions. As the main entrance to the Museum Island, the James-Simon-Galerie will serve as a central hub, providing direct access to the Ancient Architectures Tour on the main floor of the Pergamon Museum and the Archaeological Promenade. This function of the new building is particularly useful for guided groups, which constitute more than half of the visitors to the Museum Island. The distinguishing architectural element of the James-Simon-Galerie is the historical theme of colonnades translated into modern form.

Inspired by Stüler's column walkway, a new, smaller pillar-lined courtyard is being created between the James-Simon-Galerie and the Neues Museum. The tall base of the James-Simon-Galerie will continue the architecture of the

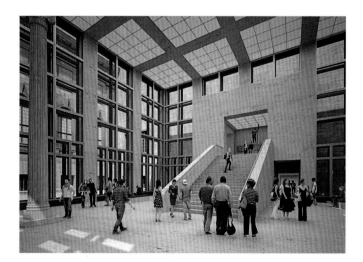

FIG. 11. Museum Island Berlin after planned completion in 2030, computer rendering with graphic indication of the main circuit of ancient architecture in the Pergamon Museum indicating the major exhibits, 2015

FIG. 12. Pergamon Museum after planned completion in 2030, computer rendering of the main foyer building (tempietto) with central staircase leading toward the Gallery of the Pergamon Altar, 2015

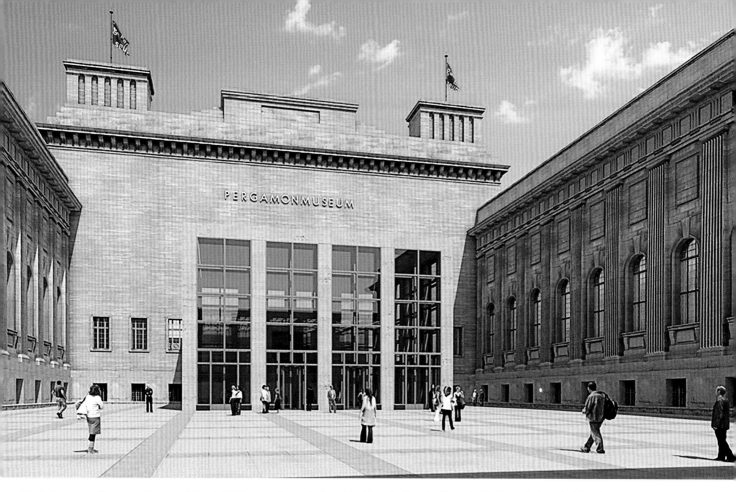

FIG. 13. Pergamon Museum after completion in 2030, computer rendering of the *Ehrenhof* (court of honor) with the main foyer building (tempietto), 2015

adjoining Pergamon Museum. The building itself is a transparent structure defined by delicate pillars and glass, offering a variety of views from both inside and outside. The James-Simon-Galerie is divided into three principal floors, a mezzanine between the upper floors, and a basement. All floors are connected by large stairs and elevators. On the uppermost floor, which can be reached via the outside flight of stairs, visitors can obtain information and tickets. The cafe and the exit to the terrace, which will be largely accessible outside of opening hours, are also found on that level. From the New Courtyard, visitors can go directly to a small foyer and the auditorium. Checkrooms, lockers, restrooms, and the museum shop will be located on the mezzanine between these two foyer levels. Here, too, visitors will be able to enjoy a view of the Kupfergraben through a large window. From the small foyer, there will be access to the special exhibitions area and the passageway to the Archaeological Promenade.

The Pergamon Museum in 2030

Hopefully around its centenary in 2030, the Pergamon Museum will be completed and fully functional for the first time in its history (fig. 13). As its main feature and attraction, it will offer to its global audience a spectacular circuit through the architectural history of five major Mediterranean cultures of antiquity–Egypt, Mesopotamia, Greece, Rome, and early Islam. No other museum in the world will mirror these ancient cultures in buildings that are as monumental, striking, and beautiful. But at its very heart will always stand the unrivaled achievement of the Pergamon Altar with its great frieze, testifying to the genius of Hellenistic artists and the acme of Greek sculpture.

1. Radt 1999, pp. 309–30, figs. 243–48; U. Kästner 2014, pp. 20–25, figs. 1–3.
2. Pirson 2014, figs. 1–12, with references to recent excavation reports.
3. Vitruvius, *On Architecture*, 3.2.6.

Susan I. Rotroff

The Moldmade Bowls of Pergamon: Origin and Influence

Among the many innovations introduced by Hellenistic potters, the most successful—to judge by both its popularity and its impact on future ceramic development—was the so-called Megarian bowl, a moldmade hemispherical cup decorated on its exterior surface with designs in relief. It was innovative in a number of ways: for its shape, a handleless drinking cup that imposed a new set of table manners; its decoration, relief designs, formally difficult to produce and therefore rare in ceramics; and its technology, the procedure of throwing a bowl within a mold, which was not previously employed in the manufacture of fine ceramics and which made the relief decoration possible. These factors combined to make the Megarian bowl one of the most widespread ceramic types of the era. In addition to the status of the best of them as gems of Hellenistic minor art, moldmade bowls offer intriguing reflections of the fine metalware that set the tone for luxury dining, and their varied decoration constitutes a rich repository of figural and floral motifs, often shared in other mediums.

Moldmade bowls originated as imitations of the precious metal drinking cups favored by Hellenistic royalty and their circles. A few of these survive,[1] and they are occasionally pictured in the hands of elite drinkers.[2] The earliest evidence for ceramic versions is found at Athens, where they probably began to be made in small numbers shortly after 225 B.C.[3] The first were mechanical copies of the metal originals, but Athenian potters soon devised a more efficient production technique and introduced an enormous array of new motifs. The industry was in full swing there by the beginning of the second century B.C. Athenian bowls were exported in considerable numbers to nearby markets

at Megara, Corinth, Aigina, and Delos, and isolated fragments have surfaced in the East and the Black Sea region.[4] Workshops that closely imitated Athenian bowls were established at Argos, on Lemnos, and at Delphi, possibly by potters from Athens,[5] but other industries arose independently, and within two generations, the moldmade bowl had been widely adopted. The most successful production center was at Ephesos, where the bowls began to be manufactured before the middle of the second century B.C., and they were soon being exported all over the Mediterranean;[6] about seven thousand examples were found on Delos, hinting at the volume of this trade.[7]

Pergamene potters too made moldmade bowls, often of outstanding quality, as attested both by the products themselves and by the existence of kilns in the city and in the extensive potters' quarter in the Kestel Valley to the east.[8] Most of the bowls recovered by the excavations of the German Archaeological Institute at Pergamon still await systematic publication, but it is possible to glean something of their style, iconography, and quality from a sample of about 500 items that have been described and illustrated in excavation reports and articles.[9] It is on the basis of this material that I address two questions: How did the Pergamene moldmade bowl industry originate? And what influence did Pergamene moldmade bowls exert beyond Pergamon itself?

Origins: Pergamon and Athens

It is usually asserted that the Pergamene industry arose in imitation of Athenian bowls,[10] a likely proposition but impossible to demonstrate. The most convincing evidence

FIG. 1. Moldmade bowl with imbricate decoration, said to come from Pergamon Antikensammlung, Staatliche Museen zu Berlin, V.I. 5860

is shape: the wheel-made rims of Pergamene bowls turn outward like those of Attic bowls, a detail that rules out the other likely source of inspiration, the Ionian bowls of the Ephesos region, where the rims are inwardly inclined. From the late third century B.C. onward, conditions were favorable for the exchange of artisanal ideas between Athens and Pergamon. Pergamon became a near neighbor to Athens with her purchase of Aigina in 210 B.C. and an ally against the Macedonians at the end of that century.[11] Whether or not this relationship was a significant factor, moldmade bowls were probably introduced at Pergamon not much later.[12]

The published corpus of material excavated at Pergamon includes only one certainly and three probably Attic bowls,[13] but few as they are, they confirm that Attic models were available there for imitation. The correspondences in moldmade design between Athens and Pergamon,

however, are not many. One possible example is a complete bowl in the Berlin Antikensammlung (fig. 1).[14] Overlapping rows of lotus petals reach almost to the grooved, out-turned lip, and a rosette surrounded by a running-dog pattern decorates the bottom. Several fragments found in Athens are nearly identical (fig. 2),[15] with the same strongly out-turned rim just above the molded decoration and the same imbricate pattern, though two different petal types alternate in the uppermost row of the Attic bowls. The medallions and their surrounding patterning are also very similar. Most significant of all, however, are the grooves that have been scraped through the glaze just below the rim and around the medallion. This purely decorative detail is an earmark of Attic production, virtually never absent on Athenian bowls and vanishingly rare elsewhere. Creation of the grooves involved an extra step, undertaken after the bowl was

FIG. 2. Moldmade bowl fragments with imbricate decoration and rosette medallion, from Athens, Agora P 11433. Rotroff 1982a, no. 16; Pnyx P 385; Edwards 1956, no. 66

already glazed and seemingly ready for the kiln. To achieve the observed degree of regularity, the grooves had to be wheel-run. To accomplish that, the potter had to affix the vessel to the wheel again, taking care not to damage the newly glazed surface, and cut the grooves through the glaze as the wheel turned. If the Berlin bowl is of Pergamene manufacture, it was made not only as a close or even mechanical copy of an Athenian bowl but also by a potter trained in Attic production procedures; no one else would think to undertake this tedious extra step. It is more likely, then, that the Antikensammlung bowl is an Attic import. Unfortunately, its Pergamene provenience is open to question; acquired from the collection of Pierre Mavrogordato in 1910, the bowl was reportedly found in Pergamon, but it might come from somewhere else altogether.

I can point to only a few unquestionably Pergamene products that reflect Athenian design and iconography, and none that reflect Athenian workshop practice. None display scraped grooves, and there are none that closely resemble the earliest Attic bowls, those that were made by taking casts from metal originals and uniformly decorated with an impossibly delicate calyx of lotus petals with nodding tips, attenuated acanthus leaves, and tendrils.[16] A few Pergamene fragments display similar calyxes,[17] but the tips of the lotus petals do not nod, and the elements are more robust. These bowls might be loose imitations of an Athenian model, but they could equally be independent creations, copies of metal bowls similar to those that inspired Athenian potters. There would have been no dearth of models at Pergamon. Although seemingly restrained and modest in comparison to other Hellenistic dynasts, Pergamene royalty undoubtedly drank from cups made of precious metal. Polybius describes how Attalos I, fleeing the forces of Philip V in a sea battle off of Chios, deflected his pursuers by leaving a display of his purple cloaks and traveling table service on the deck of his abandoned warship.[19]

The Attic and Pergamene motif repertoires are very different.[18] Attic bowls favor figured designs, while floral decoration dominates the Pergamene industry. Among Pergamene figured bowls, there is a tendency toward composition in well-defined registers, with the floral calyx set off by a horizontal line, which is rare in the Attic corpus.[20] A gorgon medallion similar to the Medusa of the Athenian Workshop of Bion occurs two or three times at Pergamon, possibly an indication of Athenian influence,[21] but the most characteristic Attic motifs—rampant goats, dancing satyrs, stock mythological characters—are absent. Most of the figures that are shared by the two industries are those that recur on moldmade bowls almost everywhere.[22]

The most convincing indicator of contact between the two industries is a pair of stamps depicting centaur musicians (figs. 3 and 4),[23] a subject that occurs repeatedly at both sites, but except for the Sardian bowls noted below, not on bowls elsewhere. One centaur walks to the right playing the double flute, while the other moves left playing a lyre or kithara.[24] Centaur pairs in other mediums are sometimes male and female,[25] but the small size of these images makes it impossible to rule on their gender, except to note that both are beardless. The stances are the same at both sites: the far foreleg raised high as though on parade and the back feet on the ground, the far leg advanced. There are differences, however; Erotes sometimes stand on the Athenian centaurs' backs, while a billowing cloak fills this space on the Pergamene stamp. In addition, the Pergamene centaurs

FIG. 3. Pergamene moldmade bowl with centaurs playing the lyre or kithara and double flute, Pergamon PE 75/175. After de Luca 1997, pl. 272

FIG. 4. Athenian moldmade bowl with centaurs playing the lyre or kithara and double flute, Agora P 28437, Rotroff 1982a, no. 212. Agora Excavations

seem to turn their heads slightly toward the viewer, while the heads of the Athenian ones are strictly in profile.

These tiny images are among the earliest preserved instances of centaur musicians, a subject that occurs with increasing regularity from the second century B.C. to the Roman period.[26] In larger works, they are often part of a Dionysiac thiasos, an association that suits them well for the decoration of drinking cups. Nonetheless, they are rare on moldmade bowls, which suggests a direct connection between the Athenian and Pergamene industries. The motif may already have been sufficiently diffused to make it impossible to trace the direction of influence, but the presence of a kithara-playing centaur on several second-century works of eastern origin makes Pergamon the more likely lender.[27]

A third shared stamp is more unusual; it shows a centaur musician leaping forward in a running gallop, its rear legs extended side by side, so that they appear to be a single leg.[28] This simple stance is easily paralleled among other quadrupeds on moldmade bowls[29] and may originate with a stamp cutter rather than in imitation of other arts. The Athenian centaur holds a trumpet to his lips with one hand and is awkwardly fitted with a stubby wing(?), possibly a repair to the original stamp. The Pergamene centaur instead plays the double flute; since he needs both hands to manage

the instrument, what looks like a backward-flung arm must be read as a cloak or animal skin. Although these differences distinguish the two stamps, the lack of close parallels either on moldmade bowls or in other mediums elsewhere again suggests a link between Athens and Pergamon.

Aside from these few instances, parallels between Pergamene and Athenian bowls are scarce, and unless more telling details emerge with the publication of the complete corpus, the question of an Athenian origin will remain unresolved. If the impetus did come from Athens, the Pergamene potters took up the shape and the technology but swiftly discarded most of the repertoire. The style and imagery of their products are distinctive, and much of them unique to the site. Gioia de Luca has demonstrated that local arts, including architecture and luxury products, served as prototypes for much of their design.[30]

Influence

Exploration of the influence Pergamene products may have had on regional and more distant industries is hampered both by the incomplete publication of the Pergamene corpus and by the spotty record of excavation and publication of moldmade bowls from sites within the possible Pergamene ambit. At present, there is no evidence that Pergamene

FIG. 5a. Bud-in-calyx motif on a bowl from Pergamon. Drawing by author, after Conze 1913, suppl. 40.1

FIG. 5b. Waster from Sardis, Sardis P98.94. After Rotroff and Oliver 2003, no. 461. Archeological Exploration of Sardis/ President and Fellows of Harvard College

relief bowls were widely exported, and traces of their influence are limited. Bowls from nearby Kyme share only a few motifs with Pergamon: a rosette framed by a swag, a reduced version of an elaborate acanthus flower, and a long petal with a beaded border.[31] Swags, an acanthus flower, and a boukranion reminiscent of Pergamon appear on fragments found at Daskyleion.[32] Their gray clay, which is typical for the site, suggests they are local products made under Pergamene influence rather than Pergamene imports. But it has also been suggested that some of the Daskyleion bowls are products of a Pontic workshop located at Mesembria, on the western shore of the Black Sea.[33] The issue remains unresolved, but the competing claims suggest that the Pergamene sphere of influence may have extended into the Black Sea region, an area to which Pergamon exported West Slope and appliqué wares on a fairly massive scale.

Much more data is available for another site, the old Lydian capital of Sardis, which was incorporated into the Pergamene realm in 188 B.C. by the terms of the Treaty of Apamea. Excavations at Sardis have unearthed a number of certain or probable Pergamene imports.[34] The most remarkable is a partially moldmade lidded jar, a hybrid with white-ground lagynos ware, decorated with painted swags in the manner of lagynoi.[35] Almost all the figured stamps on the vessel's moldmade belly are closely paralleled at Pergamon, most strikingly a unique figure constructed of straight strokes that de Luca has brilliantly recognized as a frontal Pan playing an oversized syrinx.[36]

Pergamene motifs also show up on many Sardian products. A bud growing from a leafy calyx occurs in both industries; the Sardian fragment illustrated in figure 5a and b is a waster and therefore certainly a Sardian product.[37] A mold from Sardis utilizes a reversed bud as a rim pattern, common also at Pergamon (fig. 6a and b).[38] Another displays a boukranion closely similar to the motif on Pergamene bowls (fig. 7b).[39] More significantly, its rim pattern consists of a spiral with a prominent bead at its center, a highly unusual motif found on many Pergamene bowls.[40] This pattern is so rare on Sardian bowls that this may be an imported Pergamene mold with only a limited production life at Sardis. The two industries also share musical centaurs and long petals with beaded borders.[41]

These close correspondences suggest that Pergamene potters may have been involved in setting up a workshop at Sardis, and possibly even were responsible for the establishment of production there. It is tempting to imagine that Pergamene influence arrived in the wake of the arrangements of the Peace of Apamea—that is, after 188 B.C.— arrangements that would have opened up new business possibilities for Pergamene potters. A similar scenario can be traced at Athens, when renewed control of the city's old klerouchy on Lemnos after 168 B.C. encouraged an Athenian potter to open up shop on the island.[42]

Much more data and analysis will be required to map Pergamene influence in the sphere of moldmade pottery. A small territory has been defined, and it might extend into the Black Sea region. How much farther to the east it may have reached, I do not know, but in the south, it stopped short at Ionia. Even though this too was part of the Pergamene kingdom in the second century B.C., that dominion did not extend to the moldmaker's workshop, where Ephesian potters followed a different aesthetic and, perhaps because of their coastal location and well established position as a trading center, made a far greater

6a

6b

7a

7b

FIG. 6a. Reversed bud rim motif on a bowl from Pergamon, Pergamon K660/961. Drawing by the author, after de Luca and Ziegenaus 1968, no. 359, pl. 54

FIG. 6b. Mold at Sardis, Sardis P67.102, Rotroff and Oliver 2003, no. 414. Archaeological Exploration of Sardis/President and Fellows of Harvard College

FIG. 7a. Pergamene bowl with a spiral rim pattern, with tragic mask and Amymone supporting a swag, after Conze 1913, p. 274.6

FIG. 7b. Mold for a Sardian bowl with a spiral rim pattern and a boukranion, Sardis P63.224, Rotroff and Oliver 2003, pp. 101–2, no. 401, pl. 67. Archaeological Exploration of Sardis/President and Fellows of Harvard College

business success of moldmade bowl production than their Pergamene colleagues. Pergamon's bowls, despite the remarkably high quality of the best of them, seem to have made only a limited mark outside their immediate region.

Acknowledgments

I would like to express my thanks to Theresa Huntsman, Felix Pirson, Agnes Schwarzmaier, and Lillian Bartlett Stoner for providing me with illustrations and permission to reproduce them. I am also grateful to Klaus Nohlen, who many years ago made it possible for me to see the moldmade bowls in the Pergamon storerooms, and to Kiki Karoglou and Seán Hemingway, for their valuable editorial comments.

1. See, for example, Oliver 1977, pp. 75–79, nos. 40–43; Fiorenza Grasso in Picón and Hemingway 2016, pp. 244–45, no. 182a–c.

2. For example, in the arched bower on the Palestrina Mosaic (Meyboom 1995, pp. 33–34, n. 133, pl. 21) and on the Tazza Farnese (Lightfoot 2016b, p. 83, fig. 108).

3. Rotroff 1982a, pp. 6–13; Rotroff 2006.

4. Rotroff 1982a, pp. 10–11. Recent excavations have greatly expanded the number known from the north coast of the Black Sea; for example, see Domăneanţu 2000, pp. 123–27, pl. 43 (Histria); Bilde 2010, p. 275, pl. 168 (Olbia). Personal observation has impressed me with the high numbers of Athenian bowls at Megara, Corinth, and Delos, at present largely unpublished.

5. Siebert 1978, pp. 123–26, pls. 57, 58; Rotroff 2013.

6. Rogl 2014 summarizes research on this industry.

7. Laumonier 1977.

8. Hepding 1952; Bounegru 2003.

9. A monograph by Gioia de Luca, who has been studying this material since the 1960s, is said to be nearing completion. It is to her that we owe most of the publications on the subject.

10. Japp 2011, p. 359.

11. Habicht 1997, pp. 190, 197–98, 224.

12. The earliest published contexts for moldmade bowls at Pergamon are the strata of the Asklepieion: Bauphase 8, one fragment, no closely datable material (de Luca and Ziegenaus 1968, p. 124, no. 158, pl. 43); Bauphase 9, nine fragments (ibid., pp. 130–31, nos. 192–200, pl. 45), with a Rhodian amphora handle naming the eponym Philodamos II (ibid., p. 129, no. 183, pl. 63), now dated ca. 183 B.C. (Finkielsztejn 2001, p. 192, table 19, Philodamos II). Finkielsztejn's revision of the amphora dates requires downdating of the phase, rendering impossible the connection of the destruction of this phase with Seleukos' siege of Pergamon in 191–190 B.C., as originally proposed by de Luca and Ziegenaus 1968. Pergamene potters may have begun making moldmade bowls before the end of the third century, but all we can say for certain is that they were doing so in quantity by the second decade of the second century.

13. De Luca and Ziegenaus 1968, pp. 139, 143–44, nos. 261, 291, pl. 49 (fragments of the same bowl) and perhaps Conze 1913, p. 274, suppl. 42.5; de Luca and Radt 1999, pp. 111, 114, nos. 501, 580, pls. 19, 22, suppl. 9, 14. All probably date in the late third or early second century. Attic origin has been claimed for a few others (ibid., p. 93 n. 94), but probably incorrectly.

14. Grüssinger, V. Kästner, and Scholl 2011, p. 476, no. 3.97; Ursula Kästner in Picón and Hemingway 2016, p. 171, no. 88.

15. Edwards 1956, p. 100, nos. 62–66, pl. 44, from the Pnyx; Rotroff 1982a, p. 46, nos. 16, 16bis, pls. 3, 73, from the Agora.

16. Rotroff 1982a, p. 50, nos. 49, 50, pls. 8, 73; Rotroff 1982b.

17. De Luca and Ziegenaus 1968, p. 131, no. 200, pl. 45; de Luca 2011, p. 362, fig. 2·6.

18. See de Luca and Radt 1999, pp. 99–100, for de Luca's remarks on the similarities and differences between the two industries.

19. Polybius, *The Histories*, 16.6.7.

20. For example, Conze 1913, p. 274, nos. 2, 3, suppl. 42.9, 43.2, 21.

21. Conze 1913, p. 274, suppl. 42.7; de Luca and Radt 1999, p. 114, nos. 567, perhaps 567A, pl. 20, suppl. 13. On p. 94 n. 93, de Luca suggests they are Attic (which is unlikely), but on p. 99 seems to accept them as Pergamene. For the Attic medallion, see Rotroff 1982a, p. 64, no. 171, pl. 79.

22. In what is published, these are limited to the well-known figures derived from terracotta altars; see Siebert 1978, pp. 240–46. Of these, Amymone (occasionally paired with Poseidon; see, for example, Conze 1913, p. 276) occurs most frequently; there are a few instances of a woman wreathing a trophy and the Dionysiac trio (see, for example, Conze 1913, p. 274, suppl. 41.1, 42.11; de Luca 1997, p. 367, pl. 269.a, b).

23. Pergamon: de Luca 1997, p. 368, pl. 272; see also Conze 1913, p. 274, suppl. 43.21; and de Luca and Radt 1999, p. 109, no. 471, pl. 15, suppl. 7. Athens: Rotroff 1982a, p. 70, no. 212, pls. 41, 82, and see also pp. 59–60, nos. 130, 131, pl. 25. A third stamp is very similar, but the centaur holds in one hand an unidentified object that is probably not a musical instrument ; see Rotroff 1982a, p. 59, no. 129, pl. 24. De Luca points to an Eros riding a goat as another shared motif; see de Luca and Radt 1999, pp. 99, 109, no. 471, pl. 15, suppl. 7. Compare with Rotroff 1982a, p. 62, no. 155, pls. 29, 78. The published Pergamene stamp is only partially preserved, so it is impossible to evaluate the degree of similarity between the images, but it is interesting that it occurs together with musical centaurs.

24. The lower part of the stringed instrument is invisible. In some stamps (Agora P16212, P 16213) its upper arms resemble those of the barbitos (a form of lyre) as it is depicted in Attic vase painting; see Maas and Snyder 1989, pp. 113–38, figs. 1–21). On others, such as Rotroff 1982a, p. 70, no. 212, pl. 82, they more closely resemble the upper part of a kithara; compare with the instrument, clearly a kithara, played by an Eros on the same bowl.

25. For example, a centauress flute-player and a centaur kithara-player flanking a plaque of Socrates, bronze plaques from a chest in Pompeii; see Pernice 1932, pp. 79–86, fig. 34, pls. 49–51.

26. *LIMC* 1986, s.v. Cheiron, p. 238, nos. 2–11; *LIMC* 1997, s.v. Kentauroi et Kentaurides, pp. 697–98, 710–11, 716–17, nos. 307, 308, 313, 317–25, 371–77, 383, 449, 457, 463–67; *LIMC: Supplementum* 2009, s.v. Kentauroi et Kentaurides, pp. 307–8, adds. 1, 6. A silver patera from Spain, probably of the late second century B.C., with a combination of Greek and Iberian iconography illustrates the theme in silverwork ; see Nünnerich-Asmus 1993, p. 237, pl. 7.

27. The reverse of a coin of Prusius II of Bithynia, a one-time Pergamene ally, 183–149 B.C. (Wroth 1889, pp. 210–11, nos. 7–14, pls. 38.4, 5; the position of the legs is the same, but the centaur turns his head to face the viewer); a terracotta figurine of a centaur from Priene, probably originally with a kithara, before 135 B.C. (Rumscheid 2006, pp. 282–83, 490–91, no. 262, pls. 110.3, 111.1; one back leg is missing, but the stance as preserved is the same as that of the centaurs on the moldmade bowls); the silver rhyton found at Cività Castellana (Georg Plattner in Picón and Hemingway 2016, pp. 242–44,

no. 181), sometimes claimed as a Pergamene work (Strong 1966, pp. 109–10); figures on the frieze of the Temple of Dionysos at Teos, perhaps reworked or copied in Roman times but originally late third–early second century B.C. (Hahland 1950, pp. 67–82, figs. 27, 30, 31, 34–36, 42, playing lyre, flutes, castanets, and tympanon; Ridgway 1990–2002, vol. 2, pp. 109–10; the stances of the centaurs are different). It has also been suggested that one of the centaurs unearthed in the Asklepieion of Pergamon, and approximately contemporary with the bowls, may have been a kithara player, as its reduced copy at Oplontis is; see ibid., vol. 1, pp. 311–12, n. 38, pl. 162.

28. Conze 1913, p. 274, suppl. 42.15 (Pergamon); Rotroff 1982a, pp. 59, 78, nos. 130 (bowl), 275 (mold), pls. 25, 54, Workshop of Bion (Athens).

29. For example, Conze 1913, p. 274, suppl. 42.9; Rotroff 1982a, pp. 62–63, nos. 153–58, pls. 28, 29, 78; de Luca 1990, p. 159, fig. 25.3.

30. De Luca 1990.

31. For the swag, boukranion, and rosette, see Bouzek and Jansová 1974, pp. 51, 57, 58, nos. MB 6 (mold), MB 43, MB 48, MB 49, B (mold), figs. 2, 3, 8, pls. 2, 3, 7 (Kyme); and de Luca 1990, pls. 24.2, 28.1 (Pergamon). For the acanthus flower, see Bouzek and Jansová 1974, pp. 51, 55, 57, nos. MB 8 (mold), MB 36, MB 37, fig. 2, pls. 3, 6 (Kyme); de Luca 1990, pl. 26:1, 4, 5 (Pergamon). For the beaded long petal, see Conze 1913, p. 274, suppl. 43:23; and de Luca and Ziegenaus 1968, pp, 143, 152, nos. 285, 343, pls. 51, 54 (Pergamon); Bouzek and Jansová 1974, pp. 65, 67, nos. MB 84, MB 91–MB 94, figs. 4, 5, pls. 11, 12 (Kyme).

32. Dereboylu 2003, pp. 56–57, nos. KA 10, KA 19, KA 22, pls. 42, 43.

33. Petrova 2014, p. 223.

34. Rotroff and Oliver 2003, pp. 148–52, nos. 649, 650, and probably nos. 631–33, 636, 637, 641, 642, 652, pls. 110–13.

35. Ibid., pp. 79–80, no. 306, pl. 50, there judged probably to be of Sardian manufacture, but the number of Pergamene motifs makes this unlikely.

36. De Luca 1997, pl. 269.c; de Luca 2011, pp. 362–63, fig. 1.2, 3. Other Pergamene motifs include a cocky Eros striding right (Boehringer and Krauss 1937, p. 122, pl. 58.d1; de Luca 1990, pl. 25.2); a wreath bound by fillets and tied with a bow (de Luca and Ziegenaus 1968, p. 139, no. 260, pl. 49; Grüssinger, V. Kästner, and Scholl 2011, p. 475, no. 3.90); a loutrophoros (de Luca and Ziegenaus 1968, p. 153, no. 352, pl. 55); a slave mask framed by a swag (de Luca and Radt 1999, p. 111, no. 507, pl. 18, suppl. 10); a centaur playing the double flute.

37. Rotroff and Oliver 2003, pp. 113–14, no. 461, pl. 79. For Pergamene examples, see Conze 1913, p. 274, suppl. 40:1; de Luca 2011, p. 362, fig. 2.7.

38. Rotroff and Oliver 2003, p. 103, no. 414, pl. 69. For Pergamene examples, see Conze 1913, p. 274, suppl. 43.17, 23; Pinkwart and Stammnitz 1984, p. 129, no. K 76, pl. 26; de Luca 2011, fig. 1.12.

39. Rotroff and Oliver 2003, pp. 101–2, no. 401, pl. 67; compare with de Luca 1990, pl. 24.1.

40. For Pergamene examples, see Conze 1913, p. 274, no. 6; de Luca and Ziegenaus 1968, pp. 131, 165, nos. 199, 431, 434, pls. 45, 59; Grüssinger, V. Kästner, and Scholl 2011, p. 475, no. 3.90.

41. For centaurs, see Rotroff and Oliver 2003, pp. 119–20, nos. 493–96, pl. 85 (different in detail from Pergamene stamps). For the beaded long petal, see ibid., pp. 124–25, nos. 518, 519, 526, 527, 529, pls. 90, 92. For Pergamene comparanda, see notes 22 and 30 above.

42. Rotroff 2013, pp. 20–22.

Agnes Schwarzmaier

Luxury Goods from Hellenistic Pergamon: The Archaeological Evidence

Excavations in Pergamon have not uncovered any luxury goods from the time of the Hellenistic kings. So, in fact, my essay could have been quite short. However, that would have been too easy, because the literary sources attest that the Attalids possessed vast riches and were connected with the invention and monopolistic production of various luxury goods. We have to assume, therefore, that the Pergamene kings did not only commission buildings and large-scale sculpture, and that they adorned their palaces with mosaic and wall decoration,[1] but also that they filled their homes with portable precious items.[2]

To determine what types of luxury items existed in the Pergamene palaces or were made in Pergamon—such as tableware in precious metal, semiprecious stone, or glass—we have to take an indirect approach. The most valuable and best preserved objects usually come from graves, not houses, so we should look first to the necropoleis, the city's cemeteries.[3] Several ostentatious tombs from the Hellenistic period have been found around Pergamon, large tumuli with sarcophagi or tomb chambers constructed in stone, but most of them were looted. In 1906, however, two tumuli excavated south of the city were found undisturbed, still containing grave goods.[4] The more lavish one contained a male burial from the first half of the third century B.C. Among the grave goods were arms and clay unguentaria as well as gold objects, most impressively, a golden oak leaf wreath with a small figure of Nike in the center over the forehead and two small dog's heads chased in gold.[5] Their function is not clear, but they may have belonged to a sword hilt or sheath.

The last few decades have seen several chance discoveries of Hellenistic tombs containing grave goods in precious metals, but they have not yet been adequately published. One grave near the Kestel reservoir at Pergamon yielded a relief tondo, now in the Bergama museum, which once adorned the lid of a silver pyxis. Unfortunately, the only available photographs of it are amateur shots that are online.[6] This unusual piece can be dated to the late third century B.C. and shows busts of Eros and Psyche kissing.[7]

Another find came to light in 1996, in the shovel of a backhoe.[8] It included two Hellenistic snake armbands in gold, a heavy golden finger ring (displayed in the Bergama museum), part of a gold wreath, and fragments of a silver pyxis. The gold wreath and jewelry resemble pieces from Macedonia and Thessaly.[9] The shape of the pyxis is similar to another from Asia Minor now in the Museum of Fine Arts, Boston,[10] although the Pergamene piece was more modestly decorated. Overall, these Pergamene graves seem to have belonged to the upper class, but not to the members of the royal family.

No Hellenistic glass has been found in the Pergamene necropolis. Only the acropolis and the city itself have yielded small fragments. Glass was produced in specialized workshops and imitated the shapes used for silver tableware, particularly drinking cups and plates.[11] Holger Schwarzer, who works on the ancient, Byzantine, and Islamic glass finds from Pergamon, was able to identify several press-blown Hellenistic cups, including cups with wheel cut lines and ribbed bowls, as well as fragments of mosaic glass and net-work glass (the latter two from the late second or first century B.C.).[12] He proposed that the limited amount of glass known from Hellenistic Pergamon suggests that it was largely imported, from the Levant and Alexandria, among

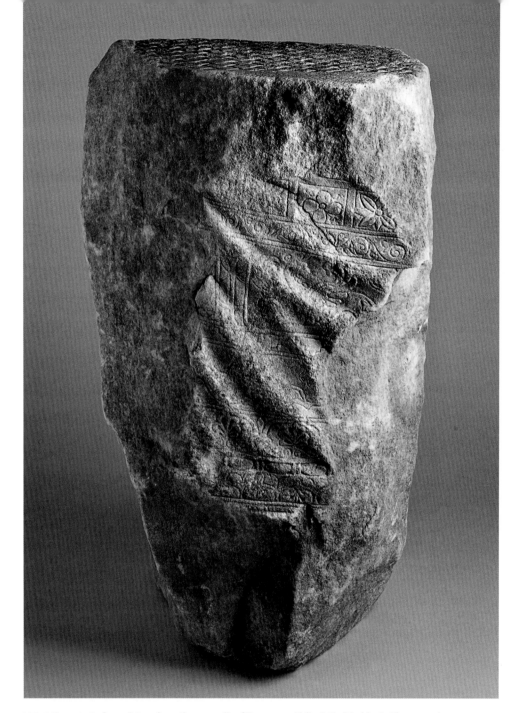

FIG. 1. Fragment of a sculpture from the acropolis of Pergamon, Hellenistic. Marble. Antikensammlung, Staatliche Museen zu Berlin (AvP VII 445)

other places. Glass was first produced in Pergamon under Roman rule, as attested by finds of raw glass and glass slag. Analyzing the chemical composition of the glass unfortunately has not helped us locate the glass workshops, because before the Roman period, raw glass was manufactured only at a few sites in the Levant and then exported throughout the entire Mediterranean.

The preserved luxury objects from Pergamon are, therefore, very few, and thus contrast starkly with what we would have expected based on the textual sources. They

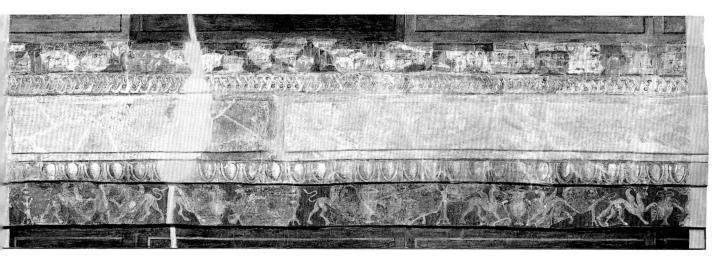

FIG. 2. Frieze, part of a painted wall decoration from Pergamon, Palace IV room A, first half of the 2nd century B.C. Stucco. Antikensammlung, Staatliche Museen zu Berlin (V 1.2-33)

relate that the founder of the dynasty, Philetairos, had a huge amount of precious metal at his disposal, taken from Lysimachos's treasury—some 9,000 talents, or 180 tons of silver, which he managed to hold onto even throughout the infighting among the Diadochi.[13] Numerous dedications of buildings and statues in Pergamon, like those in the pan-hellenic sanctuaries, testify to the Attalids' cultural-political aspirations under Attalos I, if not earlier.[14] Dedications in precious metals were also part of this picture, as is made clear by the account of Attalos I sending a gold wreath to Rome in grateful recognition of the Roman intervention against the Seleucid Antiochos III; the wreath weighed 246 pounds, around 80 kilograms![15]

Moreover, Pliny the Elder relates that after 133 B.C., the Roman aristocracy bought precious metal objects from the estate of Attalos III that were sold at auction. Pliny says that the objects strongly influenced taste in Rome and even sparked a new appetite for luxury goods.[16] He also gives the Pergamene court credit for making fine textiles, includ-ing a type of gold brocade known in the Latin sources as *vestes Attalicae*.[17] A kind of heavy embroidered tapestry called *aulea*, as well as curtains called *parapetasmata* in Greek, are also described with the term *Attalicae*,[18] because they "had been invented" in Pergamon.[19] True, literary sources credit Lydia and Phrygia with the invention of tex-tiles woven with gold, much earlier than in Pergamon, and this accords with the archaeological finds, most spectacu-larly, the purple-and-gold cloth from the Tomb of Philip at Vergina datable to about 340 B.C.[20] And tapestry was

certainly not a Pergamene invention. Nevertheless, espe-cially opulent pieces from Pergamon seem to have set the tone for the entire genre of luxury goods. Even around 15 B.C., the inscription on the statue base near the Pyramid of Cestius in Rome mentions "Attalicae," explaining that a sumptuary law prevented Cestius's heirs from interring these items in his grave as he had specified in his will.[21]

Unfortunately, we have little evidence about just what these textiles looked like. A fragment from a marble Hellenistic sculpture found on the Pergamene acropolis and now in Berlin (fig. 1) depicts part of a chair or stool with a woven seat hung with a heavy, tapestry-like cloth.[22] Despite the thick folds, one can see that it has a striped pat-tern. Two rows of squares (the lower one filled with flow-ers) are followed by a delicate vine scroll. The band below is decorated with horned, winged lion griffins facing each other on either side of a tripod. A step-meander border sep-arates them from another animal frieze, this time with a lion facing a bull. A border of lotus and palmettes, another of beads, and a final one with a Lesbian kyma pattern adorned the lower edge of the cloth. The mix of Greek and Near Eastern elements is notable here; the lion griffins and step meander take after Eastern models, while the rosettes, vegetal scroll, and architectural patterns on the lower edge have parallels from the Pergamene acropolis.[23] What's more, they might give us an idea of the colors in the cloth; the griffins might have been depicted in a light color on a red background between golden tripods like on a stucco frieze from a painted wall in Palace IV (fig. 2).[24] Strong red

tones as well as boxes framing flowers also characterize the imported fifth century B.C. carpet from a Scythian grave in Pazyryk in the Altai Mountains; it seems to take after Achaemenid models.[25]

It has been assumed that such textiles were made in royal workshops and that the purple pigment made from murex shells was the sole privilege of the king.[26] Literary sources record purple robes for Attalos I and his entourage. In 133 B.C., the royal insignia of Attalos III, his purple robe and diadem, were sent to Rome, as a sign of relinquishing his throne.[27] While basins belonging to a cloth-dyeing industry or fullery have been found on the Pergamene acropolis (on the southeast side, in the substructures supporting the later terrace under the Trajaneum), the associated ceramic finds date them to the late second or early first century B.C., that is, after the end of the monarchy.[28]

Hellenistic Pergamon had a close, albeit volatile relationship with the Ptolemies in Alexandria and the Seleucids in Antioch on the Orontes. Rhodes too, one of the richest and most important centers of trade and finance in the late third and early second century B.C., enjoyed good standing with Pergamon.[29] The Attalids' cultural-political agenda outside their own kingdom was realized through dedications in Asia Minor (including Termessos, Kyzikos, and Miletus) as well as Athens, Delphi, and Delos. The monuments bear witness to the Attalids' wealth, their carefully cultivated self-image, and their competition with the Seleucids and Ptolemies.

Truly breathtaking metal tableware—massive in scale, heavy, and beautifully decorated—must have been paraded before the public in the great festive processions of the Hellenistic kings and subsequently put on display. One such festival was led by Ptolemy II in the 270s B.C. in Alexandria; another by Antiochos IV in 167 B.C. in Daphne, the suburb of Antioch known for its celebrated grove and sanctuary of Apollo. At least, that is how they are described in Athenaios's *Deipnosophistai*, Philososphers at Dinner (or Banquet of the Learned).[30] The precious metal vessels possibly presented in the Ptolemaia, a new festival established in Athens in the 220s B.C. in honor of Ptolemy III Euergetes, not only were trendsetters for metalwork but also inspired new vessel forms in ceramic.[31] Metalware in general certainly inspired costly cups in glass as well as more modest versions in ceramic.[32] We can imagine that the metal, glass, and ceramic tablewares in the palace at Pergamon were every bit as

splendid as those in the Seleucid and Ptolemaic courts.[33] The exhibition "Pergamon and the Hellenistic Kingdoms of the Ancient World" at The Metropolitan Museum of Art offered an almost overwhelming impression of the scope of these sophisticated luxury goods. Many of the objects have been said to be connected with the Pergamene kings because of their style, such as the silver cups[34] and centaur rhyton[35] from Civita Castellana, which were thought to have been brought back from Asia Minor during the Roman campaigns there in the second century B.C.[36]

We have now come to recognize that the stylistic "koine" in the Hellenistic world makes it very difficult to distinguish the local styles of individual regions and kingdoms. Alexandrian objects, for instance, if they do not feature Egyptian motifs, cannot be differentiated convincingly from objects from Southern Italy or Asia Minor. There are, however, good reasons to think that silver cups with lotus-leaf decoration are an Alexandrian invention[37] and that this ornamental motif was then adopted in other areas, not only for silverware but also gold glass bowls and Megarian bowls.

Two wonderful examples of these gold glass bowls were found in a grave in Canosa, Southern Italy, together with other Hellenistic glass vessels. These include two millefiori glass plates, a net-work glass bowl, a bowl with a band of bosses, and a glass skyphos.[38] Scholars have suggested various dates for this assemblage,[39] but in my opinion, the pair of gold glass bowls, at least, belongs in the first half or even the middle of the second century B.C., when the ornament on silver bowls seems similar. Gold glass bowls too were long considered an Alexandrian invention, although no supporting evidence has been found in Egypt.[40] Some evidence is now known from Rhodes,[41] even if these paltry remains are hardly the best specimens of the genre: they are fragments of reject bowls from the trash heap of a glass workshop. So it seems that the leading gold glass workshops may have been located in Syria and the Levant. Still, the vegetal ornament on the bowl from Canosa draws on Alexandrian motifs and does not align with the three bowls from Civita Castellana, for instance, in the shape of the lotus leaf tips and their interior structure.

The claim that these silver cups derive from a Pergamene workshop, however, is to my mind improbable. A comparison with Megarian bowls from Pergamon, a decisively local product in terracotta that imitates the precious metal bowls, reveals very different ornamental motifs.[42]

FIG. 3. Fragments of Megarian bowls from Pergamon, clay, second 3rd of 2nd century B.C. Antikensammlung, Staatliche Museen zu Berlin (P 524, P 506, P 511, P 514)

The lower zone on a fragment of a Pergamene cup in Berlin (fig. 3, top left) contains a leafy wreath with flower stems set between lancet and lotus leaves;[43] but they remain more vegetal and less stylized than those on the silver bowls. Another example in Berlin (fig. 3, bottom left) depicts a circle of acanthus leaves around a rosette incised into the bottom of the bowl.[44] The lotus leaves are defined solely by a central rib and alternate with more acanthus leaves in a second register. Here too, the leaves are more naturally depicted. The trend continues in additional examples from the excavations in Pergamon, likewise with acanthus leaves with overturned tips.[45] The best comparandum for the Pergamene ceramic fragments so far is the gold glass bowl formerly in the Edmond de Rothschild collection (fig. 4), reportedly bought in Israel and now unfortunately lost.[46] It even features a comparable double meander pattern flanked by beaded borders under the mouth, as well as narrow lancet and acanthus leaves interwoven with flower stems. While the production site of the Rothschild bowl is unknown, it may have been made in the Levant and would

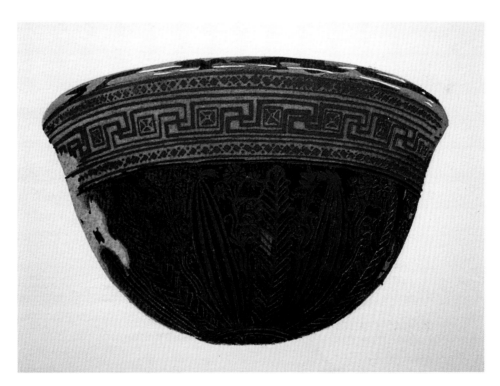

FIG. 4. Sandwich glass bowl, acquired in Palestine, Hellenistic, 2nd century B.C. Gold. Formerly Collection of Edmond de Rothschild, now lost

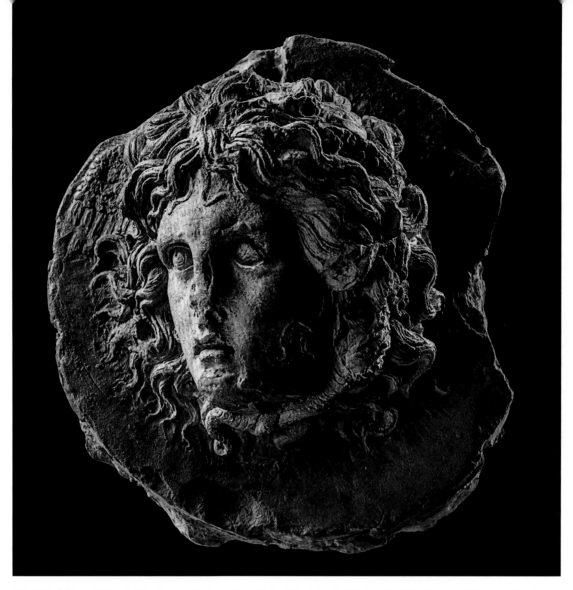

FIG. 5. Medallion with head of the Gorgon Medusa. Greek, Hellenistic, 1st half of 2nd century B.C. Clay model for a relief, perhaps used in a toreutic workshop. Antikenmuseum Basel und Sammlung Ludwig (BS 328)

therefore join the pieces that inspired Pergamene ceramic production. The silver bowls from Civita Castellana must have been made in a different region.

But now, let us turn to several pieces that can be more certainly connected with Pergamon. A terracotta medallion with a winged head of Medusa, today in the Antikenmuseum in Basel (fig. 5),[47] might have served as the model for repoussé work like a tondo at the bottom of a bowl. In very high relief, the face is shown in three-quarters view, her hair in violent movement around it. The deep-set eyes are wide open and cast deep shadow. A small, prettily curved mouth

is set between broad, full cheeks. Stylistically, this head is very near the heads on the Great Frieze of the Pergamon Altar, hinting not only at a similar date but also a direct relationship between the two. This is clear from a look at the head of Alkyoneus from the Altar's East Frieze (fig. 6). The eyes with lids framed by deep shadows are extremely similar, as are the broad cheeks, strong chin, curvy and slightly open mouth, and dramatically streaming hair shown in individual locks.[48] If the Medusa medallion really is from Taranto, then it must have been brought from Asia Minor, for it has no parallel in the toreutics of Southern Italy.

FIG. 6. Head of Alkyoneus, Great Frieze of the Pergamon Altar, east side, 2nd quarter of the 2nd century B.C. Antikensammlung, Staatliche Museen zu Berlin

Nor would that be unusual: artists' models for repoussé in bronze or precious metals were traded over very long distances, much as the finished products were. One need only think of the partial plaster cast of a Scythian cup found in a metal workshop in Memphis in Egypt, or the plaster casts found in Begram in Afghanistan.[49]

A gilded silver medallion showing a centaur or satyr head, again in the Berlin Antikensammlung (fig. 7), belongs to the same period.[50] Its findspot, Miletopolis (modern-day Kirmasti), is only about a hundred kilometers northeast of Pergamon. Both the findspot and the dramatic rendering

of the head—which resembles Hekate's enemy on the Pergamon Altar frieze (fig. 8)[51]—speak for an origin in a Pergamene workshop. Juxtaposing it with the slightly later centaur protome of a rhyton from the silver hoard from Civita Castellana, now in Vienna,[52] reveals several differences despite the common subject. The form of the face and the proportions are quite different between the two, another sign that the Civita Castellana hoard originated elsewhere.

In summary, the archaeological and literary sources for luxury goods produced or used in Pergamon offer only a schematic picture, but the same can be said for the courts

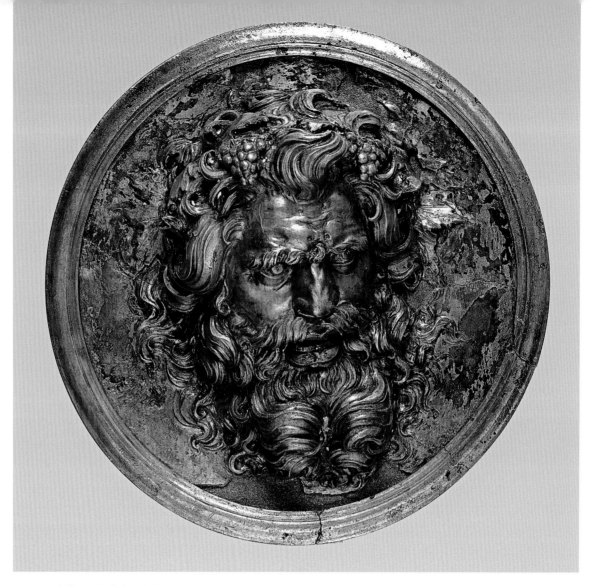

FIG. 7. Medallion with the head of a Centaur or Silenus, said to have come from Miletopolis (Kirmasti, Turkey), 1st half of 2nd century B.C. Gilded silver. Antikensammlung, Staatliche Museen zu Berlin (Misc. 10840)

at Alexandria and Antioch. Only in Macedonia do we have enough evidence, largely thanks to the incredible discoveries of unplundered graves in recent decades, to gain some idea of the precious objects that the aristocracy so eagerly sought. But perhaps the picture will change if further tombs come to light in the Pergamene necropoleis.

Acknowledgments

My warm thanks go to Stephanie Pearson for the translation of my German text, as well as to Seán Hemingway, Kiki Karoglou, Jan Stubbe Østergaard, and Rolf Sporleder for their comments and help.

1. T. Zimmer 2010, 2011, 2012.

2. On the furniture and furnishings of Hellenistic royal palaces, see G. Zimmer 1996.

3. Kelp 2011, with further references; Kelp 2014.

4. Jacobsthal 1908, pp. 428–36, pls. 25, 26; Schwarzmaier 2011, with further references.

5. Pfrommer 1990, pp. 241–42, 305–6, nos. FK 72 (Tumulus II), HK 62, pls. 6,1–3 (golden wreath).

6. Mentioned in Radt 1999, p. 287; for a picture taken by Deniz Türker on Instagram, August 25, 2015, see https://instagram.com/p/3YP3YYJT1J.

7. The dating is based on stylistic comparisons with heads and draperies on Greek box mirrors' reliefs. Compare the reliefs in the J. Paul Getty Museum,

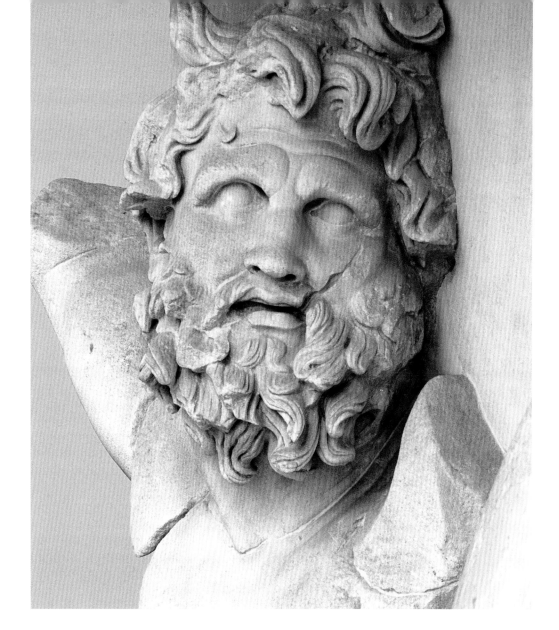

FIG. 8. Head of the enemy of Hekate, Great Frieze of the Pergamon Altar, east side, 2nd quarter of the 2nd century B.C. Antikensammlung, Staatliche Museen zu Berlin

Malibu, 91.AC.64 (see Schwarzmaier 1997, p. 301, no. 166, pl. 30,2); and in the Antikensammlung, Munich, 3427 (see ibid., p. 303, no. 168, pl. 75,3): in both cases, the faces seem inflated and have puffed cheeks and a prominent chin. Seen in profile from the side of the face, mouth and nose are pronounced. On a piece in the Antikensammlung, Berlin, Misc. 8538 (see ibid., p. 260, no. 63, pl. 33,2), the drapery is rather stiff and seems to frame the body parts like metal strips. Compare also the gold medallion with a bust of Artemis from the Stathatos Collection in the National Archaeological Museum, Athens, ST 369; see Reinsberg 1980, pp. 97–99, 102, n. 356, fig. 66; Jackson 2017, pp. 45–46, fig. 15.

8. Mentioned in Radt 1997, p. 429; Radt 1999, p. 287. The objects are being published by Ute Kelp, member of the German excavation team in Pergamon, as part of her research on Pergamene necropoleis. I am very grateful to her for showing me photographs of the find in advance.

9. Compare the snake bracelets from the Stathatos Collection in the National Archaeological Museum, Athens; see Amandry 1953, pp. 116–18, nos. 255–63, especially 255, 258, 259, pls. 45–47. For a pair of snake bracelets in the Benaki Museum, Athens, 1722, 1723, see Georgoula 1999, pp. 244–45, no. 88; Jackson 2017, p. 155, no. 98a–b. For a golden wreath in the Antikensammlung, Berlin, 30219, 497, said to be from Asia Minor, see Platz-Horster 2001, pp. 58–59, no. 35.

10. Museum of Fine Arts, Boston, 1971.47; see Oliver 1977, p. 53, no. 21.

11. Rotroff 1982b; Ignatiadou 2012.

12. Schwarzer's research project "Antikes, byzantinisches und islamisches Glas aus Pergamon" [Ancient, Byzantine, and Islamic glass from Pergamon] will end up in a book within the series Altertümer von Pergamon. For first results, see Schwarzer and Rehren 2015.

13. Rostovtzeff 1941, vol. 1, p. 553.

14. For the donation of a stoa and the dedication of several monuments and objects to Apollo at Delos by Attalos I, see Hansen 1971, p. 290. For an overview regarding the building and donation policy of the Attalids, see ibid., pp. 284–98; Schalles 1985; Pollitt 1986, pp. 281–83; and recently Schalles 2011.

15. Titus Livius (Livy), The History of Rome, 32.8.9–16 (Roman intervention), 32.27.1 (golden wreath); Hansen 1971, p. 63. Polybius (The Histories, 18.41) records that king Attalos I was not corrupted by his extraordinary wealth.

16. Pliny the Elder, Natural History, 33.148–149; Kuttner 2015, p. 53.

17. The name refers possibly to Attalos I; see Pliny the Elder, Natural History 8.196, 33.63, 37.12; Rostovtzeff 1941, vol. 1, pp. 563–64; Chioffi 2004, pp. 89–92; Gleba 2008, p. 62; and Benda-Weber 2013, pp. 181–83.

18. Valerius Maximus, Nine Books of Memorable Deeds and Sayings, 9.1.5; Tiberius Catius Silius Italicus (Silius), Punica, 14.659–660; Hansen 1971, p. 214; Sommerey 2008, p. 167, n. 151. Concerning the "aulaea Attalica," see also Benda-Weber 2013, p. 181. For parapetasmata "Attalica," see Marcus Tullius Cicero, The Orations: Verrinae 2.4.27–28.

19. Isidore of Seville, The Etymologies, 19.26.8; Hansen 1971, p. 214.

20. Andronikos 1984, pp. 191–92, 195, figs. 156, 157; Andrianou 2012, p. 46; Lapatin 2015, p. 270, pl. 176.

21. Chioffi 2004, pp. 89–91.

22. Winter 1908, pp. 350–52, no. 445, suppl. pl. 44 (drawing of the decorative borders on the cloth on p. 351); Grüssinger, V. Kästner, and Scholl 2011, p. 505, no. 5.18; Feuser n.d.

23. For example on mosaic floors, Grüssinger, V. Kästner, and Scholl 2011, pp. 519–21, nos. 5.42, 5.43 and ibid., pp. 522–23, nos. 5.48–5.50.

24. Antikensammlung, Berlin, V 1.2-33, from Palace IV, room A; see T. Zimmer 2010, p. 161, fig. 4; and ibid., pp. 504–5, no. 5.16.

25. Greenewalt and Majewski 1980.

26. Radt 1999, p. 285.

27. Blum 1998, pp. 245–47, refers to Polybius, The Histories, 16.6.4–8 (concerning Attalos I), and Plutarch, Parallel Lives: Tiberius Gracchus, 14 (concerning the insignia of Attalos III).

28. Raeck 1988, pls. 20–23.

29. Rostovtzeff 1941, vol. 2, pp. 676–81.

30. For the parade of Antiochus IV at Daphne, see Athenaios of Naucratis, Philosophers at Dinner, or Banquet of the Learned, 5.194C–195F, referring to Polybius, The Histories, 30.25–26. For the parade of Ptolemy II at Alexandria, see Athenaios of Naucratis, Philosophers at Dinner, or Banquet of the Learned, 5.196a–203b; Rice 1983; Stähli 1999, pp. 235–38; and Erskine 2013.

31. For Megarian bowls, see Rotroff 1982a, pp. 9–13; Rotroff 1982b, pp. 331–32; and Rotroff 2006.

32. Rotroff 1982b.

33. For evidence of vessels made of precious stones at the Ptolemaic and Seleucid courts, see Bühler 1973, pp. 4–5, 8–10.

34. Museo Archeologico Nazionale, Naples, 25284, 25285, 25288; see Pirzio Biroli Stefanelli 1991, p. 262, nos. 1, 2, figs. 2–5, 262; Lapatin 2015, p. 240, pl. 69; Fiorenza Grasso in Picón and Hemingway 2016, pp. 244–45, no. 182a–c. Strong 1966 and Grasso in Picón and Hemingway 2016 suggest a Pergamene origin for the bowls. Coarelli 1977, pp. 529–30, pl. 66a–b, and Pirzio Biroli Stefanelli 1991 assume a Pergamene or Syrian workshop. In contrast, see Pfrommer 1987, p. 112, n. 697. He attributes the whole treasure to a Seleucid workshop for he claims that centaur rhyta are only known from the Seleucid Empire; see ibid., p. 172, no. FK 13.

35. Kunsthistorisches Museum, Vienna, ANSA VIIa 49; see Strong 1966, p. 109, fig. 27B; Reinsberg 1980, pp. 106–8, 111–12, 200–201, figs. 73, 101, 102; Lapatin 2015, pp. 240–41, pl. 72; Georg Plattner in Picón and Hemingway 2016, pp. 242–44, no. 181.

36. Strong 1966, p. 110; Coarelli 1977, p. 530; Lapatin 2015, pp. 29, 240. For luxury goods from Asia Minor imported to Rome in the second century B.C., see Gruen 1993, pp. 85, 105–6.

37. A pair from the Fayum is now in the Antikensammlung, Munich, 4336, 4337; see Ahrens 1968, pp. 232–33, figs. 5, 6. A bronze cup from Egypt now in the Ägyptisches Museum, Cairo, J.E. 36460; see Grimm 1975, p. 26, no. 59, pl. 99.

38. Today in the British Museum, London, GR 1871, 0518. 1-10; see D. Harden 1968; and Oliver 1968. For the gold glass bowl, see Lapatin 2015, p. 236, pl. 55; and Dirk Booms in Picón and Hemingway 2016, p. 256, no. 195.

39. On the problem of dating gold sandwich glass vessels, see Saldern 2004, pp. 120–25.

40. Stern 1994, pp. 108–13.

41. Weinberg 1969. For an overview of new glass finds from the island, see Triantafyllidis 2000b, especially p. 31, and Triantafyllidis 2003b, especially p. 136, both on gold sandwich glass.

42. See also the discussion in the essay by Susan Rotroff in this volume.

43. Antikensammlung, Berlin, P 524; see Grüssinger, V. Kästner, and Scholl 2011, p. 476, no. 3.94.

44. Antikensammlung, Berlin, P 511; unpublished.

45. Fragment of a model from the Kestel workshop, Bergama Museum, 97.9.86; see de Luca 2011, p. 364, fig. 2,7. For bowl PE 88/3 from the urban quarter, see ibid., p. 364, fig. 2.6.

46. Wuilleumier 1930, pp. 29–30, pls. 11, 12; Rotroff 1982b, pp. 333–34, pl. 84.

47. Antikenmuseum, Basel, BS 328, formerly in the collection of Ernst Langlotz; see Reinsberg 1980, pp. 103–4, figs. 69, 70; and Tomas Lochman in Picón and Hemingway 2016, p. 164, no. 76. I thank Tomas Lochman for the permission to publish the photograph of the piece.

48. Winnefeld 1910, p. 55, pl. 26,4; Kähler 1948, pp. 115, 124, pl. 29.

49. Reinsberg 1980, pp. 28–35, 272, 276, 297, no. 9, figs. 12–16; Menninger 1996, pp. 93–219.

50. Antikensammlung, Berlin, Misc. 10840; see Reinsberg 1980, pp. 105–6, 111, 201, figs. 71, 72; and Agnes Schwarzmaier in Picón and Hemingway 2016, p. 248, no. 185.

51. Winnefeld 1910, p. 40, pl. 29.1; Kähler 1948, p. 123, pl. 54.1.

52. See note 35 above.

R. R. R. Smith

Diadems, Royal Hairstyles, and the Berlin Attalos

This essay is about the importance of hairstyle in Hellenistic royal portraits and the well-known and now-controversial head from Pergamon, known as P 130 or the Berlin Attalos (various views shown in figs. 3–8 and on p. 8).[1] It is one of the most effective Hellenistic ruler portraits to survive, and it contains by itself a remarkable story about royal hairstyles. The head is twice life-size (height: 40 cm) and so was from an imposing statue of perhaps 3 to 3.5 meters tall. I wrote about it back in 1988, and my interpretation has been accepted by some and challenged by others.[2] Here, I want to re-examine what is at stake in a fair and open-minded way and to respond to the latest detailed discussion of the piece.[3] New drawings and photos are offered that may clarify some of the issues. There are also new aspects to report, not least the precise find-context of the head (fig. 1).[4] The main points at issue here concern the portrait's diadem and added hair, not its name or date.

Diadems and Royal Portraits

A brief introduction about some key aspects of Hellenistic ruler portraits, notably the royal diadem, may be helpful. Ruler statues were powerful bronzes set up on inscribed bases. We have many extant bases, few statues, and some heterogeneous and disembodied heads, usually in marble, whose function is difficult to assess. Such heads, without their statue bodies, are fragments. The portrait head of a Hellenistic king, whether on coins or statues, consisted of a portrait physiognomy, a hairstyle, and a diadem. All three components were capable of variety (figs. 2a and b). Portrait faces range from a youthful, god-like beauty to more individualized and older-looking faces. Hairstyles range from

short and receding to long and Dionysian. The diadem has less variety.

The ancient *diadēma*, or royal diadem, is a plain band of white cloth tied around the head, with a reef knot at the nape of the neck and free-hanging ends. It was the main emblem of Hellenistic kingship and became important only in 306 B.C., when several of the leading Macedonian generals were acclaimed as kings and put on diadems.[5] Demetrios, Ptolemy, and Seleukos in the 290s B.C. were the earliest to issue diademed coin portraits of themselves, at the same time that the first posthumous Alexander coin portraits wearing the "normal" diadem were issued, on the famous tetradrachms of Lysimachos.[6] There was no Macedonian coronation ceremony, and this was no crown: the king put the diadem on himself, usually after a signal military victory. This was not a Louis XIV-style kingship, but one of warlords claiming a new-style legitimacy. The diadem meant king or *basileus*, and rulers without the diadem were non-royal dynasts, such as Philetairos of Pergamon was.

For the present discussion, it is vital to note the peculiar way the diadem is normally worn and not worn, as attested on both coins and sculpture. First, it is never worn around the forehead. Such a headband, worn on the brow below the hairline, is found, for example, on the posthumous Alexander portrait put out on brief experimental issues in Alexander's name by Ptolemy I in the 310s B.C. But this was not a diadem; it is a different and special attribute of Dionysos.[7] The diadem was a separate attribute, worn differently. On sculpted heads and royal coin portraits, it is *always* worn back from the brow, either behind a crest of forehead hair (fig. 2a) or, in the case of short-haired

FIG. 1. Plan of gymnasium at Pergamon. a: find-place of the Berlin head known as P 130 in late wall across front of Room H; B: Temple of Hera. After Grüssinger, V. Kästner, and Scholl 2011, p. 272, fig. 2

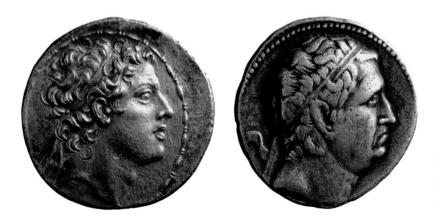

FIGS. 2a and b. a: Antiochos IV Epiphanes (r. 175–164 B.C.); b: Euthydemos I (r. ca. 230–200 B.C.). Both silver tetradrachms, obverses. Heberden Coin Room, Ashmolean Museum, Oxford University

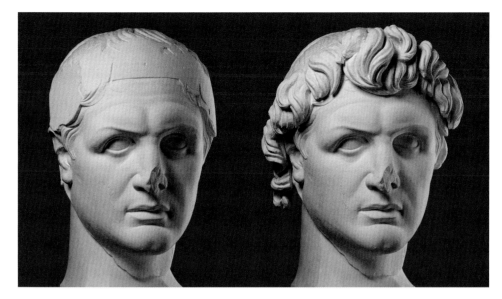

FIGS. 3a and b. Berlin Attalos, with and without added hair. Antikensammlung, Berlin P 130. Casts: Cast Gallery, Ashmolean Museum, Oxford, H 69, H 70

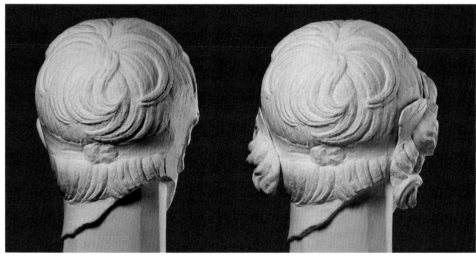

FIGS. 4a and b. Berlin Attalos, back of head, with and without added hair. Antikensammlung, Berlin P 130. Casts: Cast Gallery, Ashmolean Museum, Oxford, H 69, H 70

portraits, simply on the same line back from the brow (fig. 2b). Although in real life it is difficult to wear a head-band in this way, this position, well above the brow and behind the hairline, became fixed. The diadem in virtually all Hellenistic royal portraits known to us traced a line in the hair around the king's head, from the nape of the neck to the hair above the brow.[8]

Berlin P 130

The Berlin head wears a diadem and has two hairstyles. Controversy turns on whether it wore a diadem from the beginning or not. If one looks first at the back of the head, it seems that it did. But we will return to this later. The hairstyle was at first plain and flat, close to the skull, and consisted of long curving locks generated from a starfish

pattern at the crown of the head (we will call this phase 1). Later, a thick wreath of deeply drilled hair, made of eight delicately carved, interlocking pieces was added to carefully prepared flat surfaces cut into the original hair (we will call this phase 2). The pieces were fitted over the ears and attached with mortar. The new hairstyle included a diadem carved with the hair-wreath at its shallow, tapering upper edge, which is visible here in fig. 4b, on the added piece of hair at the back right. A line was lightly engraved over the hair, on both sides and over the brow, to mark the upper limit of the second-phase diadem and hair (visible in figs. 5 and 7a). The added hair-wreath was difficult to carve, and transforms the portrait's effect in a most striking manner (fig. 3). The facial features remained the same in both versions.

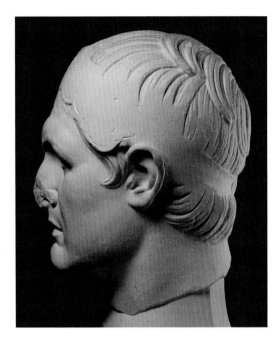

FIG. 5. Berlin Attalos, left profile, without added hair. Antikensammlung, Berlin P 130. Cast: Cast Gallery, Ashmolean Museum, Oxford, H 69

The motive and timing of this change have been debated. Some proposed explanations are implausible. I mention three. (1) *The head first wore bull's horns, later removed.*[9] There are however no sockets or holes that would be necessary to anchor such horns.[10] (2) *The head was made in the third century and was later revised in the second century in the style of the Great Altar frieze, to update it stylistically or to enhance its godlike, heroic, or "pathetic" quality.*[11] This is appealing, but on its own and without other motivation, it is difficult as a hypothesis because such elaborate later updating or enhancing of royal portraits is unattested.[12] No one thought other heads needed updating or enhancing, so why this one? (3) *The piecing of the hair, a common technique, was simply the way the head was made, and there need be no gap between the two phases.*[13] But it is clear the hairstyle was indeed fully finished in the first version, and at a later stage cut back to receive the added pieces. Hellenistic marble sculptors generally would not carve significant details only to remove them immediately afterward.

Whether there were weeks, years, or decades between them, the head certainly had two phases, one with a plain hairstyle and one with a new wreath of hair. I emphasize

that this was a considerable undertaking: it required a strong reason, an authorizing decision, and careful planning. The statue with its base was at least 4.5 meters tall and would have needed to be scaffolded. The head would have been cut back in situ, and the pieces of the intricately worked new hair were pre-carved and fitted to it with mortar and without dowels. The new hair was a difficult and painstaking piece of work.

In 1988, I argued that, in spite of appearances, the head actually wore no diadem in the first phase and represented a non-royal dynast, and in the second phase, after the subject had become king, the new hair and a diadem were added to give the statue the royal insignia and to make the hairstyle royal—to turn a dynast into a king.[14] The case seemed to me so clear that it was not pressed in great detail. Some scholars agreed, others did not and have continued to disagree.[15] The best and fullest recent re-examination by Ralf von den Hoff[16] seems certain that the head wore a diadem in the first phase. There are new things to say, first context and function.

Function and Find-Context

The original 1908 publication by Franz Winter reported vaguely that P 130 was found on the south slope of the acropolis.[17] While working in the archives for *The Berlin Sculpture Network*, Johanna Auinger discovered that the head was found precisely on the upper terrace of the gymnasium complex, in 1906, in its central exedra (Room H), built into a late wall that had been constructed between the columns that fronted the room, together with much other marble statuary (including a well-known colossal head of Herakles, Berlin Sk 1675) (see fig. 1).[18] It is possible these figures once were displayed in Room H, but it is also possible that they arrived from elsewhere in late antiquity, as building material.[19]

Even if P 130's precise display context is not knowable, it is still important to ask to what functional category of statue it belonged. The Temple of Hera on the hill outside and above the gymnasium, on a terrace almost immediately above Room H, has some evocative archaeological finds. I do not want to suggest the head came from here, merely that this is the kind of place where we can imagine it. The temple has a wide in-situ base for a seated divinity and standing figures, one of which survives.[20] Here, a ruler statue might represent a *synnaos theos*, a god sharing a

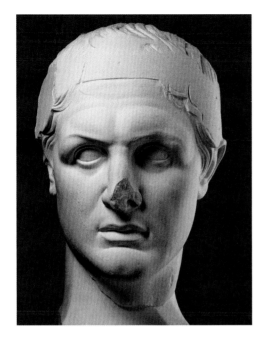

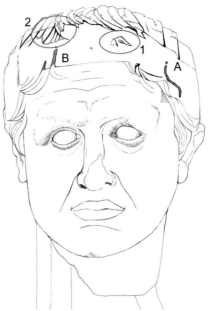

FIGS. 6a and b. Berlin Attalos, without added hair. Antikensammlung, Berlin P 130. A: Cast: Cast Gallery, Ashmolean Museum, Oxford, H 69. B: Drawing, with darkened lines emphasizing locks of hair interrupting path of putative first-phase diadem

temple with its main divinity. An indoor marble deity of this kind was an *agalma* (god), but to describe a statue that was both of a god and a recognizable portrait (*eikōn*), we find at Pergamon the special term *agalma eikonikon,* portrait cult-statue.[21] Such a term, I suggest, suits P 130 well.

Royal Hairstyle

Why then was the statue given a new hairstyle? And did it have a diadem in its first version? This question cannot be approached or settled by appeals to possible dates and identifications. It can be decided only by the physical evidence, by the "archaeology" of the marble head. Modern photos of P 130 in phase 1 are misleading: the early twentieth-century restoration drilled a series of large new dowel holes to attach the marble hair-wreath to the head.[22] Von den Hoff has worked hard to distinguish modern and ancient dowel holes and has shown that only one, a tiny hole in the center of the brow, is visible on old photos.[23] The dowel hole or holes do not much affect the issue of whether or not there was a diadem in the first phase. Some new photos and drawings of old casts may assist. In the following, I review each of the four sides of the head.

From the back, it looks at first as though the diadem was carved into the hair from the beginning (fig. 4a). The left profile too looks as though it is possible that a diadem

was carved in the hair in the first version, at least behind the left ear, where the same stretch of diadem as that seen at the back is visible (fig. 5). We might ask however what path or line the diadem could follow around the head on the left side. The later diadem carved with the added hair was positioned far above, and the surviving hair of the first version, without any traces of a diadem, extends a long way forward in front of the left ear. A first-phase diadem here would have to follow a lower path.

At the front of the head, any first-phase diadem would have to be carved low on the brow, below the preserved first-phase hair (figs. 6 and 8a), that is, in a position we have seen that the royal diadem was not worn (fig. 2 and nn. 7 and 8). This would be a unique or rare hypothetical reconstruction, difficult to support from the points of view of both archaeological method and the physical evidence. A first-phase diadem cannot have been carved farther back in the hair above the brow, along the proper path of a royal diadem, because here, it runs into two clear passages of "un-diademed" first-phase hair (these are marked 1 and 2 in figs. 6 and 8). That is, a first-phase diadem was either necessarily in an impossibly low and unattested position on the brow or farther back in the normal position, but here, it would have to run (impossibly) over clear passages of first-phase hair.

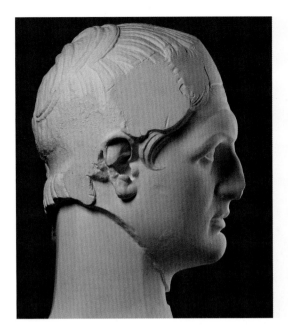

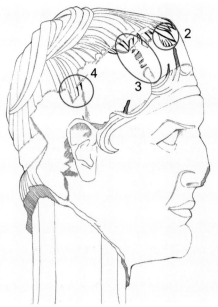

On each side of the brow, there are deep curving lines forming channels between locks of hair that are carved into the surface of the brow. There are two larger lines (marked A and B in fig. 6) and smaller ones beside them. These clearly pass over any line of a first-phase diadem. Von den Hoff has interpreted them as the result of drilling into the head *after* or in conjunction with the attachment of the second-phase crest of hair over the forehead.[24] This is certainly a possible explanation and if correct, would remove these deep lines from discussion of the presence or absence of a "low" first-phase diadem. Although my argument does not depend on them, it should be said that other explanations are possible. We might note two points. First, the lines follow contours of first-phase locks, which were picked up in the second-phase design of the hair: they could then be part of phase 1 (and would make any "low" first-phase diadem impossible). Second, the added wreath of hair was painstakingly carved and prepared *before* attachment and was attached only with mortar; to drill lines between its tightly fitted components would have been a risky and unnecessary procedure. In any case, these curving lines, even if secondary, do nothing to demonstrate there was a first-phase diadem.

The crucial evidence is found on the right side of the head. Here, a diadem in phase 1 becomes difficult, indeed probably impossible. In two or three key passages, the head

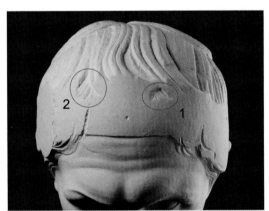

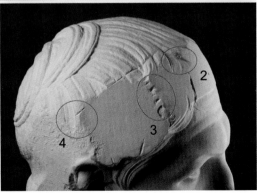

preserves carved locks of the first hairstyle where there should be parts of a diadem carved into the hair: (1) above the right ear (marked 4 on figs. 7 and 8); (2) on the right temple, where the lines between the two later cut surfaces are clearly parts of the big curving locks of the first hairstyle above (marked 3 on figs. 7 and 8); and (3) the same locks over the brow we saw from the front (again, marked 2 on figs. 7 and 8). The diagonal stacked lines at passage 3 are to be noted carefully: they are clearly parts of a long, soft, flat, backward-curving set of locks of first-phase hair whose upper strands can be easily followed above. They are also much too tall or broad to allow any first-phase diadem to go past them, whether above or below. I simply cannot find a way that a first-phase diadem could avoid these passages of preserved first-phase hair (see figs. 7 and 8). Regardless of the back or other elements, the right side seems to show there can have been no diadem in phase 1: there is no way for it to pass around the preserved hair.

The situation on the back of the head of course requires explanation (fig. 4). No separately worked hair was added across the earlier hair at the back, probably because it was less visible, perhaps against a wall. The added hair ended with the two extant pieces left and right (fig. 4b). Either there was a diadem here already (difficult in light of the evidence on the right side of the head) or there was no diadem and the sculptor of phase 2 had orders nonetheless to "join up" and complete the new diadem across the back of the head, by carving it directly into the old hairstyle. Other Hellenistic portraits of this period show how the hair at the back would have been before the diadem was carved into it.[25] If it was done well (and the sculptor who made and attached the new wreath of hair was an accomplished marble worker), there is no reason why such a modest reworking should leave traces.[26] In other words, given the impossibility of a first-phase diadem on the right side of the head, it is probably better to take the part of a knotted diadem carved into the back, not as the remains of a first-phase diadem but as a short stretch of diadem carved in the un-diademed hair of phase 1 in order to connect up the "ends" of the second-phase diadem carved with the added hairstyle (fig. 4b). Instead of being a decisive argument in favor of a diadem in phase 1, the stretch of diadem carved into the hair at the back probably shows instead how important it was symbolically that the diadem of a major royal portrait be *complete*.

P 130 therefore should probably be restored in phase 1 as an un-diademed ruler portrait, with flat, rather lank hair. Later, most likely when the dynast became king, a diadem and a wreath of hair were added. Other reconstructions that have diadems in both versions are unable either to explain the archaeology of the right side of the head or to provide a convincing concrete reason for the unusual, difficult, and far-reaching reconfiguration the head underwent. The diadem was most likely added only in the second phase and marked very specifically the subject's new position as *basileus,* for which the thick, god-like wreath of hair was more appropriate. The diadem expresses a precise new royal status, and the new hair expresses the majesty of that status.

The interpretation proposed here does not depend at all on names or dates. Stylistic dates have been proposed in the third and the second centuries for P 130 in both versions 1 and 2. The external limits of the possible chronological range are easily defined—between about 240 and 133 B.C. Attalos I took the royal diadem and title of king probably in the early 230s B.C. (the date is not known precisely) and was the first of the Attalid rulers to do so; and in 133 B.C., Attalos III bequeathed the kingdom to Rome. This is already a tight bracket, which no amount of stylistic analysis will reduce. P 130 surely belonged to a temple statue, and its subject was surely an Attalid and most likely a prince or dynast who became king and for whom the change of status was so important that this difficult and unusual modification to his statue was thought necessary. Attalos I, for whom the step from dynast to king was indeed momentous, remains a possible, perhaps even a likely candidate.

1. P-130 after its number in the catalogue in which it was first published: Winter 1908, pp. 144–47, no. 130, fig. 130, pl. 31. I am most grateful to Julia Lenaghan for suggestions, to Sasha Welm for the new drawings used here, and to David Gowers for the new photographs of the Ashmolean Museum's casts of the two versions of the head.
2. R. R. Smith 1988, pp. 79–81, 160, no. 28, pls. 22, 23. Accepted, for example, by Stewart 1990, vol. 1, p. 209, figs. 680–82; Ma 2003, p. 178, fig. 11.1. Challenged, for example, by Himmelmann 1989, p. 583; Herrmann 1993, pp. 33–35, 41, n. 21; Queyrel 2003, pp. 99–100, pls. 12–14; Hoff 2013; and, after a change of mind, Stewart 2014, pp. 62–63, figs. 33, 34.
3. For the most thorough recent treatment, see Hoff 2013, which references more than 110 bibliographical items concerning the head.
4. Auinger 2015, discussed below.
5. On the diadem, see Ritter 1965; R. R. Smith 1988, pp. 34–38; Virgilio 2003, pp. 79–82; and most recently and most fully, the papers collected in Lichtenberger et al. 2012, especially Meyer 2012 and Salzmann 2012.

6. See recently, for example, Thonemann 2015, pp. 18–22, figs. 1.21–26.

7. For Ptolemy I's posthumous Alexanders, see ibid., p. 19, figs. 1.19, 1.20. For the Dionysos headband, see Krug 1968, pp. 114–18; R. R. Smith 1988, p. 37, n. 55; and now fully Meyer 2012, who writes: "So trägt Dionysos in seinen Bildnissen ab den 2. Hälfte des 4. Jhs. v. Chr. sehr einheitlich und eindeutig ein Stirnbinde, während die Binde der hellenistischen Herrscher steht bald über den Haaransatz hinausrutscht und mit der Zeit immer mehr den Hinterkopf umschliesst." (Thus, in his portraits from the 2nd half of the 4th century B.C., Dionysus clearly and uniformly wears a head-band, round his brow, while the head-band of Hellenistic ruler lies pushed back beyond the hairline and increasingly with time encircles the back of the head.)

8. See Meyer 2012, quoted in note 7 above, and the full range of material discussed and illustrated in Salzmann 2012.

9. For the bull's horns, see Delbrueck 1912, pp. 38–41, revived and elaborated by Fleischer 1991, pp. 10–15.

10. How such horns would need to be attached can be seen clearly in a head in the Metropolitan Museum, 2012.479.10; see Zanker 2016, no. 1.

11. Some variation on this idea—a second-century updating and/or elevation—is perhaps the most common interpretation of the added hair among those who think the head also wore a diadem in the first version. See full references in Hoff 2013, s.v. Interpretation.

12. Since the facial features remained unchanged, the main reason for adjusting such portraits when it does occur—to change the subject from one ruler to another—does not apply.

13. Himmelmann 1989, p. 583; Ridgway 1990–2002, vol. 1, pp. 129–30; Herrmann 1993, p. 33, n. 23.

14. R. R. Smith 1988, pp. 79–81, 160, no. 28.

15. See references in note 2 above.

16. Hoff 2013.

17. Winter 1908.

18. Auinger 2015.

19. The full material from Room H is to be restudied and published by Ralf von den Hoff. If the statuary in the late wall was originally part of Room H, the date of the gymnasium would of course have a bearing on the date of P 130, but this is unknown. The statuary found in the best-documented such late walls at Aphrodisias (for example, the wall behind the Theatre skene building) came from various places near and far around the site; see R. R. Smith 2006, p. 44.

20. Radt 1999, pp. 186–88; Mathys 2014, pp. 38–43, pl. 12.

21. *Agalma eikonikon: IvP* 256. 7. The inscription (of the Roman period) wants to make a distinction between two statues for the same honor and, namely a bronze portrait [statue] (*eikōn chalkē*) and a [marble] cult statue that was also a portrait (*agalma eikonikon*).

22. Well illustrated in Hoff 2011, fig. 4a–d.

23. Hoff 2013.

24. Ibid.

25. Compare, for example, the hair schemes on the back of: (1) Menander (Fittschen 1991); (2) Poseidippos (Fittschen 1992); (3) Philetairos (Queyrel 2003, pl. 6.2); (4) and a Hellenistic portrait head in the J. Paul Getty Museum, Malibu (Herrmann 1993).

26. Concerning arguments about the back of the head made by von den Hoff 2013, s.v. Material and Technique, the following points may be made: (a) the greater width of the part of the diadem carved into the nape compared to the part carved with the added hair was not particularly significant, because it remained unseen and could be controlled only on the less visible right side (less visible because the head was turned slightly to its proper right); (b) the lack of precise correspondence between the locks above and below the part of the diadem on the nape is because the original hair scheme had to be no doubt adjusted here by the sculptor of phase 2: for typical un-diademed back-of-head hair schemes of this period, see note 25 above; (c) the hair "reacts" as if pressed by this part of the diadem simply because the sculptor of phase 2 did a good job in adjusting the hair scheme and carving a diadem into it that looked convincing, so, of course "the hair seems to react to the pressure of the diadem"; and (d) the diadem knot does not stand "too proud": it is flat and in fact lies in a *lower* plane than that of the locks immediately above and below it; and the knot and this part of the diadem were probably carved into the hair of phase 1 and then the lock scheme adjusted above and below to take account of it.

Olga Palagia

Pergamene Reflections in the Sanctuary of Diana at Nemi

The style of the Great Altar of Pergamon, created in the second quarter of the second century B.C., left its mark not only locally[1] but also, significantly, on the sculptural production of Rhodes. A colossal head of Helios from Rhodes, once probably attached to a pediment, provides a fine example of Pergamene reflections on the island.[2] In the late second and the first century B.C., the Pergamene style in sculpture was diffused farther afield, carried by Rhodian and Athenian artists to Rome, as witness the Laocoon by the Rhodians Agesandros, Athenodoros, and Polydoros,[3] and the Belvedere Torso, signed by the Athenian Apollonios, son of Nestor.[4] The art of Pergamon is likewise reflected in the over-life-size marble bust of a bearded god (figs. 1–4) that came to light in 1885, in the sanctuary of Diana Nemorensis on the shores of Lake Nemi, about twenty-five kilometers southeast of Rome.[5] It was recovered in the excavations of Sir John Savile Lumley, later Lord Savile, British ambassador to Rome.[6] This bust will be examined in this essay in the context of sculptures produced by Greek artists in Rome during the Republican period, while the Romans were gradually subjugating Greece.[7]

Lord Savile's excavations lasted for eight months and were more in the nature of a treasure hunt, as we have no scientific records and no full inventory of the finds.[8] They were carried out on the private land of Count Orsini, and it appears that he and Lord Savile divided the spoils afterward. Lord Savile was a native of Nottingham, and his share ended up in the Castle Museum, Nottingham, where it is now in storage. A preliminary plan of the sanctuary was provided for Lord Savile around 1886.[9] Revised plans were published in 2000 and again in 2013, based on the

excavations of 1989–2009 carried out by the University of Perugia and the Soprintendenza per i Beni Archeologici del Lazio.[10]

But before we examine the bust, let us take a brief look at its context. After Savile, further excavations by others took place in Nemi until the end of the nineteenth century, with the main purpose of acquiring sculptures. In the 1890s, many of these sculptures were purchased by the newly founded Ny Carlsberg Glyptotek in Copenhagen; others were donated to the equally new University of Pennsylvania Museum.[11] A century later, their acquisition by these two institutions generated a series of studies by Pia Guldager Bilde, Mette Moltesen, and Irene Bald Romano, published between 1995 and 2006. Although it has not been possible to investigate the excavation contexts of the sculptures' findspots, it has been established that most were found in the rooms of a portico at the back of the precinct, built against the retaining wall of the upper sanctuary terrace.[12] Some of the sculptures were not in their original locations but rather deposited in storage. They range in date from the late second century B.C. to the first century A.D., including a number of portraits from the Republican period to the early Julio-Claudian period. In addition, the recent Italian investigations at the sanctuary suggest that the temple of Diana was originally built around 300 B.C. and was renovated toward the end of the second century and again in the mid-first century B.C.[13]

An over-life-size head of Diana in Parian marble is thought to belong to the cult statue set up in this temple in the late second century B.C. (figs. 5 and 6).[14] It was made by a Greek artist in a retrospective style, reminiscent of the

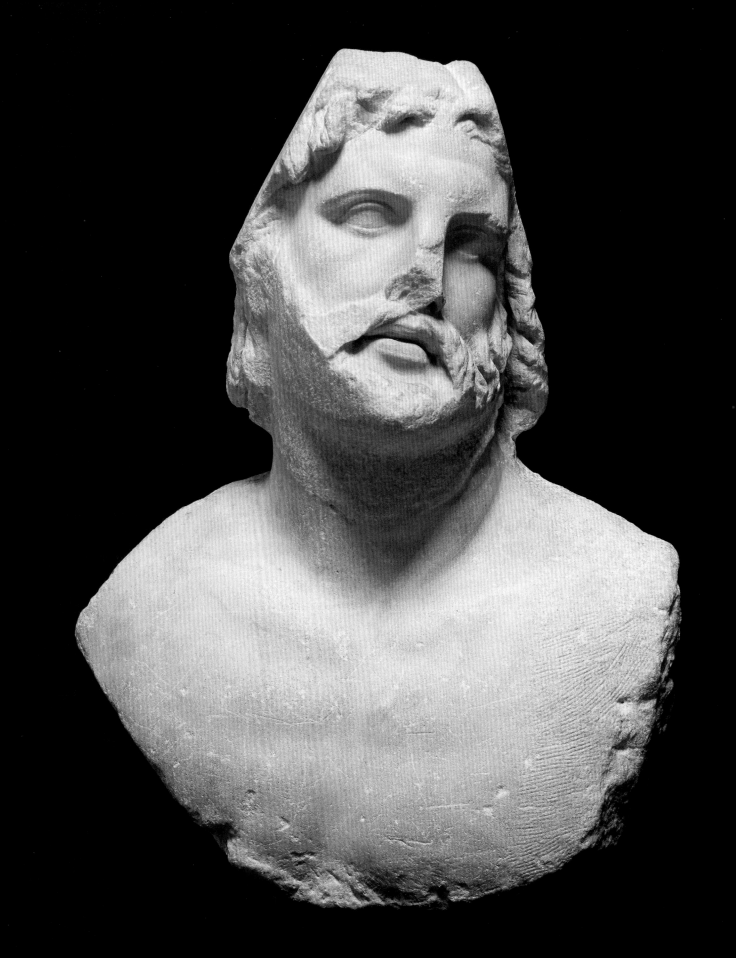

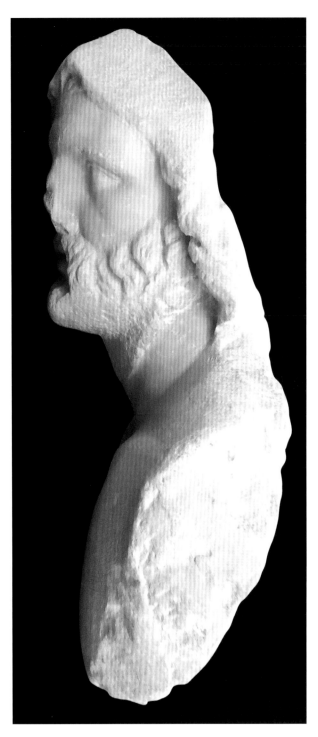

FIG. 2. Back of fig. 1

FIG. 3. Top of head of fig. 1

FIG. 4. Left profile of fig. 1

Opposite: FIG. 1. Bust of a god from Nemi, ca. 100 B.C. Marble, h. 24⅜ in. (62 cm). Castle Museum, Nottingham, N 832

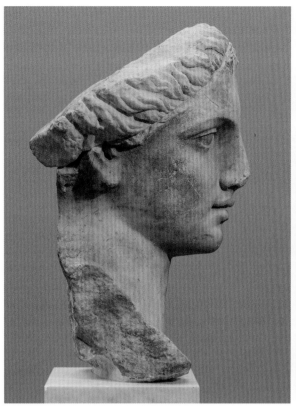

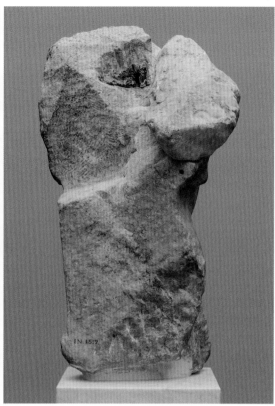

FIG. 5. Head of Diana from Nemi, profile. Marble, late 2nd century B.C. Ny Carlsberg Glyptotek, Copenhagen, 1517

FIG. 6. Back of fig. 5

fourth century. As no parts of the body were ever recovered, it is assumed to be in the acrolithic technique. The head is carved in one piece, with the neck to be inserted into a wooden body. However, the head itself was pieced. Its right side was made separately. The stepped rear is dressed with a claw chisel for the attachment of an additional piece, probably glued on. An iron dowel insulated with lead at the top of the head indicates that an additional marble piece was attached here. There are several examples of acrolithic statues from the Hellenistic period; all have marble extremities like heads with necks, hands, and feet, for example, the head and feet of Hygieia by the Athenian Attalos found at Pheneos in Arcadia.[15] Several had plaster additions, as exemplified by rough picked surfaces like that of a head of Herakles from Sparta.[16]

A second over-life-size head with neck belonging to a goddess from Nemi, probably also Diana, now in Philadelphia, has been attributed to an acrolithic statue.[17] Her back is flat, dressed with a claw chisel for attachment to a wall. Her slightly curved profile (fig. 7), however,

indicates that she may be a bust rather than a full statue, for we can postulate that she was slightly inclined downward. Her erect pose and classicizing style are easily comparable to other late Hellenistic heads from Rome, like the head of a goddess in the Capitoline Museum.[18]

The activities of Greek artists in Rome in this period are documented not only by a number of colossal cult-statue heads[19] but also by the testimony of Pliny the Elder.[20] An Athenian family of sculptors—Timarchides, Polykles, and Dionysios—were commissioned by Republican generals to create cult statues for the temples they dedicated in Rome with spoils from their victories.[21] A statue of Apollo Kitharoidos by Timarchides was set up in the temple of Apollo Medicus, while his sons, Polykles and Dionysios, sculpted the cult statues of Jupiter and Juno erected in the twin temples of Jupiter Stator and Juno Regina rebuilt by Caecilius Metellus Macedonicus after his triumph of 146 B.C.

We now come to the bust in Nottingham (figs. 1-4).[22] It is made of Parian lychnites marble, and its total height is 62 centimeters. It represents a bearded god with head tilted

upward to his proper left, giving him a passionate expression. His mouth is half-open, eyes deeply set in their sockets, brow furrowed. The high quality of the workmanship matches the exceptional quality of the marble. The size of the marble block, however, was not sufficient, and as a result, the hair and part of the moustache and beard were pieced. The joining surfaces are dressed with a claw chisel. It appears that the locks of his hair were added in three separate marble pieces attached to the sides and the top of his head. The hair at the bottom of the right side of his head may have been added in plaster, attached to a rough surface, and secured with three pins (their holes remain). The god's beard was apparently completed in plaster, which would have been attached to the curved surfaces dressed with a claw chisel. A lead pouring channel survives at the top of the head for securing a round dowel, which has now vanished. Evidence of an aborted dowel hole also survives next to the actual hole. The figure's nose is damaged. The back of the head is hollowed out to reduce the weight of the marble, while the back of the bust was flattened with a pick. A round dowel hole in this area appears to be ancient.

The outline of the bust is asymmetrical, and there are rasp marks over his left chest. Bilde detected traces of a green patina over the rasp marks and thought they were evidence of drapery added in bronze.[23] Bronze additions, however, are usually attested by pinholes, and we have none here. Bilde compared the Nottingham bust with the second century statue of Asklepios from Munychia (fig. 8)[24] and concluded that the similarities between the two were so pronounced that the Nottingham god is very likely an Asklepios or its Latin equivalent, Virbius, who acted in Nemi as a healer. Evidence of a healing cult in Nemi is provided by anatomical votives and surgical instruments.[25] Bilde's comparison laid to rest earlier identifications of the god with Jupiter, Sarapis, or Hades, none of whom had any reason to be in the sanctuary of Diana. There is, however, an even closer stylistic parallel to the Nemi god, not from Greece proper but from Italy. The Aesculapius of Ostia (fig. 9), made of Parian marble, was found in the sanctuary of Hercules and is dated to the end of the second century B.C.[26] His Pergamene look, highlighted by his pathetic expression, furrowed brow, and half-open mouth, betrays a common stylistic inspiration with the Nemi god. In addition, his hair is pieced, as is the case with the Nemi bust.

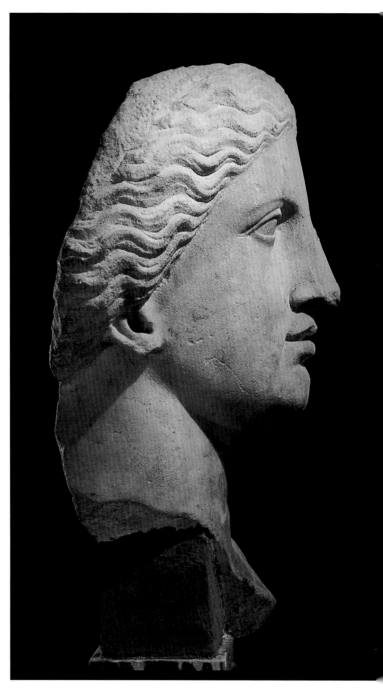

FIG. 7. Head of a goddess (Diana) from Nemi, left profile. Marble, 1st century B.C. University of Pennsylvania Museum, Philadelphia, Ms 3483

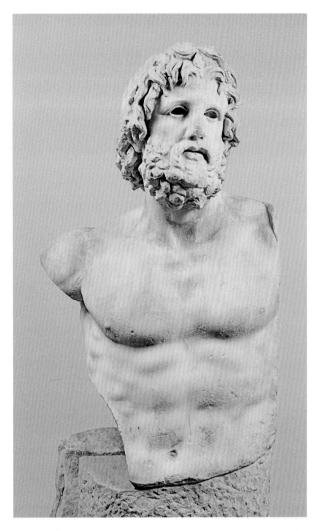

FIG. 8. Asklepios from Munychia. Marble, 2nd century B.C. National Museum, Athens, 258

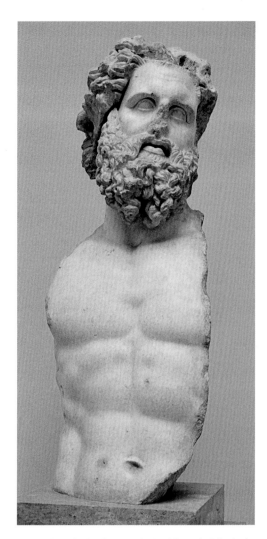

FIG. 9. Aesculapius from Ostia. Marble, end of the 2nd century B.C. Museo Ostiense, 114

However, both the Munychia Asklepios and the Ostia Aesculapius were in fact full statues, albeit pieced, not busts. Bilde interpreted the Nemi bust as part of an acrolithic statue and considered it in the same league as the two heads of goddesses from Nemi that we discussed earlier.[27] Her assessment was never challenged, and the Nemi god has passed in the bibliography of the Diana sanctuary as a cult statue of Asklepios (or Virbius), created by a Greek sculptor in the late second century B.C. alongside the other two figures. She was unable, however, to offer any examples of acroliths that included the bust of the figure.[28] On the contrary, Greek acroliths from Rome involved only heads, hollowed out and completed in plaster. Such an example is the head of Herakles from the slopes of the

Capitoline attributed in Cicero's testimony to the Athenian sculptor Polykles, who was active in the second half of the second century.[29]

If we consider a profile view of the Nottingham bust (fig. 4), it becomes quite clear that it never formed part of a full statue but was designed to be set into a marble tondo decorating the wall or the pediment of a chapel, hence its uneven sides. We have a number of parallels from the late Hellenistic period, all assigned to the period between the mid-second and the first century B.C., though none comes from Rome so far. It is remarkable that the majority of these images are pieced. The only securely dated examples, now heavily damaged, came to light on Delos. A tondo bust with a separately carved head, now lost, decorated the

pediment of the Doric temple of Isis, restored by the Athenians around 135 B.C.[30] More busts (also with separate heads) decorated a room in the sanctuary of the Great Gods of Samothrace, dedicated by the Athenian priest Helianax in honor of Mithridates VI Eupator.[31] His priesthood and by implication the monument are dated to 102/1 B.C. There were twelve busts of officers and allies of Mithridates lining the walls of the chapel and a thirteenth bust placed in the pediment above the door. The medallions with the busts were made in one piece, with cavities for the insertion of heads.

An example of a complete bust of a youthful male figure of the late Hellenistic period, though less securely dated, was found in the gymnasium of Atalante in Boeotia and is now in the Thebes Museum.[32] The bust was tentatively identified with a portrait of Mithridates VI, but the similarity is not compelling, to judge by his coin portraits.[33] The figure may well be a hero. It is remarkable that it was all carved from one piece, indicating the special care lavished on this work.

Fragments of two colossal busts of very fine quality dated on the grounds of style shortly after the middle of the second century B.C. have been attributed to Hall H of the gymnasium of Pergamon.[34]

Of uncertain date are the divine busts in Parian marble that formed part of the cargo of the shipwreck of Mahdia and are now in the Bardo Museum in Tunis.[35] The shipwreck dates from the early first century B.C., but the busts were not new, as they carry lead dowels in their backs and must have been wrenched from their original location. The busts represent a Dionysiac thiasos and may have decorated a chapel in a sanctuary of Dionysos. They all carry evidence of piecing. The best preserved bust, interpreted as Aphrodite or Ariadne, has anathyrosis on the right side for the attachment of an additional piece.[36] The bust of a female satyr from Mahdia was pieced of several marble parts.[37] It has been suggested that the busts were made in Athens in the first quarter of the first century B.C.[38]

But the closest parallels to the Nemi bust come from the palaistra of Calydon in Aitolia, which was erected above an earlier underground chamber tomb sometime in the first century B.C.[39] The life-size busts in Pentelic marble from Calydon were reassembled out of many pieces and put on display in the Agrinion Museum.[40] Peter C. Bol dated them to the late second century B.C., but recent re-examination of

FIG. 10. Bust of Eros from the Heroon of Calydon. Marble, 1st century B.C. Agrinion Museum, 30

the architecture and the inscriptions associated with this monument has lowered their date to the first century B.C.[41] The outlines of the busts and their piecing techniques are similar to the Nemi bust, except for the lack of plaster additions. The use of plaster, however, is postulated for the tondos, no fragments of which were ever found in the excavations. The style of the Calydon busts is classicizing, not Pergamene baroque like the Nemi bust. Some, such as the bust of Herakles, modeled on Lysippos's Farnese Herakles, reflect fourth century prototypes.[42] On the bust of Eros, the top of his head is carved separately (fig. 10).[43]

The evidence we have assembled so far is enough, I think, to demonstrate that the Nottingham bust was attached to a tondo and was used as architectural decoration. We do not know if it was placed inside one of the chapels or in a pediment. I postulate a similar function for the head of Diana now in Philadelphia, as she too is flat at the back and exhibits a concave profile (fig. 7). The use of such busts is paralleled by examples from Greece mainly dating from the late second and the first centuries B.C.

The two busts at Nemi very likely were produced by one or more imported Greek sculptors, who created them on the spot following the practices they had learned at home. The Pergamene style of the Nottingham bust need not indicate the origin of the sculptor. By that date, it had become so widespread that even Athenian sculptors, like Apollonios, son of Nestor, favored it.

In sum, the marble bust of Asklepios (fig. 1) from the sanctuary of Diana in Nemi was originally placed in a tondo that is now lost and was produced in the Pergamene style by a Greek sculptor of uncertain origin around 100 B.C.

Acknowledgments

I am most grateful to Carlos Picón for inviting me to this stimulating conference. Bernard Ashmole first drew my attention to the Nottingham bust in the 1970s, and I saw it thanks to the kindness of Alan MacCormick, curator of the Castle Museum in the 1970s and 1980s. My renewed interest is due to further acquaintance with the sculptures from Nemi now in Philadelphia and Copenhagen.
I am grateful to Ann Inscker of the Castle Museum, Nottingham, for permission to study and photograph the bust of a god from Nemi, and to Hans R. Goette for taking new photos of it. I am also grateful to Rune Frederiksen for facilitating my study in the Ny Carlsberg Glyptotek. My thanks are also due to Brian Rose of the University of Pennsylvania Museum for the photograph of fig. 7 and permission to use it, and to Annewies van den Hoek for fig. 9, the photograph of Aesculapius.

1. On the style of the Great Altar of Pergamon, created by artists of different origin, see Massa-Pairault 2015 and Queyrel 2015.
2. Archaeological Museum of Rhodes, E 49; see Neumann 1977; Bairami 2015, pp. 156–57.
3. Vatican Museums, Rome, 1059, 1604, 1607; see Vorster 2007, pp. 327–29, fig. 336.
4. Vatican Museums, Rome, 1192; see ibid., p. 314, fig. 315.
5. Castle Museum, Nottingham, N 832, from Nemi; see Bilde 1995, pp. 206–13, figs. 19–24.
6. On Lord Savile, see Blagg 1983, pp. 11–14.
7. Greek sculptures made in Rome were collected by and exhibited at the Capitoline Museum in Rome in 2010; see La Rocca and Parisi Presicce 2010. I am grateful to Eugenio La Rocca for giving me a guided tour of that magnificent and extremely illuminating exhibition.
8. On these excavations, see Blagg 1983, pp. 19–24; Bilde 2000, pp. 94–95.
9. Blagg 1983, fig. 2; Bilde 2000, fig. 1.
10. Ghini 2000, fig. 1; Braconi et al. 2013, pp. 13–14, 17–18, fig. 1.
11. Bilde 2000, pp. 93–96; Moltesen 2000, pp. 111–19; Bilde and Moltesen 2002, pp. 7–14.
12. Bilde 2000, pp. 96–100; Braconi et al. 2013, pp. 24–28.
13. Braconi et al. 2013, pp. 17–18, 28–31.
14. Ny Carlsberg Glyptotek, Copenhagen, 1517; see Bilde 1995, pp. 195–99, figs. 3–6; La Rocca and Parisi Presicce 2010, pp. 180, 267–68, no. I. 25.
15. Pheneos Museum; see Protonotariou-Deilaki 1961–62, pp. 57–59, pls. 63, 64.
16. Sparta Museum, 52; see Damaskos 2002, p.118, pl. 66a–b; Palagia 2014a, p. 240, fig. 154.
17. University of Pennsylvania Museum, Philadelphia, Ms 3483; see Bilde 1995, pp. 202–5, figs. 12–15; Bilde and Moltesen 2002, pp. 20–21, no. 1, figs. 6–9; Romano 2006, pp. 84–87, no. 44.
18. Capitoline Museum, Rome, 253, mid-second century B.C.; see La Rocca and Parisi Presicce 2010, pp. 257–59, no. I.16.
19. Exhibited at the Capitoline Museum, Rome, in 2010; see note 7 above. See also note 29 below for the head of Herakles from the Capitoline Museum.
20. Pliny the Elder, *Natural History*, 36.34–35.
21. For the activities of this family, see Despinis 1995, pp. 339–72.
22. See note 5 above.
23. Bilde 1995, p. 207.
24. National Archaeological Museum, Athens, 258; see Bilde 1995, pp. 209–10, fig. 25; and Andreae 2001, figs. 140–42.
25. Blagg 1983, p. 53, pl. 12; Bilde 1995, p. 212.
26. Museo Ostiense, Ostia, 114; see La Rocca and Parisi Presicce 2010, pp. 184, 270–71, no. I.29.
27. Bilde 1995, pp. 212–13; Coarelli 2013.
28. Acroliths by definition consist of wooden bodies embellished with stone heads, hands, and feet. The ancient sources are collected in Despinis 2004, pp. 4–9. Despinis's argument that statues sometimes followed a mixed technique of more or less random wooden and stone parts is based on Roman examples and is unconvincing for the earlier periods.
29. Marcus Tullius Cicero, *Letters to Atticus*, 6.1.17. Centrale Montemartini, Rome, 2381; see Vorster 2007, p. 277, fig. 239; La Rocca and Parisi Presicce 2010, pp. 179, 266–67, no. I.24.
30. Roussel 1915–16, pp. 56, 127–28, no. 74, fig. 10.
31. Michalowski 1932, pp. 9–10, fig. 45, pl. 8; Chapouthier 1935, pp. 29–36.
32. Archaeological Museum, Thebes; see Neumann 1988; Vorster 2007, p. 316, fig. 321.
33. Neumann 1988.
34. Hoff 2015. For the head in the Pergamon Museum, Berlin, AvP VII 283, see ibid., figs. 1–5; Ralf von den Hoff in Picón and Hemingway 2016, pp. 151–52, no. 58. For the head of (?) Herakles in the Archaeological Museum, Bergama, 374, see Hoff 2015, figs. 6–9. For the lost bust, combined with the head in Bergama, see ibid., fig. 10.
35. Bardo National Museum, Tunis; see Prittwitz and Gaffron 1998.
36. Ibid., p. 70, figs. 1, 2.
37. Ibid., fig. 3.
38. Ibid., p. 73.
39. Bol 1988.
40. For example, those described in notes 42 and 43 below.
41. Charatzopoulou 2006.
42. Archaeological Museum, Agrinion, 29; see Bol 1988, pp. 36–37, pl. 26a.
43. Archaeological Museum, Agrinion, 30; see ibid., pp. 40–41, pl. 31a–b.

Alessandro Viscogliosi

From Pergamon to Rome and from Rome to Pergamon: A Very Fruitful Architectural Gift

The reputation Attalos III has earned with ancient historians is certainly controversial. Nevertheless, his decision in 133 B.C. to leave his kingdom to the Roman State is probably one of the most fruitful choices an Attalid ever made in favor of the city of Pergamon.[1] Under the will of Attalos, the entire kingdom was to go under Roman domination, but Pergamon and its immediate surroundings were to remain a free city. And that is what effectively happened. The king's personal treasure was brought to Rome, with terrible consequences, culminating in the murder of Tiberius Gracchus. The town of Pergamon was not sacked after the rebellion of Aristonikos, however, and once that revolt had been quelled, the Roman Senate confirmed its status as an independent city.[2]

After 129 B.C., a vast territory named the Province of Asia thus passed under Roman rule. Once the most peripheral provinces had been given over to the Galatians, to Ariarathes of Cappadocia, to Nikomedes of Bithinia, and to Mithridates of Pontus, it still included some of the most important artistic centers of the early and mid-Hellenistic periods: Ephesus, Alikarnassos, Stratonikea, Priene, and Miletus, soon joined by Kos and Rhodes. By the mid-second century B.C., Rome had already achieved further territorial expansion. In 146 B.C., Scipio Aemilianus destroyed Carthage, thus absorbing what was left of its commercial empire,[3] and in the same year, Lucius Mummius destroyed Corinth and transformed Achaia into a Roman province.[4] By the third quarter of the second century B.C., Rome dominated all important Greek cultural centers, except Alexandria.

Did this newly born province of Asia have a role in the Hellenization of Roman culture? If so, in what terms? Rome had been in contact with Greek culture for at least 150 years, since the sack of Taras in 272 B.C.[5] In addition to the sheer monetary value of the loot, all the works of art that decorated Taras (sculptures, paintings, precious objects, including many masterpieces by foremost Greek artists) had been shipped to Rome, along with mathematicians, philosophers, and writers, one of whom, Livius Andronicus, would translate the *Odyssey* into Latin. The same thing happened with the conquest of Syracuse in 212 B.C.: Titus Livi recalls the huge booty accumulated from Syracuse and places the beginning of the Roman craze for Greek works of art to that moment.[6] Taranto was ultimately conquered in 209 B.C., but nothing proves that in the meantime, there had been an effective Hellenization of culture; in fact, the attempts to suppress Greek influence, considered pernicious and corruptive, are well known.[7] Especially in what concerns architectural and urban planning,[8] even if we find sporadic innovations in architecture (Hermodoros, Corinthian capitals, etc.), the face of the city did not change in any remarkable way.[9] Livy describes Rome as *magis occupata quam divisa*, more of a military camp than a planned town.

The original synechism and the orographic conditions that saw the development of Rome did not facilitate planning or urban design inside the city walls, at least until the Second Punic War (218–202 B.C.). But, after the second half of the second century B.C., the birth of the so-called Sanctuaries of Republican Latium, the terracing of the

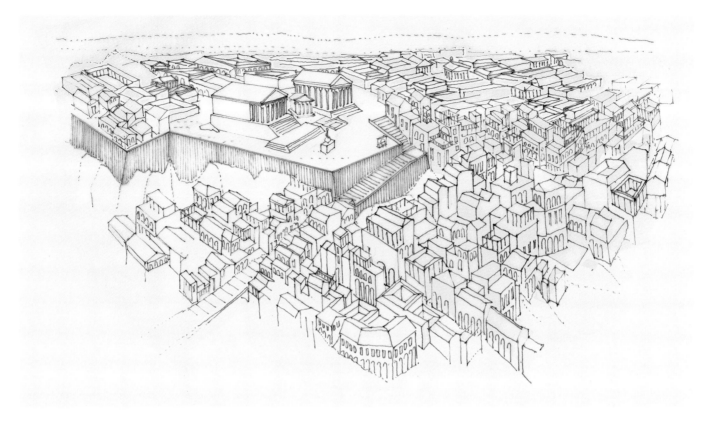

FIG. 1. The Palatine Hill at the end of the 2nd century B.C. On the terrace from left to right: the temples of Magna Mater, Juno Sospita, and Victoria *temenos*

Capitoline and Palatine hills, and the building of the *porticus* for the exhibition of works of art indicate that the Pergamene gift was responsible for the breakthrough, by then impossible to delay, of the most powerful city of the Mediterranean.[10] However, the specific modes through which Roman urbanism came into existence could favor neither shared choices nor premeditated plans. The initiative of a single *euergetes* (benefactor) was, as far as we know, unchallengeable, at least in what concerns aesthetic and formal choices. Direct knowledge of Asia Minor brought the entire Roman ruling class in contact with a yet unknown reality, in which towns, even small ones, had, in earlier centuries, enjoyed town planning works that created an urban culture resulting from specific designs that varied from vast to medium to small in scale.

The Greek world had exploited the model of their own *apoikiai* (new towns that maintain ties with their motherland), thereafter perfected by Hippodamus of Miletus, to the limit and on a large scale, finally resulting in the creation of "monsters" such as Priene, where the streets perpendicular to the shoreline were practically all stairways.[11]

The plan of Pergamon, on the contrary, avoided the forceful regularization of the mountaintop chosen by Philetairos as his capital and transformed the ancient fortress into a palatial acropolis, from which the town of the Attalids would extend downward.[12]

In the middle of the second century B.C., Pergamon entered the Roman orbit, and the so-called High City of Pergamon was the result of a number of particular interventions. All of them had conformed to a common concept, consisting of a road axis that connected two rows of terraces. The terraces facing the hinterland housed the palaces and the fortifications of the Attalids (Philetairos's tower and the Arsenal). The other one, centered on the auditorium of the theater and formed by the Agora, the sanctuary of Athena Nikephoros, the Library, and the terrace on which the Trajaneum would later be built, was open seaward. Rather than an urban plan, this model was the result of a modus operandi drawn partly from the site's irregularities and slopes and aiming to organize a system of isolated and closed terraced areas served by a meandering path traced on the minimal possible gradient.[13]

As for the terracing, it was practically invisible to an outside observer, as it could only be seen from such a distance that made it impossible to be truly appreciated in layout and volume. However, it was perfectly designed to present the best vistas, according to the various specific uses, for those who looked out from it to the west and the sea or to the east and the valleys leading to the Anatolian hinterland.[14] The urban design of Pergamon (especially of the Middle Town, where a very long path with minimal gradient constituted the spine of a complex terraced area enclosed by retaining walls) may have been a useful reference for the Romans when, without any predefined plan, they began the monumentalization of their city.

The *temenos* of the Magna Mater, on the Palatine hill, is the best example of the possible influence that Pergamon exerted on Rome (fig. 1).[15] The temple was not meant to be part of an acropolis including sanctuaries, but it stood in a space that had to be literally carved into the disorder of a residential neighborhood. Moreover, it had to adapt to both previous works, such as the Temple of Victory, and subsequent ones, such as the Temple of Apollo Palatinus. Built in a slightly later period, but with a similar model, a *porticus* designed for the exhibition of art works was erected by Lutazio Catulo on the opposite slope of the Palatine. We may suppose that similar arrangements existed on the side of the Aventine toward the Tiber and on the Quirinal facing Campus Martius. These, and other later works of urban design in Rome (figs. 2 and 3), including the later Imperial Fora, share this characteristic of having no visual connection with adjacent areas. Communication was provided solely by nonmonumental gates, and there were no visual axes to unite them.

This is incontrovertibly one of the characteristics of the urban design of Attalid Pergamon. Thus, we can assume that the Pergamene model was the prototype for the urban plan of Rome, at least before the great fires of the Imperial era forced its regularization.

The birth of the Province of Asia, which included, in addition to Pergamon and its immediate surroundings, the two great islands of Kos and Rhodes, also offered Roman architects and patrons a model for sanctuaries of a more imposing size.[16] Neither Pergamon (for topographic reasons) nor Rome (for topographic and political reasons) permitted the building of great terraced sanctuaries such as the ones of Lindos and Kos. These were erected, instead, in Palestrina, Tivoli, and Terracina, significantly, in periods coinciding with better knowledge of Pergamon.[17]

Taranto and Syracuse, both primary vehicles for the Hellenization of the mid-Roman republic, did not, apparently, present urban aspects similar to those of the East. Athens itself, while the Acropolis might have offered a distant example for the planning of Pergamon (and the Propylaea for Kos and Lindos), in spite of entering the Roman orbit at the same time as Pergamon, could not become a model for the *Urbs* because of the very different conditions in demographic and architectural density.

Pergamon was treated particularly favorably by Rome, within the limits set by the fact that the former city, nominally free, was in fact, subject to the other. The town had a Roman governor, first a *propraetor*, then a *proconsul*. In later periods, however, the Romans preferred the better-connected Ephesus. Pergamon was not sacked; it kept its famous works of art and continued to mint silver coins until it was forced to surrender to Mithridates VI in 89 B.C., an action that cost the town its status as a free city.[18] When the Romans returned, in 85 B.C., the enormous reparations demanded by Rome and the taxes, up to then avoided, reduced Pergamon to ruin. This is evident from archaeological excavations in various areas of the city, such as private houses, public buildings, the Gymnasion, and the Asklepieion.[19]

During the Proconsulate of Lucullus, things improved.[20] It was then that Diodoros Pasparos went to Rome and successfully negotiated the withdrawal of Roman troops and a reduction in taxes and tributes.[21] A short-lived economic recovery was interrupted in 49 B.C., when Metellus Scipio, a supporter of Pompey, established his winter quarters in town in Pergamon and imposed new taxes. After the death of Pompey, Caesar reduced taxation, which was increased again by Brutus, who asked Pergamon to pay 200 of the 16,000 silver talents required of the Province of Asia. At the beginning and at the end of his eastern campaign, Mark Antony proved himself equally voracious, while Augustus initiated a positive trend, interrupted only by the appropriation of the Donarius of the Galatians, ordered by Nero in order to increase the statuary decoration in his newly restored capital after the fire of A.D. 64.[22]

Augustus had already given Pergamon a temple dedicated to the cult of the Goddess Roma and her First Servant.[23] Under Hadrian, the Trajaneum was built.[24] This

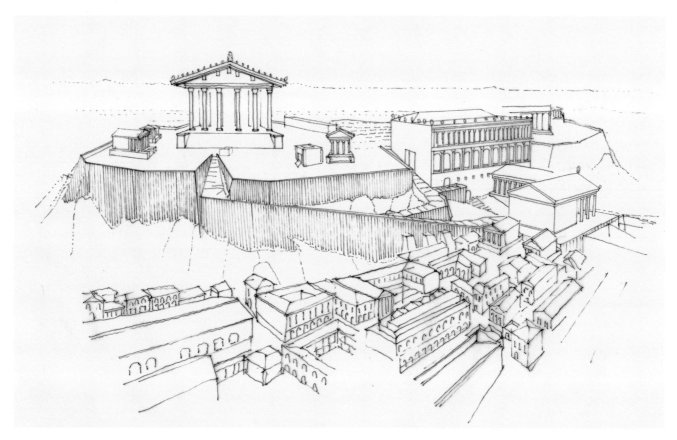

FIG. 2. The Capitoline Hill in the 1st half of the 1st century B.C., overview

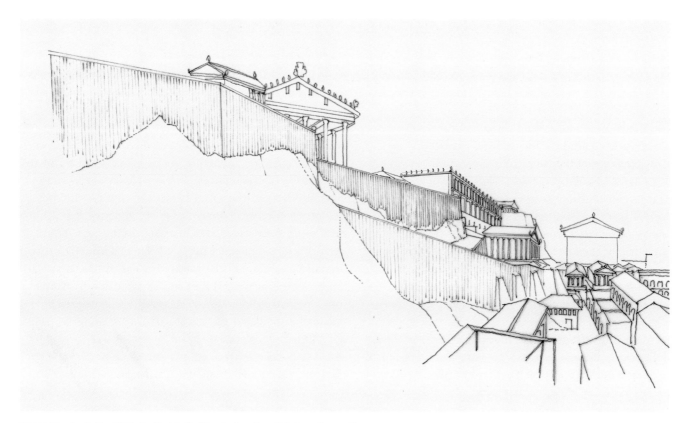

FIG. 3. The Capitoline Hill in the first half of the first century B.C., from the south

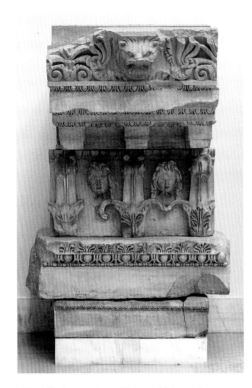

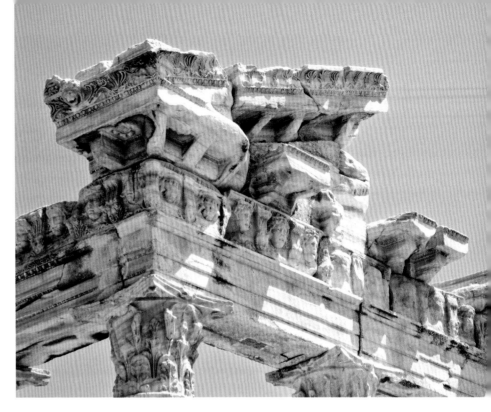

FIG. 4. Part or section of the entablature of the Pergamon Trajaneum (A.D. 114), at the Pergamon Museum, Berlin

FIG. 5. The entablature of the Temple of Apollo at Side, northwest corner, after A.D. 114

constituted a curious example of Hadrian's predilection for Pergamon: while at Ephesus, a monumental *nymphaeum* was dedicated to Trajan, on the Acropolis at Pergamon, local magistrate Aulus Iulius Quadratus began the construction of a temple dedicated to Zeus Philios and to Trajan in 114, during the emperor's reign.[25]

Then, what happened in Rome took place in Pergamon. As on the Palatine, whole residential areas were swallowed up by the terracing of the temple of Apollo Actiacus, and the only part of the Attalid palace that overlooked the Theater was buried under a powerful Roman-style substructure of *opus quadratum* (stone ashlar masonry), to disguise barrel vaults. In this way, a terrace, higher than all the others on the theater side, was achieved, and it is most likely that this construction lasted far longer than the three years of life that remained for Trajan. Even if we lack epigraphic evidence, it is highly likely that Hadrian himself, during his first visit to the province of Asia,[26] gave very detailed instructions for the architecture of the temple: a Corinthian *peripteros* (a four-side colonnade surrounding the cella) on a podium, with six columns on the front

and ten along the sides, all made of marble and stylistically as different as possible from the official architecture of the Trajanic era, such as we can still see in the Forum of Trajan and in the structure of the Pantheon. The architecture of the Pergamene temple (fig. 4) is the most innovative that could be imagined in its time, very similar to the temple of Apollo at Side, a metropolis in Pamphilia, later known for the magnificence of the buildings dedicated to the imperial cult.

The temple's frieze shows Medusa heads alternating with pseudo-triglyphs with acanthus leaves (fig. 5). They can also be found in Heliopolis–Baalbeck in the frieze of the temple of Jupiter Heliopolitanus, certainly founded under Tiberius but which probably had not reached frieze level before the time of Hadrian. Medusa heads decorated the Hadrianic frieze of the Didymaion at Miletus,[27] but above all, they (fig. 6) were part of the now lost frieze of the temple of Venus and Roma in Rome, notoriously designed by Hadrian around 121 A.D.[28] As the remaining fragments of the cornice of this temple show (fig. 7), it was absolutely identical to the temple at Pergamon.

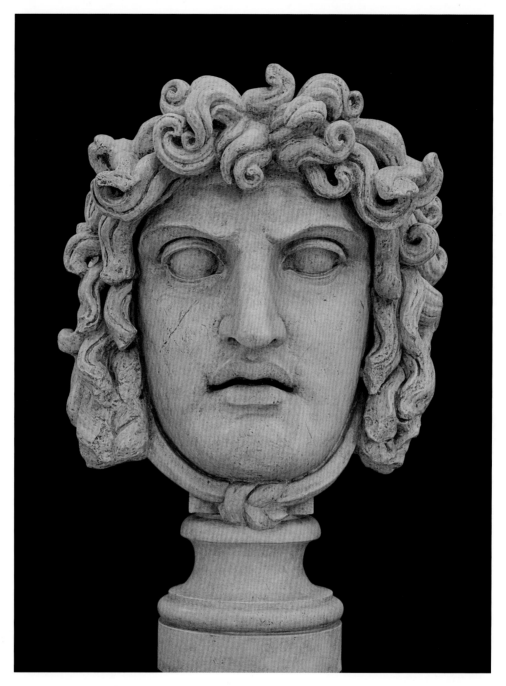

FIG. 6. Head of Medusa, from the frieze of the Temple of Venus and Roma, A.D. 121–135. Vatican Museums, Rome

We can thus assume that this latter temple directly derives from the Roman prototype, made by master artisans from the school of Aphrodisias, which enjoyed its first development under Hadrian and might have been the means by which the stunning innovations experimented with by the emperor, *peritissimus* in the field of architecture, spread throughout the Empire.[29] To Hadrian himself, we owe the monumental refurbishing of the ancient and venerable Asklepieion at Pergamon as well as new great buildings in the city, such as the Stadium, the Amphitheater, and the Sanctuary of the Egyptian Gods, and the daring decision to cover the river that flowed through the lower town

1. Caristio in Athenaios of Naucratis, *Philosophers at Dinner, or Banquet of the Learned*, 13.38; Pliny the Elder, *Natural History*, 25.6; Valerius Maximus, *Nine Books of Memorable Deeds and Sayings*, 1.8; Strabo, *Geography*, 14.1.39; Appian, *Roman History*, 12.62; Diodorus of Sicily, *The Library of History*, 34.3; Justin, *Epitome of the Philippic History of Pompeius Trogus*, 36.4. On the different opinions of historians about the dynasty of the Attalids, see Virgilio 1985 and Virgilio 1994a. About Attalos III, see, in particular, Cardinali 1910; Hansen 1971, pp. 142–43, 471–74; Radt 1999, pp. 38–39.

2. Plutarch, *Parallel Lives: Tiberius Gracchus*, 14; Hansen 1971, pp. 150–59; Hopp 1977, pp. 107–47.

3. Polybius, *The Histories*, 38.21.1; Diodorus of Sicily, *The Library of History*, 32.24; Appian, *Roman History*, 13.2.

4. Velleius Paterculus, *The History of Rome*, 1.13.

5. La Rocca 1990, pp. 351–52.

6. Titus Livi, *The History of Rome*, 25.40.1–3.

7. Vayne 1979.

8. La Rocca 2012.

9. Gros 1976; Gros 1996, p. 128; Stamper 2005, pp. 50–54; Bianchi 2010; La Rocca 2011, p. 9–10.

10. For the Italic terraced sanctuaries, see Coarelli 1983; Gullini 1983; Radt 1999, p. 55; Zevi 1999; Giuliani 2004; D'Alessio 2011.

11. Schede 1964; Castagnoli 1971, pp. 126–28.

12. Radt 1999, pp. 190–206; La Rocca 1996, p. 152.

13. Hoepfner 1996, pp. 46–47; Radt 1999, p. 55, fig. 9.

14. About the scenography of the Hellenistic sanctuaries and the integration of the structures with the surrounding landscape, see Lauter 1972; Caliò 2003, p. 54; La Rocca 2011, pp. 19–24.

15. D'Alessio 2006; Pensabene 2006.

16. For the terraced sanctuaries of Kos and Rhodes, see Lippolis 1988–89, pp. 134, 137; Giorgio Rocco in Livadiotti and Rocco 1996, pp. 163–71, s.v. L'Asklepieion; Lauter 1986, pp. 101–8; Gruben 2001, pp. 440–42; La Rocca 2011, pp. 18–20.

17. Wallace-Hadrill 2008, p. 160; La Rocca 2011, p. 23.

18. T. Reinach 1960, p. 41; Rostovtzeff 1980, p. 19; McGing 1986, p. 112.

19. Radt 1999, p. 42.

20. Plutarch, *Parallel Lives: Lucullus*, 23.1.

21. Cagnat 1901–27, vol. 4, no. 292, 2.39–40; C. Jones 1974; Virgilio 1994b.

22. Pliny the Elder, *Natural History*, 34.84; Tacitus, *Annals*, 15.45.3, 16.23.1.

23. Tacitus, *Annals*, 4.37.3; Cassius Dio, *Roman History*, 51.20.7; Deininger 1965, p. 18; Mellor 1981, pp. 978–79; Hänlein-Schäfer 1985, pp. 166–68.

24. Stiller 1895; Siegler 1966; Radt 1988, pp. 481–85.

25. Just in A.D. 114 Pergamon imposed on the rival cities of Smyrna and Ephesus after obtaining for the second time the status of *neokoria* (an official center of the Imperial cult) by Trajan. This supremacy was crowned with the title of "metropolis of Asia," conferred by Hadrian to the city in A.D. 123; see Habicht 1969, pp. 159–61.

26. Syme 1988, p. 162.

27. Pülz 1989.

28. Barattolo 1974–75.

29. Barattolo 1982.

30. Habicht 1969, pp. 8–11; Le Glay 1976; Strocka 2012.

31. Ovid, *The Festivals*, 4.247–72; Varro, *On the Latin Language*, 6, 15.

FIG. 7. Head of Medusa on fragments of the cornice of the Temple of Venus and Roma, Rome. The temple was begun in A.D. 121 and inaugurated in 135 A.D.

with two barrel-vaulted tunnels.[30] Even if further investigations should lead to redating the stadium and the amphitheater, the opulence Pergamon enjoyed remained unchanged. This is remarkable, as the town was relatively unimportant in the general economy of the Roman empire, especially in a period when a great number of ports and towns situated on crucial road crossings rose on the stage of architectural and thus social and economic history in the Roman world.

Mythical and historical connections tied Rome and Pergamon together. The legendary common origin of Romans and Pergamenes from Mysian warriors, Aeneas and Telephos, respectively, surely helped. Such a link had been proved when, in the darkest hours of the Second Punic War, the Romans asked and obtained from Pergamon the *acus Pessinuntius*, the black stone of the Magna Mater Idaea, Lady of the Ida Mountain and thus the Anatolian divinity par excellence.[31] Later, the goddess was honored in Rome, not only in a temple situated *intra moenia* but also on the Palatine (fig. 1), a few steps away from the hut of Romulus, in the place that Augustus would later choose for his personal residence. Of equal importance was the role that Pergamon played as the first capital of the Roman province of Asia Minor.

HELLENISTIC SCULPTURE

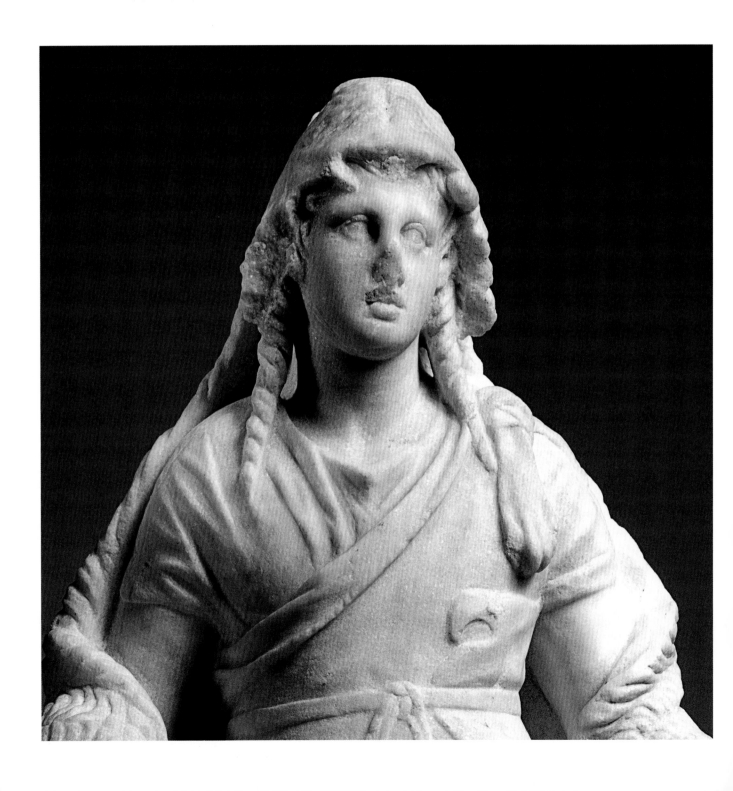

Kiki Karoglou

An Early Hellenistic Votive Statuette in The Metropolitan Museum of Art: Dionysos Melanaigis?

This essay focuses on a marble statuette of Dionysos in The Metropolitan Museum of Art that has no known parallels. Shortly after its acquisition in 1959, the statuette was published by Dietrich von Bothmer as an Attic work of the first century A.D. in Hellenistic style that possibly represents Dionysos Melanaigis, Dionysos of the black goatskin.[1] In 1986, Nikolaus Himmelmann accepted the interpretation as Melanaigis but correctly, in my opinion, dated the statuette to the early third century B.C.[2] Since then, the statuette has been largely overlooked.[3] By closely examining the ancient literary sources as well as the role of animal skins in the iconography and cult of Dionysos, this essay challenges the Dionysos Melanaigis identification and offers new insights into this figure's intriguing identity and context of dedication.

Dionysos wears a short-sleeved chiton, a large belted panther skin (*pardaleē*), long boots with overhanging flaps made of fawn skin (*endromides*), and a large goatskin worn like a hooded cape (fig. 1). The goat's forelegs are wrapped around the god's arms, while its skinned and flattened scalp covers his head. Two long corkscrew locks of hair frame his youthful face. The figure is missing: (1) both forearms, which were originally carved separately and attached with iron dowels; (2) the proper right lower leg and proper left foot; (3) part of the nose; (4) part of the animal hide draped over the right arm; and (5) its edges at the back. A large portion of the goat's snout and ears are broken off, but its long straight horns and part of the tail are visible at the back (fig. 2). Both the large size of the hide and the thickness of the horns indicate that the animal is probably a billy goat (*tragos*). Red color is

preserved on the underside of the goatskin and under the animal's scalp. X-ray fluorescence analysis (XRF) and micro sampling have revealed a finely ground red ocher pigment, probably used as an undercoat, with a chemical composition characteristic of the late Classical and early Hellenistic palette. No traces of a darker pigment on the goatskin were detected.[4]

Among the Attic sculptures used as comparanda by Himmelmann are two mid-fourth century votive reliefs often associated with the Eleusinian cults: the Mondragone relief[5] and a fragmentary relief from Karystos, which preserves the figure of Dionysos intact (fig. 3).[6] The god wears a short chiton, a belted fawn skin (*nebris*) worn diagonally, high leather boots, and a himation draped over his shoulders. He holds a thyrsos with his left hand and carries a kantharos in his right; the same attributes in all probability were held by the Metropolitan statuette.[7] The figure of Dionysos in these reliefs is thought to reflect a cult statue of the god dated about 375–350 B.C.,[8] which is often recognized in the type conventionally named The Hope Dionysos after the principal Roman replica, now in New York (fig. 4).[9] A bronze votive statuette of Dionysos from Aetolia, with its elongated proportions and pronounced spatial torsion, represents the late Hellenistic evolution of the type.[10]

Scholars inaccurately describe this fourth century B.C. Dionysos as Thracian,[11] because on Attic vases, Thracians are depicted wearing similar boots and also on account of iconographic affinities with the Thracian goddess Bendis, whose cult was introduced in the port of Piraeus, in the late fifth century B.C.[12] The same type of high leather boots and dress (short chiton, diagonally worn nebris, and himation),

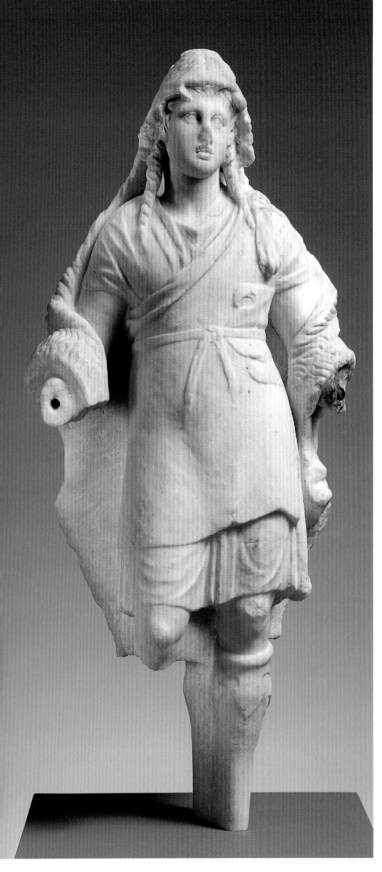

FIG. 1. Dionysos. Greek, Hellenistic, early 3rd century B.C. Pentelic marble, h. 19¼ in. (48.9 cm). The Metropolitan Museum of Art, New York, Rogers Fund, 1959 (59.11.2)

FIG. 2. Back view of fig. 1

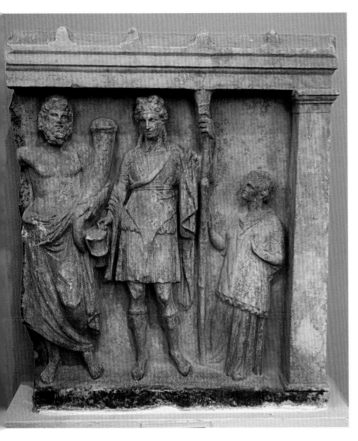

FIG. 3. Votive relief with Pluto, Dionysos, and Adorant. From Carystos, Greek, probably Attic, mid-fourth century B.C. Marble. Chalkis Archaeological Museum, Greece (MX 337). © Hellenic Ministry of Culture and Sports

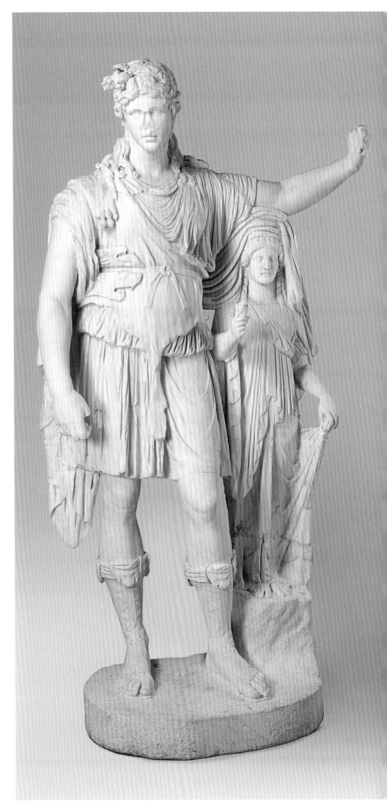

Right: FIG. 4. Dionysos leaning on a female figure ("Hope Dionysos"). Roman, Augustan or Julio-Claudian, 27 B.C.–A.D. 68. Marble, h. 82¾ in. (210.2 cm). The Metropolitan Museum of Art, New York, Gift of The Frederick W. Richmond Foundation, Judy and Michael Steinhardt, and Mr. and Mrs. A. Alfred Taubman, 1990 (1990.247)

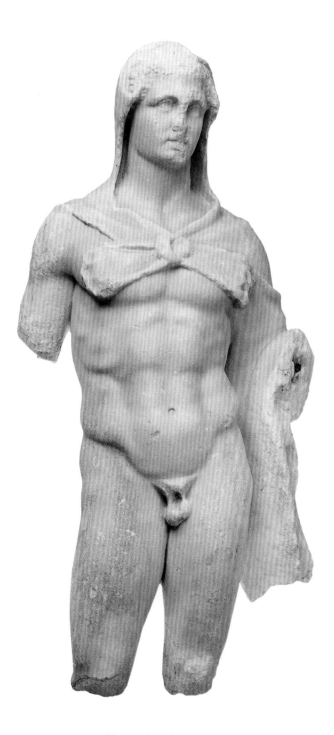

however, are worn by hunters as well as by the huntress goddess Artemis.[13]

Instead of a himation, the Metropolitan Dionysos statuette uniquely wears a goatskin as a long cloak drawn over the head. There are other examples of a complete animal skin worn in this fashion, but all are skins of wild animals rather than domesticated ones, for example, Herakles' iconic lionskin (fig. 5),[14] Dolon's wolf disguise skin (fig. 6),[15] and the elephant skins worn by Alexander and his successors (fig. 7).[16] In contrast, goatskins are worn by herdsmen as a mantle and are more processed, with the scalp and sometimes the legs of the animal removed (fig. 8).[17] Dionysos's panther skin is also unusual: instead of being worn diagonally, it envelops the body of the figure; it is much larger in size and is not anatomically accurate except for the fastening.[18]

Garments made of skins from both wild and domesticated animals were worn frequently in ancient Greece, mostly by hunters and herdsmen and by the rural population at large.[19] Skins were the products of hunting, sacrifice, and tanning. Whereas hunting and sacrifice were highly valued activities among the ancient Greeks, tanning, like all manual labor, was not.[20]

In Greek art, animal skins are worn primarily by warriors and hunters, while representations of herdsmen, travelers, and country people wearing them are but few. Aside from Herakles and Artemis, most mythological figures in animal skins originate from the world of Dionysos, including satyrs, maenads, and the god Pan, all of whom frequently wear the *pardaleē* (panther or leopard skin). Recent studies about the representations of animal skins on Attic vases have shown that garments made of skin offer a wealth of information about the status and character of their wearers. Alastair Harden, for example, observes that in the Archaic period, animal skin garments had distinct heroic connotations,[21] while Daniella Louise Widdows shows that skins of wild animals signify greater social status or physical power, and skins from male wild animals accord more status than those of animals considered less masculine.[22]

Although thought to be as fierce as the lion, the panther was nonetheless considered by the Greeks a more feminine animal, and thus, petty and deceitful.[23] The panther was also believed to have a pleasant smell that enticed its prey and itself to be lured by the smell of wine.[24] Xenophon

in his treatise on hunting describes how panthers, leopards, and other wild cats were hunted in eastern mountainous lands by various means, including the use of poison and of pits in which a bound goat was placed as bait.[25] Thus, the panther skin was a fitting attribute of Dionysos, the powerful but effeminate god, who despite being a Greek divinity, was thought in myth to come from the East.[26]

While the panther skin is a typical Dionysian garment, it is the goatskin that led to the possible identification of the Metropolitan statuette as Dionysos Melanaigis. This identification is based on Marjorie Milne's suggestion—followed by Dietrich von Bothmer and not questioned in subsequent scholarship—that the addition of the goatskin alludes to the introduction of the cult of Dionysos Melanaigis into Attica from the neighboring Boeotian town of Eleutherai. Such an interpretation conveniently accords with the statuette's alleged provenance from modern Koukouvaounes, which is located in the vicinity of the ancient Attic deme of Acharnai (fig. 9). Similarly, Himmelmann considers the statuette a learned visualization of the *aition* (origin) of the cult, something he claims was a common phenomenon in the Hellenistic period, although without offering any other examples.[27]

In 1995, Daniela Bonanome not only adopted the Melanaigis identification but also further suggested that the statuette represents Alexander the Great in the guise of Dionysos Melanaigis due to the turn of the figure's head, his upward gaze, and overall expression.[28] Other early Hellenistic marble statuettes have been identified with representations of Alexander in divine guise, most notably a Pan statuette from Pella often considered Pan-Alexander because of the presence of a band-diadem and facial features reminiscent of the king's portraits.[29]

The cult of Dionysos permeated Macedonian society long before the birth of Alexander. Therefore, it is no surprise that Dionysos became the ancestor or patron of Alexander and his successors, not least because of his eastern conquests.[30] Nor is it coincidental that both Dionysos and Herakles served as the primary models for divinization in Hellenistic art: Dionysos was born a god by a mortal mother, while Herakles was deified after the conclusion of his labors.[31]

No representations of Alexander as Dionysos, however, and indeed not many certain representations of Alexander in general survive, if one accepts Hans Lauter's minimalist

FIG. 6. Dolon disguised in a wolf skin, Greek, Attic red-figure lekythos, ca. 480–470 B.C. Terracotta, h. 6½ in. (16.4 cm). Department of Greek, Etruscan and Roman Antiquities, Musée du Louvre, Paris (CA1802)

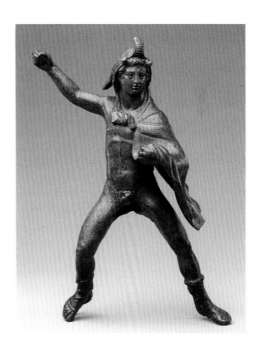

FIG. 7. Equestrian king wearing an elephant skin cloak, Greek, Hellenistic, 3rd century B.C. Bronze, h. 9¾ in. (24.8 cm). The Metropolitan Museum of Art, New York, Edith Perry Chapman Fund, 1955 (55.11.11)

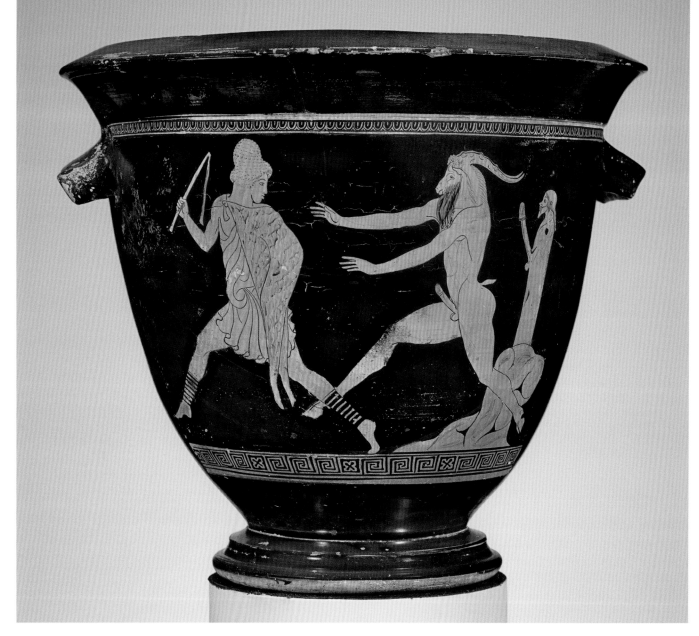

FIG. 8. Pan chases a young shepherd wearing a goatskin. Greek, Attic red figure bell krater, ca. 470 B.C. Ceramic, h. 14 9/16 in. (37 cm), diam. 16¾ in. (42.5 cm). Museum of Fine Arts, Boston, Julia Bradford Huntington James Fund and Museum purchase with funds donated by contribution (10.185)

view of Alexander's portraiture, which recognizes only the coins of Ptolemy I, the Pompeii mosaic, and the Azara herm in the Louvre, which is the only portrait of Alexander identified by an inscription.[32]

It is important to remember that ancient references about Alexander's physical appearance come from brief descriptions of the statues of Alexander made by Lysippos.[33] Plutarch, for instance, reports that the artist accurately captured the poise and slight leftward turn of Alexander's neck and his liquid gaze.[34] In a similar way, Bonanome's generic Alexander-like features describe the sculptural style of the early Hellenistic period rather than the king himself or his portrait type. As Anne Marie Nielsen succinctly admits: "We don't know what Alexander the Great looked like—we would not be able to recognize him, should we meet him in Hades."[35] Consequently, Bonanome's association of the Met Dionysos with Alexander is not substantiated.

FIG. 9. Map of Attica. From Peter Levi, *Atlas of the Greek World*, Oxford. Phaidon, ca. 1980, p. 220

Likewise, the interpretation of the statuette as Dionysos Melanaigis is problematic. It is based on the aetiological myth explaining the origin of the phratry festival of *apatouria* in Attica that was celebrated by phratries across the Ionian world, which itself is obscure and elusive. The earliest accounts come from the mid-fifth century B.C. logographer Hellanikos and the fourth century B.C. historian Ephoros, and the essential story goes as follows: "Melanthos, during a duel with the Boeotian king Xanthios to settle a border dispute between Athens and Boeotia, prevailed by relying on a trick: when a figure appeared behind Xanthios, Melanthos complained that it was not fair that another had come to fight alongside Xanthios. When Xanthios turned back to see what was going on, Melanthos struck him down."[36]

On account of the trick used by Melanthos, Hellanikos concludes that the name *apatouria* was derived from *apate* (deception).[37] It is significant that neither Hellanikos nor Ephoros mention Dionysos or a black goatskin in their accounts. Both of these only appear in much later sources, which include Konon, a Greek grammarian and mythographer (active 36 B.C–A.D. 17); a scholiast's note on Aristophanes' *Acharnians* 146 (first century B.C./A.D.); and the *Suda*, a tenth-century A.D. Byzantine lexicon.[38] In these later versions, the figure appearing behind Xanthios is now dressed in a black goatskin. In their explanations of the story, these later authors associated this deceptive figure dressed in a goatskin with Dionysos, thus introducing the god into the origin of the *apatouria*. Therefore, the earliest textual evidence casts into doubt the view that Dionysos Melanaigis played a role in the origin of the *apatouria,* and scholars have long considered he was a late intruder to the festival and its foundation legend.[39]

Dionysos Melanaigis is mentioned in two different sources, in contexts that are not associated with the *apatouria*. Pausanias refers to a cult and a temple dedicated to

the god located not in Attica but near Hermione in the Argolid, where an annual competition in music was held and prizes for swimming and boat races were offered.[40] "Dionysos Melanaigis" also appears as a lemma in the *Suda* that explains how, after the daughters of Eleuther caught sight of Dionysos wearing a black goatskin and complained, the god became angry and sent them into a frenzy. Eleuther received an oracle, which said that the madness could be stopped if he honored Dionysos Melanaigis.[41] It is noteworthy, however, that Pausanias does not mention Dionysos Melanaigis in his account of the integration of Eleutheurai into Attica and subsequent introduction of the cult of Dionysos Eleuthereus on the south slope of the Athens Acropolis.[42]

Furthermore, the epithet *Melanaigis* is not exclusive to Dionysos.[43] It may be translated more accurately "of the dark aegis" rather than "of the black goatskin." Familiar from representations of the goddess Athena, the *aegis* in art is a type of cape with the Gorgon's head at the front and a border fringed with snakes. Ancient sources invariably define the word *aigis* (αἰγίς) as a storm cloud, a shield, or a "goatskin coat" –perhaps the skin of Amaltheia, the goat that nursed Zeus. Its usage as goatskin came later, likely due to a popular etymology from αἴξ (stem αἰγ-), the Greek word for goat.[44] The aegis, however, was originally associated with Zeus,[45] a connection reiterated in Hellenistic art also through the depiction of the aegis with feathers, which I suggest are eagle's feathers.[46]

More importantly for this essay, Pausanias's description of a Boeotian temple offers the framework for establishing a more appropriate interpretation for this statuette: the temple dedicated to Dionysos *Aigobolos* (goat-slayer) at Potniae, a town situated about two kilometers southwest of Thebes. Once, according to Pausanias, people making a sacrifice to Dionysos became violently drunk and murdered the god's priest. Immediately afterward, a pestilence fell upon them, which the oracle of Delphi said could be cured by sacrificing a boy. After a few years, Dionysos substituted a goat as a victim in place of a boy.[47]

Unfortunately, not much else is known about the cult of Dionysos Aigobolos at Potniae, but its etiological myth as related by Pausanias follows a well attested structural pattern: transgression, plague, oracle, institution of human sacrifice, abolition of human sacrifice, animal substitution.[48] Foundation legends of Greek cults frequently involve animal substitution in expiatory sacrifices to placate angry gods. In myth, such was the sacrifice of a fawn instead of Iphigeneia at Aulis, while a sacrifice of a goat, perhaps dressed as a girl and named "kore," was among the rituals performed during the *Arkteia* at the sanctuary of Artemis at Brauron.[49] The vine-gnawing goat, a familiar presence in the Greek countryside, was considered an animal hostile to Dionysos and was therefore his usual sacrificial victim.[50]

The surviving cult calendars of the Attic demes illustrate the widespread worship of Dionysos and attest that the goat was his typical sacrificial victim.[51] They offer specifications pertaining to the animal's gender, age, and skin color as well as stipulate special provisions for the removal of its meat and skin. As a general rule, sacrificial animals mirror the gender of the divine recipient: male animals were offered to male gods and female ones to female deities. The cult calendar for the deme of Thorikos specifies that goats to be sacrificed to Dionysos must be tawny or black: a kid in the month of *Anthesterion* (February/March) and a *tragos* (billy goat) in the month of *Mounichion* (April/May).[52] The calendar for the Mesogaian deme of Erchia stipulates that the skins of the goats sacrificed on *Elaphobolion* (March/April) 16 on the same altar to Dionysos and his mother Semele should be given to the priestess overseeing the sacrifices, while all the meat should be given to the women and consumed on the spot.[53] Tanned sacrificial skins were valuable commodities to be sold for profit, thus ensuring the economic prosperity of sanctuaries.[54] Along with portions of their meat, the skins of the victims were awarded as perquisites (ἱερεώσυνα) to the priests or priestesses overseeing public sacrifices.[55]

In Attica, the rustic, phallic god of viticulture was honored in the *Lesser* or *Rural Dionysia* and the *Anthesteria*, which along with the *Lenaia*, and the *Great* or *City Dionysia* comprised the four Dionysiac festivals celebrated from midwinter to early spring.[56] Bulls and billy goats were given as prizes at the dramatic contests at both the Rural and City Dionysia and were subsequently offered for sacrifice. Although the complicated and much debated question of the origin of tragedy far exceeds the limited scope of this essay, it is worth noting that one of the meanings of the word *tragodia* already proposed in antiquity is "song at the sacrifice of a goat."[57]

In sum, the remarkable way Dionysos wears the skin of his sacrificial animal emphasizes its ritual significance.

Goatskins were worn by women in Dionysian rites[58] and were probably used as theatrical costumes, as we learn from Euripides's satyr play *Cyclops*, in which the chorus of satyrs bemoaning their predicament complain about their wretched goatskin cloaks (τράγου χλαῖνα μελέα).[59] I therefore propose that the Metropolitan statuette is a votive associated with an Attic festival of Dionysos, conceivably the Rural Dionysia, which was celebrated only in the countryside and where local dramatic performances took place.[60] It was perhaps a thanks offering of a priest or priestess of Dionysos or alternatively, a dedication by a member of an ephebic chorus, a suggestion that would accord with the representation of Dionysos as young and beardless.[61] Further examination of the representation of animal skins in Hellenistic sculpture and their function in cult practice is, I believe, a promising area of study.

Acknowledgments

I would like to thank Michael Padgett, William Childs, Christopher Lightfoot, and Fritz Graf for reading earlier drafts of this paper and Tom Lytle for his editorial assistance. At the Met, I thank Federico Carò and Dorothy Abramitis for examining the statuette. I am very grateful to Demetrios Christodoulou, Ephorate of Antiquities of Euboia, who kindly gave permission to use figure 3 and to Christine Kondoleon, Boston MFA, and Maria Chidiroglou, National Archaeological Museum, Athens, for providing images of objects in their care.

1. Height 21½ in. (54.7 cm), as currently restored. The statuette was reportedly found at Koukouvaones in Attica; see von Bothmer 1961.
2. Himmelmann 1986.
3. See Bonanome 1995, pp. 176–78, fig. 89; and Picón et al. 2007, pp. 204, 451, no. 238.
4. This seems to corroborate an early third century B.C. date. The examination was conducted in 2015 at The Metropolitan Museum of Art, New York, by Federico Carò, Associate Research Scientist, in collaboration with Dorothy H. Abramitis, Objects Conservator.
5. Museo Archeologico Nazionale, Naples, found at Mondragone in northern Campania, Attic, dated 350–325 B.C.; see Bonanome 1995 and Leventi 2007.
6. The relief was a dedication of a priestess to the two Eleusinian goddesses as the inscription on the epistyle of the naiskos reveals: ἱερατεύ]σασα τοῖν θεοῖν. See Daux 1964, p. 434, n. 2a, with earlier references; and Sapouna-Sakellaraki 1995, pp. 89–90, fig. 54.
7. One could reconstruct the position of the arms of the Met statuette similarly to the Dionysos holding the same two attributes on a triangular tripod base from the Street of the Tripods in Athens, now in the National Archaeological Museum, Athens, 253, dated ca. 350–325 B.C.; see Kaltsas 2003, p. 244, no. 511.
8. Himmelmann 1986, pp. 43, 45, n. 14.

9. On the type see *LIMC* 1986, pp. 436–37, no. 128a–e, s.v. Dionysos. Today the Hope copy, named after the Dutch and British art collector Thomas Hope (1769–1831), who acquired the statue in Rome for Deepdene, presides over the Roman Court of The Metropolitan Museum of Art. Dionysos's head is ancient but does not belong to the statue, which was extensively restored by the Italian sculptor and restorer Vincenzo Pacetti. Lately, Stewart has unconvincingly subdivided the type into two different variants, surmising a later date for the original of the Hope copy (300–275 B.C.). Moreover, he erroneously states that Dionysos wears a nebris instead of a panther skin; see Stewart 2017, p. 114, n. 54.
10. National Archaeological Museum, Athens, X 15209, dated 160–150 B.C.; see lately Nomiki Palaiokrassa in Picón and Hemingway 2016, p. 279, no. 223.
11. For example, Bonanome 1995, p. 168; and Leventi 2007, p. 131.
12. Bendis wears a short chiton, a nebris, a mantle, and a Phrygian cap, or alternatively a fox skin cap (*alopekis*). For example, see her earliest surviving depiction on the honorary documentary relief from Pireaus, dated 329–328 B.C., now in the Ny Carlsberg Glyptotek, Copenhagen, I.N. 462; see Moltesen 1995, pp. 138–41, no. 73. On the iconography of Thracians in fifth-century Attic vase painting, see Tsiafaki 1998.
13. For example, two late Hellenistic marble statuettes of Artemis that preserve the boots; see *LIMC* 1984, p. 652, nos. 367, 369, pl. 476, s.v. Artemis. Compare also two early 3rd century B.C. fragmentary marble statues, the one from the Athenian Agora, now in the Agora Museum, S 912, thought to represent Artemis *Boulaia* (see Stewart 2017, pp. 109–16, no. 10, fig. 20), and the other from Amphipolis, now in the Archaeological Museum, Kavala, 782, identified by Damaskos 2016 as a possible cult statue of Artemis Bendis. Note, however, that the latter does not preserve traces of an *alopekis* or a mantle, both distinguishing attributes of the Thracian deity, as the author admits; see ibid., p. 37.
14. Found in Athens in 1885, this statuette of Herakles is very similar in scale, pose, and style to the Met Dionysos; see Kaltsas 2003, p. 265, no. 553.
15. See *LIMC* 1986, p. 661, no. 2, s.v. Dolon. Homer, *The Iliad*, 10, commonly known as the *Doloneia*, gives a full account of the episode.
16. Invariably identified as Alexander the Great, Ptolemy III Euergetes, or Demetrios I of Bactria; see lately Lillian Bartlett Stoner in Picón and Hemingway 2016, p. 111, no. 12.
17. Compare the cloak of the herdsman on an Attic red figure cup at The Metropolitan Museum of Art, New York, 38.11.2, which is probably also made from a goatskin.
18. A similar rendering of the animal's flattened head under a belt can be seen on the panther skin worn by Dionysos from the Choregic Monument of Thrasylos, now in the British Museum, London, 432. The statue is an early third century addition to the monument (dated 320–319 B.C); see R. R. Smith 1991, p. 239, fig. 297. A similar panther skin spreads over the horse's back on the Horse and Groom Relief in the National Archaeological Museum, Athens, 4464; see lately Palagia 2003, especially p. 145, n. 22, fig. 4. On feline skins used as saddle-cloths, see Gabelmann 1996.
19. Aristophanes, *The Clouds*, 70–72, for instance, pokes fun at goatherds who wear leather hides (*diptherai*).
20. Widdows 2006, p. 13.
21. A. Harden 2013, p. 2, who discusses both vases and sculpture using the nebris as a case study.

22. Widdows 2006, p. 15.

23. Pseudo-Aristotle, *Physiognomics*, 809b37–810a9. Fittingly, less heroic figures like the Trojan Paris wear the panther skin in the battlefield; see Homer, *The Iliad*, 3.17.

24. Barringer 2001, pp. 99–101, discusses the relevant sources.

25. Xenophon, *On Hunting*, 11.1–4.

26. On leopard skins as characteristic foreign garments, see Carpenter 1986, pp. 65–67.

27. Himmelmann 1986, p. 45.

28. Bonanome 1995, p. 178.

29. Archaeological Museum, Pella, GL 43, early Hellenistic, ca. 300–270 B.C., height 14¾ in. (37.5 cm). The statuette was found in a residential quarter of the city, west of the House of Dionysos. See Stewart 1993, p. 428, fig. 99 (Alexander-Pan); Pantermalis 2004, p. 22, no. 3 (Pan-Alexander); see, however, R. R. Smith 1991, p. 238, fig. 289 (young Pan).

30. On the cult of Dionysos in Macedonia, see lately Tzanavari 2011, pp. 108–14.

31. R. R. Smith 1991, p. 65; Moraw 2012, pp. 245, 251.

32. Lauter 1987–88. The literature on Alexander is ever growing. For a discussion of his portraiture, see, among others, Bieber 1964 and Stewart 1993.

33. Similarly, Stewart (1993, pp. 9–10, 22–41) points out the interrelation between literary texts and artworks in his discussion of the ancient testimonia on Alexander's portraiture; see also Vokotopoulou and Koukouli-Chryssanthaki 1996, p. 204.

34. Plutarch, *Life of Alexander*, 4.1.

35. Nielsen 1993, p. 139.

36. Hellanikos in Jacoby 1923–58, vol. 4, F125, as quoted in a scholion to Plato's *Symposium*, 208D, that traces the genealogy of the Athenian king Kodros.

37. This is a patent example of a false etymology. *Apatouria* derives from *homopatoria*, which means "those with the same father"; see more recently Lambert 2001.

38. Konon, *Narrations*, 39; Scholiast on Aristophanes's *Acharnians*, 146; *Suda*, s.v. apatouria. For a discussion of the problematic state of the textual evidence and a list of the sources, see Vidal-Naquet 1998, pp. 109–10, 123, n. 15. In his "Black Hunter" Vidal-Naquet connects the aetiological myth of the apatouria festival with the Athenian institution of ephebeia, the two-year military service undergone by Athenian youths of about 16–20 years old before becoming adult male citizens, which he viewed as a rite of passage. For a recent evaluation of Vidal-Naquet's influential interpretive model and its validity in a metaphorical, rather than literal, sense as well as the refutation of the notion of the Athenian frontier area as liminal and wild, see Polinskaya 2003.

39. See, among others, Parke 1994, p. 90; and Lambert 2001, pp. 144–47. The two patron gods of the apatouria festival were Zeus Phratrios and Athena Phratria.

40. Pausanias, *Description of Greece*, 2.35.1.

41. *Suda*, s.v. Dionyson Melanaigida.

42. Pausanias, *Description of Greece*, 1.38.8.

43. Aeschylos, *Seven against Thebes*, 699–700: Μελάναιγις Ἐρινύς.

44. R. Fowler 1988, p. 104. For a discussion of the complex linguistic and interpretative problems associated with the root αἰγ-, see ibid.

45. Homer, *The Iliad*, 17.591: Ζεὺς Αἰγίοχος, "Zeus who bears the aegis."

46. Notice the similarity between the cover feathers of a "Bonelli's Eagle" (*Hieraaetus fasciatus*), a medium-sized eagle endemic to the Mediterranean, and Athena's aegis on the bronze roundel from the Archaeological Museum, Thessaloniki, 17540; see p. 136 in Ariel Herrmann's essay in this volume or the aegis of the Athena Parthenos from Pergamon (Staatliche Museen zu Berlin, AvP VII 24; see Jörg-Peter Niemeier in Picón and Hemingway 2016, p. 132, no. 39). I intend to pursue the idea of the feathered aegis and its relation to Zeus's eagle in a future publication. On the revival of the aegis's association with Zeus on the portraits of the Hellenistic kings, see R. R. Smith 1988, pp. 41–42.

47. Pausanias, *Description of Greece*, 9.8.2.

48. Hughes 1991, pp. 82, 90–91.

49. See recently Faraone 2013, pp. 58–59, who challenges the widely accepted interpretation of the *Arkteia* as a rite of passage of young girls 5 to 10 years old.

50. On the hostile relationship between Dionysos and the *tragos*, see lately Sourvinou-Inwood 2003, pp. 116–17. On sacrificial animals as "enemies" of the deity with whom they are identified in myth, see Burkert 1983, p. 77.

51. Henrichs 1990, pp. 260–64. Besides to Dionysos, goats were also sacrificed to Apollo, Artemis, and Aphrodite; see Van Straten 1995, p. 171, n. 47.

52. *Thorikos*, 33–34, 45–46, respectively, the J. Paul Getty Museum, Malibu, 79.AA.113, dated ca. 440–420 B.C. The inscription was first published by Daux 1983 (dated 385–370 B.C.?); IG I³ 256 *bis*. See the discussion by Henrichs 1990, p. 262, n. 23.

53. *Erchia* Δ, 33–40. Epigraphic Museum, Athens, 13163, dated ca. 360–350 B.C. The *editio princeps* is Daux 1963. See also Dow 1965, p. 190; *SEG* 1965, p. 541. It is noteworthy that the *Erchia* calendar mentions only female priestesses; compare with Dow 1965, p. 207.

54. Burkert 1983, p. 7; Widdows 2006, pp. 79–80.

55. See lately Connelly 2010, pp. 200–202, with references to various examples.

56. On the Attic festivals of Dionysos, see among others Pickard-Cambridge 1968, which provides the fullest collection of sources; see Simon 1983, pp. 89–104, for a brief survey.

57. Burkert (1966, p. 88, n. 2) reviews the various theories on the word's etymology. For the centrality of the goat sacrifice in the origin of tragedy, see ibid. and more recently Sourvinou-Inwood 2003, pp. 141–84.

58. Hesychius of Alexandria, *Lexicon*, s.v. tragephoroi.

59. Euripides, *Cyclops*, 80.

60. On the festivals of the Attic demes, see Parker 1987.

61. On the association of young Dionysos with the theater, see Carpenter and Faraone 1996.

Lillian Bartlett Stoner

Falling Hero: A Drunken Herakles in The Metropolitan Museum of Art

The small fragmentary bronze statuette that is the subject of this essay shows a stumbling man identifiable as a drunken Herakles and is an example of a new sculptural type that became popular in the Hellenistic world to decorate private spaces. The bronze acquired by The Metropolitan Museum of Art might be from Smyrna and was perhaps produced there. Comparison to other known examples of the type found across the Mediterranean elucidate its original cultural significance under the unprecedented and lasting influence of the Hellenistic royal courts.[1] Images of the hero's comedic excesses continued to thrive in the period defined by the growth and consolidation of Roman power, during which contrasting ideologies of decadence and dignity were increasingly at the center of both public and private discourse.

The bronze has sustained a fair amount of damage. The proper right leg is broken off above the ankle, the proper left is broken off just above the knee, and both arms are largely missing (figs. 1a–d). The physique is that of a powerful athlete gone to seed, with ribs just visible under a layer of flesh and muscle. The weight is borne on the powerful rear leg, and the right leg is thrust forward and planted. The immense strain that is evident in the leg muscles and buttocks is carried all the way up the torso to the thick collar of muscles over the shoulders and neck, which are bunched and tensed. The pectorals and abdominals are engaged, even as the abdomen protrudes, noticeably bloated. The head lolls slightly to the right, with the chin nearly resting on the broad chest. In contrast to the stressed body, the face is oddly vacant. The eyes, set beneath an overhanging brow, gaze somewhat aimlessly ahead. The

brow is creased only lightly, and the mouth is closed and relaxed. The hair is rendered in tight curls, and the thick beard helps to readily identify the figure as Herakles, evoking much earlier Classical models.

Herakles's almost contorted body has led some scholars to question the hero's precise activity. In the initial study of the statuette, Gisela Richter remarked that indeed, only the body position allowed an identification as a drunken Herakles.[2] More recently, John F. Kenfield III has unconvincingly recast the Metropolitan Herakles as a participant in a wrestling match with the giant Antaios, using as evidence the strain shown in the body and tilted head position.[3] However, to see the unbalanced figure as needing an opponent is to undermine the mastery of the statuette's workmanship: the precarious posture combined with the vacant expression is evocative of some sort of psychotropic experience.

The hero's activity can be reconstructed with a reasonable degree of certainty, based on comparison with numerous surviving statuettes and engraved gems. A bronze statuette in Parma comes closest to the New York example in pose, scale, and general modeling: the legs are splayed apart in an ambitious off-kilter step, with the massive torso drooping behind (fig. 2).[4] Other examples step forward more gingerly, and their arm positioning and attributes are instructive. Statuettes in Florence (fig. 3)[5] and Naples (fig. 4) preserve the club, which is clutched in the right hand and slung over that shoulder to offset the lurching forward step. The bronze in Naples, originally from Pompeii, preserves a festive wreath around the head and a deep drinking cup outstretched in the left hand, providing

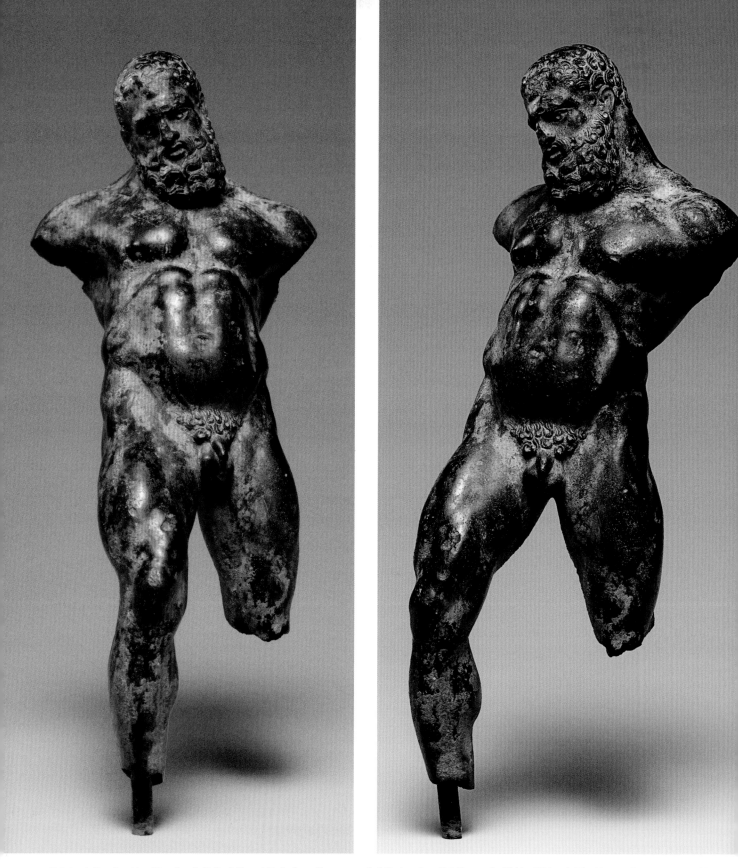

FIG. 1a–d. Drunken Herakles, Greek, Hellenistic, said to be from Smyrna, ca. 3rd–2nd century B.C. Bronze, h. 61⅛ in. (15.6 cm). The Metropolitan Museum of Art, New York, Purchase, Samuel P. Avery Memorial Fund, 1915 (15.57)

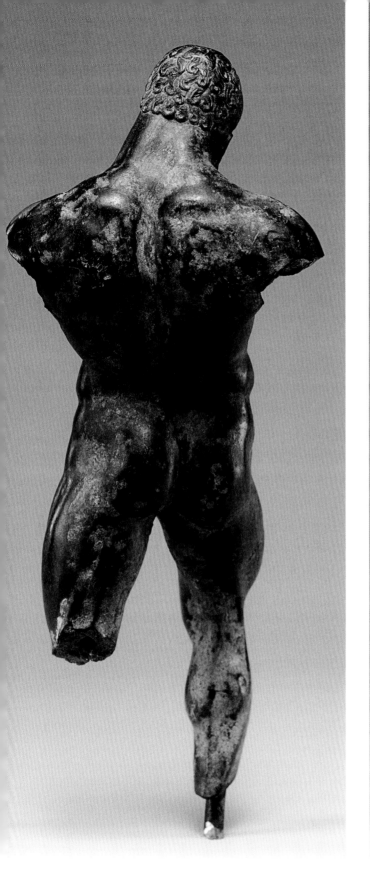
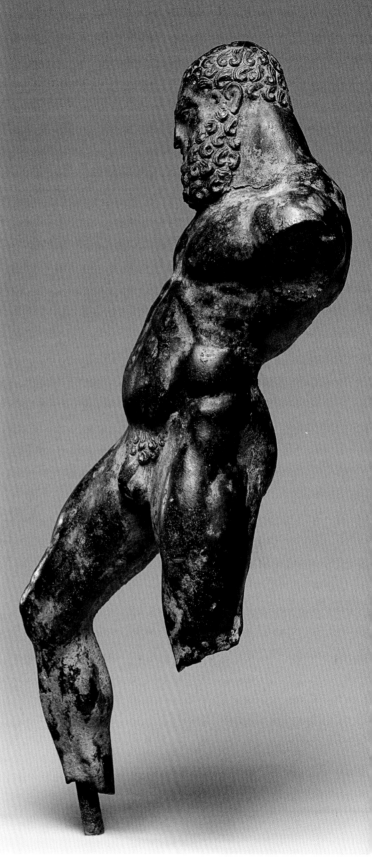

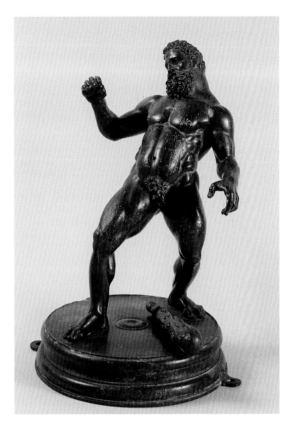

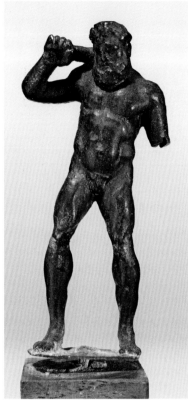

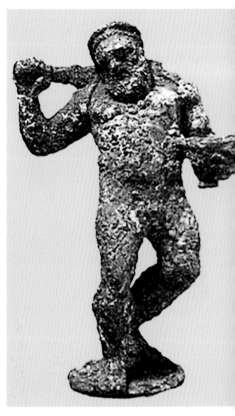

FIG. 2. Drunken Herakles. Roman, 1st century A.D. Bronze, 6⅝ in. (16.8 cm). Museo Nazionale di Antichità, Parma, B 105

FIG. 3. Drunken Herakles. Roman, 1st century A.D. Bronze, 2¾ in. (7 cm). Museo Archeologico Nazionale, Florence, 2563

FIG. 4. Drunken Herakles, from Pompeii. Roman, 1st century A.D. Bronze, 4⅞ in. (12.5 cm). Museo Archeologico Nazionale, Naples, 5266

more ballast to stay upright and a good clue why the hero stumbles along to begin with: he is fresh from a drinking party or banquet.[6] Finally, comparison with a glass ringstone in Göttingen, Germany, makes it clear that our hero takes a lurching step forward with his right leg and originally held his club over that shoulder and a big drinking cup stretched forward and out in his other hand (fig. 5).[7] As in the gem, his head slumps against his chest, and his belly is thrust outward, bloated, apparently with the wine he has consumed. Drunkenness is the best explanation for the weird pastiche of slack face and strained body.

No extant examples of the statue type in this format can be dated before the third century B.C. However, while the Drunken Herakles as a statue type was most certainly a Hellenistic innovation, it echoed a much longer artistic tradition of showing the archetypal hero as an enthusiastic participant in the symposium, engaged in drinking competitions with Dionysos, preparing enormous spits of meat for himself, and absconding with large jugs of wine.[8] From the later Classical period, the superhuman misdeeds of Herakles—incorrigible womanizing, gluttony, drunkenness, and general carousing—began to overshadow his heroic deeds, a general trend relating, perhaps, to the eventual creation by Lysippos in the late fourth century of a mature Herakles, at the end of his labors, standing in repose.[9] A close relative of this Weary Herakles, also attributed to Lysippos, is the Herakles Epitrapezios type (meaning Herakles on or at the table) known from dozens of copies.[10] Both of these clearly related Lysippan types enjoyed unprecedented popularity and were widely copied in various scales and materials all over the Mediterranean and as far east as India.[11] An example of Herakles Epitrapezios

FIG. 5. Ring-stone, Hellenistic, 1st century B.C.
Engraved glass. Göttingen University, G. 415

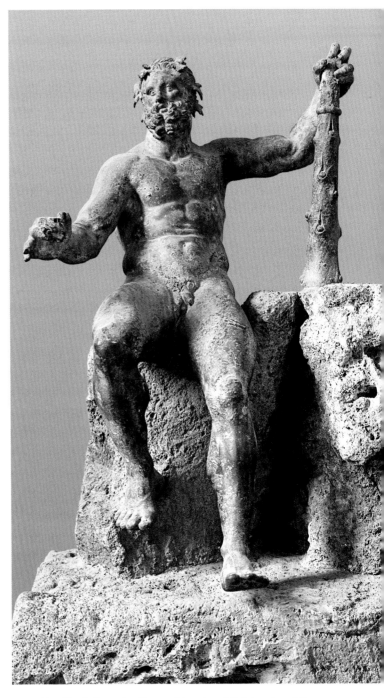

FIG. 6. Herakles Epitrapezios. Roman, 1st century B.C.–1st century A.D.
Bronze and limestone, h. with base, 37⅜ in. (95 cm). Excavated in the
peristyle of a suburban villa. Museo Archeologico Nazionale, Naples,
136683 (2828)

excavated in a suburban villa near the River Sarno in 1902
is an especially large example of the hero banqueting
(fig. 6).[12] Herakles is shown in bronze, seated on a rustic
limestone shelf, with his left arm resting on his club and his
right hand outstretched, and originally proffering a large
drinking cup (now lost). As if there was any doubt about
his activity, the ivy wreath he wears is a clear indication that
he is at a banquet.

The Epitrapezios type is linked strongly to the
Metropolitan's Drunken Herakles, by the hero's mature
body, budding inebriation, and the enormous drinking
cups they both originally held. Two Roman authors,
Martial and Statius, writing in the first century A.D.,
described in admiration a bronze statuette showing a ban-
queting Herakles in the collection of a wealthy Roman,
Novus Vindex.[13] They delighted in the hero's form, reduced

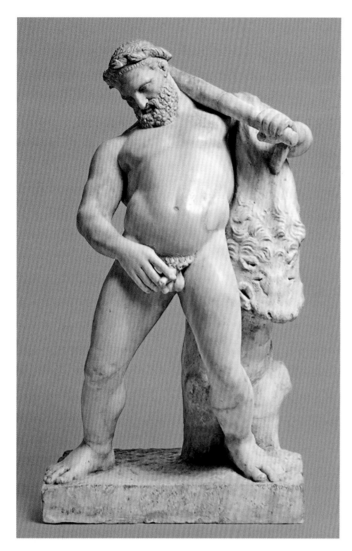

FIG. 7. Urinating Herakles, from the House of the Stags, Herculaneum, Roman, 1st century A.D. Marble, h: 20¼ in. (51.5 cm). Herculaneum, SAP 75802

Lysippan descendant. An especially fine and large example in marble was found in a garden at Herculaneum, showing the hero barely able to stay on his feet, with his club and lionskin swung over his left shoulder to maintain his precarious balance (fig. 7).[15]

Although the great majority of surviving Herakles statuettes of these types have been separated from their original contexts and are generally without secure provenance, their subject matter and general scale make them ideally suited for the decoration of private interior spaces and gardens. Although larger than many surviving examples, the seated and urinating imagery in figures 6 and 7 respectively give a sense of how statues of this genre were displayed. The Herakles Epitrapezios was excavated in a suburban villa near Pompeii and was displayed at the north end of a garden, on axis with and in full view of the triclinium, where guests would have reclined, enjoyed wine, and dined. The urinating Herakles was found in Herculaneum in the so-called House of the Stags and originally stood in the peristyle of a garden, directly adjoining the dining room, nonchalantly relieving himself in full view of the delighted diners.[16]

The small scale of the New York Herakles, along with its subject matter, makes it another likely candidate for display in a space used for banqueting, and most likely on a table.[17] Beyond being comic, the hero's bloated body and obvious inebriation were especially resonant because both embodied a distinct new strain in Hellenistic ideology that privileged the attainment of *truphe,* a Greek word that can be translated as the good life and more ambivalently, as decadence.[18] In the preceding Classical period, *truphe* was a hallmark of an Eastern despot, a contagious mode of excessive behavior to be guarded against. Soft bodies resulting from overindulgences (further adorned with rich clothes, perfume, and jewelry) were considered feminine and marked the opposite of manly self-control. Tyranny and *truphe* went hand in hand.[19] Drinking, too, was something to be controlled and moderated in the context of the symposium. Rich men stereotypically had big bellies (the direct result of their excessive appetites for rich food and wine), and bellies were portrayed in comedy and art as a sign of laziness and uncouth lust, an association that persisted into the Roman period.[20]

The gluttony of Herakles in late fifth century B.C. comedy was a common trope. His appalling eating habits are

in scale but not diminished in power, and unequivocally indicated that it was meant to adorn a table. Furthermore, both authors insist on its illustrious provenance, stating that the small bronze was created by Lysippos for none other than Alexander the Great to grace the ruler's table during his eastern campaigns.[14]

Less restrained enjoyment of the hero's misadventures can be found in another group, relating closely to our stumbling, striding Herakles. Numerous surviving examples show a visibly inebriated Herakles, now barely upright, casually urinating. The mood, style, and deployment all indicate that this type should also be seen as a

described in Epicharmus's *Busiris*: "If you saw him eating it would kill you! His throat rumbles, his jaws crack, his molars crackle, his canines screech, he blows through his nostrils and moves his ears."[21] Likewise with wine, Herakles rejects decorum. In Euripides's *Alcestis*, he arrives raucously drunk to a house in mourning and opines at length on the virtues of abandoning worries in wine and enjoying the present, a sort of alcoholic carpe diem: "Death is a debt all mortals must pay, and no man knows for certain whether he will still be living on the morrow. The outcome of our fortune is hid from our eyes, and it lies beyond the scope of any teaching or craft. So now that you have learned this from me, cheer your heart, drink, regard this day's life as yours but all else as Fortune's! . . . Have some wine with me! I am quite sure that when the fit of drinking is upon you, it will bring you round from your clotted and gloomy state of mind."[22]

By the Hellenistic period, *truphe* was the purview of the successors of Alexander who, upon finding themselves newly powerful and staggeringly wealthy, set about reimagining themselves as semi-divine kings. The portrait of Ptolemy III on a gold oktadrachm minted in Alexandria by his son Ptolemy IV Philopater, for instance, shows the ruler as a fleshy young man bristling with divine attributes, with waddles beneath his chin sloping toward his thick neck; clearly he was not an enthusiast of austerity in any form.[23] Wine flowed at many court-sponsored public festivals in the Hellenistic East, such as the *lagynophoria* of Alexandria. Many monuments large and small commemorate this festival and most notably, the famous statue of the drunken old woman in Munich who embraces her enormous *lagynos* (large wine jug) and cackles happily as she enjoys the pleasures of a festival thrown by a Ptolemaic king who fashioned himself as a living Dionysos.[24] The drunken sleep of Dionysos's companions as well as Herakles is featured in sculpture both in the round and in relief.[25]

In Late Republican Rome, when the desire to emulate Hellenistic eastern luxury and to maintain a sense of traditional Roman decorum collided, literary sources point to a complicated response to Hellenistic *truphe* ideology. Traditional "Roman values" of decorum and manly austerity were actively promoted by Octavian and others, offered in stark opposition to the "Eastern" decadence of the Hellenistic kings.[26] In this climate, morally suspect decadence (especially drunkenness and gluttony) might seem

out of place. Yet, it is absolutely clear from literature and material culture that the competitive aristocratic and merchant classes remained captivated by the Hellenistic *truphe* model, decorating their private spaces and entertaining their guests with the most evocative luxury they could manage.[27]

The rhetoric of the Late Republic on these subjects is complex. Hardliner Roman rhetoricians viewed the immoderate consumption of wine as a moral shortcoming linked to eastern despots and weak-willed men, and as a potential political liability. Indeed, drunkenness was generally perceived to be a disgrace, but one that could be either overlooked or intensified based on age, gender, class, and setting.[28]

Mark Antony, self-consciously assuming the trappings of the East and in particular of his consort, the Egyptian Ptolemaic queen Kleopatra, was a lightning rod for critics of decadence.[29] Perhaps the most famous drunk and glutton during this period, Antony's excesses were *not* forgiven by his political enemies. His biggest offense in this respect, seized upon by Cicero in his *Philippics*, was letting a night of carousing at a wedding feast affect the performance of his public office the next day, when he, according to Cicero: "vomited and filled his own lap and the whole tribunal with bits of food reeking of wine."[30]

On the other end of the spectrum, Pliny the Younger relates that even when the younger Cato (apparently a notorious drunk) had been observed stumbling home, he remained so dignified that it was the passersby who blushed with embarrassment, not Cato.[31] His sterling reputation in other areas spared him any dishonor. Even Seneca, typically opposed to such things, condoned succumbing to drunkenness at a party to please a host.[32] A social obligation, it seems.[33] All this contributes to the sense that heavy drinking in the context of the symposium or convivium was acceptable, even desirable, especially when the participants were industrious and respectable in other areas of their public lives.[34]

In this framework, the Met's Drunken Herakles staggering through a Hellenistic or late Republican dining room takes on a significance beyond mere humor. The bloated and blissful mature Herakles is the ultimate example of a man giving in to the pleasures of wine after a most distinguished heroic career. The dubious moral implications of his indulgences are instantly offset by his heroic feats, and his incorrigible appetites become charming

rather than ugly, with his previous hard work excusing otherwise unacceptable behavior. The deployment of small-scale representations of a drunken Herakles in the home can best be explained by the connection the owner or guest made with them. Herakles captured in sculpture, after a life of labors, stumbling drunkenly after a long night and carelessly urinating before the diner, tacitly grants permission for him to temporarily abandon his dignity and self-control for the evening, even exhorting him toward the coveted *truphe* of the Hellenistic kings.

1. The Metropolitan Museum of Art, New York, Samuel P. Avery Memorial Fund, 1915, 15.57, said to be from Smyrna, Hellenistic, ca. 3rd–2nd century B.C., bronze, hollow cast, and leaded; see Richter 1915; Richter 1930, pp. 194–95, fig. 133; Richter 1950, pp. 39, 393, fig. 132; Richter 1953, pp. 125, 264, pl. 104d; Kenfield 1976; Nicholls 1982, p. 322; Mertens 1985; *LIMC* 1988, s.v. Herakles, no. 880.

2. Richter 1915, p. 237.

3. Kenfield 1976.

4. Museo Nazionale di Antichità, Parma, B 105, from Veleia, bronze, h. 6⅝ in. (16.8 cm); see S. Reinach 1897, p. 206, 4; Lopez 1932; Monaco 1940, pp. 7–8, pl. 29a; Frova and Scarani 1965, p. 42, no. 4; D'Andria 1970. Nicholls (1982, pp. 324–25) considers the Parma example to be a Renaissance bronze, although it has since been shown that the Renaissance intervention was composed only of the incorrectly attached attributes, which have since been removed.

5. Museo Archeologico Nazionale, Florence, 2563, bronze, height 2¾ in. (7 cm); formerly in the Galleria degli Uffizi, Inv. del 1825, Cl. III, n. 173; see Alessandro Muscillo in Arbeid and Iozzo 2015, pp. 136–37, no. 105.

6. Museo Archeologico Nazionale, Naples, 5266, from Pompeii, 1st century A.D., bronze, height 5 in. (12.5 cm); see S. Reinach 1897, p. 207; Nicholls 1982, p. 323, n. 8; Dwyer 1982, p. 122, n. 7; *LIMC* 1988, s.v. Herakles, no. 882.

7. Engraved glass ring-stone, Göttingen University, G. 415, 1st century B.C.; see *Antiken Gemmen* 1998, no. 276, pl. 52; *LIMC* 1988, s.v. Herakles, no. 875.

8. For Herakles drinking and dining with Dionysos, see, for example, a kylix in the British Museum, London, E 66, originally from Nola, in Mitchell 2009, fig. 58. For the robbery of Herakles by satyrs, see, for example, an Apulian chous from Ragusa now in the Museo Archeologico di Taranto, 126, in Moret 1984, p. 142, no. 193, pl. 94. For the general comedic theme of Herakles as glutton and drunkard in the Archaic and Classical periods, see Noël 1983; Walsh 2008, especially chap. 6; Mitchell 2009, pp. 110–26.

9. Examples of the Weary Herakles from miniature to colossal abound all over the Hellenistic and Roman worlds; see Bartman 1992, pp. 147–70.

10. For discussion of these types, see Bartman 1986, pp. 299–311; and Cassimatis 1978.

11. For a discussion and select examples of the statue type in the Greek East, see Canepa 2015, pp. 86–90, figs. 6.1, 6.5–6.7.

12. Museo Archeologico Nazionale, Naples, 136683 (2828); see Bartman 1992, p. 182, no. 16, figs. 76, 77; Ridgway 1997, pp. 294–304, fig. III.22, pl. 69; Daehner and Lapatin 2015, pp. 220–21, no. 17.

13. Martial, *Epistles*, 9.43–44; Statius, *Silvae*, 4.6.32–47.

14. While allowing that the provenance outlined by Martial and Statius is no doubt exaggerated, Elizabeth Bartman (1992, pp. 150–51) opines that the attribution of the original commission to Lysippos for Alexander, and its function as a table ornament, seem plausible.

15. Herculaneum, SAP, 75802, from House of the Stags, Herculaneum, marble, h. 21⅞ in. (55.4 cm). 1st century A.D., marble, height, 20¼ in. (51.5 cm); *LIMC* 1988, s.v. Herakles, no. 898; the popular spectacle was also taken up on Roman gems.

16. Paribeni 1902, pp. 572–75, fig. 3; Moormann 2007, pp. 439–40, fig. 27.5.

17. It has been convincingly demonstrated that other small bronze statuettes were decorative attachments for large ornate vessels such as kraters. For such an example with a secure provenance in Greece, see the example from Vrakhori now in Cambridge University's Fitzwilliam Museum, GR.1.1864, tentatively dated to the 2nd–1st century B.C., in Nicholls 1982, pp. 325–27, pl. 82a–c.

18. Bradley 2011, pp. 23–24.

19. Dench 1998, pp. 124–26.

20. Bradley 2011, pp. 7–9.

21. Epicharmus, *Busiris*, 21, as translated in Mitchell 2009, p. 126; for discussion of Herakles's gluttony and drunkenness in late Classical literature, see ibid., p. 126.

22. Euripides, *Alcestis*, 780–800.

23. An outstanding example of the type can be found in the collection of The Metropolitan Museum of Art, Bequest of Theodore M. Davos, 1915, 30.115.21; see Richter 1931, fig. 1; and Lillian Bartlett Stoner in Picón and Hemingway 2016, p. 211, no. 135.

24. Glyptothek, Munich, 437, h. 36¼ in. (92 cm); see Fürtwangler 1910, pp. 387–98, no. 437; Himmelmann 1983, especially pp. 24–26; Zanker 1989.

25. Most famously, perhaps, is the Barberini Faun dating to ca. 230–200 B.C., which was found in Rome and is currently displayed in the Munich Glyptothek, FW 218; For an outstanding example of Herakles asleep after over-imbibing, see the late Hellenistic relief from Rome that is currently in the collection of the Bowdoin College Museum of Art, Brunswick, Maine, 1906.2.

26. This was the model appropriated by Octavian in opposition to his political rival Mark Antony; see Dench 1998, pp. 122–23. Regarding decorum and the need to control appetites, see Marcus Tullius Cicero, *On Duties* 1.93–106.

27. This tension is discussed at length by Emma Dench (1998, pp. 122–24, 134).

28. D'Arms 1995.

29. Ibid., pp. 305–7.

30. Marcus Tullius Cicero, *The Orations: Philippics*, 2.63, 2.84. See Cicero 2003, p. 314.

31. Pliny the Younger, *Letters*, 3.12.

32. Seneca, *On Tranquility of the Mind*, 17.9.

33. D'Arms 1995, p. 306.

34. Ibid., pp. 305–6.

Seán Hemingway, Dorothy H. Abramitis, and Karen Stamm

Hellenistic and Roman Victory Monuments: A Bronze Torso in The Metropolitan Museum of Art

The sculpture that is the subject of this essay is a bronze torso from a monumental statue of a military figure (fig. 1). The figure, slightly larger than lifesize, wears a cuirass of Hellenistic type decorated with two running friezes of figures in high relief that run across the abdomen and around the back. Between the friezes, a belt (*cingulum*) is tied around the cuirass; it is knotted at the front with its ends looped back into it. A cloak, pinned on the right shoulder, hangs over the figure's left shoulder, covering much of the cuirass on the left side. The figure turns to his right with his left arm down, elbow bent and enveloped in his cloak. The figure was almost certainly riding a horse, his left hand, now lost, holding the reins, and most likely, he wielded a weapon in his right hand, which is now also lost.

The statue was in the bequest in 2002 of the fashion designer Bill Blass.[1] Almost nothing is known of its provenance history except that it was a favorite piece among Bill Blass's small but choice collection of Greek and Roman antiquities. It was displayed in his elegant New York apartment, where it was sometimes photographed. In his memoir, entitled *Bare Blass*, he mentions how much he loved the statue, which he dated to the second century B.C., and he suggested that it had been under the sea for centuries,[2] although recent analysis of the accretions presented below does not support this theory. Unfortunately, no records of when or where he purchased the statue are known to the authors, and since he acquired art from all over the world, it has not been possible to document its earlier history.

The torso as it survives today was cast primarily in one large section, to which were attached the looped sections of the belt and segments of drapery, including a fragment in the front that extends from the proper left arm to the side of the chest (fig. 2). Finished edges at the opening of the neck, right arm, right shoulder, and lower cuirass indicate that the head, right arm, right shoulder strap, and the lower part of the figure were cast separately and attached. Break edges at the missing left arm and lower cape indicate areas of damage and loss. The separately cast top and bottom sections of the drapery on the front were joined to the torso by flow welds at either end. The cast upper edge of the bottom piece of drapery can be seen on the exterior when looking from above (fig. 3a). The overlapping join of the lower fragment of drapery in the front of the left arm opening can be seen on the interior (fig. 3b). Visible along the exterior join at the left shoulder is a series of shallow marks that were produced when the joins of the drapery to the shoulder were finished by hammering with a textured tool (fig. 3c). The excess metal from the metallurgical join in this area is clearly visible on the interior. Several pinning holes on the front of the cuirass and its belt provide evidence for the mechanical attachment of smaller elements, now missing (figs. 4a and b). Corrosion extending into these holes confirms that they are part of the original manufacture. Further evidence for the attachment of the belt loops to the cuirass appears on the interior, where metal was poured to create a metallurgical and mechanical bond.[3]

The interior surfaces of the torso conform to the exterior surfaces, and the walls of the casting are relatively thin and even, with a range of 2.5 to 5.0 millimeters in thickness. This is true of details such as the knot of the belt and the rosette of the cuirass frontlet, although the figural elements are slightly thicker and appear more radiopaque or

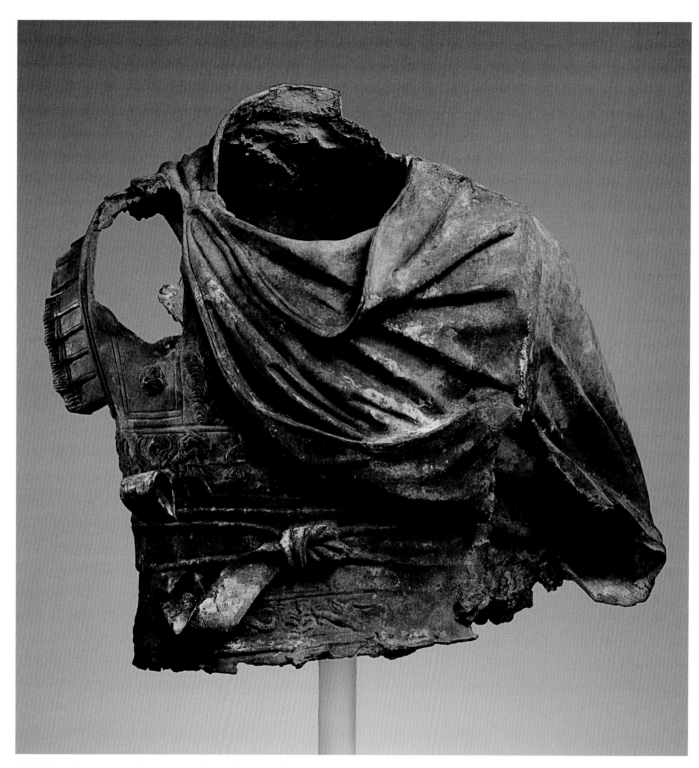

FIG. 1. Torso from an equestrian statue wearing a cuirass. Greek or Roman, 2nd century B.C.–2nd century A.D. Bronze. The Metropolitan Museum of Art, New York, Bequest of Bill Blass, 2002 (2003.407.7)

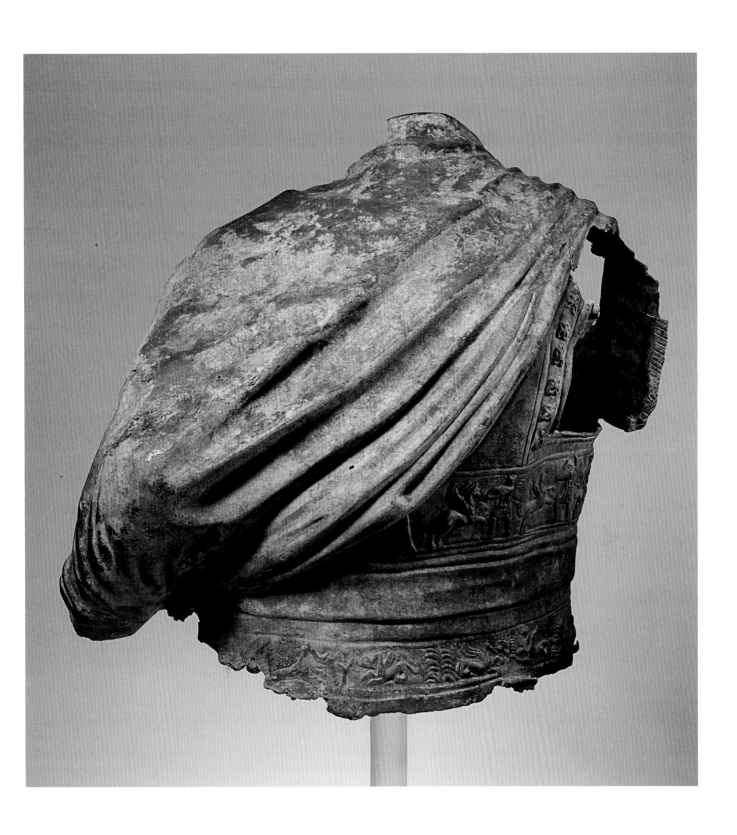

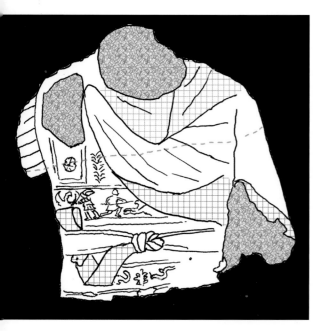

FIG. 3a. The arrow points to the gap visible at the upper cast edge of the separately cast bottom piece of drapery on the front of the cuirass

FIG. 2. Schematic of the front of fig. 1, with separately cast sections indicated by a grid pattern. The horizontal dotted line represents the location of one of the fins on the interior

FIG. 3b. Detail of the interior of the lower fragment of drapery in the front of the left arm. The arrows point to the edge of the larger section of drapery that is overlapped and joined with the fragment

FIG. 3c. Detail showing the series of shallow punch marks in the area of the join at the left shoulder

FIG. 4a. The white arrow points to pinning hole at lower edge of opening on the front of the cuirass. Red arrows point to hammered polygonal patches with cut sides on the front of the cuirass near the right shoulder

FIG. 4b. Arrows point to pinning holes on the lower front of the cuirass

FIG. 5a. X-radiograph of the front near proper right side

FIG. 5b. X-radiograph of the back with edge of proper right arm hole

whiter on the x-radiographs (figs. 5a and b). The uniform thickness and the general conformity of the interior to the exterior cast surfaces indicate that the main form of the torso was made by indirect wax casting. In addition, one can see wax joins and tooling in the interior, further adding to the argument that the torso was made by means of the indirect method of lost wax casting.

Square chaplet holes can be seen along the belt of the cuirass on the x-radiographs (figs. 5a and b), some of which are clearly visible on the interior. The statue exhibits scattered flaws that were repaired with bronze patches at the time of manufacture. There are large cast-in patches at the back of the shoulders and the left elbow as well as smaller cast patches visible throughout (figs. 6a and b). Hammered polygonal patches occur too, an example of which on the front of the cuirass exhibits cut sides of irregular length (see fig 4a).

There are a number of additional interesting and enigmatic features on the interior of the sculpture. A series of casting flashings, or fins, form a rectilinear pattern, as

FIG. 6a. Detail of x-radiograph showing irregular shaped cast patches in drapery on the back

FIG. 6b. Arrow points to an example of irregular shaped cast patch in a fold on the front

FIGS. 7a and b. Schematic of the fins that form a rectilinear pattern and the fine raised lines

outlined in figures 7a and b. The fins have irregular edges and would have penetrated the core up to a depth of 13 mm.[4] In addition, there are fine raised lines, which seem to relate to some of the deep grooves of the decorative band (fig. 8). The distinctly rectilinear pattern of the fins does not resemble randomly oriented flashing that typically occurs due to cracks in the core. The location of some of the fins has no relation to the decorative scheme, since they cut across the friezes of warriors and sea monsters as well as cross over the middle section of drapery in the front and into the drapery on the back. The interior wall of the cast also exhibits numerous small hemispherical nodules on its surface, which indicates that a liquid material containing bubbles was used as the final surface layer on the outside of the core (fig. 9).[5] The various features discussed above could be explained if the core was built up using roughly

rectangular blocks that were shaped and then covered with the addition of a liquid core material to conform closely to the exterior piece mold. Then, the rectangular pattern of flashing could reflect the gaps between the blocks that were not completely filled with the liquid coating of the core.[6]

Analysis of the cuirass was undertaken in the Met's Department of Scientific Research. A sample of the metal from the interior was analyzed by Mark T. Wypyski using scanning electron microscopy coupled with energy dispersive spectroscopy (SEM-EDS), which identified a leaded tin bronze with approximately 80% copper with equal amounts of lead and tin, and a trace of nickel; no arsenic, zinc, or antimony was detected. The interior was examined to determine if any original core material was preserved, to help characterize the origin of the deposits and specifically whether or not it gave evidence that the torso came

FIG. 8. Interior of the front adjacent to the proper right arm. White arrows point to the distinctly rectilinear pattern of the fins, and red arrows point to the fine raised line that extends across a vertical fin

FIG. 9. Detail of area with multiple hemispherical nodules on the interior wall

from the sea, as Blass had suggested. Besides bronze corrosion products, accretions in contact with the bronze on the interior of the torso are primarily a loosely bound whitish material and a beige, seemingly more tenacious layer. In addition, a loose grayish deposit resembling silt is present in some areas. Samples of each layer were analyzed using open-architecture X-ray diffraction (XRD) and SEM-EDS. Analysis of the samples (figs. 10a and b), undertaken by Federico Carò revealed that both the white and beige layers are a mixture of minerals consisting predominantly of calcite and accessory quartz and other silicate grains that were embedded within the calcite, particularly at the interface with the bronze surface. The beige layer was nearly pure calcite. The grayish deposit was characterized

a.

b.

Right top: FIG. 10a. Cross section of the white-beige accretion, as seen under reflected light in the polarizing microscope. The white-beige accretion is directly deposited on the corroded bronze surface. Copper corrosion products permeate the accretion and impart a light greenish color to the lower calcite layer. Analysis of the sample undertaken by Federico Carò

Right bottom: FIG. 10b. Composite X-ray map of the accretion cross-section (left), with single calcium (Ca), copper (Cu), and silica (Si) distribution maps (right). According to the chemical composition, the concretion is composed of calcite. Few silicate minerals are embedded in the calcite deposition at the contact with the corroded bronze surface. The bronze corrosion also trapped silicate grains during its formation. Analysis of the sample undertaken by Federico Carò

as a silty calcareous soil. There was no evidence found of a marine origin for the studied accretions or for the remains of core material.

The pose of the Met's bronze torso belongs to a tradition of dynamic equestrian sculpture that originated with Alexander the Great and his court sculptor Lysippos. The pose, although incomplete, is close to the bronze statuette of Alexander from Herculaneum astride his horse Bucephalos.[7] This fine Late Republican or Early Imperial statuette, made in the second half of the first century B.C., is a miniature copy after a Greek bronze statue by Lysippos that was part of a monumental statue group of Alexander and twenty-five of his companions on horseback, fighting the Persians at the Battle of the Granikos River. The original monument was set up at the sanctuary of Zeus at Dion on the slopes of Mount Olympus. The equestrian monuments of Alexander the Great created by Lysippos were incredibly influential. For example, the same iconography was adapted for a third century B.C. limestone funerary relief from Taranto.[8] The pose of the Met's bronze torso is perhaps even closer to the image of Alexander on horseback that appears in the Alexander Mosaic from one of the oldest and wealthiest houses in Pompeii.[9] Alexander's body has even greater torsion. He brandishes a sarissa or long Macedonian spear in his right hand and faces dramatically forward as he approaches the Persian King Darius the Third. The Alexander Mosaic likely reflects a lost Greek painting of the late fourth or third century B.C.

Given the fragmentary nature of the Met's bronze torso and its dynamic pose, it could have been part of a group. A variety of monumental multifigure statue groups in bronze were commissioned in the Hellenistic period. One prominent example that can be reconstructed from physical remains, literary references, and sculptural copies is the Lesser Attalid Dedication.[10] This grandly conceived war memorial was set up on a long series of bases on the south side of the Athenian Acropolis next to the Parthenon. The monument, probably dedicated by Attalos I around 200 B.C., included soldiers on horseback in the midst of battle. It commemorated the Attalid victories over the Gauls in Mysia as well as earlier historic and mythic Greek victories, positioning the Attalid kings as the contemporary champions of Greek culture in a long line of battles that stretched into myth.

Dynamic single figure equestrian statues were also created as well as much smaller groups. A good example of this type is a commemorative monument erected at Delphi in honor of Aemilius Paullus along the Sacred Way near the Temple of Apollo. It commemorated this Roman general's victory over the Macedonians at Pydna in 168 B.C.[11] Although nothing remains of the bronze sculpture, parts of the base survive, including the dedicatory inscription and blocks of a frieze with a battle scene that decorated the top of the pillar. A reconstruction estimates that the pillar was nearly ten meters tall, and cuttings preserved on the plinth for the statue suggest that the horse was in an animated rearing position, similar to the statuette of Alexander from Herculaneum discussed above. The monument is a prominent instance of a sculpture made by Hellenistic Greek artists for a Roman client that utilizes formal and iconographic elements from Greek art.

Despite the fact that bronze equestrian statues were one of the major types of public statuary in the Hellenistic period, preserved examples are extremely rare. No complete examples are known, only a handful of fragmentary ones, such as the fragments from a gilded bronze rider recovered from a late third century B.C. well deposit in the Athenian Agora. The figure, who has been identified as Demetrios Poliorketes, may have belonged to a statue commissioned in 307/6 B.C. that graced the top of a gate to commemorate a cavalry victory.[12]

The physical evidence for Hellenistic equestrian statuary comes primarily from statue bases. Over 190 statue bases for bronze and marble equestrian statues are known from throughout the Hellenistic world.[13] A nearly complete equestrian military marble statue dated around 100 B.C. was discovered in Melos; it exemplifies the more static type of commander on horseback in full military regalia.[14] A bronze head of a man wearing a kausia was found in the sea near the Greek island of Kalymnos in 1997, and the legs of a rider, wearing spurs, were discovered at the same site. This powerful portrait head is thought to date to the third century B.C. and originally may have belonged to a Hellenistic cuirassed equestrian statue.[15]

Several other fragments of bronze statuary were found from the same area, in fishermen's nets in the sea near Kalymnos, including a draped woman and two torsos wearing cuirasses that are believed to be from equestrian statues. Although discovered at different times, the fragments have been attributed to the same shipwreck.[16] The pose of a seated equestrian figure retrieved in 2006 from the sea near

Kalymnos is more static than the Met's torso, but the cuirass is belted in a similar fashion.[17] The belt has been associated with the Persian girdle worn by Alexander the Great that was adopted by his Successors, the Diadochs, and through them, by the Romans, who called it a *cingulum*, a term that indicated its wearer held an official post.[18] The Kalymnos cuirass features a running decorative band of incised pairs of spiral motifs that decorates the lower abdomen in a similar fashion to the lower figural frieze of the Met's torso.

The cuirass of the Met's torso is a Hellenistic type, although its double frieze with figural decoration has no precise parallel, to our knowledge, of extant Hellenistic cuirasses or Roman Imperial cuirasses inspired by Hellenistic types. Nonetheless, the best comparandum for the torso is the other bronze equestrian fragment discovered in 2009 in the sea near Kalymnos.[19] The Kalymnos statue wears a cloak pinned on the right shoulder and holds a leaden object in its left hand. Remains of the sword sheath are attached beneath the left arm; the Met's torso is missing attachments in the same area but also originally carried a sword and scabbard. The statue's right shoulder strap is decorated with a thunderbolt in high relief. The Met's torso likely also would have had a shoulder strap decorated in high relief, since it was cast as a separate element. It is notable though that the lower part of the shoulder strap is cast together with the torso, utilizing a different technique than that of the Kalymnos sculpture. A technical study of the Kalymnos piece has not yet been published, so it is not possible to make detailed technical comparisons. However, when one compares the two statues, it is evident that the Kalymnos statue exhibits a higher standard of finishing and attention to detail. It has engraved decoration and inlays, which do not occur on the Met's torso, on which the sculptor left the upper left shoulder less finished, presumably knowing that given its elevated position, it would not have been seen. Likewise, the figures on the running friezes decorating the cuirass (see fig. 1) are rather summarily executed. While the artist of the Met's torso did an excellent job of capturing the dynamic motion of the figure and showed a high degree of competency in the casting, the quality of both the decorative elements and the finishing is not as refined as is usually found in Hellenistic monumental bronzes.

The upper frieze contains helmeted figures in short tunics with short one-edged slashing swords and spears who are fighting griffins. The warriors can be identified as Arimaspians, a legendary tribe from the distant north mentioned by Herodotus who battle griffins for gold. Such combats appear in Greek art, notably in Late Classical Athenian vase painting of the fourth century B.C.,[20] as well as further afield as seen in the bronze lid and upper part of an oil flask from Praeneste, also in the Met's collection.[21] The distinctive shield of the Arimaspians, with one lunate end, is held by two of the figures on the upper frieze, making clear their identification. The lower frieze contains the repeated motif of sea creatures antithetically placed around a palm tree alternating with dolphins and palms on the front. The sea creatures are similar to the ketos, or sea monster, but with wings. They appear to be a kind of hybrid griffin-sea monster. The coarse detail does not allow for the parsing of most of the features.

Bronze equestrian statuary was also very popular in Roman times, when such statues were erected in public spaces across the Roman empire. Equestrian statuary appears in Roman art, for instance, in a fresco from Pompeii illustrating three equestrian statues erected in the Roman forum of the city,[22] and larger numbers of Imperial Roman equestrian statues are preserved than such works from the Hellenistic period. The most famous example, never buried, is the gilded equestrian statue of Marcus Aurelius on the Capitoline in Rome.[23] Equestrian sculptures were especially prominent on Roman coinage, where they frequently appear atop commemorative arches.

The Romans sometimes adopted cuirasses of Hellenistic type, and they also made dynamic bronze equestrian statuary.[24] Perhaps the best extant example is the fragmentary equestrian statue from ancient Misenum now displayed in the Museo Archeologico dei Campi Flegrei in the Castello at Baia, which represents the emperor Nerva (about A.D. 98) astride a rearing horse. Nerva wears a cuirass of Hellenistic type with sea monsters sculpted in relief on the chest.[25] Paul Zanker has noted the close iconographic parallels between this statue and the Met's torso. Zanker argues that the Met's torso, given its lesser quality, is closer to the Roman bronze statues from the Sebasteion at Bubon, Turkey, and suggests that the Met's torso should date to the Antonine period, about A.D. 150–170.[26]

Roman bronze equestrian statuary, like Hellenistic examples, is often preserved only in fragments. Another interesting comparison is a monumental portrait from Cilicia identified as the emperor Nero, which is in the collection of

the Louvre.[27] Attributed to an equestrian statue, perhaps of dynamic type like those featured on the coinage of Nero, its pathos and expressiveness recall Hellenistic ruler portraits. Hellenistic statuary was also revived in Roman times through either copies or freshly conceived adaptations. One likely example is the head of Alexander the Great from a private collection, which may belong to an Early Imperial cult statue of Alexander from Asia Minor or Macedonia.[28]

In conclusion, careful technical analysis of the Met's bronze torso reveals information about its method of manufacture, which accords broadly with known ancient techniques but also exhibits distinct technical features, especially the apparent method used for the assemblage of the core. The torso clearly belongs to a Hellenistic type, and its best parallels date to the middle Hellenistic period. However, close dating of the torso is difficult, since the Romans sometimes adopted cuirasses of Hellenistic type and in addition, given the widespread popularity of the equestrian statue as a public monument in antiquity and the dearth of preserved examples. Technical and stylistic considerations lean toward attribution of the Metropolitan torso to a somewhat provincial Imperial workshop of the first or second century A.D.

Acknowledgments

The authors wish to thank their colleagues Mark T. Wypyski and Federico Carò in the Department of Scientific Research for their kind assistance with scientific analyses of the Met's bronze torso discussed in this essay. We are also grateful to Sophie Descamps-Lequime, Marco Leona, Jeff Maisch, Carlos A. Picón, Lisa Pilosi, Richard Stone, and Linda Borsch.

1. For the statue formerly in Blass's collection, see Seán Hemingway in Hemingway, Milleker, and Evans 2004, p. 8; Picón et al. 2007 pp. 184, 447, no. 211.

2. Blass 2002, pp. 138–39.

3. A similar method was used to attach the right wing of the Met's bronze statue of Sleeping Eros; see Hemingway and Stone 2017, especially p. 50.

4. A series of horizontal flashings occurs on the interior of a bronze herm in the collection of the J. Paul Getty Museum, Los Angeles, dated to the first century B.C.; see Mattusch 1996, p. 189, fig. 3e. See also Maish 2017. Fins in a

regular pattern, although somewhat different in appearance than featured in the Metropolitan Museum's work, also occur on the bronze leg in the Musée du Louvre, Paris, associated with the Chatsworth Apollo head in the British Museum, London, dated to the fifth century B.C., and are discussed in detail in Bouquillon et al. 2006, pp. 237–50, especially p. 241, fig. 18.

5. Similar hemispherical nodules occur on the interior of the base of a statue of Artemis, formerly in the collection of the Albright Knox Gallery, Buffalo, New York; see Mattusch 1996, p. 279, fig. 35n. They have also been interpreted as caused by bubbles in a liquid core material.

6. The use of brick cores is noted in later sculptures; see Castelle, Bourgarit, and Bewer forthcoming.

7. Museo Archeologico Nazionale, Naples, 4996; see Fiorenza Grasso in Picón and Hemingway 2016, pp. 114–15, no. 15.

8. Museo Archeologico Nazionale, Taranto, 113,768; see Laura Masiello in Picón and Hemingway 2016, p. 115, no. 16.

9. Museo Archeologico Nazionale, Naples, 10020, from the House of the Faun, Pompeii; see Herrmann 2016, p. 10, fig. 8; and Picón 2016, p. 2, fig. 1.

10. Acropolis, Athens, Akr. 15451, 15455, 15461, 15465, 15471–15473; see Stewart 2004; Coarelli 2014, pp. 14–27; and Papini 2016, p. 43.

11. See Pollitt 1986, pp. 155–58, figs. 162–64; Ridgway 1990–2002, vol. 2, pp. 76–84.

12. Agora Museum, Athens, B 1382, 1384; see Camp 2001, p. 170, fig. 164.

13. For a list, see Siedentopf 1968.

14. National Archaeological Museum, Athens, 2715; see Bergemann 1990, no. P4, pls. 2, 5a, 12a–c; and Kaltsas 2003, no. 619.

15. Archaeological Museum, Kalymnos, 3901; see Kalliope Bairami in Picón and Hemingway 2016, pp. 212–13, no. 138.

16. Koutsoufakis and Simosi 2015, p. 75.

17. Ephorate of Underwater Antiquities, Athens, 2006/1; see ibid., pp. 75–77, fig. 5.4.

18. Koutsoufakis and Simosi 2015, p. 76.

19. Ephorate of Underwater Antiquities, Athens, 2009/28; see ibid., p. 76, fig. 5.3.

20. See, for example, an Athenian red-figure pelike in The Metropolitan Museum of Art, New York, X.21.21.

21. The Metropolitan Museum of Art, New York, 10.230.1.

22. Oliver 1996, p. 148, fig. 5.

23. See Sommella and Parisi Presicce 1997.

24. For a discussion of Hellenistic cuirasses as a precedent for Roman cuirassed statues, see Stemmer 1978, pp. 133–38.

25. Museo Archeologico Nazionale, Naples, 15743; see Bergemann 1990, pp. 82–86, no. P31, pl. 56.

26. Zanker 2016, pp. 174–76, no. 63.

27. Department of Greek, Etruscan, and Roman Antiquities, Musée du Louvre, Paris, Br 22, Br. 23; see Lahusen and Formigli 2001, pp. 150–52, no. 90.

28. See Cornelius Vermeule in *Search for Alexander* 1980, pp. 102–3, no. 9.

Sophie Descamps-Lequime and Dominique Robcis

The Hellenistic Legacy of Metallic Polychromy: Roman Statuettes of an African Boy in the Pose of an Orator

Scholars continue to discuss the question of origin and dating of different series of statuettes that appear, in subject and style, to belong to Egyptian production during the Hellenistic period but were found at provincial sites of the Roman empire.[1] Are they Hellenistic or Roman? Were they produced in an Alexandrian workshop or elsewhere in places that shared with Hellenistic Egypt a common international vocabulary[2] thanks to the diffusion of genuine Alexandrian patterns? Could such patterns have circulated for centuries, with reappearance here and there?[3] Or could the items have been brought from Egypt by their owners, such as soldiers spreading within the boundaries and to the far limits of the Roman empire? These questions remain open. One type that exemplifies the Hellenistic Alexandrian versus the Roman is that of the figure of an aged hunchbacked dwarf with a rooster and a lagynos; the Ptolemaic creation is known from a few examples, one of which was found in Augst, Switzerland, and another version that is in Strasbourg, France, in an A.D. 100 context.[4] Another type that exemplifies the same topic is that of the figure of an African boy in the pose of an orator, known from three statuettes uncovered respectively in Chalon-sur-Saône, France, Augst, Switzerland, and Avignon, France.[5] That category will be discussed later in this essay.

Very few Hellenistic bronze statuettes depicting African youths have been discovered in Egypt.[6] They usually are rough castings and attest that Egyptian craftsmen were more interested in modeling, instantaneous pose, and ethnic characteristics than in polished surfaces and refined details. However, the preserved corpus on which to base these observations is very small, and statuettes such as the Met's

Baker Dancer (see p. 18)[7] underline the difficulties of embracing sculptural research and tendencies of Hellenistic Egyptian production that spanned centuries. A pair of seated African youths, purchased in Cairo in 1904,[8] was certainly cast in the same Egyptian workshop by bronze workers who combined similar molds to build their wax-working models. Alexandrian markets offered the sculptors the opportunity to observe and to translate into metal twisted and suffering chained bodies that evoke the tragic condition of human beings reduced to slavery. Another chained statuette is said to have been found near Memphis, close to Cairo.[9] It is as three-dimensional as the pair from Cairo. The pose is complex. One must turn around or manipulate the very well balanced small figure to appreciate the arched body, thin limbs, and flat feet, and to discover the shackled hands. The figure's raised head and glance suggest that the artist tried to express the wounded pride of the model. Two isolated crouching small black figurines were also uncovered in Egypt.[10] Their function as part of the decor of a bronze lamp can be inferred from a well-preserved exemplar in which a similar small figure of an African blowing on a flame is crouched on a curved reservoir.[11]

But what about the statuette of an African youth discovered in Reims, northern France? Was it an import?[12] Could it have been produced in Roman Gaul after a circulating pattern?[13] A similar question might be asked about another youth discovered in 1763 in Chalon-sur-Saône, France, in a wooden (most likely modern) box with seventeen other small bronzes (fig. 1).[14] The figure is wrapped in a himation, with his left arm concealed under the cloth and a papyrus or parchment scroll, now missing, in his right

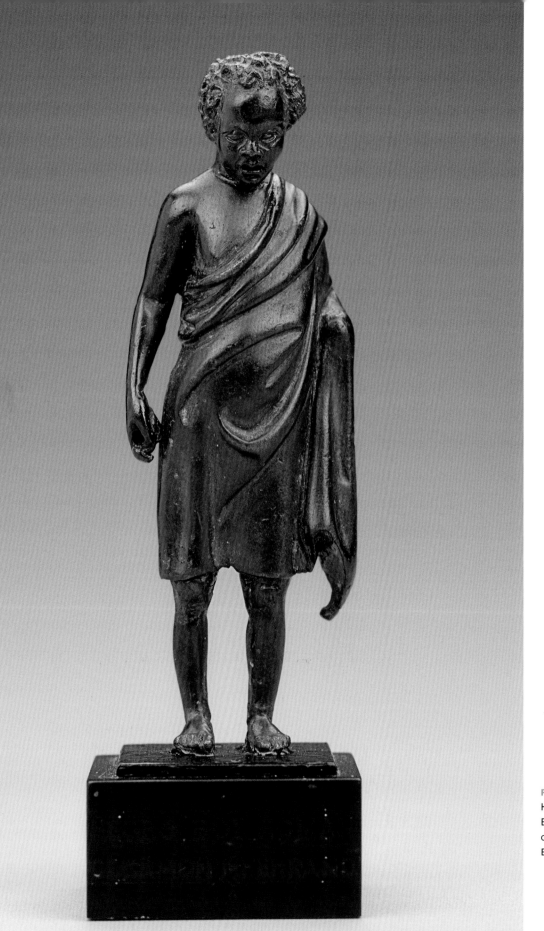

FIG. 1. Black African Youth, Greek, Hellenistic, ca. 150–50 B.C. Bronze, h. 3⅛ in. (8 cm). Museum of Fine Arts, Boston, John H. and Ernestine A. Payne Fund (59.11)

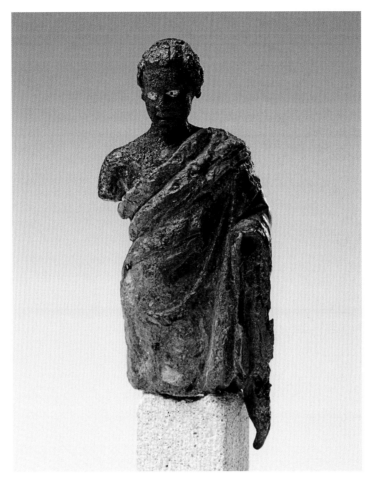

FIG. 2. Black African Youth, Augst, Switzerland. Roman, Imperial period. Bronze, preserved h. 2⅝ in. (6.8 cm). Museum Augst, 61.6532

hand. He is in the pose and garb of a Greek philosopher or of an orator, as conveyed by his parted lips. This well-educated Ethiopian,[15] very far from earlier examples in subject matter, evokes a much larger sculpture, possibly echoed by the figure of a philosopher standing on a capital in the collection of The Metropolitan Museum of Art.[16] The pose is identical, with the head bent forward and a slightly protruding belly, a posture that seems inaccurate for a young man but understandable in the context of a citation of a well-known sculpture such as the one echoed by the Metropolitan work.

A second statuette of the same type came to light in Augst, Switzerland, near Basel, in 1961 (fig. 2).[17] The legs are missing, as well as the right arm and the left hand that was not covered by the himation; they were cast separately. And indeed, despite the small size of the statuette—its preserved height, from the top of the head to the tip of the himation, is 6.8 cm—it was cast in five or six parts, which were assembled by soldering: the head with the bust, the himation, the right arm (if not broken), the left hand, and the two legs. This was done purposely in order to create a contrast between the garment and the skin. Moreover, it is a hollow cast. Eyes are inlaid with silver. Lips are slightly parted. Samples taken from the bust and mantle were analyzed by Atomic Absorption Spectroscopy and attest to the use of two different alloys. The himation is a ternary copper alloy with tin and lead, thus a bronze. The head is a black copper, with an intentional addition of gold and small

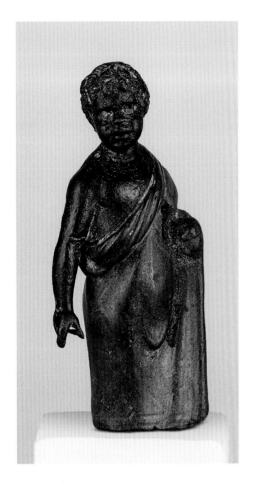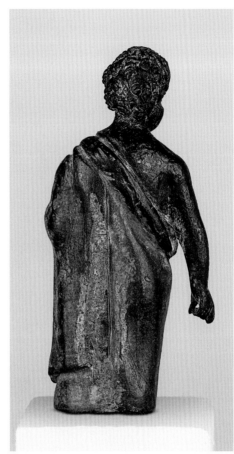

FIG. 3. Black African Youth, Avignon. France. Roman, Imperial period. Bronze, preserved h. 2⅜ in. (6.1 cm). Musée d'Archéologie nationale, Saint-Germain-en-Laye, France, 32.542

FIG. 4. Back of fig. 3

amounts of silver and arsenic.[18] When attained through certain recipes, yet to be discovered, this type of alloy with gold or with gold and silver develops a particular long-lasting black patina. The results concerning the youth from Augst could not be understood clearly when published in 1994, since the research on black bronze and black copper conducted by Alessandra Giumlia-Mair and Paul Craddock had started only a few years earlier.[19] Black bronze (or black copper, if there is no tin in the copper alloy) was put in relation with so-called Corinthian bronze, an alloy, thought to be magical, made of bronze, gold, and silver, described by ancient authors such as Pliny the Elder, Plutarch, and Florus as more precious than silver and eventually than gold, and as having been discovered fortuitously as a result of a fire when the city of Corinth was sacked in 146 B.C.[20] At the time it was first cleaned, the bust of the statuette from Augst was not identified as having

been intentionally patinated black in antiquity. It was described only as of a red brownish color.

In the first publication about it, the African Youth from Augst was compared with a third statuette, found in Avignon, southern France (figs. 3 and 4).[21] The more child-like and chubby-cheeked figure is wrapped in a himation with no long fold on the left side. The right hand was holding an attribute now missing, most probably a scroll. There is a metallic bridge between the thumb and the little finger. The lips are slightly parted. The legs, cast separately, are missing. They were soldered, as were the legs of the African youths from Augst and Chalon-sur-Saône. Circular remains of the welding are seen in the concave cavity under the mantle of the Augst Youth.[22] The preserved legs of the second statuette seem to have been attached the same way, since solder and a different texture are visible around the thighs (fig. 5). For the statuette from Avignon, the

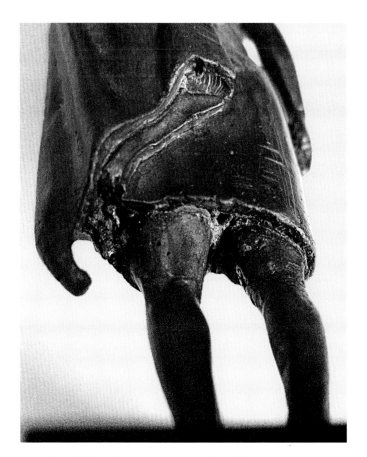

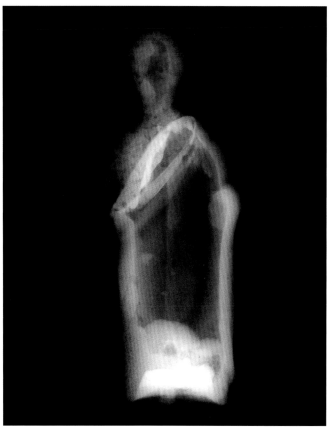

FIG. 5. Detail of fig. 1, showing solder around the thighs

FIG. 6. X-Radiograph of fig. 3

soldering of the legs was made through lead poured in the concavity under the mantle, as confirmed by the Centre de Recherche et de Restauration des Musées de France (C2RMF), which investigated the figure thoroughly. A close observation and X-radiographs show that, apart from the legs, the statuette was cast into two other separate pieces, the bust and the himation, once again intentionally, in order to assemble different copper alloys. These two parts were joined with lead. The himation is hollow cast with very regular walls, demonstrating the substantial mastery of the casting (fig. 6). Thanks to the AGLAE particle accelerator, nondestructive analyses were performed by PIXE. They confirm that the himation is a ternary copper alloy (Cu 81.3%; Sn 14.3%; Pb 3.5%), whereas the bust (approximately) is a black bronze, with the addition of gold and silver (Cu > 92%; Sn ca. 1.8%; Ag ca. 2%; Au ca. 0.7%). X-Ray diffraction, PIXE, and RBS reveal that the

well preserved black coating, which developed on the bust, head, and right arm, is a cuprite-based patina containing gold and silver, with an approximate composition of Cu 65 to 85%; Ag 3 to 7% and Au 1%.[23] It is about 0.008 millimeters (8 μm) thick. The odd physical phenomena, empirically discovered in ancient times, of a cuprite, which instead of appearing red, is black to the human eye, can currently be explained thanks to the most recent research on nanoparticles.[24] The young boy has thick curly hair with notches made in the wax before casting. The eyes of the figurine are inlaid with silver. The pupils were drilled out and present a conical cavity, which could be observed under 3D Digital Microscopy. The cavity of the right eye retains gold dust, which corresponds to a very tiny fragment of gold leaf (fig. 7). This means that the tool used to drill the pupil out contaminated the cavity and was that of a goldsmith. Thus, the small black youth was most probably created in a

workshop where goldsmiths worked. That is not a surprise, since gold and silver were involved with different stages of the production of such precious items: they already had been melted down with copper to produce the required small amount of basic alloy and must have been used to introduce different metallic colors after casting. We cannot decide if craftsmen of different expertise shared tools, or if they intervened one after the other on the same precious piece—the goldsmith for the making of the silver-leaf eyes, the drawing of the line encircling the iris, and the drilling out of the hole—but this contamination is a clue that helps us approach the possible organization of a Corinthian bronzes workshop. Besides, it confirms that the pupils were intended to remain hollow, the 0.75 millimeter high dark conical cavity giving the direction of the glance with accuracy. With 3D Digital Microscopy, it became apparent that the 0.5 to 0.6 millimeter high lips of the open mouth were engraved and inset (fig. 8), retaining a slightly red color (copper?). But due to corrosion, we could not distinguish their metal composition from that of the surrounding and could not come to a clear conclusion by PIXE, although such an inset is technically plausible.

Thus, we are certain that three colors (black for the skin, yellow for the mantle, and white for the eyes) were combined

to create the little figure, but we cannot confirm the presence of an eventual fourth (red?) one. Nevertheless, this polychromy is at least identical to that of the youth from Augst. Maybe it was even richer if red had been added.

We know of other precious items that display a taste for metallic polychromy, but black copper was used mainly for small inlays introduced in the ornamentation of larger items (pieces of furniture, vessels, garments, armors[25]) to contrast with silver, copper, or gold, as a background or among a succession of repeated motifs. It was exceptionally used in the round as a basic alloy intended to blacken, after a specific treatment, the surface of a three-dimensional item. As a matter of fact, and up to now, black copper or black bronze examples from the classical world identified with certainty after examination and analyses are very few; the two small statuettes from Augst and Avignon are among them. This does not mean that larger black statuettes and plastic items did not exist, but their gleaming color comes from another technique founded on a sulfer-based patina, a technique attested by many more examples, from the second half of the second century B.C. onward.[26]

Corinthian bronzes were very expensive, as can be inferred from Pliny the Younger, who gives the testimony of the small statue of an old man he had acquired after

FIG. 7. Detail of fig. 3, showing a fragment of gold leaf in the pupil's cavity (right eye). 3D Digital Microscopy, X 500. The fact that this fragment (ca. 80 x 120 cm) is partially trapped in white concretions confirms that it is an ancient pollution

FIG. 8. Detail of fig. 3, showing the open mouth with parted lips. 3D Digital Microscopy, X 50. On the right side of the upper lip, a groove could correspond to the presence of an inlay

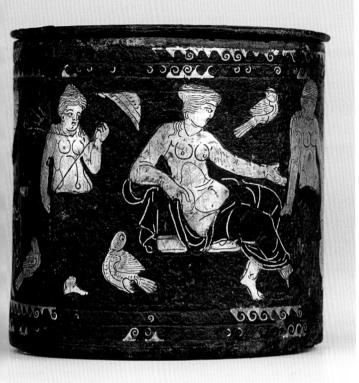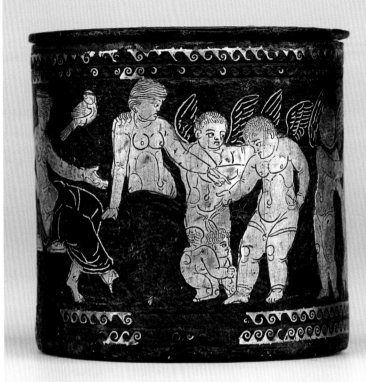

FIG. 9a and b. Inkpot, Vaison-la-Romaine. France, 3rd quarter of the 1st century A.D. Brass, pure copper, "black copper," gold, and silver, h. 1¾ in. (4.4 cm). Musée du Louvre, département des Antiquités grecques, étrusques et romaines, Paris, Bj 1950

coming into a legacy.[27] And as demonstrated by the statu- ettes from Avignon and Augst, black bronze and black cop- per were difficult to cast, particularly in the round.[28] When used as an inlay and because they were hammered after having been cast, black bronze and black copper could be kept in a very good state of conservation, as illustrated by an inkpot, dated typologically from the third quarter of the first century A.D., which was found in Vaison-la-Romaine, southern France. The black copper drapery of Venus and wings of the Erotes, enhanced with gold threads, are per- fectly well preserved and still of a deep black color com- pared to the corroded brass inkpot's body and pure copper inlays such as Psyche's wings and drapery nearby (fig. 9).[29] This phenomenon was already observed in ancient times, as testified by Cicero when he wrote that Corinthian bronze became hardly oxidized.[30]

We do not know of any Hellenistic Corinthian bronze, although they might have appeared after the middle of the second century, as attested if we rely on ancient literature.

The technique was learned most probably through Egypt, where the knowledge was never lost, since Egyptian models can be traced from the beginning of the second millennium to the first half of the first millennium B.C.[31] It was prac- ticed by Minoans, but later lost after Mycenaean civiliza- tion collapsed; Greek craftsmen certainly did discover it again under Ptolemaic pharaohs.

The fact that the inkpot from Vaison and the African Youth from Avignon come from two important neighbor- ing cities (Vasio and Avennio) of the province of Gallia Narbonensis, in the southern part of Gaul—a Roman con- quest of the late second century B.C. and one of the earliest regions of the Roman Empire to have been influenced by Greek and Roman culture—could reveal, if not local pro- duction, at least a particular local taste for precious small items with metallic polychromy based on Hellenistic mod- els.[32] The inkpot was produced when Pliny the Elder was writing his *Natural History*, which states that four colors (red, yellow, white, and black) were used exclusively on the

palette of the greatest fourth century B.C. Greek painters such as Apelles. Could the date of the inkpot be the same as that of the Youth from Avignon? Both are small, precious, and of great mastery. The African Youth found in Augst should be added to this particular production.

The African Youth from Chalon-sur-Saône seems to have been repatinated *à l'antique*, as was the rule at the end of the eighteenth century. The statuette seems different from those discussed above, since it is a solid cast. Nevertheless, the similar dimensions and pose, the added legs, and the fact that it shares with the African Youth from Avignon the same flattened fold hanging on the back (the statuette from Chalon presents a rivet at the waist; the boy from Avignon retains traces of lead soldering along the fold) show that they were both appliqués attached to a support. They were, though three-dimensional, applied on a relief or on a certain type of utensil that has yet to be identified.[33]

The Roman African youths from Augst and Avignon should be interpreted in terms of their Hellenistic legacy. Their subtle metallic polychromy includes them in a small distinct group, one worth expanding, of very few preserved statuettes, the corpus of the still-mythical Corinthian bronzes.

Acknowledgments

We would like to thank Carlos Picón and Seán Hemingway for their kind invitation to attend the Met symposium and Hélène Chew, curator at the Musée Archéologique National, Saint-Germain-en-Laye, France, for giving us the opportunity to study the statuette from Avignon, 32.542, kept in her collection. We are most grateful to Seán Hemingway and Kiki Karoglou, who made a number of edits to the English translation and gave us advice to enhance this essay.

1. As already highlighted, among others, by Claude Rolley in the 1980s; see Rolley 1983, pp. 210–12.
2. As Mario Iozzo (in Stampolidis and Tasoulas 2014, p. 130, no. 21) pointed out: "the veristic intent, accentuated by crude realism … are characteristics that would direct us to an Alexandrine environment, although the progress of research scholarship has shown that these elements are characteristic—albeit with different nuances and variations—of all schools of the middle Hellenistic period."
3. On the diffusion of Egyptian patterns through plaster casts, see Boube 1986.
4. For the dwarf, see Sophie Descamps-Lequime in Picón and Hemingway 2016, p. 174, no. 94. For the dwarf found in Augst, and in the Augst Museum, no. 66.3966, see Kaufmann-Heinimann 1977, pp. 81–82, no. 84, pls. 88, 89; and Kaufmann-Heinimann 1998, pp. 85–87, no. 84. For the dwarf discovered in Strasbourg, now in the Musée Archéologique, Strasbourg, 11.987.5.1; see Schnitzler 1995, pp. 74–75, no. 70.
5. For the hypothesis of an Alexandrian original statue from the late third century B.C. echoed by the small versions, see Mario Iozzo in Arbeid and Iozzo 2015, p. 186, no. 164.
6. Boucher 1976, pp. 183–84; Bolender 2000, p. 93.
7. See p. 18, fig. 8, in this publication; see Joan R. Mertens in Picón and Hemingway 2016, pp. 224–25, no. 158.
8. Staatliche Museen zu Berlin, 10485, height 5¼ in. (13.3 cm); 10486, height 4⅜ in. (11 cm); partially hollow cast, left arm/leg and right arm/leg cast separately; see Neugebauer 1951, pp. 78–81, pl. 36; Snowden 1976, pp. 213–14, figs. 276, 277 ; and Bolender 2000, pp. 93–97, figs. 3, 4.
9. Département des Antiquités Grecques, Etrusques et Romaines, Musée du Louvre, Paris, Br 361, height 5¼ in. (13.2 cm); see Neugebauer 1951, p. 81 (very close to the two statues from Berlin); Rolley 1983, p. 212; and Bolender 2000, pp. 93–95, fig. 1. For another statuette of an African youth, bought in Cairo, see Bolla 1998, pp. 17–20, fig. 7a, b.
10. Département des Antiquités Egyptiennes, Musée du Louvre, Paris, E 11750, purchased in 1925; see Bolender 2000, p. 93, n. 27. Collection Fouquet, location unknown, from Lower Egypt, length 4 in. (10.2 cm); see Perdrizet 1911, p. 57, no. 93, pl. XXV; and Bolender 2000, p. 93, n. 28.
11. Département des Antiquités Grecques, Etrusques et Romaines, Musée du Louvre, Paris, Br 4634; see Sophie Descamps-Lequime in Picón and Hemingway 2016, pp. 160–61, no. 69.
12. Concerning the general taste for black figures outside Egypt throughout the Roman empire and the influence of Isiac cults in the diffusion of African types in the first centuries A.D., see Snowden 1976, pp. 224–29, n. 266.
13. Musée d'Archéologie Nationale, Saint-Germain-en-Laye, France, 818, height (without base) 6¼ in. (16 cm); see ibid., pp. 224, 226–27, 229, figs. 295, 296; and Rolley 1979, p. 16. Bolla (1998, p. 18) underlines the fact that in Durocortorum, Gallia Belgica (now Reims, France), "the more ascertained ancient structures are from the first half of the first century A.D." (translations by the author); she mentions the statuette of another black servant as well, from Aquincum, Pannonia Inferior (now Hungary): a "military Tiberian camp, the capital of Pannonia from 106 A.D. onward." The

two statuettes should be more Roman than Hellenistic (ibid., p. 20), with the conclusion for the group she discusses: "The dispersal of discovery localities (Egypt, Pannonia, Gaul) seems to indicate . . . several production centers in different places of the Roman Empire." See also Fleischer 1967, pp. 152–53, no. 205, pl. 108, for the statuette of a black dancer from Carnuntum, Pannonia Superior (now Austria).

14. See Marion True in Kozloff and Mitten 1988, pp. 124–27, no. 19; and Seán Hemingway in Picón and Hemingway 2016, pp. 160–61, no. 70. We are most grateful to Christine Kondoleon, Curator of Greek and Roman Art at the Museum of Fine Arts, Boston, for her help and to Richard Newman, Head of Scientific Research, and Christie Pohl for their investigations of the statuette. On the 1763 eventually heterogeneous discovery of Chalon-sur-Saône, see Rolley 1979, p. 16; Rolley 1983, pp. 218–23; Aghion 1993; and Kaufmann-Heinimann 1998, pp. 250–52, fig. 202. About the Caylus African youth as a Renaissance's work, see Irène Aghion in Aghion and Hellmann 1988, pp. 43–45, no. 8, pl. III; Bolla 1998, p. 18, n. 78. Compare Bolender 2000, pp. 95–99, figs. 5, 6.

15. Ethiopian (literally "burnt face") was the generic word used in ancient Greek literature to designate black Africans; see Bolender 2000, p. 91, n. 1.

16. The Metropolitan Museum of Art, New York, 10.231.1; see Marion True in Kozloff and Mitten 1988, pp. 154–59, no. 26.

17. See Steiger 1967, pp. 192–93, 195, pls. 62.1–8 (possibly from Egypt), particularly pls. 62.2, 62.6, for the separately cast hollow bust and mantle, see Snowden 1976, pp. 226, 229, fig. 293; Kaufmann-Heinimann 1977, p. 81, no. 83, pl. 88.

18. Kaufmann-Heinimann and Liebel 1994, p. 231, nos. 6, 6°. Two samples were analyzed from the mantle: Cu 83.09%, Sn 8.60%, Pb 7.73%, Au 0.06%, Ag 0.21%, As 0.09%; Cu 80.96%, Sn 8.56%, Pb 10.12%, Au <0.01%, Ag 0.03%, As 0.07%. One sample was analyzed from the head: Cu 97.54%; Sn 0.35%; Pb 0.47%; Au 0.97%; Ag 0.39%; As 0.21%. See also Giumlia-Mair 2000, p. 595; and Franken 2002, pp. 186–88, on the different alloys intentionally chosen for mantle and bust.

19. Giumlia-Mair and Craddock 1993.

20. Pliny the Elder, *Natural History*, 34.1; Plutarch, *Morals: The Oracles at Delphi*, 5.395B–C; Florus, *Epitome of Roman History*, 1.32.

21. Its left hand was not cast separately, and its legs are missing. Formerly in the Hoffmann ancient collection, purchased in 1891; see Steiger 1967, p. 193, pls. 63.1–5; and Snowden 1976, pp. 226, 229, fig. 294.

22. Steiger 1967, pl. 62.8.

23. First investigations on the statuette were conducted at the C2RMF (PIXE and RBS) by Marc Aucouturier and François Mathis, FZ 36610 (2004), Analytical Report Z 3359. We want to express our gratitude to them. X-Radiographs were made by Thierry Borel. In 2015, the statuette was re-examined in the C2RMF (3 D Digital Microscopy; X-Ray fluorescence) and new X-Radiographs were realized by Elsa Lambert, who we deeply thank.

24. Aucouturier, Mathis, and Robcis 2017.

25. One may add to the different items already discussed by Giumlia-Mair and Craddock (1993, pp. 15, 27–29), the *Mensa Isiaca* from Rome (Museo Egizio, Turin, C 7155; see Vassilika 2006, no. 70), and the cuirass of a large statuette, possibly depicting Nero (British Museum, London, 1813, 0213.1; see Letizia Ceccarelli in Sapelli Ragni 2009, pp. 120–21, no. 10). An oinochoe from Egyed, Pannonia (now Hungary; Magyar Nemzeti Múzeum, Budapest, 10.1951.104; see Martin Bommas in Beck, Bol, and Bückling 2005, pp. 63–64, no. 33) should also be mentioned, even if nothing is said about the black patinated details of the gold and silver Egyptian figures inlaid in the copper body.

26. The Mahdia shipwreck gives a *terminus ante quem* for its cargo, which contained black bronzes coated with a copper sulfide patina; see Willer 1994. This type of patina introduced a new contrast between black and white: in the statue of a child god in the Saint Louis Art Museum, 36:26 (see Mattusch 1996, pp. 55, 237–40, 242, no. 25, pl. 4) and the statuette of an archaistic Athena in the J. Paul Getty Museum, Malibu (see ibid., pp. 120–21, fig. 83). There is also a contrast between black, white, and red: in the statue of the Child Dionysos, which was formerly in the Fleischman ancient collection and is currently in the J. Paul Getty Museum (see ibid., pp. 55, 237–42, no. 26; the red color is given by the ribbons). The three-color polychromy is illustrated by a Black Banausos as well; see Marion True in Kozloff and Mitten 1988, pp. 128–31, no. 20; and Bolender 2000, pp. 97–98. In that case, however, the statuette is completely black, which is different from more complex statuettes from Augst and Avignon that have only flesh that is black. See also the black hoof of the Artemision horse, which had a sulfur-based patina to make it that color and different from the horse's skin; see Hemingway 2004, pp. 62–63, pl. 3.

27. Pliny the Younger, *Letters*, 3.6.

28. The skin of the African youth from Augst was said to be porous; see Kaufmann-Heinimann and Liebel 1994, p. 232. See also Giumlia-Mair 2000, p. 595, about the "poor casting properties of this alloy."

29. Descamps-Lequime 2005, pp. 12–13, 15, 20, figs. 11–13, 17–19, 24.

30. Cicero, *Tusculan Disputations*, 4.14.32.

31. Delange 2007.

32. The unusual hollow casting for very small statuettes should be explored as a technical clue.

33. A late Flavian or Trajanic statuette of a reciting child, wearing a comic mask pushed back on his head and with the same dimensions and a partially flat back, could belong to a relief as well; see John J. Herrmann Jr. in Kozloff and Mitten 1988, pp. 357–58, no. 71.

HELLENISTIC DECORATIVE ARTS AND THEIR INFLUENCE ON ROMAN ART

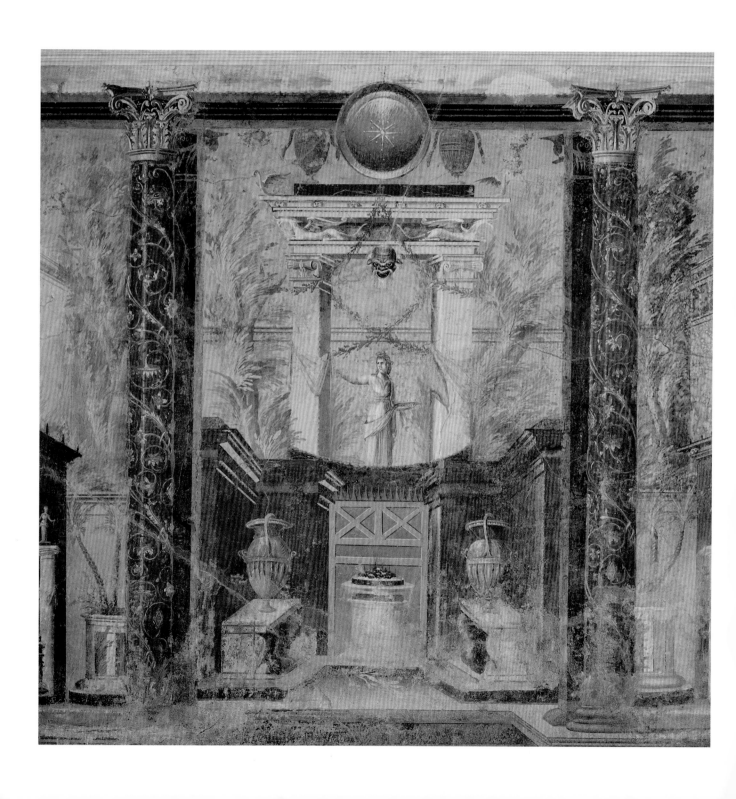

Ariel Herrmann

The Hamilton Fragment and the Bronze Roundel from Thessaloniki: Athena with the Gorgoneion Helmet

A magnificent bronze roundel recently excavated in Thessaloniki (fig. 1)[1] draws attention to a marble relief, at present lost but amply documented, that reproduces the same type: Athena wearing the Gorgoneion as a headdress.

The Hamilton Fragment

The marble fragment first appeared as plate XLIV in *Specimens of Antient Sculpture, Aegyptian, Etruscan, Greek and Roman: Selected from Different Collections in Great Britain by the Society of Dilettanti*, volume 2, published in 1835 (fig. 2). The text for this plate reads in part: "It is of very elegant Greek workmanship; and having been found in Rome towards the end of the last [18th] century, was for many years in the possession of Canova, who gave it to its present proprietor, in testimony of his regard, and as the best specimen of Greek art which had been found in Rome during his time."[2]

The recipient was William Richard Hamilton (1777–1859),[3] who had acted from 1799, often under adventurous circumstances, as private secretary to the Earl of Elgin. Later W. R. Hamilton became a substantial political figure and antiquarian in his own right, but he remained a trusted advisor for Lord Elgin.[4] From 1809 to 1822 Hamilton served in the British Government as Under-Secretary for Foreign Affairs, and from 1822 to 1825 as Minister and Envoy Plenipotentiary in Naples. Although he was rejected twice before being elected to the Society of Dilettanti in 1811, he eventually became the society's secretary, acting in this capacity from 1830 until his death. His resourcefulness and fair-mindedness seem to have been widely respected.

Hamilton may already have been on friendly terms with the sculptor Antonio Canova (1757–1822), but they became

especially close when both men were in Paris during the autumn of 1815. The two played crucial roles in bringing about the restitution of the masterpieces that had been seized by Napoleon from the papal collections and elsewhere in Italy. Canova had been charged by Pope Pius VII with the diplomatically fraught task of extracting the works of art from Napoleon's imperial museum in the Louvre, and with making the practical arrangements for their packing and transport.[5] Hamilton had access to such public figures as Wellington, Castlereagh, and the Prince Regent. It was, at least indirectly, thanks to his intense advocacy that the Prince ordered the return of most works that could safely travel, claiming nothing for Britain. In a remarkable gesture of good will, the Prince Regent agreed to subsidize the otherwise prohibitive shipping costs. Hamilton and Canova were also prominent figures in the negotiations over the Elgin Marbles. The celebrated sculptor visited England late in 1815, and testified in favor of the acquisition before a parliamentary committee.[6]

The small sculpture that Canova gave to Hamilton was the perfect collector's piece, a portable fragment with an exquisite style and a provocative, arcane iconography. A distinctive feature of the representation is Athena's Gorgoneion-mask headgear. The face of Medusa surmounts her brow rather than being displayed on the aegis. Athena's own hair, in loosely twisted strands, is bundled upward and back under the mask, while other locks flow down on her neck and shoulders. Her face, turned sharply toward the viewer's right, is a narrow oval with the delicate but austere features typical of the goddess. By contrast, the countenance of Medusa has a slightly flattened aspect, as if detached from

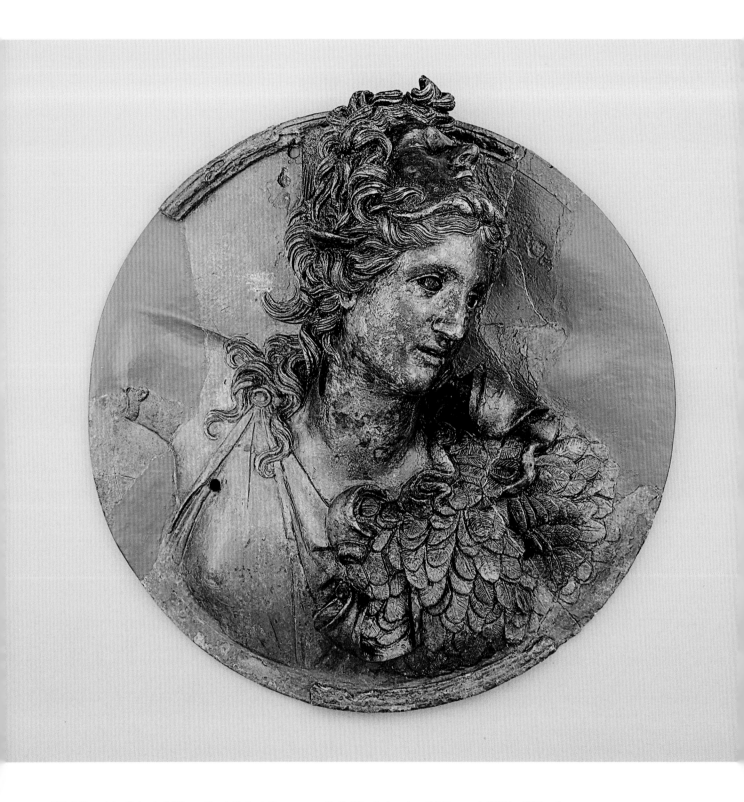

FIG. 1. Roundel with bust of Athena, Greek, Hellenistic, ca. second half of the 2nd century B.C. Bronze, h. 10¾ in. (27.2 cm). Archaeological Museum of Thessaloniki, MO 17540

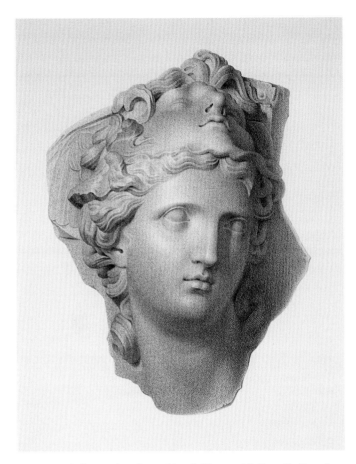

FIG. 2. Detail of engraving of a marble relief fragment in the collection of W. R. Hamilton. *Specimens*, 1835, pl. XLIV

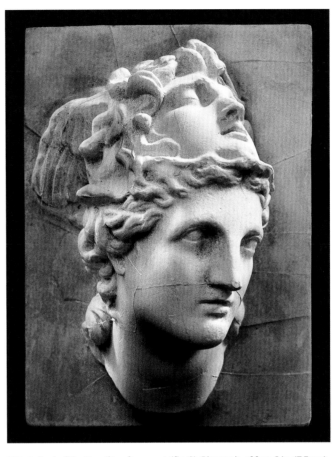

FIG. 3. Cast of the Hamilton fragment (fig. 2). Plaster, h. of face 3 in. (7.5 cm). Antikenmuseum Basel und Sammlung Ludwig, Skulpturhalle, Basel, SH 1808

its supporting bone structure. Closed eyes and a blank expression suggest the vacancy of death, while steeply contracted brows convey the only reminiscence of pain. Thick mid-length locks spring back from the brow and temples, merging at the sides with Athena's own upswept tresses. Snakes outline the lower border of the face and knot together under the chin.

Casts

The present whereabouts of the Hamilton fragment is unknown,[7] but casts of it can be found in many nineteenth century collections. They corroborate the enthusiastic description in *Specimens* 1835. An early example in Weimar, collected by Goethe in 1824,[8] shows the fragment with the same irregularly broken edge seen in that publication. Other casts are in Erlangen[9] and Göttingen,[10] and another was formerly in Berlin.[11] The well-preserved example illustrated here (fig. 3) was acquired for the Basel Skulpturhalle in 1857.[12] In these later casts, the head has been set on a rectangular background slab.[13]

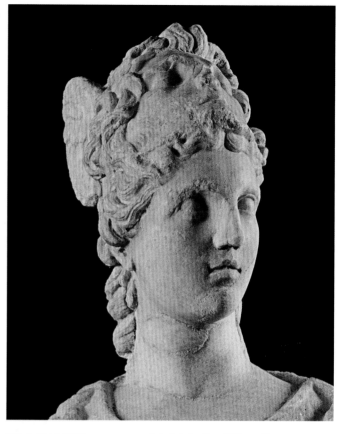

FIG. 4. Head of Athena on an unrelated statuette of Nike. Roman, ca. 1st century A.D. Marble, h. of face 3 in. (7.5 cm). Galleria dei Candelabri, Vatican Museums, Rome, IV 9 (162)

FIG. 5. Head of Athena on an unrelated statuette of Athena. Roman, ca. 1st century A.D. Marble, h. of face 3 in. (7.5 cm). Vatican Museums, Rome, storerooms, 88

Replicas and Reflections

The Hamilton fragment does not stand alone. In all, six ancient marble versions of the same Athena type with the Gorgoneion headgear can be identified.

1. Relief fragment; once London, collection of William Richard Hamilton (fig. 2).[14]
2. Head restored on a statuette of Nike; Vatican Museums, Galleria dei Candelabri, Rome (fig. 4).[15]
3. Head restored on a statuette of Athena; Vatican Museums, storerooms, Rome (fig. 5).[16]
4. *Trapezophoros* with the inscribed name, in the genitive, of MN (ligate) Cordius Thalamus; found in P. Manfredo Fanti, Rome, in 1879; Centrale Montemartini, storerooms, Rome (fig. 6a).[17]

5. *Trapezophoros*; Centrale Montemartini, storeroom, Rome (fig. 6b).[18]
6. *Trapezophoros*; once Sotheby's New York (fig. 7).[19]

The examples vary in workmanship and probable date, but all are of the Roman period. Two (nos. 2 and 3) are fragmentary heads that are almost in the round like the Hamilton piece and agree with it in size. Both were adapted for early restorations of unrelated statuettes. The other three examples (nos. 4–6) are reflections on table supports (*trapezophoroi*) of a special form. These supports have a pilaster-like shape, with pegs or stylized zoomorphic heads projecting along their narrow sides, and each is adorned on its main side with a bust of the goddess in relief.

FIG. 6a and b. Two trapezophoroi, Roman, ca. 1st century B.C. (with the inscription MN CORDI THALAMI). Marble, h. 23¼ in. (59 cm). Nr. 2788. Once Capitoline Museums, Rome, both now, Centrale Montemartini, storeroom, 859, 2788

FIG. 7. Trapezophoros, Roman, late 1st–2nd century A.D. Marble, h. 30¾ in. (78.1 cm). Once Sotheby's, New York

Modern Versions

The authenticity of Hamilton's relief was questioned almost from the beginning because of its bizarre iconography and mannered style.[20] A number of modern examples contributed to an aura of suspicion around the type.[21] Seventeenth and early eighteenth century versions, however, are evidence that an ancient model, now lost, must have been available in Rome well before the discovery of the Hamilton fragment.

This model evidently preserved the left shoulder with the aegis, as well as the head. An imposing over-life-size bust in Galleria Borghese, Rome (fig. 8), is first described in 1650 and must have been made in the early seventeenth century.[22] The head is nearly frontal and the ample breasts have been reduced so that the bust has an almost masculine appearance, but the feathered aegis with its scrolling border precisely reproduces a part of the ancient prototype otherwise known only from the inconspicuous *trapezophoros* reliefs that were found much later, and from the Thessaloniki roundel itself. The same rendering of the aegis characterizes a miniature Baroque bust in the Vatican Museums (fig. 9). Although the right shoulder is lowered as in the Borghese bust, the strongly turned head and the small scale are very close to the ancient model.[23] That the source for the modern copies was a high relief is suggested by discrepancies in the treatment of the back of the head.

FIG. 8. Bust, Italian, first half of the 17th century A.D. Marble, h. without foot, 32¼ in. (82 cm). Galleria Borghese, Rome, CCXXXI

FIG. 9. Bust of Athena. Italian, ca. 17th century A.D. Marble, h. of face, 3 in. (7.5 cm). Magazzino delle Corazze, Vatican Museums, Rome, 4691

The Thessaloniki Relief

An unequivocally ancient version of the type was discovered in 1990, during a rescue excavation in downtown Thessaloniki (fig. 1), in the ruins of an ancient building that may have been the Macedonian royal palace. The bronze roundel was found with other fittings that adorned a two-wheeled ceremonial vehicle.[24]

The details of Athena's head and of the Gorgon's face correspond almost exactly to the Hamilton fragment. In the Thessaloniki example, the chest and shoulders are preserved; the goddess turns her head sharply to her left and raises her right arm as if to brandish a weapon. Traces of a snake bracelet can be seen on her upper arm, bared by the peplos, and a round brooch secures the garment on her right shoulder above her substantial breast. Her left shoulder and lowered arm are covered by a thickly feathered aegis. Three scrolling curls along its edge reveal the aegis's leathery underside, and a snake slithers downward from the uppermost scroll among the high-relief feathers.

The tondo is framed by a simple profiled border, separately made, of the kind usual for the emblemata of vessels and the phalerae attached to horse trappings. Here, however, the main part of the roundel is cast, not worked in repoussé. The goddess's piercing eyes are rendered with carefully fitted inlays.[25] Although archaeological evidence so far published does not firmly establish the roundel's

date, the superb modeling, spontaneous yet refined, and the highly finished details make it seem certain that this is an original work of the Hellenistic period.

The Thessaloniki roundel has rightly been compared to some of the bronze fittings from the Mahdia wreck, and on the strength of this similarity ascribed, like the Mahdia bronzes, to a Delian workshop.[26] However, the correspondence is not so close as to go beyond the loosely comparable time, style, and technical features, and the attribution of the Mahdia bronzes themselves to Delos is far from certain.[27] It is true that no other fittings resembling the Thessaloniki roundel have been found in northern Greece, but not many important bronzes of any kind have survived there, so the argument is one *ex silentio*.

Iconography

Because of her brandishing gesture, the Athena of the Thessaloniki relief has been described as an Athena Promachos, or as Athena Alkidemos, patron goddess of Pella. Such images, familiar from Early Hellenistic coinage, are typically archaistic in style. The city's protective goddess, shown full length, advances with measured stride and directs her resolute gaze straight ahead.[28] Her hieratic pose is emphasized by the fishtails and stiff parallel folds of her drapery. Our type, as best exemplified by the Thessaloniki roundel, is quite different. There is no hint of retrospective mannerisms. The strongly turned head of the goddess, her parted lips, her disheveled hair, and side-slipped aegis imply that she is actually engaged in hand-to-hand combat. She raises her right arm to aim a spear, while glancing down and toward her left as if at a fallen or cowering opponent. The context of this action can only be the Gigantomachy.[29]

The Headdress

The construction of Athena's gruesome headgear has troubled observers.[30] Where does the Gorgoneion's hair end and that of Athena begin? Is the goddess wearing the Gorgon's spoils as a pushed-up face mask or as a helmet? In the Thessaloniki roundel, a small wing is set far back on the upper right side of the head. Wings are proper to the Gorgoneion, not to Athena, and their presence implies that Medusa's scalp covers Athena's entire head like a helmet.[31]

Apart from our type, the very rare representations of a Gorgoneion worn on the head seem inspired by a misunderstanding, or at least a re-interpretation, of the

tilted-back Corinthian helmet. This is evident in the colossal Gallo-Roman head of Minerva excavated at Avenches,[32] which is at an opposite stylistic pole from the highly sophisticated Thessaloniki relief. An apparent *unicum* is the stucco medallion from Begram, cast from a toreutic original.[33] An idealized Julio-Claudian female, seen in profile, wears a flimsy looking aegis, complete with Gorgoneion, draped lightly over her head like a veil.

The Prototype

An approximate dating for the Thessaloniki type in the second half of the second century B.C. seems borne out by the typically High Hellenistic hair arrangement, with locks gathered upward in rolls and bunches into a bulky arrangement with many escaping strands. Forerunners are "Nyx" in the Gigantomachy frieze, and the type known from one of its replicas, now in the Metropolitan Museum, as the Stroganoff head.[34] These Baroque heads, however, have puffy, heart-shaped faces. Athena's narrower and more refined countenance is closer to that of the Late Hellenistic Sleeping Hermaphrodite.[35] The Hermaphrodite's intricate coiffure, although more orderly, is similarly proportioned, with loosely twisted strands pulled upward and back around the face, while longer locks "escape" along the neck or are rolled closely at the nape.

It has been assumed that the Athena with the Gorgoneion mask, like other important types, must be derived from a monumental work.[36] It is difficult, however, to imagine a complete Gigantomachy at this pitch, although the duel of Athena and a Giant would not be out of the question. The ancient reflections are all under life size, and are either bust-length excerpts in relief, shown from the same point of view and cut off in exactly the same way, or backless heads that may well come from relief tondi.[37] The representation seems iconographically and compositionally complete, concentrating all essentials of the image in the head and bust. Whatever the ultimate source, the surviving versions probably descend from a roundel resembling the Thessaloniki relief,[38] rather than directly from a large-scale, full-length statuary prototype.

The type's prestige is suggested by the way it was replicated in marble reliefs, not only in bronze fittings that could serve the same function as the original. Since the marble reflections are all most likely from the vicinity of

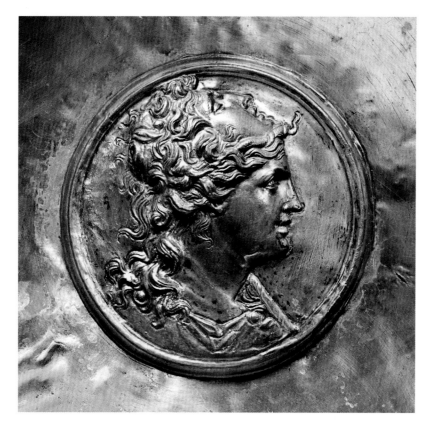

FIG. 10. Emblema of a bowl. Greek, Hellenistic, ca. late 2nd–1st century B.C. Silver with gilding, diam. of the *emblema*, 3¼ in. (8.2 cm). Private collection

Rome, it seems probable that a version was on view there. This was almost certainly not the Thessaloniki roundel itself, which is likely to have remained in Macedonia until it was eventually buried.

Serial production, even at a very high qualitative level, is well attested in the later Hellenistic period, although the methods by which it was achieved remain controversial.[39] A duplicate of the Thessaloniki roundel was evidently brought to Rome, perhaps among the spoils of the Mithridatic wars. The text of *Specimens* may not be far off in suggesting that it served as the decoration of a ceremonial shield, one that would have been carried in triumph or displayed in a public setting.[40]

The Silver *Emblema*

One variant on the Thessaloniki type is seemingly late Hellenistic in date. A silver bowl in a private collection (fig. 10) has a related image as its *emblema*.[41] The beardless head, this time seen in profile, has a mane of long curls that fall partly on the shoulders and are partly gathered upward.

The upswept tresses merge with the hair of a Gorgoneion exactly like, and worn in the same way as, the one worn by Athena on the Thessaloniki roundel. Twisted snakes form the lower border of the Gorgon face, while a projecting flap among the locks of hair suggests the helmet's lower edge. The headgear is further demarcated from the wearer's hair by gilding, making it clear that an entire helmet is worn, not just a pushed-back face mask.

Despite the flowing curls of the Gorgoneion helmet, the wearer has a stern and masculine appearance. The features are Alexander-like, but with slightly different proportions. The receding forehead with its prominent so-called "Michelangelo bar," the straight, jutting nose, bulbous at the tip, and the short chin are familiar from coinage as identifying traits of Mithridates VI Eupator of Pontus (r. 112–53 B.C.). A spiral-twisted scepter placed diagonally behind the bust implies that this is a royal portrait. The bust is draped in a garment, apparently of rather heavy material, that is drawn up high around the base of the neck and fastened on the left shoulder with a pellet-like round brooch.[42]

The head on the silver *emblema* wears the Gorgoneion helmet, but it is the only version that departs from the three-quarter view and does not reproduce the aegis-clad bust of the Athena reliefs. The portrayal of a male ruler with any attribute of a female divinity would be extremely unusual, although Athena's helmet may be more acceptable because it is derived from male battle attire.[43] The original image must have been a potent one and widely known, if this quotation was expected to enhance the Pontic king's prestige.[44]

In any case, the possible link to Mithridates as well as the presence of a Hellenistic version in Macedonia seem to situate the prototype of the Athena roundel in the Greek East, most likely in the Pergamene orbit, as its mix of high sophistication with passionate directness might suggest.

Acknowledgments

I am grateful to Carlos Picón for involving me with the exhibition "Pergamon and the Hellenistic Kingdoms of the Ancient World" and for giving me the opportunity to publish this essay. My special thanks go to Jörg Deterling. When I sent him a sketch of this article in April 2016, he pointed out to me his important comment on the same topic in Deterling 2013, p. 290, n. 79. Since then, he has been generous in sharing material and observations. I also thank Jasper Gaunt, Tomas Lochman, and Claudia Valeri for help both practical and scholarly.

1. Archaeological Museum, Thessaloniki, 17540, found in 1990 in Kyprion Agoniston Square, height 10¾ in. (27.2 cm); see Tasia 1993 for the excavation of the site; Vokotopoulou 1997, pp. 206–7; Adam-Veleni 2000, for the fullest publication of the bronze roundel and the four associated animal-head fittings; Polyxeni Adam-Veleni in Daehner and Lapatin 2015, pp. 232–33, no. 22; Polyxeni Adam-Veleni in Picón and Hemingway 2016, p. 186, no. 204.

2. *Specimens* 1835, pl. XLIV. Volume 2 was long in preparation, with some plates ready even before the appearance of volume 1 in 1809. The extensive text entries for the plates are unsigned. See Abeken 1839, pp. 226–27, pl. K; Caetani Lovatelli 1881, p. 228; Michaelis 1882, p. 435; Kaschnitz von Weinberg 1937, pp. 50– 51, no. 88; Lippold 1956, p. 279; Voretzsch 1957, pp. 25(A), 26, n. 89.

3. Not to be confused with the ambassador Sir William Hamilton or the painter/dealer Gavin Hamilton.

4. See Michaelis 1882, pp. 74–76, 79–82, on the activities of William Richard Hamilton. See ibid., pp. 434–35, for objects in his collection; St. Clair 1967, pp. 29–31; and many brief references throughout. William Richard Hamilton was the author of *Memorandum on the Subject of Lord Elgin's Pursuits in Greece* (Hamilton 1811, with a second, revised edition in 1815).

5. Eustace 1997; Johns 1998, especially chap. 6, pp. 145–69, on Canova and the British, and chap. 7, pp. 171–94, on Canova and the repatriation of the papal collections.

6. Michaelis 1882, pp. 145–46; Johns 1998, p. 156.

7. Voretzsch 1957, p. 26, n. 89, on his unsuccessful attempts to trace Hamilton's fragment through a descendant of Hamilton and the British Museum, London.

8. Klassik Stiftung Weimar, Museen, Goethe's Kunstsammlung, GPI/00159; see Abeken 1839, pl. K; Voretzsch 1957, p. 25(A), 26, n. 89, pls. 6.1, 6.2, 7.2. Goethe obtained the cast from the sculptor Christian Friedrich Tieck on April 13, 1824. I thank Katharina Krügel and Thorsten Valk for this.

9. University of Erlangen-Nuremberg, Cast collection, I 27. This cast was acquired between 1858 and 1863 and was supplied by Antonio Vanni, who was active in Frankfurt am Main. I thank Martin Boss for this information. Jörg Deterling first sent me the reference and a photograph from the archive of Paul Arndt (1865–1937).

10. Archaeological Institute of the University, Göttingen, Cast collection, A790. I thank Daniel Graepler for his help and Jörg Deterling for the reference and photograph.

11. Friederichs and Wolters 1885, pp. 555–56, no. 1439, for a cast then in the Königliche Museen, Berlin. I owe this reference to Tomas Lochman.

12. Skulpturhalle Basel, 223, background slab 7⅞ x 6 in. (20 x 15 cm), length of face 3 in. (7.5 cm); see *Führer durch das Gypsmuseum* 1893, no. 173, as Kopf der Nike mit Medusenmaske, Hochrelief im brit, Museum; and Bernoulli and Burckhardt 1907, vol. 1, p. 144, no. 223. I thank Tomas Lochman for bringing the cast to my attention. Ella van der Meijden was helpful in giving me access to it at the Skulpturhalle.

13. A cast of the fragment with irregular contours, as in *Specimens* 1835, pl. XLIV and the Weimar cast, appears in an unattributed nineteenth century painting with a still life composition of casts and other paraphernalia in an artist's studio; see Christie's London 2017, lot 55. A real cast is evidently depicted, since the angle is slightly different from that in the *Specimens* 1835 engraving and the lighting has changed. Michaelis (1882, p. 435) remarks when listing Hamilton's fragment: "The slab on which this very beautiful head is fastened is presumably a modern addition."

14. See note 2 above.

15. Helbig 1869; Caetani Lovatelli 1881; Kaschnitz von Weinberg 1937, pp. 50–51, as a comparison for no. 88; Lippold 1956, pp. 277–79, Galleria dei Candelabri, IV 9(162), p. 279, pl. 127, for the head; Voretzsch 1957, p. 25(D); Werner Fuchs in Helbig 1963–72, vol. 1, pp. 427–28, no. 539. The statuette was excavated by Gavin Hamilton at Cornazzano near Galeria in 1772, but there is no information as to where the head was found. The assemblage, topped by a helmet that has since been removed, was once quite famous and is the subject of the two dramatic etchings by Piranesi; see Piranesi 1778–80, pls. 64, 65; Ficacci 2000, p. 626, figs. 794, 795. Since the head is a fragment, with the back part missing and the proper left side summarily carved, it seems to come from a high relief. Its fluid yet detailed and sophisticated workmanship, much like that of the Hamilton fragment if less refined, was dated by Fuchs to the late first century A.D.

16. Kaschnitz von Weinberg 1937, pp. 50– 51, no. 88; Lippold 1956, p. 279; Voretzsch 1957, p. 25(B); Werner Fuchs in Helbig 1963–72, vol. 1, pp. 427–28, no. 539. I am grateful to Claudia Valeri for giving me access to this piece in the marble conservation laboratory of the Vatican Museums, and for helpful discussion of it. A recent cleaning confirms Kaschnitz von Weinberg's

observation that the head was originally of quite fine workmanship but has been very extensively restored and reworked. The face has a twice-remade nose, bruised eyebrows, and retouched lips with an exaggerated philtrum. The lower left sides of the cheek and chin are patched. The entire back of the head, the wings, and the upper part of the Gorgoneion's hair are new. Athena's hair, subtly rendered along the hairline, has been coarsely recarved at the sides, especially on the proper right, where the volume of the coiffure is considerably reduced and new tresses have been applied to the neck. The non-ancient treatment has evenly striated locks between slot-like, widely separated drill channels (compare the similar workmanship on a modern bust, see note 23 below). The left side is less drastically modified. Its original sketchy handling is still evident and speaks to the probability that the head came from a high relief.

17. Once Palazzo dei Conservatori, Musei Capitolini, Rome, 859; see Stuart Jones 1926, p. 121, Galleria, 79; Voretzsch 1957, p. 25(C); Simon in Helbig 1963–72, vol. 2, pp. 298–99, no. 1475a. Noted as a comparison by Kaschnitz von Weinberg 1937, pp. 50–51; Lippold 1956, p. 279, and Werner Fuchs in Helblg 1963–72, vol. 1, p. 428. The forthright carving, still Hellenistic in feeling, is dated by Simon to the mid-to-late first century B.C.; see Erica Simon in Helbig 1966–72, vol. 2, pp. 298–99, no. 1475, for interpretation of such objects as *trapezophoroi* rather than altars. A ritual function, probably funerary, is suggested by the fact that this example is inscribed. The man honored might be a freedman of Manius Cordius Rufus, a moneyer of the mid-first century B.C. Caetani Lovatelli 1881 had raised this possibility but considered the piece much later on the basis of the inscription's letter forms.

18. Musei Capitolini, Rome, 2788; see Voretzsch 1957, p. 25 (C), Erica Simon in Helbig 1966–72, vol. 2, pp. 298–99, no. 1475b. As far as one can tell given the piece's battered condition, the workmanship appears clumsier than that of the Cordius Thalamus *trapezophoros*. However, the bucrania on the reverse sides of both pieces are similar. According to Simon, their triangular form is pre-Augustan and suggests a date in the mid-first century B.C.

19. Sotheby's New York 1999, lot 292, previously in a Japanese collection but probably from Italy. The piece was called to my attention by Jörg Deterling. Although it has the same form as the other two *trapezophoroi*, its fluent and even flamboyant workmanship suggests a Flavian or later date. The eyes are hollowed for inlay.

20. Abeken 1839, pp. 226–27: "The expression of the face and the character of the work are such that some proficient connoisseurs of the arts felt themselves disposed to doubt the authenticity of the monument, while others no less expert defended it strongly", Braun 1854, p. 37, says that the head "shows an almost modern sensitivity"; Smith 1904, p. 433, in describing the modern no. 2658 remarks that "the head, *Specimens* 1835, pl. 44 . . . also appears questionable." The cast in the Skulpturhalle Basel (see note 12 above) was put aside in the twentieth century as reproducing a non-ancient work, but fortunately it was retained in storage.

21. A small head of the type was once shown to me by a London dealer who later consigned it to auction. At the time, I suggested the Thessaloniki

medallion as an iconographic parallel for the piece, which appears to be of Italian, perhaps seventeenth century, workmanship. I owe Jörg Deterling the reference to it as Sotheby's London 2011, lot 36. A modern example in the British Museum, London, 2658, is on the same scale but is very different in style; see Smith 1904, p. 433. Deterling informed me of a head restored on the figure of a muse in the Library of the Empress Elizaveta Feodorovna, Pavlovsk; see Pinkwart 1965, pp. 189–90, no. 11; and Kuchumov 1975, pl. 62. This head may be of an unusual in-between size, since it fits a figure that is only slightly under life size, with a height of 42½ in. (108 cm), when bent forward rather than standing to its full height.

22. Galleria Borghese, Rome, CCXXXI; see Caetani Lovatelli 1881, pp. 229–30; and Faldi 1954, p. 15, no. 9. See also Abeken 1839, p. 226, n. 4.

23. The miniature bust, no. 4691, is stored in the Magazzino delle Corazze of the Vatican Museums, Vatican City. The sculpture is severely weathered, of poor quality and quite unlike the Borghese bust in style. As in the ancient examples, the length of the face is 3 in. (7.5 cm); see Stuart Jones 1926, p. 121, Galleria, no. 79, who was probably referring to this piece when he noted: "Amelung has discovered a small bust in the round of the same subject, in the *magazzino* of the Vatican (unpublished)." It may be one of the two small modern examples of the type once in the Casino of Pius IV according to Caetani Lovatelli 1881, p. 230. I thank Claudia Valeri for giving me access to this piece. Jörg Deterling sent me a scanned photograph of it from the archive of Paul Arndt, University of Erlangen-Nuremberg.

24. See note 1 above. So far, the roundel has so far no parallels among the decorations of the wagons or chariots, including those, mostly of Roman date, that are found quite frequently in the Balkans; see Mercklin 1933. Four animal-headed attachments that were excavated with the Athena tondo are, however, more typical of vehicle fittings in their workmanship and typology. It even seems possible that the roundel may have been made for some other purpose and adorned the vehicle in a second use.

25. The treatment is unlike the partially silvered rendering typical of fine Roman bronze statuettes or the putty-like filling sometimes used in the eyes of small colored-stone sculptures.

26. For the attribution of the Thessaloniki roundel to Delos, see Barr-Sharrar 1994, p. 554, n. 9; Adam-Veleni 2000, p. 157. Especially close to it among the bronzes from the Mahdia wreck are two ornaments for a votive ship or prow-shaped base; see Horn 1994, pp. 452–53, 460–61, figs. 1, 2, 11, 12. These are also cast, with forcefully modeled busts almost fully in the round. Despite the under-life-size scale, they have inlaid eyes. Horn (ibid., p. 463) sees Attic and eastern Mediterranean stylistic affinities.

27. Even if some or all of the Mahdia fittings can be attributed to Delos, their characteristics are not limited to that center. The island had no significant indigenous population or local artistic traditions. Its prosperity and position as a trading hub in the Late Hellenistic period attracted artists from many parts of the ancient world.

28. Kraay 1966, nos. 797, 798, pl. 217, for examples on the coinage of Ptolemy I as satrap.

29. The composition can be imagined as a version of the widespread scheme seen, for example, on a bronze relief in Palestrina; see Quattrochi 1956, p. 42, no. 108, fig. 46.

30. Michaelis (1882, p. 435) approvingly quotes Helbig 1869: the goddess "has conquered the foe by holding before her face the mask of Medusa, and now pushes up the horrible object so as to view the field of victory with her own countenance."

31. A wing appears in the engraving and casts of the Hamilton fragment. None is visible, however, on the Galleria dei Candelabri Nike head, although there could be the stump of a small one among the eroded waves of hair. The head on the Athena statuette has wings, restored but possibly based on ancient traces. The *trapezophoros* reliefs have pairs of large wings. A flange, evidently the lower edge of a helmet-like headgear, appears in the hair over Athena's right temple in most versions. The finely detailed Thessaloniki roundel seems to show a similar projection on the partially hidden left side.

32. Musée Romain d'Avenches, RS 9a; see Bossert 1983, p. 22, pl. 9-20. The same is apparently true for the helmet on the bronze statuette of a warrior; see Ghezelbash 2016, no. 18. Compare with coins of the late first century A.D. from Aigeai in Cilicia that show the hero Perseus with a Gorgon-mask helmet; see Levante 1986, p. 1700.

33. National Museum of Afghanistan, Kabul; see Voretzsch 1957, p. 25(E), pl. 5, for interpretation and comparative material.

34. Richter 1954, p. 110, no. 218, for the example in the Metropolitan Museum, from the Stroganoff Collection, 21.88.15. She cites two other replicas, one in the British Museum, London, 1566 (see A. Smith 1904, no. 1566) and one in the Musée Archéologique Saint-Pierre, Vienne, France, 1629, 15.07.1922, now R 2001-5-005 (see now Danièle Terrer in Lavagne 2003, p. 5, no. 5). This reference was given to me by Jörg Deterling, who informed me of two further replicas, both unpublished, in Berlin and Vienna, Austria. He also pointed out a reduced adaptation from Antioch in the Princeton University Art Museum; see pp. 186–89, no. 52.

35. Palazzo Massimo alle Terme, Rome, 1087; see Marina Sapelli in La Regina 1998, pp. 136–39.

36. Deterling (2013, p. 290), calls it "the most interesting Athena statue of Hellenistic times," and remarks in n. 79 that "the type is so far known only in statuettes and relief reflections."

37. In the casts of the Hamilton fragment and in the Galleria dei Candelabri head, as well as in the modern examples except for the slightly over-life-size Borghese bust, the face measures about 3 in. (7.5 cm), from parting of the hair to chin. To judge from its overall dimensions, the Thessaloniki roundel is on the same scale as the small marble examples, although a measurement of the face is not available.

38. Busts in medallions are a well-known feature of Late Hellenistic architecture and decoration, although they are usually not in strong action. A few parallels, however, do come to mind. The bust of Artemis on a gold roundel in the Stathatos Collection, National Archaeological Museum, Athens, ST 0369 is cut off in the same way as the Athena bust and has the right arm raised in a comparably dynamic gesture; see Amandry 1953, no. 233; Higgins 1980, pl. 52. I owe this comparison to Jörg Deterling. A bronze appliqué in the Cleveland Museum of Art, 85.184, dated to the late 2nd century B.C., shows a bust-length Skylla violently brandishing an oar; see Walter-Karydi 1998; Michael Bennett in Picón and Hemingway 2016, pp. 252–53, no. 191.

39. Mattusch 2015; Ridgway 2015. Barr-Sharrar 2016 supplies a needed corrective, pointing out the limitations, especially with ancient materials, of reusable molds except for the simplest objects or parts thereof. In n. 4 she observes: "What seems too often disregarded in this discussion is the facility with which artists can reiterate, particularly in a malleable material like clay or wax, an idea they have once resolved, i.e., repeat a model for another casting, whether by the direct or indirect method." See Ridgway 2016 for a response.

40. "The monument here represented seems to have formed part of an alto-rilievo on a disk of about ten inches in diameter, perhaps the umbo of a votive shield"; see *Specimens* 1835, text to pl. XLIV.

41. I am grateful to the owner for permission to illustrate this piece.

42. Is it the chlamys frequently adopted by Hellenistic rulers, in which case the left shoulder fastening would be very odd, or is it an unusually high-necked version of Athena's peplos, fastened on both sides but with the other brooch hidden among the curls of hair on the right shoulder?

43. There are ancient anecdotes, always negative in tone, about personages like Alexander or Caligula adopting the attire of female divinities, but visual evidence is almost nonexistent. For a possible exception, see Megow 1987, pp. 221–22, no. A 110 ("Domitian as Minerva"). The attributes are again the warlike ones of Athena.

44. An alternative suggestion is that a female ruler is portrayed. The profile head lacks Mithridates's usual sideburns. The scepter, although it is a symbol of royalty in general, is used on coins and gems especially to characterize royal women, who had no other attribute denoting their status. Dynamis (r. 47 B.C.– A.D. 8), queen of the Bosporan Kingdom, comes to mind. A granddaughter of Mithridates, she ruled alongside three successive husbands and at times in her own right. It is worth noting that Dynamis's father, Pharnaces II, and the first of her husbands, Asander, issued baroque, Mithridates-like portrait coins. See R. R. Smith 1988, p. 34, n. 22, on the scepter as a royal attribute; ibid., p. 43, on queens and their lack of other insignia; ibid., pl. 75, nos. 8, 16, for Arsinoe III and Kleopatra I with the scepter; Lillian Bartlett Stoner in Picón and Hemingway 2016, p. 312, no. 263, for the intaglio by Gnaios of a Late Hellenistic queen, often identified as Cleopatra Selene, with a scepter. See R. R. Smith 1988, pls. 8, 78, for Juba I of Numidia, the rare likeness of a male ruler with a scepter, spiral-twisted like the one on the *emblema* (as opposed to the trident-scepter of Ptolemy III or the spear of Ptolemy V, in ibid., pl. 75, nos. 9, 11, where the weapon tips are shown).

Joan R. Mertens

Innovation in Hellenistic Athenian Pottery: The Evolution from Painted to Relief Wares

FIG. 1. Panathenaic prize amphora with Athena. Greek, Attic, Hellenistic, 1st half of the 2nd century B.C. Terracotta. Antikensammlung, Staatliche Museen zu Berlin, Preussischer Kulturbesitz (V.I. 4950)

From the ninth century B.C. into the late fourth, the center of Greek pottery production and innovation was Athens. It is here that the major shapes, techniques of decoration, and figural subjects were developed. The scenes were painted or drawn with a clay preparation onto the surface of the wheel-made clay vase that was fired in a kiln. At the end of the process, the decoration appeared either as dark against a light background in the black-figure technique (fig. 1) or, beginning about 530 B.C., light against a black background in the red-figure technique (fig. 2). During the course of the fourth and third centuries B.C., the traditional ceramic production with a preponderance of painted decoration gave way to one in which mold-made relief wares predominated for narrative representation.[1] This radical departure is the focus of our attention.

Two major factors drove the production of Archaic and Classical pottery, particularly in Athens. First, the function of many vases was linked to specific Attic rituals such as funerals, or to social institutions, notably the symposium (drinking party).[2] The symposium was a gathering of Athenian citizens—male only, of course—for conversation and pleasure. The vases required included drinking cups, kraters to hold the diluted wine, jugs for dipping and pouring, and rarer novelties. During the late sixth and fifth centuries B.C., sympotic shapes were a big item of production in the Athenian potter's quarter known as the Kerameikos. Indeed, Susan Rotroff estimates that over fifty percent of the fine wares found in the Athenian Agora, the city marketplace, between the sixth and first century B.C. were connected to drinking.[3] The survival of the symposium, albeit in modified form, through the Hellenistic period, continued the demand for sympotic vases.[4]

FIG. 2. Pelike (jar) with Greeks fighting Amazons. Greek, Attic, Late Classical–Early Hellenistic, attributed to the Amazon Painter, 2nd half of the 4th century B.C. Terracotta. The Metropolitan Museum of Art, New York, Rogers Fund, 1906 (06.1021.195)

A second factor behind the production of vases was the export trade to Italy. From the late seventh through the first half of the fifth century B.C., the major market for Athens but also other Greek centers was Etruria, as documented by the thousands of examples that have come to light at sites like Vulci and Tarquinia. During the mid-fifth century, the flow of trade shifted from the Tyrrhenian to the Adriatic coast of Italy, with Spina as a major destination. From the second half of the fourth century B.C. on,[5] the decline in imported Attic wares was steep and final. For the Kerameikos, the disappearance of the western market made an economic difference and changed its products, as discussed below.

At the end of the Peloponnesian War against Sparta (434–404 B.C.), Athens lost her political primacy in Greece.

This historical watershed can also mark the beginning of the gradual but progressive phasing out of time-honored figural decoration in the red-figure technique, although it still enjoyed a late flowering in the so-called Kerch style (fig. 2), named after the site of ancient Pantikapaion in present-day Ukraine that yielded large numbers of such vases.[6] They display a predilection for polychromy as well as embellishments in low relief, often gilded. A spectacular example in the Pergamon exhibition[7] is the hydria from Amphipolis, with its remarkably preserved reds, blues, and gold, applied after the vase was fired. Representative pieces of slightly earlier, mid-fourth century date in the Metropolitan Museum's collection include a pelike (jar) (fig. 2), a popular shape, with traces of blue in addition to

FIG. 3. Oinochoe (jug) with the personification of Pompe (Procession). Greek, Attic, Classical, mid-4th century B.C. Terracotta. The Metropolitan Museum of Art, New York, Rogers Fund, 1925 (25.190)

FIG. 4. Lekythos (oil jar) with the healing of Telephos. Greek, Attic, Hellenistic, late 4th century B.C. Terracotta. The Metropolitan Museum of Art, New York, Fletcher Fund, 1928 (28.57.9)

the now also more prevalent white. Noteworthy as well is a refined oinochoe (fig. 3), showing the female personification of Pompe (a procession) between Eros and Apollo.[8]

In this late phase, probably the most remarkable innovation was the rendering of the subject matter not with drawing but in low relief applied to the surface of the vase. The masterpieces in The Hermitage Museum, St. Petersburg, are tours de force of molding and finishing.[9] The Metropolitan, however, owns a modest example of particular pertinence to Pergamon. A small Attic squat lekythos (fig. 4) is decorated with appliques depicting Telephos, the mythological founder of Pergamon, being healed by Achilles, the Greek hero of the Trojan War. Telephos had been wounded by the Greeks on their way to Troy, and the Delphic oracle

pronounced that whoever had inflicted the wound would also be the one to heal it.

The creativity of the traditional Attic ceramic tradition is manifest in the highpoints that it still attained, but the prevailing direction from the third century B.C. on was toward entirely black-glazed vases on which the decoration consisted of motifs in various combinations of relief, polychromy, and gilding. Athenian workshops rapidly created and disseminated new styles of decoration, to a considerable extent drawing on established practices of incorporating features in relief[10] into wheel-made pottery but also responding to contemporary influences from other sources. A long view of vase production in Athens is like a slowly turning kaleidoscope. There are a limited number of

FIG. 5. Oinochoe (jug). Greek, Early Hellenistic, 2nd quarter of the 3rd century B.C. Terracotta. Archaeological Museum, Thessaloniki (5152)

FIG. 6. Pyxis (toilet box). Greek, Macedonian, Hellenistic, 3rd–2nd century B.C. Terracotta. The Metropolitan Museum of Art, New York, Gift of Madame Politis, in memory of her husband, Athanase G. Politis, Ambassador of Greece to the United States, 1979 (1979.76a, b)

variables—shapes, techniques, subjects, and artistic factors such as the likely influence of metalware. During the Hellenistic period, these variables stand in a considerably different relationship to one another than earlier.

The first major Hellenistic fabric to emerge in Athens about 275 B.C. was West Slope Ware, named after the area of the Akropolis where it was first found in quantity (fig. 5).[11] To a considerable extent, it perpetuates established shapes, with a radical diminution of figural subject matter. A notable exception is the skyphos from the Athenian Agora showing an outdoor sanctuary on one side and a hunting scene on the other.[12] The usual decoration, executed with incision as well as added white and a yellowish orange, favors checkerboards and metope-meanders as

well as swags, tendrils, and an occasional marine or animal form. A graceful influence from metal-working occurs in the necklaces or wreaths around the neck or body of a vase, derived from earlier black-glazed pottery with similar gilded adjuncts.[13] Recent scholarship has noted parallels between the decoration of West Slope Ware and the somewhat earlier Gnathian pottery of Apulia,[14] raising the possibility of influence from Southern Italy, even though evidence of imports to Greece is very scarce. The wide geographical connections characteristic of Hellenistic pottery are also indicated by the popularity of West Slope Ware in Asia Minor and the area of the Black Sea as well as in Cyprus and the Levant. The Museum's one example (fig. 6) is a pyxis attributed to a Macedonian workshop.

FIG. 7. Plakettenvase (ribbed vase with appliques), Greek, Ptolemaic, Hellenistic, attributed to the Group with Horizontal Ivy Leaves, ca. 275–250 B.C. Terracotta. The Metropolitan Museum of Art, New York, Purchase, 1890 (90.9.1)

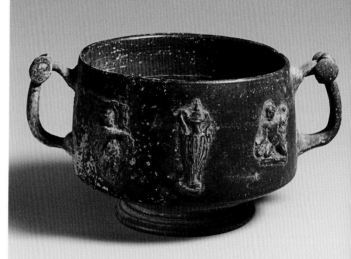

FIG. 8. Cup. Greek, Pergamene, Hellenistic, ca. 150–100 B.C. Terracotta. The Metropolitan Museum of Art, New York, Gift of J. Pierpont Morgan, 1917 (17.194.1846)

In the context of black-glazed vases with strong influence of metalware in their decoration and with complex geographical interconnections, it is pertinent to mention the class of *Plakettenvasen*,[15] exemplified at the Metropolitan by an amphora (fig. 7) found in Alexandria, Egypt. Around the top of the body appear two plaques depicting Herakles with his club and two showing Eros with a cornucopia. Datable about 275–250 B.C., such vases are believed to have evolved from Attic black-glazed works with gilded adjuncts as reinterpreted in South Italian workshops, possibly in Tarentum, from which artists emigrated to found new production centers in Alexandria and perhaps Crete. As against earlier painted vases, the priority is decorative effect, not the legibility of the scenes. Other types of relief vases flourished as well, with Pergamon as a major center.[16] Individual motifs are featured alone or in combination, as embellishment or as an iconographical reference, for instance, to gods such as Dionysos or Eros or to the heroes Herakles or Theseus (fig. 8).[17]

This practice of deploying subject matter paratactically or continuously occurs not only on fabrics with a dark surface and/or subjects in relief but also on those favored in

FIG. 9. Hadra hydria (water jar). Greek, Cretan, Ptolemaic, Hellenistic, ca. 226–225 B.C. Terracotta. The Metropolitan Museum of Art, New York, Purchase, 1890 (90.9.5). The inscription gives the name of Hieronides of Phokaia, whose cremated remains were deposited in the vase

FIG. 10. Lagynos (flask). Greek, Hellenistic, 2nd–1st century B.C. Terracotta. The Metropolitan Museum of Art, New York, Rogers Fund, 1947 (47.11.1)

the Hellenistic East that show a light ground and painted or relief motifs. The collections of The Metropolitan provide good examples in the strong holdings of Hadra Ware (fig. 9),[18] funerary vessels popular during the third and second centuries B.C. evidently produced in Crete and disseminated particularly to Ptolemaic Egypt. Compare also the lagynoi,[19] jug-like containers that are attested throughout the Mediterranean world. They are connected with Dionysiac observances; around their ample sloping shoulders, they show wreaths and musical instruments, as in fig. 10 or on an occasional vase such as a lagynos, or a dolphin.

The most significant manifestation in Athens of decoration based on the combination or repetition of individual relief elements occurs with the emergence about 225 B.C. of the hemispherical mold-made bowl (fig. 11).[20] This was a new shape, the production of which began with the creation of a wheel-turned mold. The decoration of the intended bowl was impressed into the interior of the mold with stamps made of clay, wood, occasionally also metal, after which the mold was fired in the kiln. Into the interior of this form, clay was then pressed to fill the hollows; the mold with the clay bowl within it was again turned on the

FIG. 11. Hemispherical relief bowl. Greek, Hellenistic, late 3rd-2nd century B.C. Terracotta. The Metropolitan Museum of Art, New York, Bequest of Armida B. Colt, 2011 (2012.477.11)

wheel to achieve a smooth interior surface. After the bowl had shrunk sufficiently to allow removal from the mold, it was fired.[21] The mold-made hemispherical bowl became the predominant vase for drinking in Athens, and indeed throughout the Greek world, between the late third and the middle of the first century B.C.[22] The ramifications of this phenomenon deserve consideration because it represents the adoption of a totally new drinking vessel into the traditions of the time-honored Athenian symposium, which was also changing during the Hellenistic period.[23] The absence of handles and a foot required a different way of drinking and ended such entertainments as kottabos. Furthermore, the iconography that previously was so tied to the world of the elite participants in the symposium and was undoubtedly noted during their gatherings had, for all intents and purposes, disappeared.

The brief summary above regarding major innovations and trends in Athenian, and wider Greek, pottery between the late fifth into the third century B.C. has emphasized the emergence of fabrics that brought to the fore dark surfaces and relief effects. The influence that is cited as the single most important determinant is that of metal, predominantly silver, vases (fig. 12). Certainly unprecedented in Hellenistic Athens was the visibility and civic sanction of metalware, including pretentious metalware—as opposed to pottery—in public entertainments. Susan Rotroff has presented compelling reasons why, and her argument is worth summarizing briefly. She divides Athenian purchasers of vases, particularly for the symposium, into "the metal class" and "the clay class." During the Archaic period, the symposium was restricted to the elite, "the metal class," who could afford metal vases, but the number of individuals and pieces was limited. The political and social democratization introduced during the Classical period brought with it public meals but a continued aversion to extravagance and display. During the Hellenistic period, "we find the metal class again conspicuous, and conspicuous consumption in vogue, as wealthy potentates hosted meals for the city."[24] While Rotroff's remarks were directed particularly to the popularity of metal kraters, they have a wider bearing.

The Greeks' knowledge of, and access to, exquisitely wrought utensils and other objects representative of Eastern luxury after Alexander the Great's campaigns provided models to adapt. However, the presence of potential models does not account for the integration of these novelties into the Greek repertoire of shapes and uses. The hemispherical mold-made bowl with a vegetal calyx appears to have been an Athenian invention derived from Alexandrian antecedents in metal and glass.[25] From Athens, the type spread very rapidly through southern Greece especially, the Aegean, Asia Minor, the Levant, and southern Russia. The decoration was predominantly floral. The numerous figural motifs perpetuated the time-honored repertoire of mythological subjects, like the gods or the labors of Herakles and Theseus, but rarely in a sequential narrative.[26]

The so-called Homeric bowls are a distinct subgroup of relief vases that stand out for their figural, narrative iconography.[27] They seem to have appeared in the late third or early second century B.C., and while they were dependent on Athenian innovations, their greatest popularity lay in Macedonia and regions under Macedonian control. They depict episodes relating to the Trojan War drawn from the epic cycle, mainly the *Iliad* and the *Odyssey*, but also from the Classical Athenian tragedians—Aischylos, Sophokles, and especially Euripides, probably reflecting his particular popularity during the Hellenistic period. The relief friezes

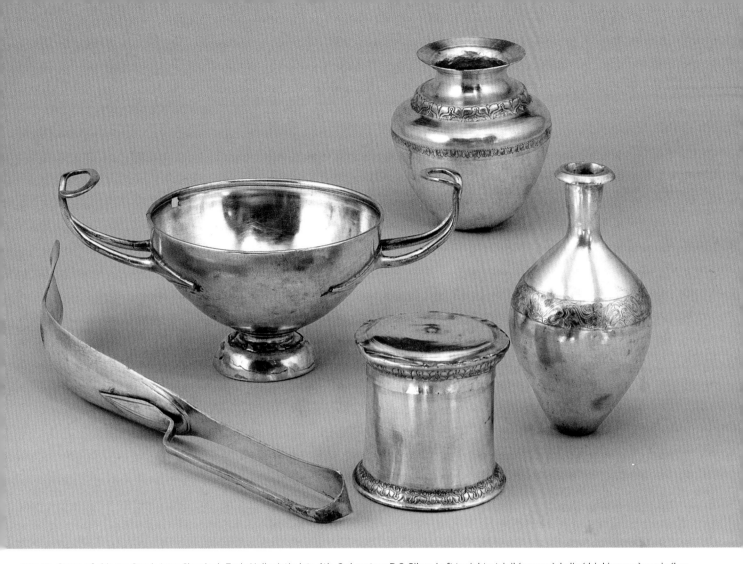

FIG. 12. Group of objects. Greek, Late Classical–Early Hellenistic, late 4th–3rd century B.C. Silver. Left to right: strigil (scraper); kylix (drinking cup); pyxis (box with lid), silver and gold; oinochoe (jug), silver and gold; bottle, silver and gold. The Metropolitan Museum of Art, New York, Bequest of Walter C. Baker, 1971 (1972.118.154-.158)

show thematically connected subjects, often with identifying inscriptions. For example, a vase in the Metropolitan's collection[28] shows Iphigenia being brought to Aulis, a representation based on Euripides's *Iphigenia in Aulis,* first performed in 405 B.C. (fig. 13). Although the scenes on the bowl do not follow the story perfectly sequentially, they depict Agamemnon, Iphigenia's father, secretly giving a servant a letter for his wife, Clytemnestra, in which he withdraws his request for their daughter to be sent to Aulis for sacrifice so that the Greek army can set sail for Troy. Menelaos, Agamemnon's brother, takes possession of the letter and quarrels with Agamemnon. In the detail illustrated, the inscription states that a messenger informs Agamemnon of Iphigenia's arrival. The final vignette shows Iphigenia and Orestes seated in a cart at Aulis.

On a bowl in Berlin (fig. 14)[29] with Odysseus slaying the suitors of his wife, Penelope, following his return home from the Trojan War, the written component is even more prominent. The three scenes from the *Odyssey* depict the capture and hanging of Melanthios together with Athena encouraging Odysseus and his son, Telemachos.[30] The inscriptions not only identify the protagonists but also cite specific passages from the epic. To a modern-day viewer, the subject matter on the bowl, the images and complementary texts, appear paramount, outweighing any niceties of composition or execution.

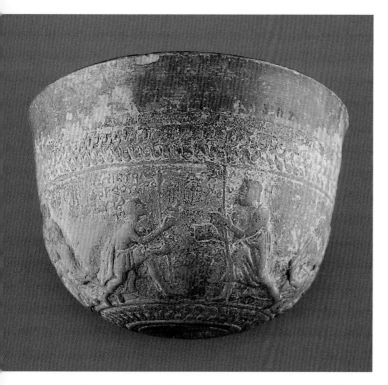

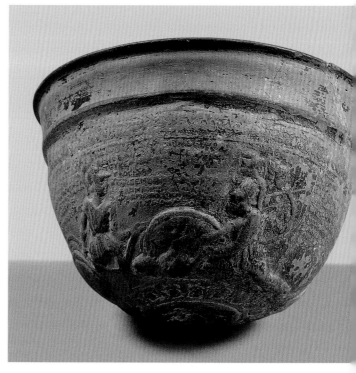

FIG. 13. Hemispherical relief bowl with Iphigeneia in Aulis. Greek, Hellenistic, 2nd century B.C. Terracotta. The Metropolitan Museum of Art, New York, Purchase, 1931 (31.11.2)

FIG. 14. Hemispherical relief bowl with Odysseus on his return to Ithaka. Greek, Hellenistic, 2nd century B.C. Terracotta. Antikensammlung, Staatliche Museen zu Berlin, Preussischer Kulturbesitz, 3161n

Even the most superficial review of ceramic production in Greece, and specifically Athens, between the fourth and second century B.C. reveals a remarkable picture. First of all, the Hellenistic pottery from Athens highlights the extent to which its antecedents were inextricably connected with the culture and social institutions of the polis. The shift in political power to Macedonia followed by the growing internationalization brought by the political events of the Hellenistic period dissolved these connections but also spread the creations of the Kerameikos more broadly and quickly than ever before. Ceramic production underwent a reinvention, as illustrated by West Slope Ware and the hemispherical mold-made bowls. Unlike the unprecedented splendor, even ostentation, in so many contemporary mediums—for instance architecture, metalwork, or jewelry—the pottery became ever more unpretentious. The Homeric bowls, however, suggest that the association between communal drinking of some sort and representations of Greek myth and history was not to die out. Among the numerous factors behind the discursive narrative depictions on Archaic and Classical vases, one presupposes the relative rarity of literacy; the picture told the story, possibly reinforced by the addition of an inscribed name. The glosses and quotations on the Homeric bowls presuppose the existence of available written sources of reference. The text tells the story; the picture is illustration.

These considerations also open broader, admittedly even more speculative issues such as how an ancient Athenian might have evaluated the aesthetics of a decorated vase in relationship to its iconography or, indeed, his own relationship to the vase he was using. It is difficult to overlook evidence for an anthropomorphic element in Athenian ceramics before the Hellenistic period. During the sixth and early fifth centuries B.C., black-figure cups greet their users and enjoin them to drink well;[31] inscriptions praise the beauty of youths of the time, indicating an awareness of such qualities;[32] and on an amphora in Munich, Euthymides notes an achievement never matched

by his contemporary, Euphronios.[33] Although these instances are terse and relatively rare, and although the speakers and the addressees are often undefined, the vases are parties to a dialogue. During the fifth century and into the fourth, the anthropomorphism is visible in the articulation of vase shapes and in their ornament derived from human embellishment, notably necklaces, pendants, or wreaths; West Slope Ware reflects the end of this feature. Hellenistic pottery shows us the variables of the Greek ceramic tradition—shape, technique, subject matter, metallic influence—repurposed for a basically utilitarian function, serving an unprecedentedly broad, indeed international, community. Special fabrics such as the Homeric bowls stand out as manifestations of an occasional resurgent interest in a specific type of iconography. Although it lacks the attainments of previous periods and some contemporary arts, thanks to the considerable surviving material and the research of such scholars as Susan Rotroff, Hellenistic pottery is compelling owing to the many processes of transformation that it documents.

Acknowledgments

I wish to thank Delphine Tonglet for information about the distribution of Attic pottery in Etruscan territory after the fifth century B.C. Maria Nassioula has generously shared some of her work on Homeric bowls with me. I am indebted to Polyxeni Adam-Veleni, Johannes Laurentius, Agnes Schwarzmaier, and Julie Zeftel for their help with photographs and to Melissa Sheinheit with computer issues.

1. For a general introduction into Greek pottery, see, for example, R. Cook 1996 or Boardman 2001.
2. See, for example, Lissarrague 1999a.
3. Rotroff 1996, p. 7.
4. Rotroff 2009, pp. 144–46.
5. Rendeli 1989, especially pp. 561–62; Govi 2006, especially pp. 112–13; Sassatelli 2010, especially pp. 158–59.
6. Kogioumtzi 2006; Lapatin 2006.
7. Katerina Peristeri in Picón and Hemingway 2016, pp. 119–20, no. 23.
8. Illustrations of all works of art in the Museum mentioned here can also be found on the Metropolitan Museum's website, www.metmuseum.org.
9. Zervoudaki 1968. For particularly good illustrations, see Cohen 2006a and Lapatin 2006. For the possible influence of vases with relief on painted examples, see Mertens 2013, especially pp. 418–19.
10. Cohen 2006a; True 2006.
11. Rotroff 1991; Rotroff 1997; Rotroff and Oliver 2003.
12. Athenian Agora, P6878; see Rotroff 1997, vol. 1, pp. 270–71, no. 271; Mertens 2016, fig. 65.
13. See notes 9 and 10 above and Kopcke 1964.
14. Rotroff 1997, vol. 1, pp. 41–43; Alexandropoulou 2002.
15. Dohrn 1985; Andreassi 2013.
16. Schäfer 1968, especially p. 100 (addendum); Japp 2011.
17. See also Metropolitan Museum, New York, 06.1021.270, 17.194.2027, attributed to a Pergamene workshop.
18. B. Cook 1966; Rotroff 1997, vol. 1, pp. 223–24. See also Metropolitan Museum, New York, 90.9.14.
19. Rotroff 1997, vol. 1, pp. 225–32; Bessi 2005.
20. Rotroff 1982a; Rogl 1996; Rotroff 1997, vol. 1, p. 11; Rotroff 2006; Rogl 2008, pp. 26–31; Ursula Kästner in Picón and Hemingway 2016, p. 171, no. 88.
21. Rotroff 1982a, pp. 4–5.
22. Ibid., p. 1.
23. Rotroff 2009, pp. 145–46.
24. Rotroff 1996, p. 27.
25. Rotroff 1982a, pp. 6–13.
26. Ibid., pp. 15–25.
27. Sinn 1979 and the review. Rotroff 1986. See also the recent work of Maria Nassioula (Nassioula 2013), with further comments in Nassioula 2009.
28. See Sinn 1979, pp. 109–10, no. MB 52.
29. See ibid., pp. 89–90, no. MB 21.
30. Homer, The Odyssey, 22.180–240.
31. In the extensive literature, see Wachter 2003 and Heesen 2011, especially vol. 1, pp. 233–41.
32. In the vast literature on kalos inscriptions, see usefully Lissarrague 1999b. For two recent publications with various perspectives on the subject, see Wachter 2016 and Yatromanolakis 2016.
33. Staatliche Antikensammlungen, Munich 2307; see Beazley 1963, vol. 1, p. 26,1.

Marsha Hill

Regarding *Kallainopoioi*: Notes on Hellenistic Faience

The Greek term for faience-producers was *kallainopoioi*, or turquoise-makers, signaling the blue color range associated with the material.[1] Indeed, Hellenistic faience exhibits a rich range of blues from robin's egg to cerulean, along with greens and other colors, inventive decoration of great beauty, new and larger forms, and new technology that make it yet another high point in the long history of the material. In this brief contribution, I describe the Hellenistic faience repertoire and offer a few observations stimulated by the chefs d'oeuvre that formed part of the exhibition "Pergamon and the Hellenistic Kingdoms of the Ancient World."

Egyptian Faience in the Centuries Preceding Alexander's Arrival

Tjehenet is the known term for Egyptian faience and is based on the root for shine or gleam, a term also applied to semiprecious stones such as turquoise.[2] It is a silica based ceramic with a generally white body to which color could be added through the self-glazing process or through application.[3] The material has limited plasticity, so that most pieces were formed in molds. In pharaonic periods, after molding most often in a single mold, further working took place through incision and inlay before a final firing. Faience existed in Egypt probably since the end of the sixth millennium B.C. and in pharaonic culture had magico-divine associations based on its color and shine, associations it held alongside semiprecious stones long before glass or other glazed materials came into being. It was very heavily reserved for temple and tomb uses across the spectrum of Egyptian society.[4] Traditionally, faience was glazed in a variety of blue shades, but the much beloved material

was always a magnet for creativity, as it is rich with inventive possibilities. Real tour-de-force creations were achieved throughout Egyptian history, in a range including large statuary to innovations in coloring.[5]

During the centuries preceding Alexander's arrival in Egypt, fine delicate matte faience objects in shades of turquoise to green to light blue and relief decorated flasks typify seventh to sixth century production in the country. Simultaneously, alongside production in Egypt at this time, faience was also made in Cyprus and Rhodes and perhaps elsewhere.[6] During the ensuing Persian Period, when it was a Persian satrapy, Egypt continued to produce fine faience, but for one hundred years, there was also a great stylistic internationalism. A number of magnificent creations in faience, employing new techniques, are known from that time, but it is no longer evident where they were being produced, whether in Egypt, in the Levant, or in the Achaemenid capitals, where a long tradition of faience and glazed brickwork existed.[7] Certainly, there were some movements of artists who both drew from and reinvigorated local industries in response to new patrons. Thereafter, the Egyptian tradition continued to be strong in the fourth century, when consummate control of age-old skills of color inlay in faience are represented by large tiles forming the names of Nectanebo II (360–343 B.C.), whose Persian conquerors were deposed in Egypt by Alexander in 332 B.C. The smaller Mediterranean industries seem to have disappeared from the scene before the Ptolemaic period, as there are no traces of production after the fourth century.[8]

While Hellenism as an attitude and a style coalesced with the time of Alexander, ample evidence in Egypt of a

growing international population was already apparent long before that. Land reclamation and settlement of the western Delta began in the Third Intermediate Period (1070–664 B.C.), and the area became newly prominent with the capital of Dynasty 26 at Sais from 664 B.C. From the seventh century B.C., Egyptian rulers encouraged a flourishing Mediterranean trade involving Greeks from many islands and city-states: the coastal cities Canopus and Thonis / Heracleion, with large immigrant and merchant populations, served as gateways for trade down the westernmost Canopic Nile branch to the Egyptian and Greek trade city Naukratis near the capital at Sais and onward to the great city of Memphis, where Greeks, Cypriots, Carians, and Near Easterners formed enclaves within the country's capital. Conflict with the imperial powers of Assyria and then Persia in the Near East dominated the same centuries, and the Egyptians relied on Greek alliances and troops to help fight their expansion. And Egypt experienced heavy engagement with the Achaemenid empire for over two centuries, for more than a century of that actually under the rule of a Persian satrap, thus absorbing the same Achaemenid influences that also underlie some Hellenistic developments. In many ways, Egypt was primed for the reception of Hellenism.

But before undertaking a brief view of Hellenistic faience, one area of its production offers a cautionary tale. It exposes as thoroughly Egyptian a faience style and type that has long been termed Greek, at least by Egyptologists, and at the same time, brings attention to an important modern project in the study of Egyptian-Greek interaction *and* in the study of Late Period through early Ptolemaic Egypt.

Naukratis, excavated over a century ago, is being reexamined: the scattered finds are being gathered, their records reconstituted, and the material studied by an interdisciplinary team of experts; questions are being pursued with targeted fieldwork, and the results are thoroughly presented in an ongoing web-based research publication by the British Museum.[9] In addition to the record of Egyptian and Greek coexistence and the gradual and selective processes of interaction that the project illuminates, the Naukratis review has provided a sounding of the art of the Egyptians and the various Greek city-states resident there from the seventh through the second century B.C. It has also clarified an indigenous Egyptian informal style and subject group manifested in figurines, often termed "erotic

FIG. 1. Macrophallic figure, Egyptian, 6th-4th century B.C. Faience, h. 1⅞ in. (4.7 cm). The Metropolitan Museum of Art, New York, Theodore M. Davis Collection, Bequest of Theodore M. Davis, 1915 (30.8.163)

figures," extant since at least the sixth century B.C. but insufficiently attended to by Egyptology (fig. 1).

For generations, Egyptian studies have attributed these erotic figures to Greek and Hellenistic influence, if they were mentioned at all; the dates were not secure; the style seemed unaware of Egyptian formal style; and the subject matter seemed, or was wished to be, foreign.[10] However, there are now plenty of supporting indications from across the Nile Delta and from Memphis that this is a style and subject matter with indigenous roots that first appeared much earlier than the Hellenistic period. Naukratis, with its very long time span and its flood of results that are now being carefully analyzed, brings this fact into focus.[11]

The style and subject group exists across materials, mainly local limestone and terracotta figurines at Naukratis

itself but also faience elsewhere, and is especially popular across the Egyptian Delta and in Memphis. The figures seem to be connected with great Egyptian mythic festival cycles about the rebirth of the sun child from a great goddess and with a nurse who had been enticed back from a distant land to enable this continuity: an ithyphallic youth (the child god) and his attendants who are priests appear among the figures, as do a nude goddess (alternatively the child's mother or his partner) and her attendants, and extravagant couplings among parties take place. Bes as the protector of the sun god was everywhere. First millennium Egypt saw a huge surge in the imagery that can be related to such myths and associated festivals, and indeed, there is growing consideration of the possibility that widespread sexual revels actually took place at these festivals, as Herodotus described having seen in the area of Bubastis in the eastern Delta.[12]

So, these are forms that used to be thought Hellenistic in origin by Egyptologists but are now understood as having long indigenous roots, but they are also of interest as a stratum of small arts that represents one way Egyptian art looked at the period. They raise awareness of certain artistic strata incorporating plasticity associated with movement, interactive figures, and attention to festivals/music/dance, zones in which connections might be facilitated. Some of the festival type figures, including the ithyphallic individuals and animated Bes-images, occur as motifs on decorated vessels, as discussed further below.

Shifting to Hellenistic Production

At the same time that Naukratis clarifies the Egyptian origins of the erotic style figurines it also offers a view of the precocious use in Egyptian-style terracotta figure production of techniques that were adopted from Greek-style figurine makers and that were eventually associated with Hellenistic faience production in Egypt.[13] We have to envision that Egyptians were working on limestone and terracotta items such as those already characterized not far from Greek coropolasts working on their own sorts of production and that they seamlessly acquired some of these technological changes in interactions within communities of artisans.

With the arrival of the Ptolemaic period, distinctive Hellenistic faience can be characterized by the employment of multiple molds and new forms. Surely there had been and continued to be workshops throughout Egypt for the production of pharaonic-style small amulets and figures, but for the new more elaborate Hellenistic pieces, discussed in further detail below, only three production locales have been identified: Alexandria by the pure density of the faience finds;[14] Memphis by likelihood, as investigation of a Roman production site reveals evidence for earlier activity;[15] and Athribis by archaeology.[16]

Suggestions have been made that the increasingly close association of faience makers, coroplasts, and pottery makers at this time might have led to the addition of clay to Hellenistic faience to improve its workability, but this is not proven, and the most recent considered opinion is that this probably did not happen.[17] On the other hand, it is the case, on the basis of the careful analysis of finds at Athribis, that saggars, pottery receptacles in which numerous faience vessels could be stacked for firing, were already in use in the Ptolemaic period.[18] Saggars are best known as a means of facilitating mass production from Roman pottery technology, but they also protect the ware and stabilize and standardize the kiln environment for the items being produced.

The Hellenistic Faience Repertoire

Regarding the actual faience production of the period, Marie-Dominique Nenna divides vessel production into four useful categories: simply glazed works, examples with marbled paste or marbled glazes, vases with appliqués, and vessels decorated in superimposed or concentric zones.[19] Plastic or specialty vases and statuary are additional areas of production.

The first two categories are not discussed in this essay, except to note that the function of simply glazed vessels expanded from traditional ritual and funerary purposes to include household wares in the Ptolemaic period.[20] This was the beginning of the loss of the functional distinction of faience, and by the Roman period, faience was used very heavily for household wares.

Vessels with Appliqués

Vases with appliqués are best known through the more than 250 examples with figures of Ptolemaic queens that are attested by fragments, 90 percent of them from Alexandria, the remainder from other sites in Egypt and distributed about the Mediterranean, especially at sites connected with the Ptolemies.[21] The complete oinochoai (wine jugs) were vessels about 30 centimeters in height that were associated

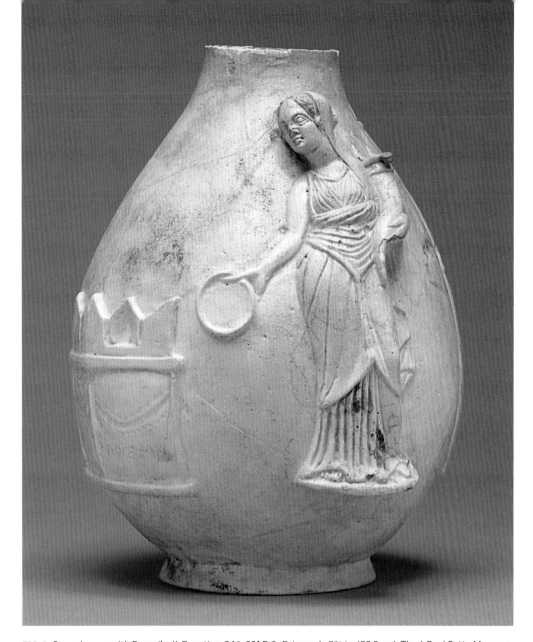

FIG. 2. Queen's vase with Berenike II, Egyptian, 246–221 B.C., Faience, h. 8¾ in. (22.2 cm). The J. Paul Getty Museum, Malibu (96.AI.58)

with the royal cult and surely emphasized the Ptolemaic queen's identification with the Egyptian goddess Isis.[22] The vases might have been distributed or purchased for use at festivals connected with the royal family, and they surely also had domestic and funerary uses, since a number of examples were found in household areas and cemeteries in Alexandria. Adoption of the Egyptian material for this Ptolemaic ritual vessel is an acknowledgment of the symbolic stature of the medium in Egyptian culture.

A Getty vase (fig. 2) illustrates the figure of the queen pouring a libation from a *phiale* at an altar with a pillar standing behind her, a scene suggesting that underworld gods are addressed.[23] The queen holds the cornucopia adopted by Ptolemaic queens; the contents in both works illustrated here are sheaves of wheat, rather indistinct cakes, and a bunch of grapes spilling from the mouth of the horn that are missing but are indicated by the break surface at the horn's rim.

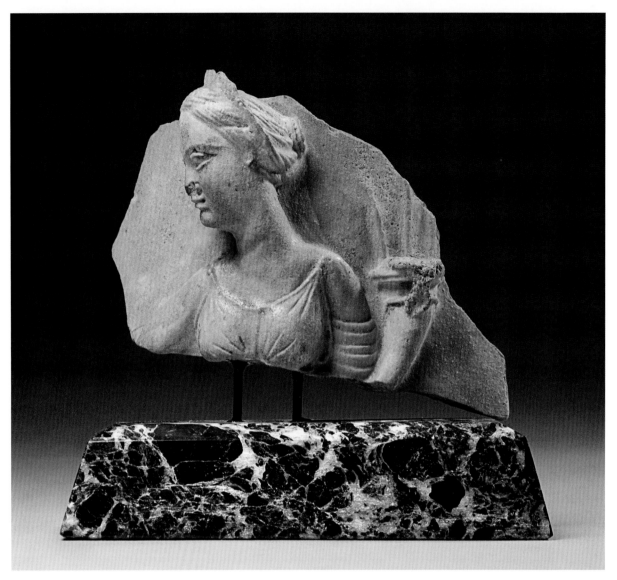

FIG. 3. Fragment of Queen's vase attributed to Berenike II, Egyptian, 246–221 B.C. Faience, h. 1¹⁵⁄₁₆ in. (5 cm). Collection of Nanette B. Kelekian

The vessel type extends from Arsinoe II in the first half of the third century B.C. until the mid-to-late second century B.C. The Getty vase bears the name of Queen Berenike II (246–221 B.C.), and the smaller unpublished fragment in a private collection almost certainly also represents Berenike II (fig. 3). As a result of the queen's relatively long reign, the vases depict her in different styles, which have been attributed to her early, middle, and mature reign.[24] The Getty queen with her round face and wearing the himation drawn up over her hair departs from the style of the group that has been set into a sequence, but other features point to its date in the middle reign of Berenike.[25] The private collection fragment depicts the queen in what has been termed the mature style, wearing the *stephane* that the Ptolemaic queens adopted from Greek goddesses. The fine lines of the portrait of the mature woman survive unblurred; the fleshy neck is delicately treated. The hair on both images retains traces of an applied dark blue cobalt glaze that pooled in the carved interstices to create a contrasting lighter covering on heights and darker in depths.

Other types of vases with appliqués include pieces with emblemata: heads of rulers, Alexander, or Dionysus with

FIG. 4. Shallow bowl with relief decoration on interior and exterior, Egyptian, from Athribis, 2nd half of the 3rd century B.C. Faience, diam. 7¼ in. (18.5 cm). Welc 2014, 90, Bowl 2

whom the Ptolemies emphasized their association.[26] These are based on metal Persian or Greek prototypes and are quite unanticipated in Egypt, where the bust form, in what is termed by scholars of ancient Egypt the aegis form, is well known but is not usually incorporated as part of a vessel.

Rarely preserved except in fragments are large closed vessels assembled from several molds, where the mold-lines serve as ground lines for elaborate appliqué scenes.[27]

Decorated Vessels

Faience vessels on which every void is filled with concentric relief decoration are famed Hellenistic products. The decoration was created with plaster molds, unlike Egyptian Third Intermediate Period relief chalices, which were carved before final firing, and the repertoire includes, for

instance, Nilotic decoration, Bes figures, griffins, garlands, and wave patterns. Forms are generally open, ranging from bowls to rhyta.

Richly imagined decoration characterizes bowls from debris areas associated with a third century workshop at Athribis.[28] One shallow bowl has vegetal decoration on the exterior. The interior (fig. 4) centers on a spikey floral element, and three figural registers are topped by a wave pattern; from the innermost ring outward, griffins alternate with palmettes, blanketed elephants parade in file, and figures from griffins to gazelles and warriors to (in a fragment not included in this figure) centaurs engage in combat. Elephants, apparently African, are rare on faience vessels and are thought to originate in the Ptolemaic kings' strategy of employing these behemoths in battle.[29] Hunting and combat

FIG. 5. Shallow bowl with relief decoration on interior and exterior, Egyptian, 1st half of the 2nd century B.C. Faience, diam. 6⅝ in. (16.9 cm). The Metropolitan Museum of Art, New York, Purchase, Lila Acheson Wallace Gift, 1988 (1988.18)

friezes draw on newly arrived artistic ideas in combination with the long format of hunt scenes in nature derived from much earlier Egyptian tombs that were still visible.

The Athribis vessels are decorated with two-tone glazes, a darker and a lighter color, probably created by differential pooling, although other techniques have been noted too.[30] In the case of a remarkably vivid bowl (fig. 5), the second color was actually inlaid, and the glazing took place by efflorescence during firing, reprising the age-old Egyptian virtuoso technique.[31]

Plastic Vases

Remarkable plastic vessels were created: rhyta with dolphin or boar-head foreparts, elephant vases, and extravagant Bes vases, among others. [32]

The charming Baltimore duck vase, with its almost naturalistic coloring and three-dimensionally rendered raised wing-tips, relates to several other faience fowl vases, offering a snapshot of a type with its variations (fig. 6).[33] A second vase, which is in the Louvre, appears very similar to the Baltimore duck, even to the unusual half-rosette markings beside the tail (fig. 7).[34] Both vases have a small

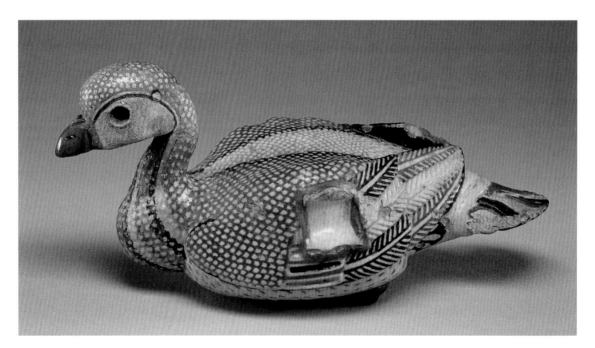

FIG. 6. Vessel in the shape of a duck, Egyptian, Ptolemaic period, 305–30 B.C. Faience, l. 7⅛ in. (18 cm). The Walters Art Museum, Baltimore (48.421)

hole on the back above the tail between the wing tips. The feather and coloration patterns are not exactly the same, however, and the colors of the Louvre vase are, at least as preserved, more muted. A third vase, in Athens, has been known only in a very old drawing depicting the duck raising its wings and pulling back its small head.[35] A new drawing based on photographs (fig. 8) shows a hole on its back between the wing tips and a smaller hole on its breast. The body pattern is related to the examples just discussed, but otherwise, the surface is quite worn, making the treatment hard to judge. A fourth vessel, which is in the British Museum, shows what is apparently a goose, which with its slightly longer neck lifts and turns its head back toward a riding Eros leaning against a mouth and neck placed in the center of its back, while a second opening is found on the front of the bird's body.[36] In contrast to the bird's elegant torque, the pattern of its brown and white breast and upper wing feathers is ornamental rather than natural, and its wings are only represented in drawing on the body. All but the Athens vase had a large ring handle.

It has been suggested that all four vases had Eros-riders, but it is difficult to understand why the Baltimore and

FIG. 8. Drawing of vessel in the shape of a duck, Egyptian, Ptolemaic period, 305–30 B.C. Faience, l. 5¾ in. (15 cm). National Archaeological Museum, Athens, 2637

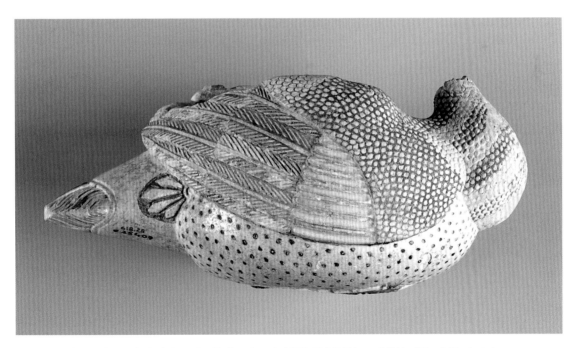

FIG. 7. Vessel in the shape of a duck, Egyptian, Ptolemaic period, 305–30 B.C. Faience, l. 7½ in. (19 cm). Musée du Louvre, Paris, E 25407

Louvre vases show no surface disturbance where the Eros might have been attached, and the Athens vase simply cannot be judged.[37] Ducks and duck vessels are subjects in both Egyptian and Greek cultures, although here, the vessel type and the theme seem firmly Greek. On the other hand, the verisimilitude of the color of the Baltimore vase with green, yellow, white, brown, and blue, and, more particularly, the dotted or dashed areas on the underbodies of at least the Baltimore, Louvre, and British Museum examples to indicate more lightly feathered spans, are very much in the long tradition of the Egyptian representation of birds.[38] More strikingly than most of the appliqué or decorated vessels, this group speaks about the continuity of certain Egyptian artistic techniques.

Statuary

Although the subject of Ptolemaic faience statuary is too large and diverse to be covered in detail in a brief essay such as this one, it should be mentioned. Small statuary of Egyptian gods continued to be made and, gradually also Egyptian gods in more Hellenistic form. Greek gods did not appear frequently in faience, except perhaps Aphrodite, who was rather closely identified with Isis-Hathor.[39]

Small-scale depictions of rulers in faience, glazed steatite, or Egyptian blue are known in pharaonic periods,[40] and their poses, when preserved, generally indicate that they suited, like metal statuary, ritual roles in divine temples. Metal and faience statuary continued to be made in the Ptolemaic period in the Egyptian style, and some certainly served the same purposes. But a number of small faience heads in Greek style of male and female rulers that were certainly not emblemata presumably fit statuettes that served in some way in Ptolemaic ruler cults much as the queen's vases did, their material embodying a reference to a sacred purpose.[41]

In conclusion, archaeology in Alexandria and the push for archaeological investigation in the Egyptian Delta in the last thirty to forty years have brought new information about Late Period and Ptolemaic sites, about settlements and settlement patterns. A modern focus on technology has enriched our understanding. Review and selective re-excavation of older projects have likewise been immensely fruitful. Hopefully, this work can continue, bringing new understanding of the complex currents in artistic and craft production in the Hellenistic era.

Acknowledgments

I would like to acknowledge the extent to which Marie-Dominique Nenna's work has been my guide in this brief contribution. I am grateful to my colleagues in the Greek and Roman Art Department for asking me to participate in the highly rewarding symposium accompanying the exhibition. Professor Karol Myśliwiec of the Polish Center of Mediterranean Archaeology and lead excavator at Athribis kindly gave his permission to use figure 4. Geneviève Pierrat-Bonnefois, Musée du Louvre, Paris, and Eleni Tourna, National Archaeological Museum, Athens, provided information and images of objects in their care, for which I am very grateful.

1. Nenna 2005, p. 165.
2. Conveniently Nicholson 2013, p. 18.
3. A cementation practice was also used especially for beads. Ibid., pp. 15–21, gives a useful summary of the origins and earlier technological history of faience.
4. Patch 1998.
5. Recent survey exhibitions include Friedman 1998; Busz and Gercke 1999; and Caubet and Pierrat-Bonnefois 2005.
6. For an Archaic Greek faience vessel attributed to a Rhodian workshop, see The Metropolitan Museum of Art, New York, 1996.164, illustrated on the Museum's collection online database. Other East Greek Archaic faience vessels in the shape of hedgehogs (41.162.90, 41.162.121) and aryballoi (33.11.1, .2) can be seen in the Met's collection.
7. Fontan and Le Meaux 2005; Pierrat-Bonnefois 2005; Caubet 2009.
8. Nenna 2006, p. 199. The question of the existence of faience workshops outside Egypt during the Hellenistic Period is not entirely resolved. The white faience alabastron in the J. Paul Getty Museum, Malibu, 88.AI.135 (see Alexis Belis in Picón and Hemingway 2016, pp. 230–31, no. 165), has been pointed out, along with a few other pieces, as atypical for Egyptian production. Nenna (2014, pp. 355–56) comments that it is difficult to be categorical about whether this piece and a few others she names in public and private collections were made in Asia Minor or Egypt. Perhaps there are clues yet to be discovered that will once again partially decenter faience production.

9. Villing 2017. Metropolitan Museum, New York, 1972.118.142, is also attributed to a Naukratis faience workshop.

10. Thomas 2017a, pp. 4–6.

11. Ibid.

12. Herodotus, *The Histories*, 2.60.

13. Thomas 2017a, p. 78; Thomas 2017b, p. 3. Certain suggested connections remain disputed; see Nicholson 2013, p. 19.

14. Nenna and Seif El-Din 2000, pp. 4–5.

15. Nicholson 2013, p. 147.

16. Welc 2014, pp. 47–53.

17. Nicholson 2013, p. 135.

18. Welc 2014, pp. 47–48.

19. Nenna 2005, p. 165.

20. Ibid., pp. 165–67.

21. Ibid., p. 167; Thompson 1973 is the definitive study.

22. Thompson 1973, pp. 117–22; Nenna 2005, p. 167.

23. David Saunders in Picón and Hemingway 2016, pp. 228–29, no. 162.

24. Thompson 1973, pp. 84–87.

25. The face bears some resemblance to a fragment in the Kunsthistorisches Museum, Vienna, V 2019, which Thompson (1973, p. 143, no. 58) considers strongly Egyptianizing unlike most of the series and suggests might date to the late third century. The vase in the J. Paul Getty Museum, 96.AI.58, actually bears the name of Berenike, however, and has other features that belong squarely mid-reign or later of Berenike, as analyzed by Arielle P. Kozloff in Friedman 1998, p. 200.

26. E.g., Metropolitan Museum, New York, 1981.450, 2000.308.

27. Nenna and Seif El-Din 2000, especially pp. 277–83, 292–94, nos. T7.3, T8.2c, figs. 36–42; see Nenna 2014, pp. 355–56, fig. 7a, b, for a large and complex piece seen on the art market.

28. Welc 2014, pp. 71–122, for relief decorated bowl type B1 and especially bowls on pp. 84–93, nos. 1–3. The bowl discussed here is ibid., pp. 88–91, no. 2.

29. Ibid., pp. 76–78, for elephants; ibid., pp. 79–80, for hunting scenes.

30. Ibid., p. 64. Mao 2000 reports the glazing technique for the Baltimore rhyton (see Marden Fitzpatrick Nichols in Picón and Hemingway 2016, p. 230, no. 164) involved application of a dark glaze, which was then wiped away from raised surfaces, followed by the application of an overall transparent glaze of the desired lighter color.

31. Arnold 1987; Wypyski 1998.

32. Nenna and Seif El-Din 2000, pp. 245–48; ibid., pp. 247–48, no. 270, pl. 46, is the forepart of a rhyton, which consists of a dolphin clenched in the arms and legs of a satyr who is followed by a frog; the mouth of the satyr forms the mouth of the vase.

33. Reeder 1988, p. 208; Marden Fitzpatrick Nichols in Picón and Hemingway 2016, p. 229, no. 163. The vessel was purchased from Dikran Kelekian in 1926. Nenna and Seif El-Din 2000, pp. 299–303, lists plastic vases. On ibid., pp. 300–301, among those specific animals, she adds to the examples discussed here: a duck with folded wings in the Egyptian Museum, Cairo, JE 37663, from Oxyrhynchos, and the tail of a duck with crossed wing tips in the Greco-Roman Museum, Alexandria, P.14047 (see ibid., p. 300, no. 421, pl. 61). See also the faience head of a duck, in the Metropolitan Museum, New York, 1997.292; conveniently referred to here as ducks, in fact, different types of fowl may be depicted (Geneviève Pierrat-Bonnefois, personal communication).

34. Nenna 2005, pp. 168, 170–71. The vessel in the Musée du Louvre, Paris, E 25407, was purchased on the art market in 1955.

35. National Archaeological Museum, Athens, 2637, acquired in 1880 with the Ioannis Dimitriou collection, 6 in. (15 cm). I am grateful to Eleni Tourna, curator of the Egyptian collection, for information and photographs.

36. British Museum, London, GR.1875.11-10.2; see Parlasca 1976, pp. 140–41, discussing the vase and the accompanying one found at Tanagra in the context of other exported Ptolemaic faience.

37. Nenna 2005, p. 168; see Lunsingh Schuerleer 1988 for an Eros he supposes might have sat upon such a vase.

38. There is a long tradition of naturalistic coloring of fowl in Egyptian painting; ducks and geese come up especially frequently, seen in both marsh and offering scenes. For paintings involving greens, yellows, blues, and/or dots or dashes, signifying the lighter or sparser belly feathers, note two offering fowl on the Middle Kingdom coffin of Djehutynakht (Museum of Fine Arts, Boston, 20.1822), ducks flying overhead in ceiling paintings from the New Kingdom palace paintings from Malqata (Metropolitan Museum, New York, 12.180.258) and Amarna, and ducks and ducklings as offerings in the fourth-century B.C. Tomb of Petosiris (see Cherpion, Corteggiani, and Gout 2007, p. 136). For three-dimensional faience examples with naturalistic coloring, see a small example dated to the New Kingdom in the Musée du Louvre, Paris, E 10857 (see Friedman 1998, pp. 128, 219); a faience vessel of a plucked duck in the Museum of Fine Arts, Boston, 1996,108, dated to the late Third Intermediate Period or Late Period, has the stray feathers marked by dashes (see Friedman 1998, pp. 116, 215).

39. Seif El-Din and Nenna 1994.

40. Perdu 2002, pp. 158–61, provides a list of pre-Ptolemaic first millennium royal and private faience (and related vitreous-material) sculptures.

41. Thompson 1973, pp. 199–205, includes a few heads from statuettes.

Christopher S. Lightfoot
Hellenistic Glass: All That Glitters Is Not Gold

The Hellenistic glass industry was the result of the union of two divergent traditions—one associated with Classical Greece and the making of core-formed vessels, and the other belonging to the Achaemenid royal court, for which tableware made of cast and cut glass was produced.[1] This essay highlights some of the important questions that remain unanswered with regard to Hellenistic glass.[2] The problem turns largely on the fact that Hellenistic glass is relatively rare—the fine tableware can be considered certainly as a luxury item—and many of the surviving examples are either stand-alone pieces such as the gold-glass bowl from Tresilico (essay on pp. 177–85) or come from problematic assemblages such as the Canosa Group or the finds from the Antikythera shipwreck.[3]

The only well-dated colorless cast vessels known in the Greek world from the Classical period are small utilitarian objects, stands used to support core-formed amphoriskoi. Examples are known principally from Rhodes, but their place of production is uncertain.[4] Contemporary luxury glass tableware was inspired by Persian vessels in gold, silver, semiprecious stone, and especially rock crystal, which could be closely imitated in colorless glass. There was some considerable variety in shapes, and there may have been several production centers, including Rhodes and Macedon.[5] Core-formed glass, on the other hand, was restricted to a limited number of containers imitating the shapes of Greek vases. It was popular throughout the Mediterranean world,

FIG. 1. Oinochoe (jug). Hellenistic, mid-4th–early 3rd century B.C. Core-formed glass, h. 7¹¹/₁₆ in. (19.6 cm). The Metropolitan Museum of Art, New York, Gift of Renée E. and Robert A. Belfer, 2012 (2012.479.7)

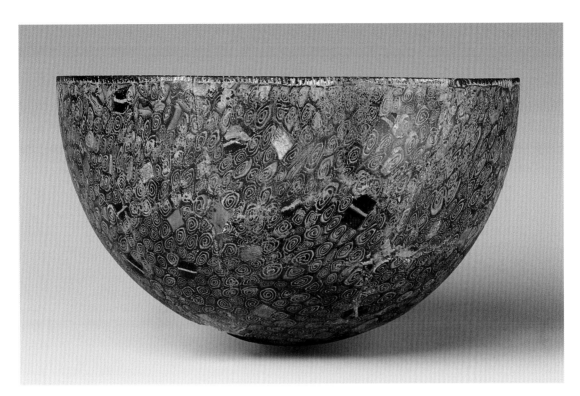

FIG. 2. Hemispherical bowl. Hellenistic, early 2nd century B.C. Mosaic gold-glass, cast, diam. 6½ in. (16.5 cm). The Metropolitan Museum of Art, New York, Gift of J. Pierpont Morgan, 1917 (17.194.281)

and Rhodes was a major but not the only producer. The industry flourished from the Archaic period until the end of the Hellenistic period (mid-sixth through late first century B.C.). But, until the end of the fifth century B.C., the vessels were small in size, and it was only during the late Classical and Hellenistic periods that glass alabastra, oinochoai, and amphoriskoi were made in more expansive sizes and more exuberant styles of decoration (fig. 1).[6] Generally, the core-formed industry changed very little until it was superseded by the Roman blown glass industry in about the time of Augustus (r. 27 B.C.–A.D. 14).

By contrast, the development of a Hellenistic cast glass industry, making principally tablewares for use and display at parties, led to the introduction of several important innovations that enhanced the appeal and value of glass vessels. The first and most significant was the introduction of decolorized glass for making vessels in the "Achaemenid style," a term that has been used to refer to both shape and decoration.[7] Another innovation, foreshadowed to some extent by the creation of inlays, was the use of gold glass, a technique that involved placing gold foil between two layers of colorless glass.[8] The gold foil was worked with a sharp tool in order to reveal a design, usually floral or geometric, within the glass, imitating the gilding applied to the relief decoration on silver bowls.[9] The most striking and unusual addition was the introduction of figures to the decorative scheme.[10] The small gold-leaf bowl illustrated on page 178, found in a tomb at Tresilico in Calabria, is unique, and its figural decoration probably owed much to paintings, vases, or gilded silver vessels.

Another advance was the reintroduction of mosaic glass making. The technique had been used first in Mesopotamia and Egypt during the Late Bronze Age, but now it reappeared in new and striking applications. Mosaic glass was principally made of small, brightly colored canes in star or spiral patterns, but sometimes including monochrome or gold-glass segments (fig. 2).[11] Other types include a design known as network or *reticella,* in which trails of colorless or translucent glass containing twisted opaque threads are coiled around in a spiral or, later, in

FIG. 3. Two network mosaic bowls with base ring. Hellenistic, mid-1st century B.C. Glass, cast. Left: diam. 3¼ in. (8.3 cm). The Metropolitan Museum of Art, New York, Gift of J. Pierpont Morgan, 1917 (17.194.263). Right: diam. 3⅞ in. (9.8 cm). The Metropolitan Museum of Art, New York, Gift of J. Pierpont Morgan, 1917 (17.194.560)

strips (fig. 3).[12] The inspiration for this novel form of decoration remains unclear, but similar twisted threads were frequently added to the rims of other mosaic vessels (fig. 2). Another way to enhance the glass was to make it either in a deep translucent color or in striking bands of colored and colorless glass.[13] Fusing differently colored glass together required considerable technical skill. These are the principal innovations that the glassworkers employed while the glass was still hot.

In addition, other craftsmen worked the vessels once they had cooled and hardened, providing the surfaces with cut or painted decoration. They borrowed the carving technique from Achaemenid glassware and copied it so successfully that, in some cases, it is now impossible to decide whether an individual piece was made before or after the fall of the Persian Empire in 331 B.C. The principal form of decoration was a floral pattern of radiating petals that covered much of the underside of the vessel. Vegetal designs remained popular throughout the Hellenistic period (fig. 4).[14] Among the most accomplished examples are the broad finned bowls from Canosa in Italy and Xanthos in Lycia (modern Turkey).[15] They can be regarded as combining Persian and Greek elements. Although no Hellenistic glass rhyta have survived, their existence is recorded, and a fragmentary example found at Persepolis in 1959 provides an Achaemenid prototype.[16] A cup with a lion protome belongs to the same class of eastern glassware.[17] Dated to the late Hellenistic period (second half of the second century B.C. or later), a unique bowl covered with horizontal grooved decoration found on the Aegean island of Kalymnos has been seen as "a direct reflection of Achaemenid metalwork."[18] So, it could be argued that Persian influence on Hellenistic glass was subtle, persuasive, and enduring.

Other cut designs, however, echo those used exclusively to decorate Greek pottery and silverware. For example, there are cast hemispherical glass bowls with cut decoration in a geometric pattern of pentagons and hexagons.[19] In the Pergamon exhibition at the Metropolitan, there were examples of similar terracotta and silver bowls.[20] Surface painting or enameling was also introduced, and it may be assumed that in that case, the glass was intended

FIG. 4. Bowl. Hellenistic, late 4th century B.C. Glass, cast and cut, diam. 5¹⁵/₁₆ in. (15.1 cm). The Metropolitan Museum of Art, New York, Gift of Henry G. Marquand, 1881 (81.10.34)

largely for display or presentation rather than for use. Marianne Stern has argued that lidded bowls decorated with gilding and painted designs were made in northern Greece, "probably in Macedonia," and form some of the earliest examples of this type.[21] Other scholars have suggested an eastern (Alexandrine) origin or an Italian (Campanian) production center.[22] Unfortunately, the painted decoration is in most cases poorly preserved; vegetal designs are again common, especially on the lids, but some appear to have harbor scenes with ships or depict buildings (sanctuaries?) in a rural setting with trees.[23] Figural scenes, however, are rare.[24]

The painted situla in the Metropolitan's collection provides another unusual example of Hellenistic glass.[25] In addition to its remarkable painted and gilded decoration, it is noteworthy as an example of how Hellenistic glassware adapted to the needs of the Greek symposium. Recently, other examples of glass that were adapted for use in the preparation and serving of wine have emerged with the identification of a three-part glass psykter in a tomb deposit of the late fourth or early third century B.C. in Aetolia in western Greece.[26] Glass lagynoi provide another example.[27] All three are novel adaptations of vessels more commonly made of terracotta or metal, highlighting the fact that Hellenistic workers introduced sophisticated and innovative items into the repertoire of cast glass. Drinking cups became a common component in glass tableware. Here, too, changes were made during the course of the Hellenistic period, drawing on Greek forms and traditions in terracotta and metal.[28] "Achaemenid style" cast glass cups and bowls lacked handles and bases, but the Greeks had long preferred drinking vessels that had handles and stood on a foot or base.[29] To produce such cast glass cups required considerable time, skill, and effort, since the handles were not applied as trails as in the case of handles on contemporary core-formed glass but applied probably as solid blocks to the sides of the vessel and then fashioned in the manner of stone or gem carving.[30] Many of these cups or skyphoi have ring handles. The example from Canosa is regarded as one of the earliest, but the type proved so popular that it persisted into Roman times.[31] There are three colorless examples in the Metropolitan (17.194.94,

FIG. 5. Two skyphoi. Hellenistic, 3rd–1st century B.C. Glass, cast and cut. Left: diam. 5¼ in. (13.3 cm). Gift of J. Pierpont Morgan, 1917 (17.194.888). Right: diam. 13¼ in. (33.7 cm). The Metropolitan Museum of Art, New York, Gift of Henry G. Marquand, 1881 (81.10.94)

17.194.888, 81.10.94); the last, of exceptional size measuring 13¼ in. (33.7 cm) in diameter, is said to be from Cumae, Italy (fig. 5, right).[32] They imitate vessels carved out of solid blocks of rock crystal. It may be noted that finger rings carved out of either rock crystal or glass blocks also first appear in Hellenistic times.[33] Maud Spaer, who noted an example found at Dor in present-day Israel, believed the Aegean region to be "the most likely place of origin" for such rings.[34]

The wide distribution of finds of luxury Hellenistic glass provides a topic for lively discussion. The famous Berlin amphora, for example, is said to have been found at Olbia on the north coast of the Black Sea, and the Canosa group, which figures large in the debate about Hellenistic glass, comes from southern Italy.[35] These disparate find-spots prove, if nothing else, that luxury glassware was scattered widely across the Hellenistic world. The question of where the Canosa group was produced remains unresolved, although other groups are attributed to Macedonia or Rhodes.[36] Certainly, the lack of evidence for glass working at Alexandria in Egypt has discouraged scholars from

attributing that location with a major role in the industry. Another argument is that few major pieces of Hellenistic glass have been found in Egypt.[37] Yet, objects such as the pectoral that featured in the Pergamon exhibition display such clear Egyptian characteristics that the existence of an Egyptian glass industry in Ptolemaic times cannot be denied.[38] Indeed, it has been proposed that cast mosaic glass vessels began to be produced in Alexandria at the end of the third century B.C.[39] The significance of Egyptian faience is not to be overlooked (essay by Hill, pp. 158–67), and it is worth remarking that tombs at Canosa furnished, in addition to glass, examples of hemispherical faience bowls decorated with similar floral and geometric designs.[40] Discussion of the production centers of Hellenistic glassware has thus focused on two of the successor kingdoms, the Antigonids in Macedon and the Ptolemies in Egypt, while the third, that of the Seleucids, whose empire stretched from Syria to Bactria, has largely been ignored. It is, however, inconceivable that luxury glass was not in demand there too even before the Seleucids occupied Ptolemaic Koile Syria and Palestine in

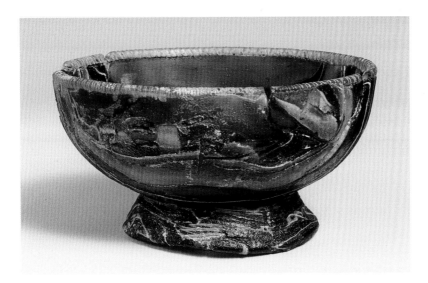

FIG. 6. Striped mosaic bowl with base ring. Hellenistic, early 1st century B.C. Glass, cast, diam. 3½ in. (8.9 cm). The Metropolitan Museum of Art, New York, H.O. Havemeyer Collection, Bequest of Mrs. H. O. Havemeyer, 1929 (29.100.86)

201 B.C.[41] Likewise, did the Attalids and other Hellenistic rulers not play a role in the creation and consumption of glass tableware? It is, however, reported that no luxury glassware has been found at Pergamon, and all the fragments of late Hellenistic cast bowls (including ribbed and mosaic examples) found during the excavations are regarded as imports.[42]

The dating of much Hellenistic glass is also problematic. The Canosa group, which is dated generally to the late third or early second century B.C., includes a large finned bowl similar to the one found on the Antikythera shipwreck, an event that is placed in about 70 B.C., some 100 to 150 years later.[43] It has been argued that the Canosa and Xanthos finned bowls are earlier and so are "ancestors" of a group including the Antikythera example that was made less carefully.[44] Even if so, it still means that styles did not change noticeably in more than a century. Likewise, the Antikythera finds include eight intact or fragmentary mosaic glass bowls with applied bases, comprising two forms—one with an upright rim and convex side, the other with a flaring rim and an S-shaped side. They display three types of construction and decoration—mosaic, network, and striped or "ribbon" glass (fig. 6).[45] The first two types can be found in the Canosa group, again providing evidence for a long tradition.[46] The striped mosaic example,

however, is unusual for Hellenistic glass and may be taken as a forerunner of the Roman use of such decoration.[47] Additionally, the applied base ring on these bowls is a feature that finds its closest parallel in the large jars such as the mosaic glass example in the British Museum, said to be from Tarquinia, central Italy.[48] The Metropolitan's exhibition featured another jar of the same form but decorated with a banded agate mosaic pattern.[49] This type of design is not represented in the Canosa group and may be seen as a later development, perhaps even inspired by rulers such as Mithridates VI of Pontus (r. 120–63 B.C.). He was a passionate collector of gems and precious-stone vessels that probably included various pieces in banded agate.[50] One of the most impressive glass examples is the large vase that was found, together with two others (one in banded mosaic, the other in colorless glass), in a mid-first century B.C. grave near Palaiokastro (ancient Metropolis), Thessaly.[51] It has been suggested that the occupant of the grave was an Italian immigrant.[52]

This raises the question of whether Hellenistic glass existed in Rome. The earliest Roman literary references to glass occur in the 60s B.C., and it was only in the Augustan period that glass seems to have become both fashionable and plentiful in the imperial city. But luxury glassware may have trickled into Rome for some time before that, as part

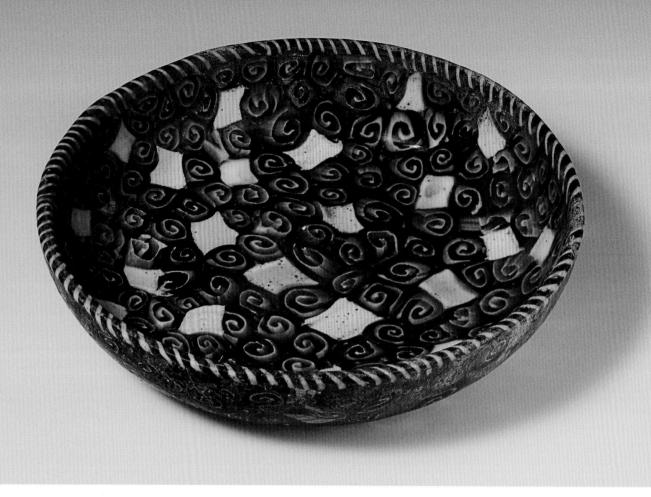

FIG. 7. Mosaic dish. Hellenistic, 2nd–1st century B.C. Glass, cast, diam. 5⅛ in. (13 cm). The Metropolitan Museum of Art, New York, Gift of Henry G. Marquand, 1881 (81.10.43)

of the trappings of the refined private, if not public, life enjoyed by the Republican elite in the second half of the second and first half of the first century B.C. Some evidence supports this view. First, there are vessels found in central Italy, such as the British Museum's mosaic jar from Tarquinia and two mosaic vessels in the Metropolitan that are said to be from the Roman Campagna (fig. 7).[53] As David Grose noted, Canosa itself (ancient Canusium) was in the sphere of Rome and its staunch ally throughout the Hellenistic period.[54] In addition, a few of the glass fragments reported to have been acquired in Rome principally during the second half of the nineteenth century have been identified as belonging to Hellenistic mosaic bowls.[55] They can be dated to the late second and the first century B.C.,

and this dating finds corroboration in the use of similar fragments in wall mosaics in Republican Italy.[56]

During the three centuries between the deaths of Alexander the Great (323 B.C.) and Queen Cleopatra VII of Egypt (30 B.C.), the ancient glass industry underwent marked changes, driven first by the example of Achaemenid luxury glass tableware and then by the desire to create attractive glass substitutes for contemporary vessels in metal, terracotta, and semiprecious stone. Under the Romans, the ancient glass industry was to be revolutionized by the invention of glassblowing, and as a result, glass became both ubiquitous and affordable. However, there remained a place for luxury glass, which owed a great deal to its Hellenistic predecessor.

1. I dedicate this essay to the memory of David F. Grose, who gave a paper on this very subject nearly forty years ago; see Grose 1981. This is not the place to discuss the question of cast glass before Alexander's conquest of the Persian Empire; for divergent views, see, for example, Grose 1989, pp. 80–81, and Ignatiadou 2013, p. 334. The term cast glass is used here to denote glass vessels made by a technique that was not core-forming and predated the invention of glass blowing. The precise details of how cast glass vessels were made remain the subject of much discussion and disagreement among glass scholars and practitioners, but the term as used here does not imply the use of a closed mold.

2. The illustrations for this essay have been chosen from the collection of Hellenistic cast glass in the Department of Greek and Roman Art at The Metropolitan Museum of Art, New York, which includes fifty-one intact or nearly complete vessels as well as numerous fragments. However, most of the glass that featured in the Museum's Pergamon show is also referred to in the text here.

3. Both assemblages were discussed at some length by Grose; see Grose 1981, pp. 63–66.

4. D. Harden 1981, pp. 84–85, 168, n. 82, nos. 191, 199; Triantafyllidis 2015, citing other examples, with references. Both mainland Greece and Rhodes have been suggested, but neither is convincing; Phoenicia, or Phoenicians, perhaps working in Rhodes, would be a more obvious choice.

5. Triantafyllidis 2003a, p. 15; Simpson 2005, p. 108.

6. The Metropolitan's extensive collection of core-formed glass includes several examples of larger vessels, measuring over 6 in. (15 cm) in height. There are eight alabastra: 81.10.295, 91.1.1362, 91.1.1386, 91.1.1392, 17.194.745, 17.194.789, 30.115.34, 30.115.36; three oinochoai: 91.1.1383, 17.194.601, 2012.479.7; and three amphoriskoi: 74.51.320, 17.194.594, 30.115.41. See Lightfoot 2016b, pp. 79–80, fig. 104.

7. Ignatiadou 2002b, pp. 64–65. For use of the term "Achaemenid style," see Stern 1999, pp. 25, 31–32, 34, figs. 5–7; Triantafyllidis 2000a, pp. 195–96; Ignatiadou 2002a, pp. 13, 15, figs. 3, 5; J. Jones 2002. Despina Ignatiadou has more recently preferred the term "Ionian type"; see Ignatiadou 2013, p. 325.

8. Some gold glass was also decorated with colored enamel that added details to the gold design, as in the case of a skyphos fragment in the Metropolitan, 23.160.76; see Oliver 1969; and Ignatiadou 2013, p. 161, no. 8.

9. See the British Museum, London, GR 1871,0518.2 (Dirk Booms in Picón and Hemingway 2016, p. 256, no. 195); and Museum of Art and Archaeology, University of Missouri-Columbia, 77.198 (Christopher S. Lightfoot in ibid., p. 256, no. 196). For Metropolitan Museum, 17.194.281, see Oliver 1968, p. 49, fig. 4.

10. Gold glass with figural decoration can be seen on furniture inlays and finger rings dated to the second half of the fourth century B.C.; see Stern 1999, p. 40, fig. 20; Ignatiadou 2002b, p. 66; and Ignatiadou 2013, pp. 189–93, 196, figs. 137–53.

11. British Museum, London, GR 1871,0518.3 (see Dirk Booms in Picón and Hemingway 2016, p. 258, no. 198); The Corning Museum of Glass, New York, 58.1.38, 55.1.2 (see Karol Wight in ibid., pp. 258–59, nos. 199, 200).

12. D. Harden 1968, p. 27, no. 6; Stern and Schlick-Nolte 1994, pp. 71–72. In the latter, their manufacture is associated with the use of a potter's wheel; see note 13 below.

13. Metropolitan Museum, New York, 17.194.2535 (see Christopher S. Lightfoot in Picón and Hemingway 2016, p. 262, no. 206); Corning Museum

of Glass, New York, 98.1.97 (see Karol Wight in ibid., p. 263, no. 207).

14. National Archaeological Museum, Athens, A 23712, which Christina Avronidaki (in Picón and Hemingway 2016, pp. 292–93, no. 239), described as "made by rotary pressing." Rosemarie Lierke was first to propose that cast glass was formed on a potter's wheel; see Lierke 1991. It is a theory that has been repeated often and so has gained wide acceptance. It has no basis in fact, but discussion of the subject merits more space than can be allowed here; see Whitehouse 2000, p. 2. For other examples with vegetal designs, see Nenna 1999, pp. 94–97, nos. C239–C257, pl. 30; and Triantafyllidis 2006a, pp. 153–54, 158–59, fig. 8.

15. D. Harden 1968, pp. 27–28, no. 7, figs. 20–22; De Juliis 1989, p. 449, nos. 40, 41; Lightfoot 1990, p. 86, with references, fig. 2; Tatton-Brown 2002, p. 92, fig. 3.

16. Attested in an Asklepieion inventory at Athens as a dedication between 268/267 and 245/244 B.C.; see Stern 1999, pp. 32–33; and Stern 2002, p. 354. For the fragmentary rhyton on display in the Tehran Archaeological Museum (as of October 2016), see Fukai 1977, p. 20, fig. 8; and Simpson 2005, pp. 107, 122, no. 121.

17. *Ancient Art from the Shumei Family Collection* 1996, pp. 60–61, 189, no. 25; Ignatiadou 2013, p. 104, fig. 60.

18. Triantafyllidis 2006b, p. 326.

19. Lightfoot 2016c, nos. 34–36. Fragments of another hemispherical bowl in green glass were found in the *tomba degli ori* at Canosa; see De Juliis 1989, p. 449, no. 48.

20. Antikensammlung, Staatliche Museen zu Berlin, 30854; see Hemingway 2016b, p. 86; and Sarah Japp in Picón and Hemingway 2016, p. 171, no. 86. A similar terracotta hemispherical bowl was excavated at Tarsus; see F. Jones 1950, p. 219, no. 113, fig. 125. From the Museo Regionale di Aidone, see Laura Maniscalco in Picón and Hemingway 2016, p. 241, no. 178. For additional detail about the silver example attributed to Morgantina, see Guzzo 2003, pp. 53–54, 80, no. 6, fig. 22. For other silver examples, see Carter 2015, pp. 172–75, 186–87, nos. 38, 43.

21. Stern 1999, pp. 46–50, figs. 22–24; see also Ignatiadou 2013, pp. 140–50.

22. Cavassa 2016, p. 37, nn. 81, 82, with references. There is also an "Achaemenid style" colorless dish in the British Museum, London, that is said to come from Cumae; see Oliver 1970, pp. 10–11, fig. 6; and Simpson 2005, p. 119, no. 114.

23. Stern and Schlick-Nolte 1994, pp. 262–67, nos. 69–70; Cavassa 2016, pp. 31–36, fig. 9.

24. Lightfoot 2016c, no. 33.

25. Metropolitan Museum, New York, 2000.277; see Lightfoot 2003, pp. 19–21, figs. 3–5; Ignatiadou 2013, pp. 107–8, fig. 66; and Christopher S. Lightfoot in Picón and Hemingway 2016, p. 255, no. 194.

26. Triantafyllidis 2003a, pp. 13–14; Triantafyllidis 2011, pp. 45, 49–50, 56–57, figs. 2–5.

27. Corning Museum of Glass, New York, 71.1.18; see Karol Wight in Picón and Hemingway 2016, p. 175, no. 95.

28. For metal and terracotta parallels for a glass kotyle found in a tomb at Thessaloniki, see Ignatiadou and Lambrothanassi 2013, pp. 28–29, fig. 4b–e. A glass kylix-kantharos from a tomb at Pydna, Macedonia, dated to ca. 300 B.C., is an early example of Hellenistic footed and handled drinking cups, and there are parallels for it in silver and pottery; see Ignatiadou 2000, pp. 36–38, fig. 5; Ignatiadou 2002a, p. 13, fig. 4; and Triantafyllidis 2003a, p. 13.

29. See, for example, Mertens 2010, p. 81, an Attic black-figure kylix (Metropolitan Museum, 56.171.34).

30. The glass kotyle is described as a "skyphos to which handles and a base have been attached"; see Ignatiadou and Lambrothanassi 2013, p. 25, figs. 2–4a. The handles were probably added but as shapeless blanks fused to the side of the vessel while still hot. Once it had cooled, the handles were then cut, ground, and polished to such an enormous extent that joins are difficult to discover and are now invisible to the naked eye. I wish to thank David Hill for clarification on this point in email correspondence from March 3, 2017.

31. Tatton-Brown 2002, p. 92, fig. 4. Another skyphos but with a low base ring in the Musée du Louvre, Paris, MNC 2200, is also from Canosa; see Arveiller-Dulong and Nenna 2000, p. 177, no. 208.

32. Froehner 1879, p. 138, pl. XIII, 77; Oliver 1967, pp. 30, 32, no. 3, fig. 25. Oliver states that "the [surviving] handle and ring base were added separately." This is more likely than that they were integral and carved out from the body. However, similar vessels in rock crystal and banded agate definitely had handles and bases carved from a single block of stone. In either case, it is clear that the handles were shaped by extensive carving once the glass had cooled. For similar skyphoi found in Turkey, see Lightfoot 1990, pp. 87–89, fig. 3.

33. "Hellenistische Glasfingerringe" in Haevernick 1981, pp. 198–203. For early Macedonian examples, see Ignatiadou 2002a, p. 21, fig. 10; and Ignatiadou 2013, pp. 186–88, nos. MR1–MR4.

34. Spaer 2001, p. 206, fig. 87.

35. Antikenmuseum, Berlin, 30219,254; see Platz-Horster 1995. For the Canosa group, which is scattered in different collections, see D. Harden 1968, pp. 21–31; and Stern 1994, pp. 97–99.

36. Stern 1994, p. 108; Triantafyllidis 2000b, pp. 31–32; Ignatiadou 2002a, p. 24.

37. Nenna 1999, p. 63, pl. 38. For fragments of mosaic hemispherical bowls from the Sciatbi necropolis, Alexandria, see Oliver 1968, p. 59, nos. 4–5.

38. Corning Museum of Glass, New York, 94.1.1; see Karol Wight in Picón and Hemingway 2016, p. 257, no. 197.

39. Nenna 2002, p. 154.

40. Grose 1989, p. 191, figs. 103, 104. A faience "Queen's Vase" was found at Xanthos, as I noted in my report on the glass finned bowl from the same site; see Lightfoot 1990, pp. 86–87, n. 10. Compare the Queen's Vase with Berenike II from the J. Paul Getty Museum, 96.AI.58; see David Saunders in Picón and Hemingway 2016, pp. 228–29, no. 162. It does not seem impossible that both were imported from Alexandria.

41. For the development of the Hellenistic glass industry in this region during the mid-second century B.C., see Grose 1989, p. 193; Grose 2012, pp. 1, 6–8, 24–50.

42. Agnes Schwarzmaier at the Pergamon symposium, June 21, 2016. See also Schwarzer and Rehren 2015, pp. 107–8, pls. 1.4–9.

43. National Archaeological Museum, Athens, A 23714; see Hemingway 2016b, pp. 88–89; and Seán Hemingway in Picón and Hemingway 2016, p. 292, no. 240.

44. Oliver 1968, pp. 54–55.

45. National Archaeological Museum, Athens, A 23723; see Christina Avronidaki in Picón and Hemingway 2016, pp. 292–93, no. 241.

46. Oliver 1968, p. 55.

47. Matheson 1980, p. 13, no. 38

48. British Museum, London, GR 1869.6-24.8; see Oliver 1968, pp. 57, 61, fig. 11; and Tatton-Brown 2002, p. 96, fig. 14. Donald Harden first noted these similarities; see D. Harden 1968, p. 42.

49. Metropolitan Museum, New York, 91.1.1303; see Christopher S. Lightfoot in Picón and Hemingway 2016, p. 260, no. 202.

50. Lightfoot 2016b, p. 81.

51. National Archaeological Museum, Athens, A 14261; see Weinberg 1992, pp. 23–25, 56–57, 97, 98, no. 48; and Christina Avronidaki in Picón and Hemingway 2016, p. 261, no. 204.

52. Zervoudaki 2002–3, pp. 55–58, 66–67.

53. Froehner 1879, p. 138, pl. III, 14, 15; Oliver 1968, pp. 62, 65, nos. 28, 3, figs. 23, 24, 26. Additionally, there is a fluted bowl found at Vulci, now in the Museo Nazionale Etrusco, Villa Guilia, Rome; see Weinberg 1961, p. 386, fig. 2, pl. 93, b.

54. Grose 1981, p. 62.

55. Lightfoot 2016a, p. 36.

56. Boschetti 2011, p. 76, fig. 23, showing a fragment of a network mosaic bowl used in the nymphaeum at Segni (Latium), dated to the first half of the second century B.C.[sic]. A late second or early first century B.C. date seems more probable for the building.

Christopher S. Lightfoot and Carmelo Malacrino

The Tresilico Sandwich Gold Glass Bowl

The bowl in the Museo Archeologico Nazionale, Reggio di Calabria (fig. 1) was found in 1904 in Tresilico at a place known as Chiese Cercate in the territory of Varapodio in the province of Reggio Calabria, near Oppido Mamertina.[1] It came from Tomb 8, which was one of eighteen tombs excavated by a local named Antonio Cananzi.[2] The tomb, measuring 1.8 meters in length, 0.58 meters in width, and 1.27 meters in height, was found intact, containing a single burial, probably of a woman. It was made of bricks with stamped tiles as the roof cover, a form of construction typical for Hellenistic tombs in the area.[3] The bowl was the only glass in the tomb and must have been a prized possession. The only other find of some value was a pair of gold earrings of a type found throughout the Hellenistic world and dated to late fourth–third century B.C.[4] These two objects were imports to southern Italy. All the other finds were more mundane and probably of local manufacture; they were two terracotta fusiform alabastra, typical of the third century B.C.;[5] two terracotta balsamaria with tripartite base, typical for the region;[6] fragments of a bronze mirror, decorated at the center with a six-petaled rosette within a circle;[7] a lead pyxis and lid;[8] an iron stylus, found near the left hand of the deceased;[9] a small bronze coin, now lost;[10] and a terracotta lamp, dated third–second century B.C.[11] Based on the evidence of the finds, the tomb has been dated to the first half of the third century.[12]

The Tresilico glass bowl has attracted much attention and has been published numerous times.[13] Its interest lies firstly in that it was made in the sandwich gold glass technique. This involved making two separate cast bowls that fit tightly together, one inside the other;[14] a layer of gold foil was applied on the exterior of the inner, smaller bowl, and then the two bowls were put together, leaving the gold decoration sealed within.[15] Secondly and, perhaps, more importantly, the bowl is the only surviving example of Hellenistic glass in the sandwich gold glass technique that has figural decoration. Most examples, as in the case of the two hemispherical bowls in the British Museum, show rich vegetal patterns.[16] There is, however, one notable exception that is worth mentioning here. It is a fragment (fig. 2) now in the Pushkin State Museum of Fine Arts, Moscow.[17] It depicts an Egyptian-style temple building, flanked to its right by a tall rectangular base on which there is the front half of a human-headed animal, identified as a sphinx. Two other columnar bases supporting hawk statues stand in front of the temple, and there is also a small reclining lion that appears to act as the base for one of the temple's columns. No human figures are visible, although they could have existed on the lower half of the scene that is enclosed by a circular line and wave pattern. The scene, however, was clearly quite different than the one on the Tresilico bowl, which has a hunting scene, set in a rural landscape. The main action shows a huntsman on a rearing horse; he thrusts a long spear at a leopard that turns to face its attacker. A tree to the right gives the impression of the woodland setting and at the same time fills the upper part of the tondo, where two birds with spread wings are also shown. Below the ground line, there is a secondary hunting scene, in which a diminutive figure, armed with bow and arrows, aims from cover at two leaping long-horned wild goats or antelopes, while a hare emerges from below. The last animal has also been identified as a hunting dog, but it

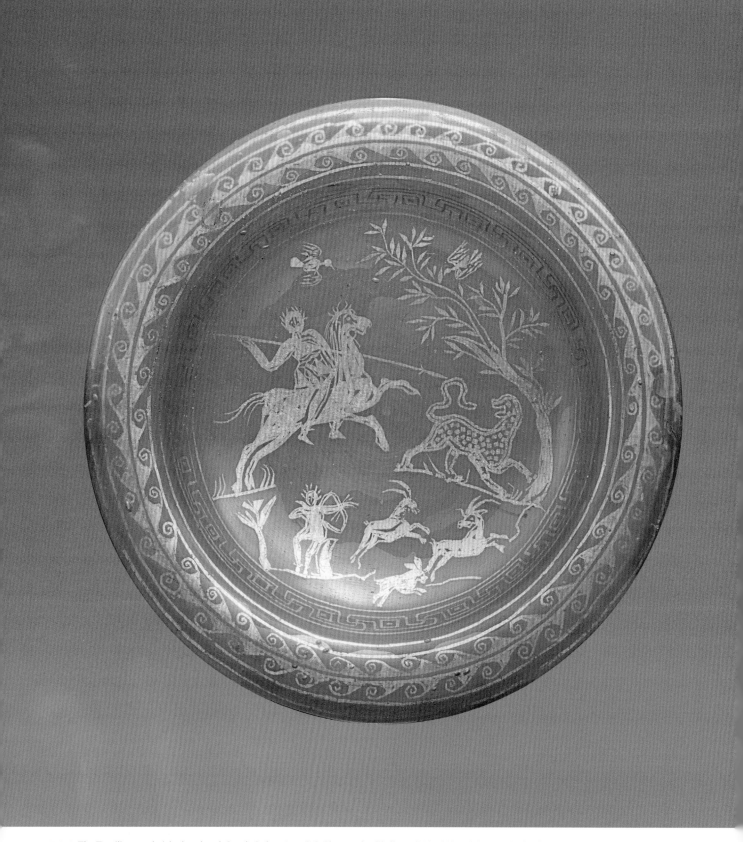

FIG. 1. The Tresilico sandwich glass bowl. Greek, 3rd century B.C. Glass and gold, diam. 6¼ in. (16 cm). Museo Archeologico Nazionale, Reggio di Calabria, 6171

FIG. 2. Sandwich glass fragment with Egyptian temple-style building. Hellenistic. Gold, h. 2⅜ in. (6 cm). Pushkin State Museum of Fine Arts, Moscow, I 1a 2648

has short legs, a stocky body, and long ears.[18] Additionally, if the animal were a dog, there would be the danger that the archer could shoot it by mistake. Among a group of blown, late Roman shallow bowls with cut decoration depicting various hunting scenes, there is an example found at Bonn (fig. 3) showing a scene that is comparable in some respects to that on the Tresilico bowl. There is a mounted huntsman riding toward the right, brandishing a long spear. Before him stands a tree to which is tied a net, and in the foreground, two hounds chase a hare toward the net. The dogs and hare resemble each other, but the dogs have long tails and the hare has slightly longer ears.[19]

Hunting scenes are common throughout ancient art, but it is now difficult to trace the precise influences that led to the choice of this subject on the Tresilico glass bowl. Indeed, since the very use of figural decoration on glass vessels is previously unknown, models in other mediums have to be sought. Wall paintings, sculpture, and mosaics may be cited as offering comparanda, but

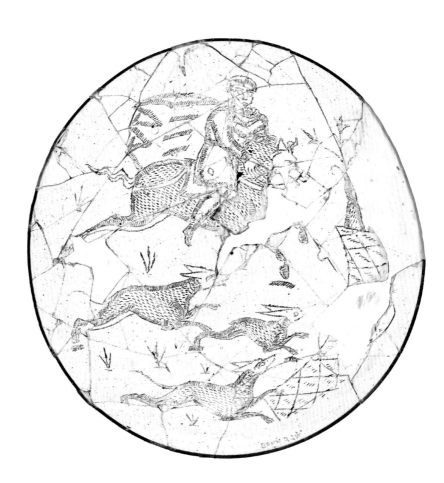

FIG. 3. Bowl decorated with a carved hunting scene. Roman, first half of the 4th century A.D. Glass, diam. 7¹⁄₁₆ in. (18 cm). Rheinisches Landesmuseum, Bonn, 314. After Follmann-Schulz 1988, pl. 51

FIG. 4. Phiale mesomphalos. Greek, late 5th century B.C. Gilt silver, diam. 8 in. (20.3 cm). The Metropolitan Museum of Art, New York, Gift of Mary and Michael Jaharis, in honor of Thomas P. Campbell, 2015 (2015.260.3)

large-scale depictions of hunt scenes should not be seen as providing direct models for small works of art such as this glass bowl.[20] By association, vase paintings provide one avenue of investigation. There is, for example, in the Metropolitan's collection, an Attic lekythos (41.162.146) attributed to the Athena Painter, dated about 480 B.C., on which a hare hunt is depicted on a white ground around the body of the vase: it shows a running man chasing a hunting dog that is in pursuit of a large hare, with a tree forming the central focus of the scene. Silver vessels are also decorated with hunting scenes, as on a silver gilt phiale mesomphalos (fig. 4), also in the Metropolitan, that dates to the late fifth century B.C. The central boss is surrounded by three bands of floral decoration, above which is a broader field showing a continuous frieze of four hunters on horseback, brandishing spears; they gallop over an uneven ground and appear to encircle two deer, a stag and a doe, that flee from two of the horsemen on the left but toward the two on the right.[21] Faience vessels from Ptolemaic Egypt were also decorated with hunting scenes.[22] Of particular note is an example in the Archaeological Museum of Thessaloniki that depicts four scenes divided by trees (fig. 5): a dog chases a doe; a female archer (identified as Artemis) attacks with a lance a deer, accompanied by a dog and a hare; a dog chases a deer; and a dog pursues a wild boar preceded by a hare.[23] In relation to the Tresilico bowl, it is worth comparing the depictions here of a hare and a dog—two very different-looking animals.[24] Additionally, among the many different faience animal pendants there is one representing a hare; an example (fig. 6) in the Metropolitan's collection comes from the Cesnola Collection of Cypriot Art, but it was presumably

FIG. 5. Kalathos from Neapolis, Thessaloniki. Greek, Ptolemaic, 200–150 B.C. Faience. Archaeological Museum of Thessaloniki, Greece, 2829

made in Egypt.[25] Although these examples may provide generic models or parallels for elements of the scene on the Tresilico bowl, there are others that require further investigation.

The leopard shown on the bowl is not among the animals that are usually depicted in hunting scenes. Moreover, as with other big cats, the leopard should be the hunter, not the hunted. Indeed, in one panel on the Roman mosaic found at Lod (fig. 7), one such spotted cat (called there a panther) is shown holding on to an animal (wild goat) that has long, curved horns that are similar to those of the two animals hunted by the archer in the lower scene on the Tresilico bowl.[26] Whereas lions do appear in this role, being the appropriate sport of kings and emperors, leopards (or panthers) are more often seen in a religious context, either accompanying the god Dionysos or drawing his chariot.[27]

FIG. 6. Amulet in the form of a hare. Egyptian, probably Ptolemaic, 304–30 B.C. Faience, l. 1 in. (2.5 cm). The Metropolitan Museum of Art, New York, The Cesnola Collection, Purchased by subscription, 1874–76 (74.51.4505)

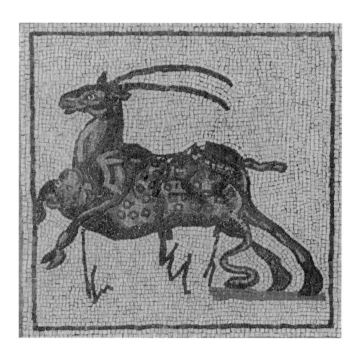

FIG. 7. Detail of the Lod Mosaic. Roman, early 4th century A.D. After *Lod* 2015. Israel Antiquities Authority and Lod Mosaic 2015, p. 63, fig. 44

The animal can be closely associated with Ptolemaic Egypt, where it is recorded that Ptolemy II (r. 283–246 B.C.) had thirty large cats, distinguished by the names παρδάλεις and πάνθαροι (leopard or other large spotted cat), in his Grand (Dionysiac) Procession in the 270s B.C.[28] Spotted felines also occur on the Late Hellenistic mosaic found in the Shatbi district of Alexandria.[29] Mentioned at Ptolemy II's Procession are chariots pulled by various types of horned caprids, including ὀρύγες, identified as antelopes.[30] The two horned beasts on the Tresilico bowl clearly are meant to be some such animal. Additionally, Athenaios's description of the Procession includes the famous reference to ὑάλινα διάχρυσα (glass interwoven with gold).[31] Although it has been argued that this does not refer to sandwich gold glass vessels, nevertheless it makes clear that glass was a rare luxury worthy of display in Ptolemaic Egypt.[32]

It is, therefore, possible to envisage a connection between the Tresilico bowl and the production of sandwich gold glass in Ptolemaic Egypt, probably in Alexandria itself. This is not to say that the Tresilico bowl was necessarily inspired directly by imagery from the Ptolemaic court or, indeed, other Macedonian royal iconography. Nevertheless, it has been suggested that the hunting scene

may be related to a painting known as the "Ptolemaeus venans" by the painter Antiphilos, who was born in Egypt probably in the mid-fourth century B.C.[33] The example of the wall paintings in Tomb 1 at Marisa in Israel provides a more fitting analogy. The tomb, which dates to the latter part of the third century B.C., is regarded as a type of catacomb that derives from Egypt.[34] The wall paintings in the tomb include an animal frieze in Chamber D, which has attracted attention principally for the depictions of exotic and imaginary animals. However, of particular relevance here is the scene at the right hand end of the south wall, which is regarded "as an appendage to the main part of the frieze."[35] It is the only part of the frieze that has human figures: it depicts a hunting scene with a mounted hunter aiming a spear at a female leopard rearing up in front of him. The rider is accompanied by a dog who runs alongside his horse, and behind the horse, an attendant is shown blowing a trumpet. The leopard, labeled above as a *pardalos*, is bleeding from a wound caused by an arrow stuck in her chest, and she is being attacked by another dog that has seized her tail.[36] A tree behind the leopard separates this scene from the rest of the frieze of animals: the first animal to the left is clearly a lion with a mane, although it is labeled as a *pantheros*.[37] It is worth noting that the attendant, and possibly the rider as well (both figures have had their faces scratched out), wears a wreath. The two figures on the Tresilico bowl also wear wreaths.

The similarities between the Marisa wall painting and the Tresilico bowl are striking, and arguments can thus be made for seeing them as belonging to a common artistic tradition that had its roots in the art of the Ptolemaic court. A further link is provided by the fragment in Moscow, mentioned above, that is decorated with an Egyptian temple scene. How such a fine piece of luxury glassware came to be deposited in a tomb at Tresilico remains a mystery, but this is part of the larger question surrounding the glass hoards from Canosa and the production of Hellenistic luxury glass as a whole.[38] It is, therefore, important to consider a scientific approach in order to try to identify the composition of the glass used in the Tresilico bowl and thus to compare it with other examples. The analysis of the glass used in the Tresilico bowl shows that it belongs to the usual type found in most ancient glass with a soda-lime silica composition made from natron.[39] In the use of manganese as a decolorant, the bowl conforms to other Hellenistic glass,

and, perhaps significantly, it matches most closely a dish in the Metropolitan's collection (1999.315) that may belong to the Canosa group of glasses. Although this may imply a common origin, as Mark Wypyski suggests, it does not help to determine their place of production.

It remains to discuss two other aspects of the Tresilico bowl: (a) the non-figural decoration and (b) the shape. There are two registers of decoration surrounding the central figural scene. One appears between two circular lines on the cavetto; it is an intricate meander pattern of two interweaving lines that form swastikas where they intersect and that enclose a series of squares, each with a central square solid dot. The pattern is slightly irregular and uneven. Parallels for this pattern on Hellenistic sandwich gold glass are rare: it appeared on the now lost Rothschild blue bowl, said to be from Palestine, although there, the design was bolder and more regular, and diagonal crosses decorated the squares that are enclosed by the meander pattern.[40] It also occurs on two very similar hemispherical bowls, one in the Museum of Art and Archaeology, University of Missouri-Columbia, and the other in the collection of the World of Glass museum, St. Helens, England.[41] Elsewhere on glass, the meander pattern is found on an early Roman imperial mold-pressed bowl, known from two fragments now in the British Museum and the Metropolitan.[42] However, of greater relevance is its appearance on Hellenistic silverware and ceramics.[43] The second register extends from the top of the cavetto to the outer lip of the broad, convex rim; it comprises four circular lines, set in pairs to either side of a double wave pattern that decorates most of the rim's width. The wave pattern is more common and appears on several other examples of sandwich gold glass: the two Canosa bowls in the British Museum,[44] the Geneva bowl,[45] the Olbia fragment,[46] the fragment in Moscow with the Egyptian scene,[47] and a fragment in the Metropolitan (23.160.76).[48] Wave decoration is a common motif on silverware, faience, and terracotta vessels; for example, on two of the silver bowls from the so-called Morgantina hoard, on faience bowls such as one in the Met (essay by Hill, fig. 5), and on Hadra hydriai such as one in the Met (fig. 8).[49] The appearance of the wave and meander designs on the Tresilico bowl can thus be seen as part of the decorative repertoire used in Hellenistic art. However, the fact that the gold decoration extends to the rim means that the construction of the

Tresilico bowl is significantly different from that of the two British Museum sandwich gold glass bowls from Canosa (see below).

The shape of the bowl, on the other hand, is unusual. It has been compared with two cast vessels found at Pydna (Makrygialos, northern Greece) in a Hellenistic tomb dated to the end of the fourth century B.C.[50] But, significantly, it is not represented among the glassware from Canosa.[51] The profile drawing of the bowl that appeared first in Richard Delbrueck's publication is misleading in that it shows in section a single, solid body that gives no indication of the two separate layers, but according to Donald Harden, "the ends of both layers coincided" at the outer lip of the rim.[52] This is not the case with the Canosa bowls, where the outer layer only extends up the side to the point where the gold decoration ends.[53] Nevertheless, Delbrueck's drawing provides an accurate impression of the shape, which Harden described as "the body being saucer-shaped, while the rim has a broad flange and curves downward at the lip."[54] According to Mauro Cristofani, the shape has some similarity with terracotta "piatelli" of the late fourth and third centuries B.C. that have a broad rim and shallow body.[55] However, these plates stand on a tall pedestal foot. In fact, the shape of the Tresilico bowl finds no close parallel in either ceramic or metal vessels.[56] It cannot have served as a drinking bowl because of its wide rim, but its concave body means that it could not stand alone in a stable, upright position if it was placed on a table as a serving dish. Perhaps, then, it was used as a cover that was placed over another vessel with a thick vertical rim, on which the underside of the flange rested. It might, therefore, bear some relationship to Hellenistic cast and painted pyxides.[57] Yet, the Tresilico bowl is not the only type of Hellenistic glassware that seems to defy interpretation in terms of shape and function. The large finned bowls that are represented in both the Canosa group and the finds from the Antikythera shipwreck might appear to be too large and unwieldy to be drinking vessels, but they were presumably used as such and, when empty, were placed upside down, thereby showing off the cut decoration to its best effect.[58] Nevertheless, it is clear that the Tresilico bowl was intended to be viewed from above, as befits a cover or lid.

Finally, in several accounts of the Tresilico bowl and other Hellenistic sandwich gold glass, mention is made of a circular medallion that was acquired by Theodore Graf in

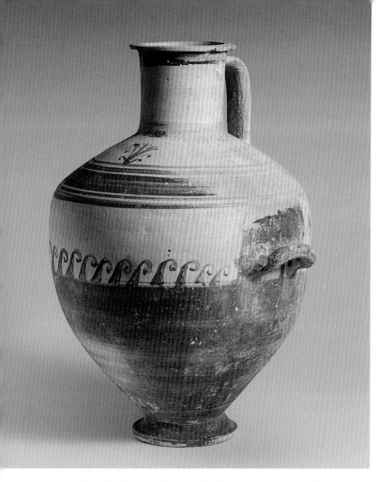

FIG. 8. Hadra hydria (water jar). Greek, Ptolemaic, 3rd century B.C. Terracotta, h. 15¾ in. (40 cm). The Metropolitan Museum of Art, New York, Purchase, 1890 (90.9.49)

Egypt.[59] The piece is now lost and is only known from a drawing, which shows the bust of a female warrior wearing a plumed helmet and carrying a spear and a shield. The figure has been identified as a personification of Alexandria. This medallion has no bearing on the present discussion, since it was probably an example of later blown gold glass. Most Roman examples bear Christian or Jewish imagery, but there are exceptions, including two fragments in the Metropolitan: one (17.194.2343) showing the deity Oceanus, and the other (28.57.24) depicting a victorious charioteer.[60]

1. Christopher S. Lightfoot thanks Giulia Cesarin for her invaluable help and advice during the preparation of this paper. Both authors gratefully acknowledge the permission that was granted for this publication by the Ministero dei Beni e delle Attività Culturali e del Turismo, no. 64, September 1, 2016: Museo Archeologico Nazionale di Reggio Calabria. For the location of Tresilico, see Costamagna 1999.
2. Cananzi 1906.

3. Cristofani 1966, p. 65, citing other examples.
4. Ibid., pp. 71–73, no. 7, fig. 5. There is, for example, a pair from Cyprus in the Cesnola Collection at The Metropolitan Museum of Art, New York, 74.51.3458, .3459; see Karageorghis 2000, p. 290, no. 477. Another example, acquired in Kütahya, is now in the Museum of Anatolian Civilizations, Ankara, 64-3-69; see Bingöl 1999, p. 64, no. 32. For examples in the Benaki Museum, Athens, see Jackson 2017, pp. 128–29, nos. 51–53.
5. Cristofani 1966, p. 67, nos. 1a, b, fig. 2
6. Ibid., p. 68, nos. 2a, b, fig. 2.
7. Ibid., pp. 69–70, no. 3, fig. 3.
8. Ibid., pp. 70–71, no. 4.
9. Ibid., p. 71, no. 5.
10. Ibid., p. 71, no. 6.
11. Ibid., p. 73, no. 8, fig. 2. The tomb goods are also shown in Galli 1937, figs. 1, 2.
12. Cristofani 1966, p. 73.
13. Moretti 1913; Delbrueck 1914, pp. 199–200, fig. 9, which shows the bowl, with profile drawing, and earrings; Rostovtzeff 1941, vol. 1, p. 373, pl. 44,1; Schüler 1966, p. 50, fig. 6, where the bowl is captioned "Late Hellenistic(?), Parthian(?)"; Adriani 1967, p. 112, pl. 5A (a very clear and precise line drawing of the figural scene); D. Harden 1968, pp. 32–33, figs. 31, 32; Ciancio 1980, p. 32; Lattanzi 1987, pp. 103, 105; Saldern 2004, p. 124, pl. 109, describing the bowl as "completely unique"; Rosella Agostino in Marzatico, Gebhard, and Gleirscher 2011, pp. 600–601, no. 5.82, dating the bowl to the second century B.C.; Cima and Tomei 2012, p. 110, no. 17; Ignatiadou 2013, pp. 144–45, 161, no. 5, fig. 96; Cesarin 2016, pp. 42–43; Christopher S. Lightfoot in Picón and Hemingway 2016, p. 118, no. 20
14. The term "cast glass" is used here to denote glass vessels made by a technique that was not core-forming and predated the invention of glass blowing. It does not imply the use of a closed mold but rather that of a "former" over which the hot glass was slumped. The technique has also been called "mold-pressing"; see Gudenrath 1991, p. 222.
15. It has been supposed that the two layers were "fused [together] by a light firing"; see Saldern 1959, p. 46; D. Harden 1968, p. 24; and Stern 1994, p. 109. Scientific investigation of the two Canosa bowls in the British Museum, however, produced no evidence to show that the two layers were either fused or glued together; see Bimson and Werner 1969, p. 125.
16. D. Harden 1968, pp. 23–25, figs. 1–8. See the British Museum, London, GR 1871,0518.2 (Dirk Booms in Picón and Hemingway 2016, p. 256, no. 195); and Museum of Art and Archaeology, University of Missouri-Columbia, 77.198 (Christopher S. Lightfoot in ibid., p. 256, no. 196).
17. Pushkin State Museum of Fine Arts, Moscow, I 1a 2648; see Rostovtzeff 1941, vol. 1, p. 373, pl. 44, 2; and Auth 1983, pp. 39–40, fig. 1. This must be the piece that is erroneously referred to as a "bowl" that "shows a Nilotic scene"; see Dirk Booms in Picón and Hemingway 2016, p. 256, no. 195.
18. Those who accept it as a dog include D. Harden 1968, p. 32; Saldern 2004, p. 124; and Rosella Agostino in Marzatico, Gebhard, and Gleirscher 2011, p. 600. Rostovtzeff (1941, p. 373), who was uncertain about this animal, identified the bird above the horseman as an eagle, symbolizing victory.
19. Follmann-Schulz 1988, pp. 119–20, no. 459, pl. 51.
20. For discussion of some major works, see Cesarin 2016, pp. 44–46.

21. Hemingway 2016a.

22. See the essay by Marsha Hill in this volume, pp. 158–67; Cesarin 2016, p. 47.

23. Archaeological Museum of Thessaloniki, 2829; see Nenna and Seif El-Din 2000, p. 88.

24. Illustrated in Vokotopoulou 1996, p. 55 with detail.

25. For another example in the Egyptian Art Department, see Arnold 1995, p. 23, no. 21, identified as the desert hare (*Lepus capensis*). According to Arnold, it was "not considered worthy prey for princely hunters." Arielle Kozloff, on the other hand, stated that "hares often appear as victims in royal hunts along with gazelles and small foxes"; see Arielle Kozloff in Walker 1996, p. 73.

26. See *Lod Mosaic* 2015, p. 63, fig. 44. Horned animals, identified as the ibex (wild goat), appear in hunting scenes on Hellenistic Hadra hydriai; see Christopher S. Lightfoot in Walker and Higgs 2001, pp. 117–18, no. 142. An example with a scene of a leaping goat confronting a cupid is in the Metropolitan, New York, 90.9.9; see B. Cook 1966, p. 13, no. 25, pl. 6.

27. For example, on the mosaic still in situ at the House of the Masks, Delos, dated before the sack of Delos in 88 B.C.; see Brown 1957, pp. 75–76, pl. 43,2.

28. Athenaios of Naucratis, *Philosophers at Dinner, or Banquet of the Learned*, 5.201C. The πάνθαρος is also listed in Herodotus, *The Histories*, 4.192, among the wild animals found in Africa.

29. Greco-Roman Museum, Alexandria, 21643; see Brown 1957, pp. 77–78, pl. 44.1, where the mosaic is dated ca. 50 B.C.–A.D. 50; Jacobson 2007, pp. 42, 45, nn. 2, 4, gives a date of 290–260 B.C. For a full discussion of the date of the Shatbi mosaic, see Daszewski 1985, pp. 106–9.

30. Athenaios of Naucratis, *Philosophers at Dinner, or Banquet of the Learned*, 5.200F; see Toynbee 1973, pp. 146–47.

31. Athenaios of Naucratis, *Philosophers at Dinner, or Banquet of the Learned*, 5.199F.

32. Stern 2007, pp. 372–74.

33. Pliny the Elder, *Natural History*, 35.37 (114), 35.40 (138). According to Pliny, he ranked among the *primis proximi* ("next to the first") and his finest work was of a satyr wearing a panther skin, known as the *aposcopeuon* ("shading his eyes"). This connection has been made by, among others, Cesarin 2016.

34. Jacobson 2007, pp. 17, 48.

35. Ibid., p. 42.

36. Ibid., pp. 25, 27, pls. 11, 12.

37. Ibid., pp. 27–29, pls. 13, 14.

38. For this complex subject, see Stern 1994. Fragments of sandwich gold glass have been recovered from the site of an ancient glass workshop on Rhodes; see Triantafyllidis 2000b, p. 31.

39. See the essay by Mark Wypyski in this volume, pp. 186–89.

40. Wuilleumier 1930, pp. 29–30, pls. 11, 12; Saldern 1959, p. 47, no. 4; Adriani 1967, p. 107, pl. 6.

41. Museum of Art and Archaeology, University of Missouri-Columbia, 77.198; see Christopher S. Lightfoot in Picón and Hemingway 2016, p. 256, no. 196. World of Glass Museum, Saint Helens, England, 1974.021; see Grose 1989, p. 187, fig. 98.

42. British Museum, London, GR 1893,1009.4; and the Metropolitan Museum, New York, 1995.86; see Lightfoot and Picón 2015. The manufacturing technique used for this piece involved a closed two-part mold and is different from "cast" glass.

43. For example, on one of the silver bowls said to be from Morgantina, Museo Regionale di Aidone, 6; see Guzzo 2003, p. 49, fig. 7. For ceramic examples, see Lightfoot and Picón 2015, p. 26.

44. British Museum, London, GR 1871,0518.1, 1871,0518.2; see note 16 above. A wave pattern is also "etched" on the underside of the rim of a large plate found in a Macedonian tomb at Pydna; see Ignatiadou 2000, pp. 35–36, fig. 4; and Ignatiadou 2013, p. 145, figs. 94, 95.6, 95.10, 95.11.

45. Musée d'Arts et d'Histoire, Geneva, MF 3634; see Saldern 1959, p. 47, no. 6, fig. 32; D. Harden 1968, p. 38, fig. 34.

46. State Hermitage Museum, Saint Petersburg, Оп. 1903.222; Kunina 1997, p. 257, no. 49, with addorsed wave pattern immediately above floral decoration.

47. See note 17 above.

48. Oliver 1969, p. 12, figs. 1–3; below the frieze containing vine tendrils and bunches of grapes , a single band of fine waves.

49. For the silver bowls, see Guzzo 2003, pp. 47–50, figs. 2, 7; Laura Maniscalco in Picón and Hemingway 2016, pp. 240–41, no. 178. For other examples of Hadra hydriai at the Metropolitan, see B. Cook 1966, pp. 22, 24, nos. 5, 8, pl. 2.

50. Archaeological Museum of Thessaloniki, Πυ 6435, Πυ 6436; see Ignatiadou 2000, p. 36, figs. 1, 2. The plate found there certainly has a broad, horizontal rim. In a more recent publication Ignatiadou (2013, p. 141) has in fact identified these two vessels as belonging together as a bowl and cover.

51. See, for example, Grose 1989, p. 186, fig. 92; and Stern 1994, pp. 98–99, figs. 177–80.

52. Delbrueck 1914, p. 198, fig. 9; D. Harden 1968, p. 32, fig. 31; Cristofani 1966, 74, fig. 6.

53. Similar construction is found on the bowl in Geneva (see note 45 above); see Deonna 1925, pp. 15, 17, fig. 2. Compare also the fragment in the Metropolitan, 23.160.76 (see note 48 above), on which the outer layer "folds over" the inner layer at the top of the vessel; see Oliver 1969, p. 11, fig. 4. This, in effect, held the inner layer securely in place.

54. D. Harden 1968, p. 32.

55. Cristofani 1966, p. 76. In n. 34, he cites as examples black-glazed ware from Teano in Mingazzini 1958 and Mingazzini 1969. See, for example, Mingazzini 1958, comparing especially p. 6, no. 8, pls. 1, 2.2, the latter of which is also decorated with a wave pattern on the rim.

56. The same is stated for the glass from Pydna; see Ignatiadou 2013, p. 144.

57. For example, see Arveiller-Dulong and Nenna 2000, pp. 168–70, nos. 197, 198; and Lightfoot 2016c, no. 33. See also Ignatiadou 2013, pp. 140, 145–48, figs. 98–104.

58. D. Harden 1968, pp. 27–28, 43–44, no. 7a–c, figs. 20–22; De Juliis 1989, p. 449, nos. 40, 41.

59. Kisa 1908, vol. 3, p. 838, fig. 354; Adriani 1967, p. 112, fig. 1; Cesarin 2016, p. 50.

60. For other examples, see Filippini 2000, pp. 127, 129–30, nos. 2, 6; Page 2006, p. 42, fig. 14.1.

Mark T. Wypyski

Chemical Analysis of the Tresilico Gold Glass Bowl

While an abundance of compositional data has been compiled for glasses from the Late Bronze Age, as well as the Roman and late Classical periods, comparatively little information exists on glass from the Iron Age and the Hellenistic period. The exhibition "Pergamon and the Hellenistic Kingdoms of the Ancient World" at The Metropolitan Museum of Art provided an opportunity to add to our understanding of Hellenistic glassmaking by allowing us to perform compositional analysis of the famous Tresilico gold glass bowl from the Museo Archeologico Nazionale in Reggio di Calabria (essay by Lightfoot and Malacrino, pp. 177–85).[1] Completely non-invasive, non-destructive surface analysis of the colorless glass was accomplished with X-ray fluorescence spectrometry (XRF) in the laboratory of the Scientific Research department. Comparative analyses were also done on samples of three colorless glasses from the collection of The Metropolitan Museum of Art by X-ray microanalysis, using energy dispersive and wavelength dispersive X-ray spectrometry in the scanning electron microscope (SEM-EDS/WDS).

Research in historical glass chemistry has long recognized that the vast majority of glass from the Mediterranean world and Western Asia can be characterized as having soda-lime-silica compositions, that is, glass containing soda (sodium oxide), lime (calcium oxide), and silica (silicon oxide) as the three main constituents.[2] Two main categories or types have been established, differentiated mainly by the concentrations of magnesium and potassium.[3] Early glasses containing relatively high concentrations of magnesium and potassium are thought to have been produced with the ash of certain plants as one of the main ingredients. This plant ash was used as the source of the sodium in the production of the glass, but would also contribute other, presumably unintentional, significant additions to the glass composition in the form of magnesium, potassium and calcium oxides, as well as small amounts of other elements such as phosphorus.[4] Glasses containing relatively small amounts of magnesium and potassium, however, are thought to have been produced with a mineral source of soda, commonly referred to as *natron,* a naturally occurring evaporitic deposit found along saline lakes, consisting mostly of a mixture of sodium carbonate minerals, along with small amounts of other compounds including chloride and sulfate. The best-known source of mineral soda for glassmaking in the ancient world was from the Wadi Natrun in Egypt, although textual evidence attests to other possible sources of natron, such as Lake Pikrolimni in Macedonia.[5] High magnesium plant ash glass compositions are characteristic of Late Bronze Age glass from Egypt and Mesopotamia, while low magnesium natron glass is well known from throughout the Mediterranean world from about the mid first millennium B.C. to the late first millennium A.D.

Base glass can be produced with only two main ingredients: one of the sources of soda discussed above, and a source of silica, generally in the form of sand or possibly quartz pebbles. Naturally occurring sand deposits do not consist solely of grains of silica, and generally contain significant amounts of other minerals such as calcite, feldspars, clay, and iron oxides, which can contribute calcium, aluminium, magnesium, potassium, and iron, as well as silicon to the glass composition. Most glass is naturally tinted

to some extent by the small amounts of iron oxide present in the raw materials, which can give a yellow, green, or bluish color to the glass. To produce a colorless or near-colorless glass, unless the raw materials are of unusual purity, i.e. contain extremely low levels of iron, a decolorant material of some kind must be added to counteract the color due to iron oxide. Analyses of ancient glass have shown that compounds of antimony or manganese, or both together, appear to have been intentionally added to glass intended to be colorless. An early survey of ancient glass indicated that antimony oxide was first used as a decolorant sometime about the 7th century B.C., and the use of manganese oxide was widespread by the first century B.C., with manganese totally replacing antimony after the 4th century A.D.[6] Although it is not actually clear when manganese first began to be used as a decolorant, some authors give a start date of around the second century B.C. based on Edward Sayre and Ray W. Smith's early work.[7] Robert Brill, however, has published several analyses of colorless glass from Rhodes, dated late third–second century B.C., which were decolorized with manganese.[8]

Before discussing the analytical results, some caveats about surface analysis of glass should be noted. Quantitative compositional analysis of well-prepared micro-samples using techniques such as X-ray microanalysis in the scanning electron microscope, as was done here of three glasses from the Met collection for comparison, can provide highly accurate and reliable results. While surface analysis with XRF has the advantage of not requiring a sample to be removed from the object, this form of analysis, indeed any form of surface analysis, suffers from a number of problems that can compromise the quality of the data obtained, and thus any interpretations based on these findings.[9] Factors such as detector geometry to the specimen and elements present in the glass matrix under investigation can profoundly affect the calculated quantitative results obtained. It is even more important, however, that the surface layer of a glass, even one that appears pristine visually, may be significantly chemically altered due to weathering. While this does not affect the qualitative identification of the elements present, assuming there is no surface contamination with another material, it will, however, affect the quantitative values. The most well-known effect observed in glass weathering is the dissolution and loss of alkali (soda) from the surface. Observations in the Met

Table 1. Compositional Analysis Results (Weight %)

Element—Oxide:	Tresilico Bowl (XRF)	MMA 74.51.312 (EDS/WDS)	MMA 23.160.76 (EDS/WDS)	MMA 1999.315 (EDS/WDS)
Sodium - Na_2O	12.5	16.2	16.5	13.8
Magnesium - MgO	1.6	0.47	0.64	1.6
Aluminum - Al_2O_3	3.5	0.28	2.4	2.5
Silicon - SiO_2	69.8	72.1	68.5	68.7
Phosphorus - P_2O_5	0.2	0.11	0.13	0.19
Sulfur - SO_3	0.3	0.23	0.37	0.06
Chlorine-Cl	0.8	0.66	0.77	0.96
Potassium - K_2O	1.5	0.71	0.69	1.5
Calcium - CaO	8.4	7.1	8.5	8.9
Titanium - TiO_2	0.1	0.02	0.06	0.06
Manganese - MnO	0.6	nd	0.88	1.3
Iron - Fe_2O_3	0.4	0.17	0.46	0.37
Copper - CuO	nd	nd	nd	nd
Strontium - SrO	0.1	0.05	0.08	0.09
Antimony - Sb_2O_5	0.1	2.0	nd	0.06
Barium - BaO	ns	0.01	0.02	0.02
Lead - PbO	nd	nd	nd	nd

nd = not detected.
ns = not sought.

Scientific Research laboratory have also shown that along with depletion of soda, weathered glass layers may also exhibit somewhat higher concentrations of aluminium, magnesium, potassium, iron, and other elements relative to the original glass composition, depending on the extent and depth of the weathered layers. To avoid or mitigate these problematic effects and achieve better quantitative results, a small area on the surface of a weathered glass may be polished to remove or at least reduce the weathered, chemically altered layers before analysis. When this is not possible, as in the case with the Tresilico bowl, microscopic examination of the glass surface may reveal areas with small chips or losses or areas of abrasion where some of the outer weathered glass has already been removed. Focusing the instrument on these spots may allow for analysis of the underlying glass with little interference from the weathered glass.

Table 1 lists the results of the analyses of four colorless glasses: the Tresilico bowl, from a tomb excavated in the province of Reggio Calabria;[10] and from the Metropolitan Museum, an alabastron, a gold-glass skyphos fragment, and a dish with gilding.[11] The results show that, not surprisingly, all four glasses have soda-lime silica compositions. All four have relatively low concentrations of magnesium and potassium, consistent with glass produced with natron. While three of the glasses contain relatively high levels of aluminium, the alabastron has a rather low concentration, well under 0.5 percent. The alabastron also differed from the other three glasses analyzed here in containing antimony as the decolorant. The other three glasses all contain significant amounts of manganese, although traces of antimony were detected in both the Tresilico bowl and the Met dish with gilding. The very small amounts of antimony present in these glasses were almost certainly not intentional additions, but probably represent the addition of some glass that contains antimony to the glass batches used to produce these two objects.

Table 2 is a plot of the magnesium and aluminium oxide values of these four glasses, along with selected glasses from other studies. Most of these glasses have reported magnesium oxide values from about 0.5 to 0.8 percent, with aluminium oxide content from somewhat less than 2 percent to about 2.7 percent. Colorless glass from northern Greece, from a Macedonian tomb at the site of Pydna, dated to the fourth century B.C.,[12] and from

excavations at Vergina, also dated to the fourth century B.C.,[13] were found to be decolorized using antimony. Another glass, from the Macedonian Great Tomb at Lefkadia and dated to the second century B.C., also has a similar composition.[14] The points marked Rhodes 1, 2, and 3 are data from glass from a bead factory on Rhodes.[15] As indicated on the plot, the glass designated Rhodes 1 utilized antimony as the decolorant, while Rhodes 2 used manganese, although a trace of antimony was also reported. Rhodes 3, a colorless glass bead, is interesting in that it contains significant amounts of both manganese and antimony. Colorless glass containing seemingly intentional amounts of both decolorants appears to be rare in this period, but is more well known in colorless glass from the Roman period.[16] Rhodes 4 represents glass bowl fragments from a necropolis at Rhodes, dated second–first century B.C., all decolorized with manganese.[17] One fragment from this site identified as colorless glass cullet, rather than a bowl fragment, contains a large amount of antimony rather than manganese, while two of the bowls were reported to contain traces of antimony, evidence of some mixing of different glasses. A vessel fragment from

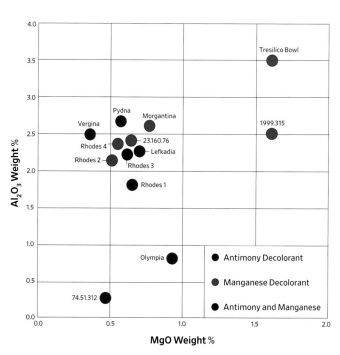

TABLE 2. Plot of magnesium oxide versus aluminium oxide concentrations for selected late Iron Age and Hellenistic colorless glasses.

Morgantina in Sicily, probably dated third–second century B.C., also used manganese as the decolorant.[18]

Four glasses in the plot stand out from the main group. The alabastron analyzed here, as well as a glass from Olympia, dated to the fifth century B.C.,[19] were both found to be decolorized with antimony and have much lower aluminium contents than all of the other glasses discussed here. This would indicate that a different, purer, silica source was used in the production of these glasses than the type of sand generally thought to have been used in making natron glass. Two other glasses stand out from the main group. As seen in table 1, both the Tresilico bowl and the gilded dish from the MMA utilized manganese as the decolorant, and have comparable aluminium values to the main group of glasses. These glasses differ from the others, though, in containing somewhat higher concentrations of magnesium and potassium than typically found in natron based glasses. This may indicate the use of a less commonly utilized natron or silica source (or both) in the production of these glasses, which added somewhat more magnesium and potassium containing minerals to the glass batch.

The compositions determined for the Tresilico bowl and the Met gilded dish appear to be very similar, and may imply a common origin, at least for the glass from which the pieces were produced. The Met dish has been described as being a close parallel to the Canosa group of Hellenistic glasses from the British Museum, and, like them, probably comes from Southern Italy.[20] The Tresilico bowl has also been compared to the Canosa group glass. Donald Harden dated the Canosa group to the third century B.C., and also suggested a third century date for the Tresilico Bowl.[21] The possible connection between these important glasses shows it would be extremely useful for the study of Hellenistic glass to conduct comparable analyses of the Canosa group glasses to see if they form a compositional group with the glass used to produce the Tresilico bowl.

Acknowledgments

I wish to thank Dr. Carmelo Malacrino, Director of the Archaeological Museum of Reggio di Calabria, and the Italian Ministry of Culture and Tourism for allowing me to carry out the analysis of the bowl. Permission for the publication of the results was issued by the Ministero dei Beni e delle Attività Culturali e del Turismo n. 64, September 1, 2016–Museo Archeologico Nazionale di Reggio Calabria.

1. Museo Archeologico Nazionale, Reggio di Calabria, 6171, dated to the first half of the third century B.C.; see Christopher S. Lightfoot in Picón and Hemingway 2016, p. 118, no. 20.
2. Turner 1956; Sayre and R. W. Smith 1961.
3. Sayre and R. W. Smith 1961; Sayre and R. W. Smith 1967.
4. Freestone 2006.
5. Shortland et al. 2006.
6. Sayre 1963.
7. Shortland and Schroeder 2009.
8. Brill 1999, vol. 1, pp. 51, 272–73, nos. 3500–3516; vol. 2, pp. 63–64.
9. Kaiser and Shugar 2012.
10. Cristofani 1966, p. 73. See also note 1 above.
11. The Metropolitan Museum of Art, New York: 74.51.312, alabastron, probably Phoenician, dated ca. 625–600 B.C; 23.160.76, gold-glass skyphos fragment, dated to the second century B.C.; and 1999.315, a dish with gilding, dated to the second century B.C.
12. Blomme et al. 2017.
13. Brill 1999, vol. 1, pp. 51–52, 260, 269, nos. 3750–3755; vol. 2, p. 65.
14. Ibid., vol. 1, p. 52, no. 501; vol. 2, p. 65.
15. See note 8 above.
16. Jackson 2005.
17. Brill and Stapleton 2012, pp. 48, 115.
18. Brill 1999, vol. 1, p. 52, no. 919; vol. 2, p. 66. For discussion, see Grose 1982, pp. 23–24, fig. 3.
19. Brill 1999, vol. 1, pp. 51, 270, no. 3395; vol. 2, p. 62.
20. Lightfoot 2003, pp. 18–19.
21. D. Harden 1968, p. 32.

Paul Zanker

The Frescoes from the Villa of Publius Fannius Synistor at Boscoreale in The Metropolitan Museum of Art

In 1903, the Metropolitan Museum acquired a series of frescoes from a villa at Boscoreale, which had been excavated only three years earlier and sold off by the landowner. The rest of the frescoes ended up in the Museo Archeologico Nazionale in Naples as well as in a number of other museums. The villa is located on the slopes of Mount Vesuvius, less than two kilometers from Pompeii. It consisted of the living quarters decorated with frescoed walls, arranged around a central peristyle, to which a bathroom and the kitchen quarters were attached. To the left of the entrance hall were spaces used for agricultural purposes, where various tools were found.[1] To the right, there probably were other rooms associated with the working of the fields. In other words, this was a *villa rustica*, and the rooms around the peristyle, decorated with such elaborate frescoes, would have been used by the owner on his occasional visits to the villa, especially when he invited guests for supper.

These paintings comprise a typical example of the manner in which the Roman upper classes decorated their reception rooms during the several decades before about 40–30 B.C. There was great admiration for Greek culture, and Romans tried in every possible way, including their personal lifestyle, to adopt the ways of Greek aristocrats, even of Hellenistic kings. Leading men considered themselves their equals, and they expressed this in the decoration of their private and reception rooms. This style was, in turn, imitated by a wider stratum of wealthy Romans, such as the owner of our villa.

But let us first turn to a consideration of the rooms, making use of the remarkable reconstructions that were first published in 2010 by the Department of Greek and

Roman Art at the Metropolitan and later improved upon by the firm Stanton-Abbott.[2] Since then, Alix Barbet and Annie Verbanck-Piérard have produced an exemplary publication of all the known frescoes, assigning them to their original locations in the villa.[3] Thus, in spite of the regrettable dispersal of the material, we can now get a much better picture of the original decoration of the villa, which transported the viewer into an extraordinary world of fantasy.

According to the only available plan, published by Felice Barnabei in 1901 (fig. 1),[4] at the time of the sale of the frescoes, one first crossed an entryway framed by columns, from which several steps led up to a hallway about ten meters wide, marked off by four columns and corner pilasters (fig. 2). Passing through the *fauces* (a passageway, C on the plan), one reached the central peristyle court (E). The *fauces*, and also the neighboring room D, were decorated with the early Second-Style fashion of colorfully painted stripes and rectangles that simulate marble panels (fig. 3). Painted Corinthian columns stood before the wall in the *fauces*, while in Room D, there were pilasters with swags between them, from which hung various objects. On the preserved fragment, we can make out a double flute.

Little remains of the wall decoration in the square peristyle E (about 22.5 meters on a side). Painted columns that are wide with low vegetal capitals imitated the actual capitals of the peristyle (fig. 4). Splendid garlands with all sorts of plants and fruits also hung from these. The painted wall below consists of a socle and a high frieze, topped off by a molding rendered in minute detail. Only small fragments survive of objects painted on the tall frieze with black background, one depicting fillets and precious vessels, another,

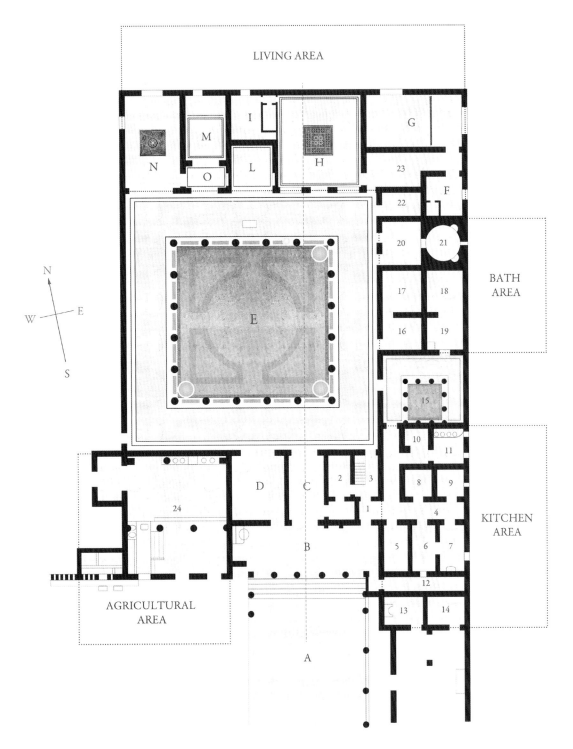

LIVING AREA

N

M

I

G

O

L

H

23

N

F

22

20

21

BATH
AREA

17

18

E

16

19

N

E

W

E

S

15

10

11

24

D

C

2

3

8

9

1

4

KITCHEN
AREA

5

6

7

B

12

AGRICULTURAL
AREA

13

14

A

THE VILLA PUBLIUS FANNIUS SYNISTOR

0 5 10 15 20

FIG. 1. Plan of the Villa of P. Fannius Synistor, Roman, Late Republican, ca. 50–40 B.C. Published in *La Villa Pompeiana di P. Fannio Sinistore*, Felice Barnabei (Italian, 1842-1922), 1901

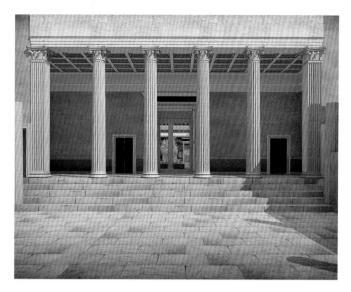

FIG. 2. Virtual model of the Villa of P. Fannius Synistor, entrance A, B

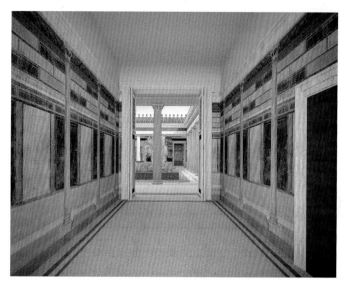

FIG. 3. Virtual model of the Villa of P. Fannius Synistor, looking north from inside room C *(fauces)* to the peristyle (E). The fresco panels on the right side are in the Musée du Louvre, Paris (P101 [MND615])

FIG. 4. Virtual model of the Villa of P. Fannius Synistor, southwest corner of peristyle E. The fresco fragments are in the Museo Archeologico Nazionale di Napoli (s.n. 2, s.n. 6) and the globe with a gnomon on top is in The Metropolitan Museum of Art, New York, Rogers Fund, 1903 (03.14.2)

FIG. 5. Model of the Villa of P. Fannius Synistor, room G, looking southwest. The fresco fragment on the south (left) wall is in the Musée Royal de Mariemont, Morlanwelz, Belgium (R56). The 3 fragments on the west (right) wall are in the Museo Archeologico Nazionale di Napoli (s.n. 1)

a big, broad-bellied hydria. But at the time of the excavation, Barnabei could make out a whole series of other objects, and Barbet has now published his drawings.[5] All of them apparently showed prizes for the victors in Greek athletic competitions, intended to transport the Roman viewer into the world of the gymnasium.

The most elaborate paintings in the Villa are found in the impressive reception rooms of the north wing of the porticus. One first entered the elongated room Room G,[6] on the right, probably a small *triclinium*, or dining room (about 9 x 4.65 meters), for use during the cooler seasons. On the two well-preserved walls, we see, in the middle of a red wall, a closed door on one side and a gated entryway on the other, which leads to distant columned porticoes. Above the gable of the entryway looms a round temple with a nude statue of Aphrodite inside.[7] Above a closed door on the front wall is a statue of Eros painted to look like bronze (fig. 5).

The large reception Room H (8.3 x 7.3 meters) presumably also could have been used as a *triclinium* when a big group of guests was expected.[8] In front of the entrance, still on the wall of the porticus on either side of the entry, we are greeted by two winged Genius figures with satyr's ears. They each carry a golden libation bowl, which may evoke the offerings that were performed at the beginning of the banquet (fig. 6). During the day, limited light coming through the large windows next to these figures would have entered the room, while at night, the flickering light of oil lamps on candelabra would have provided the only illumination. Entering into the room, the viewer was confronted by an abundance of paintings and figures intended to arouse a variety of different reactions and associations. Although once again the paintings are only partially preserved, thanks to the reconstruction, we can gain a reliable impression of the original decoration. Let us look at the pictures on the left and right sides of the room that are thematically connected.

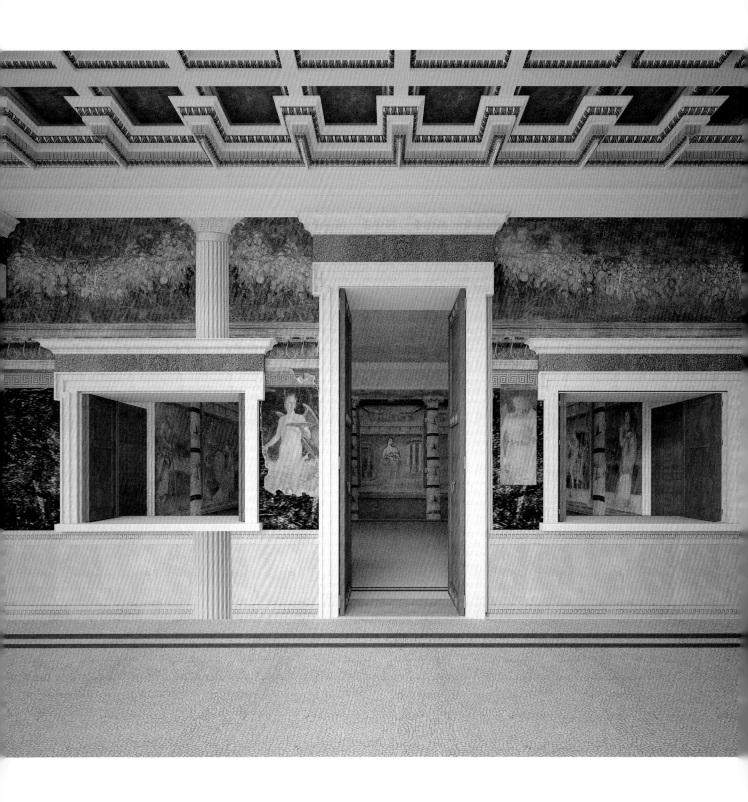

FIG. 6. Virtual model of the Villa of P. Fannius Synistor, entrance to room H, on the north wall of the peristyle. Fragments of frescoes showing winged guardian figures: left of door, Musée du Louvre, Paris (P23 [MND613]), and right, Allard Pierson Museum, Amsterdam

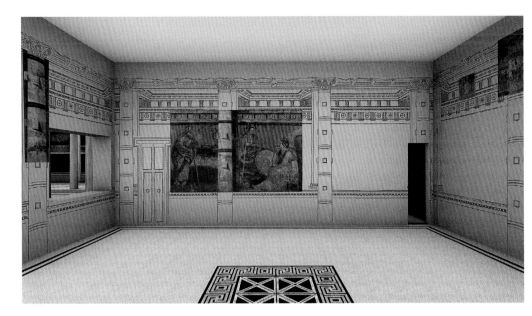

FIG. 7. Virtual model of the Villa of P. Fannius Synistor, room H, looking west. Fresco fragment on the left: Museo Archeologico Nazionale di Napoli (s.n.5)

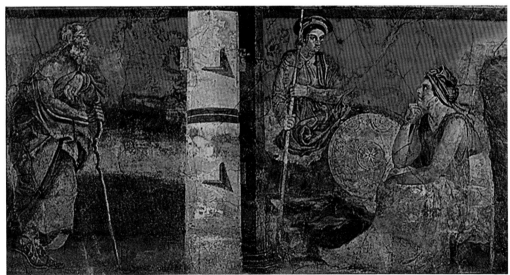

FIG. 8. Detail of the fresco panels in figure 7

On the left wall (fig. 7), there is a door to the left and to the right. Between these, on the painted wall topped by a triglyph-and-metope frieze, one saw three decorated surfaces separated by columns with projecting bosses. The columns must have continued farther up, with the result that we can restore a view through to farther columned halls, as on the front side of the room. On the portion of the fresco in Naples, a bearded philosopher stands at the left, leaning casually on a knotty staff, looking toward the two figures on the far side of the column (fig. 8). There, a woman sits in a rocky landscape, holding a spear with both hands. Thanks to her headgear, the *kausia*, and a diadem, we can readily identify her as the personification of Macedonia. She looks down toward a second woman seated below and looking up at her. Her tiara suggests she should be called Persia or, more generally, Asia. Between the two women is the Macedonian shield with its eight-pointed star, which can be understood here as a symbol of Asia's subjugation to Macedon, hence the cowering and subservient pose of the figure of Asia. In his article "Spear-Won Land at

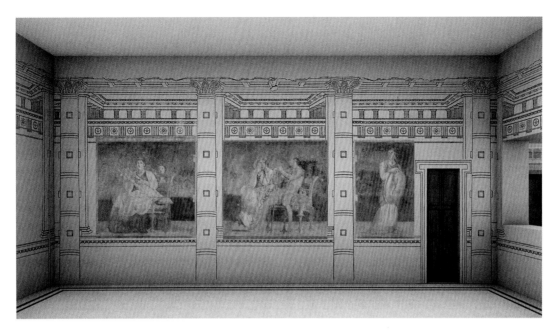

FIG. 9. Fresco panels in the Villa of P. Fannius Synistor at Boscoreale, room H, right wall. The Metropolitan Museum of Art, New York, Rogers Fund, 1903 (03.14.5-7)

Boscoreale: On the Royal Paintings of a Roman Villa," R. R. R. Smith was able to add further nuance to this interpretation.[9] With both hands, Macedonia rams her spear into a territory, rendered in brown, beneath a blue body of water that Smith has convincingly identified as the Hellespont. He demonstrates that Alexander and the Hellenistic kings used the expression "spear-won land" to justify their conquest of and rule over the lands of Asia. Seen in this way, the image takes on a broader meaning that could be decisive for how it was understood in a period when the Romans were steadily expanding their rule to the east. It is still debated if there was a third picture between this section and the narrow door, as was the case on the other side of the room. I believe we must assume that there was.

Like these paintings, the ones on the right side of Room H (fig. 9), now housed in the Metropolitan Museum, have been cut out of their original context, and so we must imagine both ensembles in the same architectural framework.[10] In both cases, the painted figures are on the simulated wall. In the central picture is a royal couple that clearly gave the Roman copyist some difficulty. The woman has been shifted too close to the throne of the ruler, since we see only the footstool but not the seat, and she has the appearance of a cutout (fig. 10). The ruler sits on a gilded and richly decorated throne, but it is seen from below, like that of his wife, so that he appears to wobble. He is nude,

FIG. 10. Fresco panel from the Villa of P. Fannius Synistor at Boscoreale, room H, right side. The Metropolitan Museum of Art, New York, Rogers Fund, 1903 (03.14.6)

and we see only a cloak falling over his right thigh. His hands rest on a scepter, and he appears to be looking at his wife. She wears a blue-gray chiton and a broad, light-colored mantle that she has also drawn up over her head. She rests her head in one hand and seems to look pensively

past the ruler, toward the woman with a shield on the other side of the column.

This royal couple and the figures on either side of them have been identified and interpreted in very diverse ways ever since their discovery. I cannot go into all these many interpretations here and instead refer the reader to the critical overview by Klaus Fittschen.[11] For my purposes, another observation of Smith's seems to be of particular importance. He noticed that the ruler is not wearing a royal diadem over the close-cropped hair on the nape of the neck. But before we come to the inference that Smith draws from this, let us look at the scenes on either side of the royal couple.

At the left, a woman sits on an elaborately carved and decorated chair with armrests and plays a big kithara embellished in gold. She wears a golden diadem in her long locks, which suggests that she too belongs to the royal family. The girl standing behind, also wearing a diadem, could be her little sister. But the female figure on the right, possibly a priestess, is crucial to the whole interpretation (fig. 11). She holds an oval shield propped on her knee and looks up, as if she were seeking an explanation for the appearance of a naked male figure reflected in the shield. Remarkably, this awkward figure clearly wears a royal diadem in his hair. Along with Smith and others, I think it likely that what we have here is the prophecy, in the form of an oracle, of the birth of a successor to the royal couple. I am also persuaded by Smith's suggestion that the oracle is linked to the couple by depicting them on the day of their wedding, yet completely differently from each other. The woman is veiled as a bride would be, and while waiting for her groom in the bridal chamber, she thinks of the son she hopes to bear. This is implied in her gaze toward the shield. Meanwhile, her husband is shown as the ruler on his throne. On this basis, Smith looks for a king who, at the time of the birth of his successor, was not yet king (hence the lack of a diadem) and comes to the tentative conclusion that he must be "certainly Macedonian, and probably Antigonid."[12] But this conclusion, even if it is right, only applies to the Hellenistic original that must be the source of our paintings. We do not know whether that original has been faithfully copied at Boscoreale (as Smith has to assume) or rather, as I suspect, only in excerpts. One may also doubt if the owner of a *villa rustica* on the slopes of Vesuvius could have understood such a specific and highly

FIG. 11. Fresco panel from the Villa of P. Fannius Synistor at Boscoreale, room H, right side. The Metropolitan Museum of Art, New York, Rogers Fund, 1903 (03.14.7)

complex narrative program. He could instead have simply commissioned from the painters' workshop a "majestic interior, one that makes explicit the regal associations of the architectural paintings."[13]

Only small fragments survive from the front wall of Room H (fig. 12). The articulation of the wall was the same as on the sides, but in this case, more of what remains comes from the upper section, with the capitals of the row of columns and the view into the columned hall lying

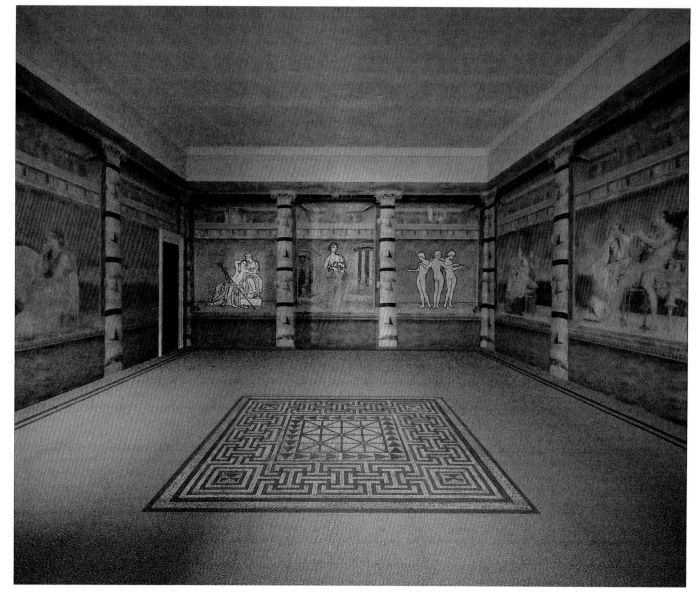

FIG. 12. Virtual model of the Villa of P. Fannius Synistor, room H, looking north

beyond the painted wall. In addition, there are two (originally three) small panel paintings (*pinakes*) with images of open shrines. The figures on the left-hand *pinax* seem to be, once again, Macedonia and Asia, that is, a replica in miniature of the large painting. The right-hand *pinax* shows a woman with her chin propped on her hand and, next to her, a second woman wrapped in a blue mantle and unarmed. Both are looking at an object set before them, possibly an altar. Thus, at least one of these two pictures relates to the large-scale paintings on the right wall. But are they in fact also connected to the three big pictures immediately below them?

Of these three, only one is preserved, and then only in part. Aphrodite stands in the middle on a socle, on which the pilasters that frame the picture also stand. The goddess's right foot rests on a podium, suggesting that she is a statue. She wears a yellow mantle and a light colored garment underneath, and she holds the boy Eros in one arm.

FIG. 13. Detail of fresco panel from the Villa of P. Fannius Synistor at Boscoreale, room L, west wall. The Metropolitan Museum of Art, New York, Rogers Fund, 1903 (03.14.4)

In the landscape behind, we can make out a building on the left with two columns and a female statue in front of them. On the right are the remains of a round temple on an island. Three small figures, two Erotes and a Psyche, can be seen on the steps of the temple. The now lost pictures on either side could apparently still be read at the time of the excavation. Barnabei describes them as Ariadne with Dionysos reclining against her and the Three Graces, both groups following familiar statue types.[14]

Starting from the two *pinakes* over the wall, Smith attempts to combine the large paintings on the front wall with those on the side walls into a unified program. Along with Aphrodite and the Three Graces, he interprets the Dionysos and Ariadne group as a mythological paradigm for a happy wedding. I would, instead, place more weight on the fact that these divinities are represented very differently, as statues, and thus, I would associate the imagery more directly with the real life of the villa's occupants and their guests at dinner. Dionysos, Aphrodite, and the Graces are, after all, the gods who preside over joie de vivre and the enjoyment of the here and now.

I skip over the small Room I and proceed to Room L, which opens onto the porticus. Here again, we glimpse objects that conjure a sanctuary (fig. 13). Garlands hang from bucrania before the wall divided into sections by pilasters, and from the branches hang objects that all refer

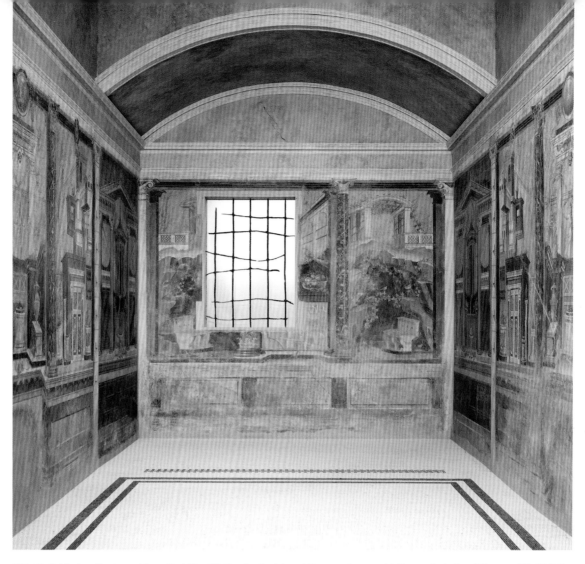

FIG. 14. Cubiculum (bedroom) from the Villa of P. Fannius Synistor at Boscoreale, room M. Roman, Late Republican, ca. 50–40 B.C. Frescoes, 8 ft. 8½ in. x 10 ft. 11½ in. x 19 ft. 7⅛ in. (265.4 x 334 x 583.9 cm). The Metropolitan Museum of Art, New York, Rogers Fund, 1903 (03.14.13a–g)

to the cult of Dionysos. On a section of the wall now in the Metropolitan Museum, the hanging objects include a *cista mystica* with slithering snake, a satyr mask, and a small bell; on the fragment in Mariemont, an animal hide, another little bell, and satyr head; and on the fragment in Amiens, a large bell and double flute.

We come to the last two rooms, first room N at the extreme left, where little remains of the decoration, but enough to gain an idea of what it once would have looked like. Again, the articulation of the walls was composed of vistas behind painted columns, and, at least in the final phase, there was a large window providing a view into the surrounding countryside. On the only two fragments that

survive, sacred landscapes with temples and altars can be seen on a red ground.

The almost fully preserved paintings from the *cubiculum* (Room M) have been impressively reconstructed in the Metropolitan (fig. 14). Since the large window crudely punctures frescoed walls and is, furthermore, not compatible with a typical bedroom, I am assuming that the window was added in a later phase, when the room was no longer being used as a *cubiculum*. Its original function was as a place one could withdraw to and relax. For the modern viewer, the effect of this plethora of pictures is rather ambivalent; one can only admire the frescoes, yet at the same time, their density and proximity can be oppressive.

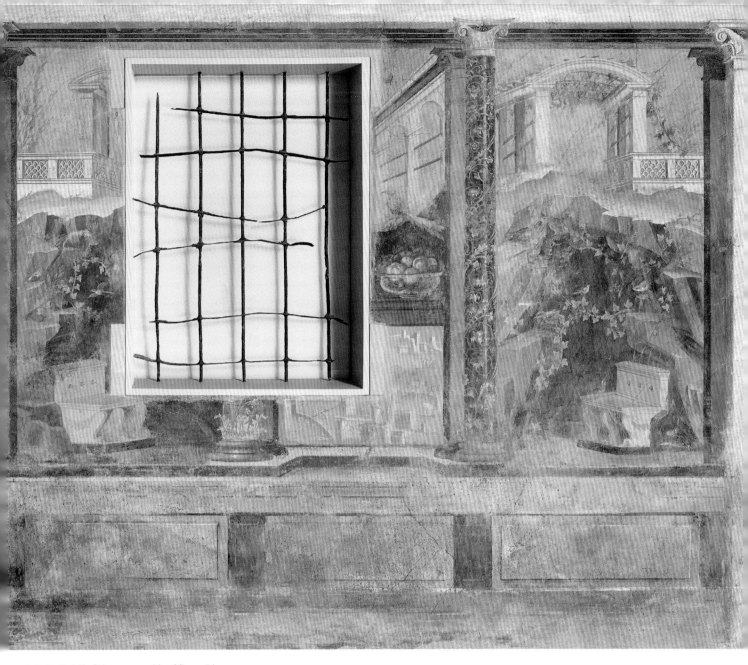

FIG. 15. Detail of the narrow side of figure 14

On the narrow side of the room, we see three vistas, divided from one another by red columns with gilded vines spiraling around them and by pilasters. To the left and right are mirror images of the same park. Between the columns, we see the remains of a kind of windowsill with a lovely glass bowl of fruit resting on it. Above it, the view again takes us into a park with a pavilion similar to those in the pictures on either side. In the fully preserved picture at right, the view opens to a grotto overgrown with vines, a

marble fountain with three spouts placed before it (fig. 15). Inside the cave, we can make out the statue of a goddess standing on a tall podium. Above the cave is a marble pavilion, overgrown with ivy, and a fence, also marble, which separates the garden from the open fields beyond.

When the villa owner lay down on the couch, his thoughts were carried into a very different world. When facing the walls of both sides of the room, he was looking into two different shrines. Directly before him, he saw a

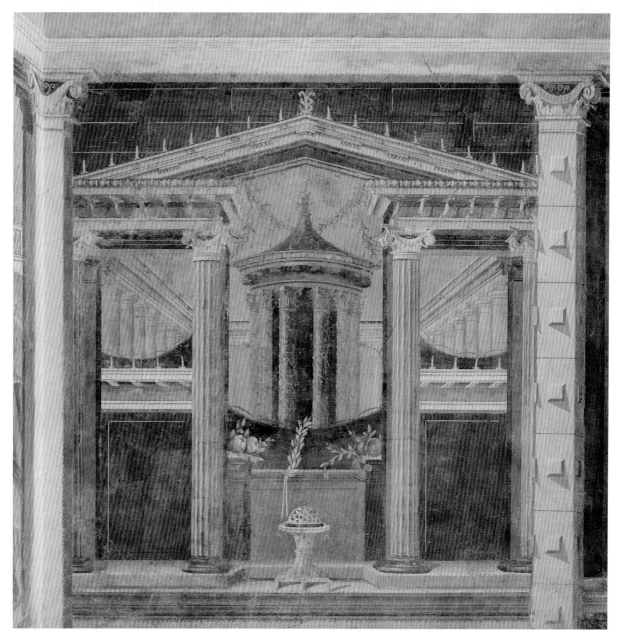

FIG. 16. Detail of the left side of the right wall of figure 14

round temple encircled by columns (fig. 16). But his gaze was denied access to the sacred precinct, because it is closed off by a wall going halfway up, topped by a molding, on either side and an entryway in the middle with a garland hanging above. In front stands a small incense altar, while votive offerings of garlands and fruit standing on pilasters to the left and right would have inspired the ancient viewer to prayer. This same urge would have come over him as he stood in the middle of the room and looked at the sequence of three pictures on the long walls. Once again, he saw the same scenes on both sides, a sanctuary with an Egyptianizing pillar monument and a bronze statue. The one on the left wall, in archaizing style, holding torches in her outstretched hands, represents either Artemis or Hekate. The goddess stands in a sacred grove surrounded on either side by turreted houses and porticoes rising to the sky. Access to this shrine is barred as well, by gates under the superimposed houses at left and right, and

by a sealed entryway in the middle, with an altar on which the sacrificial fire burns. Further offerings, in the form of golden vessels, stand on stone benches.

And yet, as similar as the two side-walls are, one crucial difference is to be found in the bronze statues depicted in the center. On the left wall is the goddess with the torches, while the other is either a priestess performing a sacrifice or an assistant. She holds a tray of offerings in her left hand and reaches out her right in a gesture of prayer toward the goddess on the opposite wall (figs. 17 and 18). The same figure appears on a wall of the Villa at Oplontis (Torre Annunziata), a clear indication that the painters' workshops had at their disposal a limited range of particular figure types from which the patron could choose. This should warn us to be cautious of overly specific interpretations.

Why, then, did the owner of this *villa rustica* have such rich assemblages of images, with fantasy architecture, painted on his walls, not only in the *cubiculum*, but in all the rooms intended for display? And was he but one among many such patrons who favored these kinds of frescoes, also found in the Villa at Oplontis, as well as more modest houses in Pompeii, Rome, and farther afield? We seem to be dealing with a genuine fashion trend in the middle of the first century B.C. To be sure, the scene of Asia,

Macedonia, and of a Hellenistic royal family, all in life-size figures, is thus far unique, but this could be an accident of preservation. We can see evidence of the same phenomenon in the portraits of Hellenistic rulers set up by the Senator and Consul for the year 15 B.C., L. Calpurnius Piso, in his villa at Herculaneum, alongside Greek military commanders, poets, and philosophers.[15]

The frescoes from our *villa rustica* and its contemporaries in the period of the Second Style raise questions that have barely been addressed in the scholarship. One question pertains to the political and social situation around the middle of the first century B.C., another to the mentality of the Roman aristocracy of the period. I cannot go into these topics here, only raise the questions and call attention to some possible new perspectives.

When Julius Caesar had himself named *dictator perpetuus*, his followers saw in him the creation of a monarchy, and his opponents murdered him precisely because they did not want a state of one-man rule. A number of the aristocracy, like Cicero, who had earlier been such ardent republicans, acknowledged the battle for supremacy of a few military commanders and became partisans of one or another of these. In this situation, all the imagery drawn from Hellenistic royal residences with their grand reception

rooms, and even of a Hellenistic royal family, must have been understood by both aristocrats and ordinary people in the context of contemporary events and the mood of the times. Rome had become the ruler of the Mediterranean, and her republican constitution now existed only on paper.

It is, nevertheless, striking that the vistas into sanctuaries and offerings and even altars in our villa take on such a central role. These images must have inspired the viewer's fantasy with an immediacy that was hard to escape. But we need to ask ourselves whether, alongside all the fascination with Hellenistic architectural prospects and Hellenistic rulers, the paintings were not intended to arouse and satisfy feelings of religious piety. The sacred precincts are closed off, but right before the viewer's eyes are votive offerings, even altars burning such offerings. Yet nowhere do we see any people, so that the role of the worshipper standing before an altar falls to the viewer standing before the image. What is the meaning of all these references to pious behavior? Are they not an expression of a religious attitude and religious needs?

In any case, we cannot reconstruct the thought processes of contemporary Romans, but only observe certain phenomena and make conjectures. Besides, it was only a relatively short period during which rooms were decorated in this manner. Once Augustus came to power, the decorative styles changed radically. Depictions of architecture became highly mannered, and there are small scenes of romantic landscapes and Egyptianizing motifs, such as from the cubiculum at Boscotrecase, on view in the Metropolitan Museum.[16] By the 20s B.C. at the latest, the owners of houses and villas no longer had scenes of small sanctuaries, Hellenistic style audience halls, or royal families on their walls, but rather mythological subjects that have at best a personal association with the lives of individuals and not with matters of politics and society. In the meantime, Octavian had established himself as sole ruler in Rome, even if in the guise of a *res publica restituta*, for which he was granted the honorific title Augustus. There was no longer a need to dream about monarchs and kings, for now the Romans had one of their own, even if he was known by another name. He lived on the Palatine, directly beside the temple of his patron god, Apollo. It was not long before the Romans were allowed to—then required to—worship him and most of his successors as divinities of the state.

1. Bergmann 2013.

2. Bergmann et al. 2010; Stanton-Abbott Associates, "Villa at Boscoreale, Pompeii, Italy," Computer-Render website, http://www.computer-render.com/Pages/Bosco_1.html. See also Baker et al. 2013.

3. Barbet and Verbanck-Piérard 2013, vol. 1.

4. Barnabei 1901.

5. Barbet 2013.

6. Eva Dubois-Pelerin in Barbet and Verbanck-Piérard 2013, vol. 1, pp. 43–51, pls. 14–17.

7. There is a very similar motif in one of the rooms of the large Villa at Oplontis; see De Franciscis 1975, fig. 23.

8. Eva Dubois-Pelerin in Barbet and Verbanck-Piérard 2013, vol. 1, pp. 52–63, pls. 18–21.

9. R. R. Smith 1994, pp. 109–13.

10. Bergmann 2010, p. 25, figs. 40, 41; Eva Dubois-Pelerin in Barbet and Verbanck-Piérard 2013, vol. 1, pl. 18a, b; Stanton-Abbott Associates, "Villa at Boscoreale, Pompeii, Italy," Computer-Render website, http://www.computer-render.com/Pages/Bosco_1.html.

11. Fittschen 1975, p. 100, appendix. In the most recent discussion, Palagia (2014b) adduces comparable wall paintings in well-known Macedonian tombs of the late fourth century. However, I think it would be a mistake to assume that these are directly connected to, or even imitated in, the Villa at Boscoreale.

12. R. R. Smith 1994, p. 125.

13. Ibid., p. 126.

14. Barnabei 1901, pp. 54–55.

15. Pantermalis 1971, pp. 173–209; Neudecker 1988, pp. 110–14.

16. Roman, Pompeian, Early Imperial, Augustan, last decade of the 1st century B.C. Fresco, 91¾ x 45in. (233.1 x 114.3 cm). The Metropolitan Museum of Art, New York, Rogers Fund, 1920 (20.192.1-17); see Blanckenhagen and Alexander 1990.

BIBLIOGRAPHY

Abadie-Reynal 2003
Catherine Abadie-Reynal, ed. *Les céramiques en Anatolie aux époques hellénistique et romaine: Actes de la table ronde d'Istanbul, 22–24 mai 1996*. Varia Anatolica 15. Istanbul and Paris.

Abeken 1839
Guglielmo (William Ludwig) Abeken. "Terrecotte di Ruvo." *Annali dell' Istituto di Corrispondenza Archeologica* 2, no. 2, pp. 223–28.

Adam-Veleni 2000
Polyxeni Adam-Veleni. "Metallio Athinas kai tesseris kephales zoov apo ti Thessaloniki" [Medallion of Athena and four heads of animals from Thessaloniki]. In *Myrtos: Meletes sti mnimi tis Ioulias Vokotopoulou* [Myrtos: Studies in memory of Julia Vokotopoulou], pp. 141–57. Thessaloniki.

Adriani 1967
Achille Adriani. "Un vetro dorato alessandrino dal Caucaso." *Bulletin de la Société archéologique d'Alexandrie* 42, pp. 105–27.

Aghion 1993
Irène Aghion. "Caylus au travail: A propos de la trouvaille de Chalon." *Eutopia* 2, no. 2, pp. 163–79.

Aghion and Hellmann 1988
Irène Aghion and Marie-Christine Hellmann, eds. *Vrai ou faux?: Copier, imiter, falsifier*. Exh. cat. Paris. 2nd rev. ed., 1991.

Ahrens 1968
Dieter Ahrens. "Bericht der staatlichen Kunstsammlungen: Neuerwerbungen; Staatliche Antikensammlungen und Glyptothek." *Münchner Jahrbuch der bildenden Kunst* 19, pp. 229–33.

Alexandropoulou 2002
Anna Alexandropoulou. *Gnathia- und Westabhangkeramik: Eine vergleichende Betrachtung*. Münster.

Alfaro and Karali 2008
Carmen Alfaro and Lilian Karali, eds. *Vestidos, textiles y tintes: Estudios sobre la producción de bienes de consumo en la antigüedad; Actas del 2. Symposium internacional sobre textiles y tintes del mediterráneo en el mundo antiguo*. Purpurae Vestes 2. Valencia.

Alfaro, Wild, and Costa 2004
Carmen Alfaro, John Peter Wild, and Benjamin Costa, eds. *Actas del 1 Symposium internacional sobre textiles y tintes del mediterráneo en época romana*. Purpurae Vestes 1. Valencia.

Amandry 1953
Pierre Amandry. *Collection Hélène Stathatos*. Vol. 1, *Bijoux antiques*. Strasbourg.

Ancient Art from the Shumei Family Collection 1996
Ancient Art from the Shumei Family Collection. Exh. cat. New York.

Andrade forthcoming
Nathanael Andrade. "The Silver Coins of Syrian Manbog (Hierapolis-Bambyke)." *American Journal of Numismatics* 29.

Andreae 2001
Bernard Andreae. *Skulptur des Hellenismus*. Munich.

Andreae 2003
Bernard Andreae. *Antike Bildmosaiken*. Mainz am Rhein.

Andreae and Kyrieleis 1975
Bernard Andreae and Helmut Kyrieleis, eds. *Neue Forschungen in Pompeji und den anderen vom Vesuvausbruch 79 n. Chr. verschütteten Städten: Selected Papers from a Meeting Organized by the Deutsches Archäologisches Institut and the Gemeinnütziger Verein Villa Hügel, June 11–14, 1973*. Recklinghausen.

Andreassi 2013
Giuseppe Andreassi. "*Plakettenvasen*: Una proposta di catalogo su base morfologica." In *Vetustis novitatem dare: Temi di antichità e archeologia in ricordo di Grazia Angela Maruggi*, edited by Giuseppe Andreassi, Assunta Cocchiaro, and Antonietta Dell'Aglio, pp. 25–50. Taranto.

Andrianou 2012
Dimitra Andrianou. "Eternal Comfort: Funerary Textiles in Late Classical and Hellenistic Greece." In Carroll and Wild 2012, pp. 42–61.

Andronikos 1984
Manolis Andronikos. *Vergina: The Royal Tombs and the Ancient City*. Translated by Louise Turner. Athens.

Antiken Bronzen 2000
Antiken Bronzen, Werkstattkreise: Figuren und Geräte; Akten des 14. Internationalen Kongresses für Antike Bronzen in Köln, 21. bis 24. September 1999. Kölner Jahrbuch 33. Berlin.

Antiken Gemmen 1998
Antiken Gemmen in deutschen Sammlungen: Berlin, Braunschweig, Göttingen, Hamburg, Hannover, Kassel, München. Vol. 3. Munich.

Apollonios 1967
Apollonios of Rhodes. *The Argonautica*. Translated by R. C. Seaton. Cambridge, Mass., and London. First printed 1912.

Arbeid and Iozzo 2015
Barbara Arbeid and Mario Iozzo, eds. *Piccoli grandi bronzi: Capolavori greci, etruschi e romani delle collezioni mediceo-lorenesi nel Museo Archeologico Nazionale di Firenze*. Exh. cat. Florence.

Arnold 1995
Dorothea Arnold. "An Egyptian Bestiary." *The Metropolitan Museum of Art Bulletin*, n. s., 52, no. 4 (Spring).

Arnold-Biucchi 2006
Carmen Arnold-Biucchi. *Alexander's Coins and Alexander's Image*. Cambridge, Mass.

Arveiller-Dulong and Nenna 2000
Véronique Arveiller-Dulong and Marie-Dominique Nenna. *Les verres antiques*. Vol. 1, *Contenants à parfum en verre moulé sur noyau et vaisselle moulée VIIe siècle avant J.-C.–Ier siècle après J.-C*. Paris.

Association Internationale pour l'Histoire du Verre 2000
Annales du 14e congrès de l'Association internationale pour l'Histoire du Verre, Italia / Venezia–Milano 1998. Lochem.

Aucouturier, Mathis, and Robcis 2017
Marc Aucouturier, François Mathis, and Dominique Robcis. "Les bronzes noirs antiques: Nouvelles observations et mécanismes de création." In "Bronzes grecs et romains: Etudes récentes sur la statuaire antique," edited by Sophie Descamps-Lequime and Benoît Mille. Special issue, *Technè* 45, pp. 115–23.

Auinger 2015
Johanna Auinger, " '... Zwei überlebensgrosse wohlerhaltene Köpfe ...' aus dem Gymnasion von Pergamon: Zum Fundort des Herrscherporträts AvP VII 130 und des Herakleskopfes Sk 1675." In Grüssinger et al. 2015, pp. 64–69.

Austin and Bastianini 2002
Colin Austin and Guido Bastianini. *Posidippi Pellaei quae supersunt omnia*. Biblioteca Classica 3. Milan.

Auth 1983
Susan H. Auth. "Luxury Glasses with Alexandrian Motifs." *Journal of Glass Studies* 25, pp. 39–44.

Bairami 2015
Kalliope Bairami. "Rhodes and Pergamon: Affinities in Large-Scale Sculpture." In Grüssinger et al. 2015, pp. 156–64.

Baker et al. 2013
Drew Baker, Richard Beacham, Martin Blazeby, and Hugh Denard. "The Digital Visualisation of the Villa at Boscoreale." In Barbet and Verbanck-Piérard 2013, vol. 2, pp. 165–95.

Barattolo 1974–75
Andrea Barattolo. "Sulla decorazione delle celle del Tempio di Venere e di Roma all'epoca di Adriano." *Bullettino della Commissione Archeologica Comunale di Roma* 84, pp. 133–48.

Barattolo 1982
Andrea Barattolo. "Afrodisia e Roma: Nuove testimonianze per la storia della decorazione architettonica." *Mitteilungen des Deutschen Archäologischen Instituts, Römische Abteilung* 89, pp. 133–51.

Barbet 2013
Alix Barbet. "Reconstitution et Restitution des Peintures de Boscoreale." In Barbet and Verbanck-Piérard 2013, vol. 2, pp. 149–63.

Barbet and Verbanck-Piérard 2013
Alix Barbet and Annie Verbanck-Piérard, eds. *La villa romaine de Boscoreale et ses fresques.* 2 vols. Arles.

Barnabei 1901
Felice Barnabei. *La villa pompeiana di P. Fannio Sinistore scoperta presso Boscoreale: Relazione a s. e. il Ministro dell'Istruzione Pubblica con una memoria.* Rome.

Barr-Sharrar 1994
Beryl Barr- Sharrar. "Five Decorative Busts." In Hellenkemper Salies 1994, pp. 551–58.

Barr-Sharrar 2016
Beryl Barr-Sharrar. Response to Brunilde Ridgway on Daehner and Lapatin 2015 from September 2, 2015. *Bryn Mawr Classical Review,* open access online journal, February 29, 2016. http://bmcr.brynmawr .edu/2016/2016-02-29.html.

Barringer 2001
Judith M. Barringer. *The Hunt in Ancient Greece.* Baltimore and London.

Bartman 1986
Elizabeth Bartman. "Miniature Copies: Copyist Invention in Hellenistic and Roman Periods." PhD diss., Columbia University, New York.

Bartman 1992
Elizabeth Bartman. *Ancient Sculptural Copies in Miniature.* Columbia Studies in the Classical Tradition 19. Leiden.

Beazley 1920
John Davidson Beazley. *The Lewes House Collection of Ancient Gems* [Catalogue of Mr. E. P. Warren's Collection of Ancient Gems]. Oxford.

Beazley 1963
John Davidson Beazley. *Attic Red-Figure Vase-Painters.* 3 vols. 2nd ed. Oxford.

Beck, Bol, and Bückling 2005
Herbert Beck, Peter C. Bol, and Maraike Bückling, eds. *Ägypten Griechenland Rom: Abwehr und Berührung.* Exh. cat. Frankfurt and Tübingen.

Benda-Weber 2013
Isabella Benda-Weber. "Textile Production Centres, Products and Merchants in the Roman Province of Asia." In Gleba and Pásztókai-Szeöke 2013, pp. 171–91.

Bergemann 1990
Johannes Bergemann. *Römische Reiterstatuen: Ehrendenkmäler im öffentlichen Bereich.* Beiträge zur Erschliessung Hellenistischer und Kaiserzeitlicher Skulptur und Architektur 11. Mainz am Rhein.

Bergmann 2010
Bettina Bergmann. "New Perspectives on the Villa of Publius Fannius Synistor at Boscoreale." In Bergmann et al. 2010, pp. 11–32.

Bergmann 2013
Bettina Bergmann. "*Realia*: Portable and Painted Objects from the Villa of Boscoreale." In Barbet and Verbanck-Piérard 2013, vol. 2, pp. 79–103.

Bergmann et al. 2010
Bettina Bergmann, Stefano De Caro, Joan R. Mertens, and Rudolf Meyer. "Roman Frescoes from Boscoreale: The Villa of Publius Fannius Synistor in Reality and Virtual Reality." *The Metropolitan Museum of Art Bulletin* 67, no. 4 (Spring).

Bernoulli and Burckhardt 1907
Johann Jakob Bernoulli and Rudolf Burckhardt. *Die Gipsabgüsse in der Skulpturhalle zu Basel.* 2 vols. Basel.

Bessi 2005
Benedetta Bessi. "Il *lagynos*: Una forma 'dionysiaca.'" *Rendiconti* (Accademia Nazionale dei Lincei, Classe di Scienze Morali, Storiche e Filologiche), ser. 9, 16, no. 2, pp. 241–75.

Bhandare 2007
Shailendra Bhandare. "Not Just a Pretty Face: Interpretations of Alexander's Numismatic Imagery in the Hellenistic East." In *Memory as History: The Legacy of Alexander in Asia,* edited by Himanshu Prabha Ray and Daniel T. Potts, pp. 208–56. New Delhi.

Bianchi 2010
Fulvia Bianchi. "Il tempio di Giove Statore e la scena del teatro di Marcello: Maestranze e modelli decorativi tra epoca tardo repubblicana e media età imperiale." *Atti della Accademia nazionale dei Lincei: Classe di scienze morali, storiche e filologiche; Rendiconti* 21, pp. 285–321.

Bianchi Bandinelli 1977
Ranuccio Bianchi Bandinelli, ed. *La cultura ellenistica.* Vol. 2, *Le arti figurative.* Storia e Civiltà dei Greci 10. Milan.

Bieber 1964
Margarete Bieber. *Alexander the Great in Greek and Roman Art.* Argonaut Library of Antiquities. Chicago.

Bilde 1995
Pia Guldager Bilde. "The Sanctuary of Diana Nemorensis: The Late Republican Acrolithic Cult Statues." *Acta archaeologica* 66, pp. 191–217.

Bilde 2000
Pia Guldager Bilde. "The Sculptures from the Sanctuary of Diana Nemorensis; Types and Contextualisation: An Overview." In Brandt, Leander Touati, and Zahle 2000, pp. 93–110.

Bilde 2010
Pia Guldager Bilde. "Mouldmade Bowls." In *The Lower City of Olbia (Sector NGS) in the 6th Century BC to the 4th Century AD,* edited by Nina A. Lejpunskaja, Pia Guldager Bilde, Jakob Munk Højte, Valentina V. Krapivina, and Sergej D. Kryžickij, vol. 1, pp. 269–88. Black Sea Studies 13. Aarhus.

Bilde and Lawall 2014
Pia Guldager Bilde and Mark L. Lawall, eds. *Pottery, Peoples and Places: Study and Interpretation of Late Hellenistic Pottery.* Black Sea Studies 16. Aarhus.

Bilde and Moltesen 2002
Pia Guldager Bilde and Mette Moltesen. *A Catalogue of Sculptures from the Sanctuary of Diana Nemorensis in the University of Pennsylvania Museum, Philadelphia.* Analecta Romana Instituti Danici, Supplementum 29. Rome.

Bimson and Werner 1969
Mavis Bimson and A. E. Werner. "The Canosa Group of Hellenistic Glasses in the British Museum: Technical Observations on the Sandwich Gold-Glass Bowls." *Journal of Glass Studies* 11, pp. 125–26.

Bingöl 1999
F. R. Işık Bingöl. *Ancient Jewellery.* Ankara.

Blagg 1983
Thomas F. C. Blagg. *Mysteries of Diana: The Antiquities from Nemi in Nottingham Museums.* Nottingham, U.K.

Blanckenhagen and Alexander 1990
Peter Heinrich von Blanckenhagen and Christine Alexander. *The Augustan Villa at Boscotrecase.* With contributions by Joan R. Mertens and Christel Faltermeier. Deutsches Archäologisches Institut, Römische Abteilung, Sonderschriften 8. Mainz am Rhein.

Blass 2002
Bill Blass. *Bare Blass.* Edited by Cathy Horyn. New York.

Blömer and Nieswandt 2016
Michael Blömer and Heinz-Helge Nieswandt. "Atargatis und Alexander der Große: Ikonographische Überlegungen zu einer Münze aus Manbij/Hierapolis." In *"Man kann es sich nicht prächtig genug vorstellen!": Festschrift für Dieter Salzmann zum 65. Geburtstag,* edited by Holger Schwarzer and Heinz-Helge Nieswandt, vol. 1, pp. 13–30. Marsberg.

Blomme et al. 2017
A. Blomme, P. Degryse, E. Dotsika, Despina Ignatiadou, A. Longinelli, and A. Silvestri. "Provenance of Polychrome and Colourless 8th–4th century BC Glass from Pieria, Greece: A Chemical and Isotopic Approach." *Journal of Archaeological Science* 78, pp. 134–46.

Blum 1998
Hartmut Blum. *Purpur als Statussymbol in der griechischen Welt.* Antiquitas ser. 1; Abhandlungen zur alten Geschichte 47. Bonn.

Boardman 1975
John Boardman. *Intaglios and Rings: Greek, Etruscan and Eastern; From a Private Collection.* London.

Boardman 2001
John Boardman. *The History of Greek Vases: Potters, Painters and Pictures.* London.

Boardman 2015
John Boardman. *The Greeks in Asia.* London.

Boardman and Vollenweider 1978
John Boardman and Marie-Louise Vollenweider. *Catalogue of the Engraved Gems and Finger Rings: Ashmolean Museum, Oxford.* Vol. 1, *Greek and Etruscan.* Oxford.

Boehringer and Krauss 1937
Erich Boehringer and Friedrich Krauss. *Das Temenos für den Herrscherkult: Prinzessinnen Palais.* Altertümer von Pergamon 9. Berlin.

Bol 1988
Peter C. Bol. "Die marmorbüsten aus dem Heroon von Kalydon in Agrinion: Archäologisches Museum Inv. Nr. 28–36." *Antike Plastik* 19, pp. 35–47.

Bol 2007
Peter C. Bol, ed. *Hellenistische Plastik.* Vol. 3 of *Die Geschichte der antiken Bildhauerkunst.* Mainz am Rhein.

Bolender 2000
Ute Maria Bolender. "Repräsentation von negroiden Typen (Aethiopen) in hellenistischen Bronzen." In *Antiken Bronzen* 2000, pp. 91–101.

Bolla 1998
Margherita Bolla. "Bronzi figurati romani acquistati in Egitto." *Rassegna di Studi del civico museo archeologico e del civico gabinetto numismatico di Milano,* nos. 61–62, pp. 7–37.

Bonanome 1995
Daniela Bonanome. *Il rilievo da Mondragone nel museo nazionale di Napoli.* Monumenti 10. Naples.

Bonner 1944
Campbell Bonner. "Eros and the Wounded Lion." *American Journal of Archaeology* 49 (October–December), pp. 441–44.

Bopearachchi 2017
Osmund Bopearachchi. "Alexandre le Grand et les portraits des souverains Indo-grecs." In *Bilder der Macht: Das griechische Porträt und seine Verwendung in der antiken Welt,* edited by Dietrich Boschung and François Queyrel, pp. 255–66. Morphomata 34. Paderborn.

Boschetti 2011
Cristina Boschetti. "Vitreous Materials in Early Mosaics in Italy: Faience, Egyptian Blue, and Glass." *Journal of Glass Studies* 53, pp. 59–91.

Bossert 1983
Martin Bossert. *Die Rundskulpturen von Aventicum.* Acta Bernensia 9. Bern.

Boube 1986
Jean Boube. "Modèles antiques en plâtre près de Sala (Maroc)." *Revue archéologique,* n.s., no. 2, pp. 301–26.

Boucher 1976
Stéphanie Boucher. *Recherches sur les bronzes figurés de Gaule pré-romaine et romaine.* Bibliothèque de l'Ecole Française de Rome 228. Rome.

Bounegru 2003
Octavian Bounegru. "La production des ateliers de céramique de Pergame (vallée de Kestel): Un aperçu general." In Abadie-Reynal 2003, pp. 137–40.

Bouquillon et al. 2006
Anne Bouquillon, Sophie Descamps, Antoine Hermary, and Benoit Mille. "Une nouvelle étude de l'Apollon Chatsworth." *Revue archéologique* 42, no. 4 (January), pp. 227–61.

Bouzek and Jansová 1974
Jan Bouzek and Libuše Jansová. "Megarian Bowls." In *Anatolian Collection of Charles University: Kyme 1,* edited by Jan Bouzek, pp. 13–76. Prague.

Bracey 2011
Robert Bracey. Review of Holt and Bopearachchi 2011. *Numismatic Chronicle* 171, pp. 487–94.

Braconi et al. 2013
Paolo Braconi, Filippo Coarelli, Francesca Diosono, and Giuseppina Ghini, eds. *Il santuario di Diana a Nemi: Le terrazze e il ninfeo; Scavi 1989–2009.* Studia Archaeologica 194. Rome.

Bradley 2011
Mark Bradley. "Obesity, Corpulence and Emaciation in Roman Art." *Papers of the British School at Rome* 79, pp. 1–41.

Brandt, Leander Touati, and Zahle 2000
J. Rasmus Brandt, Anne-Marie Leander Touati, and Jan Zahle, eds. *Nemi, Status Quo: Recent Research at Nemi and the Sanctuary of Diana.* Occasional Papers of the Nordic Institutes in Rome 1. Rome.

Braun 1854
August Emil Braun. *Vorschule der Kunstmythologie.* Gotha.

Brill 1999
Robert H. Brill. *Chemical Analyses of Early Glasses.* Vol. 1, *Catalogue of Samples,* and vol. 2, *Tables of Analyses.* Corning, New York.

Brill and Stapleton 2012
Robert H. Brill and Colleen P. Stapleton. *Chemical Analyses of Early Glasses.* Vol. 3, *The Years 2000–2011, Reports, and Essays.* Corning, New York.

Brown 1957
Blanche R. Brown. *Ptolemaic Paintings and Mosaics and the Alexandrian Style.* Monographs on Archaeology and Fine Arts 8. Cambridge, Mass.

Bühler 1973
Hans-Peter Bühler. *Antike Gefässe aus Edelstein.* Mainz.

Burkert 1966
Walter Burkert. "Greek Tragedy and Sacrificial Ritual." *Greek, Roman, and Byzantine Studies* 7, no. 2, pp. 87–121.

Burkert 1983
Walter Burkert. *Homo necans: The Anthropology of Ancient Greek Sacrificial Ritual and Myth.* Translated by Peter Bing. Berkeley.

Busz and Gercke 1999
Ralf Busz and Peter Gercke, eds. *Türkis und Azur: Quarzkeramik im Orient und Okzident.* Exh. cat. Wolfratshausen and Kassel.

Caetani Lovatelli 1881
Ersilia Caetani Lovatelli, "Un'antica stele votiva con Minerva di bassorilievo avente sul capo la gorgone." *Bullettino della commissione archeologica comunale di Roma,* ser. 2, 5 (January–December), pp. 225–37.

Cagnat 1901–27
René Cagnat. *Inscriptiones graecae ad res romanas pertinentes.* 4 vols. Paris.

Caliò 2003
Luigi Maria Caliò. "La scuola architettonica di Rodi e l'ellenismo italico." In *Santuari e luoghi di culto nell'Italia antica,* edited by Lorenzo Quilici and Stefania Quilici Gigli, pp. 53–74. Atlante Tematico di Topografia Antica 12. Rome.

Camp 2001
John M. Camp. *The Archaeology of Athens.* New Haven and London.

Cananzi 1906
Antonio Cananzi. *Appunti sopra una meravigliosa coppa da libazione decorata con disegni di stile arcaico a laminette di oro, messe a mosaico fra due vetri … rivenuta … in una tomba … della provincia di Reggio Calabria (Italia) e note sulla necropoli sudetta, etc.* Messina.

Canepa 2015
Matthew P. Canepa. "Bronze Sculpture in the Hellenistic East." In Daehner and Lapatin 2015, pp. 86–93.

Cardinali 1910
Giuseppe Cardinali. "La morte di Attalo III e la rivolta di Aristonico." In *Saggi di storia antica e di archeologia: A Giulio Beloch nel trentesimo dell' insegnamento nel Ateneo romano amici-colleghi-discepoli,* pp. 269–320. Rome.

Carpenter 1986
Thomas H. Carpenter. *Dionysian Imagery in Archaic Greek Art: Its Development in Black-Figure Vase Painting.* Oxford Monographs on Classical Archaeology. Oxford and New York.

Carpenter and Faraone 1996
Thomas H. Carpenter and Christopher A. Faraone. *Masks of Dionysus.* Myth and Poetics. Ithaca.

Carroll and Wild 2012
Maureen Carroll and John Peter Wild, eds. *Dressing the Dead in Classical Antiquity.* Stroud.

Carter 2015
Martha L. Carter. *Arts of the Hellenized East: Precious Metalwork and Gems of the Pre-Islamic Era.* With contributions by Prudence O. Harper and Pieter Meyers. London.

Cassimatis 1978
Hélène Cassimatis. "Héraklès et Lysippe: La descendance." *Bulletin de l'Institut français d'archéologie orientale* 78, pp. 541–64.

Castagnoli 1971
Ferdinando Castagnoli. *Orthogonal Town Planning in Antiquity.* Translated by Victor Caliandro. Cambridge, Mass.

Castelle, Bourgarit, and Bewer forthcoming
Manon Castelle, David Bourgarit and Francesca G. Bewer. "The *Lasagna* Method For Lost Wax Casting of Large 16th Century Bronzes: Searching for the Sources." In *Medieval Copper, Bronze and Brass: History, Archaeology and Archaeometry of the Production of Brass, Bronze and Other Copper Alloy Objects in Medieval Europe (12th–16th Centuries), Proceedings of the Symposium of Dinant and Namur, 15–17 May 2014,* edited by Nicolas Thomas and Pete Dandridge. Etudes et Documents, Archéologie. Namur.

Caubet 2009
Annie Caubet. "De l'Égypte à Suse, à propos de faïences perses achéménides." *Monuments et Mémoires de la Fondation Eugène Piot* 88, pp. 5–27.

Caubet and Pierrat-Bonnefois 2005
Annie Caubet and Geneviève Pierrat-Bonnefois, eds. *Faïences de l'antiquité: De l'Egypte à l'Iran.* Exh. cat. Paris and Milan.

Cavassa 2016
Laëtitia Cavassa. "Des pyxides en verre à décor peint à l'époque hellénistique (fin IVe–fin IIe siècle avant J.-C.)." *Journal of Glass Studies* 58, pp. 21–56.

Cesarin 2016
Giulia Cesarin. "Hunters on Horseback: New Version of the Macedonian Iconography in Ptolemaic Egypt." In *Alexander the Great and the East: History, Art, Tradition,* edited by Krzysztof Nawotka and Agnieszka Wojciechowska, pp. 41–50. Philippika 103. Wiesbaden.

Chapouthier 1935
Fernand Chapouthier. *Le sanctuaire des dieux de Samothrace.* Exploration Archéologique de Délos 16. Paris.

Charatzopoulou 2006
Catherine Charatzopoulou. "L'héroon de Kalydon revisité." In *Rois, cités, nécropoles: Institutions, rites et monuments en Macédoine; Actes des colloques de Nanterre (décembre 2002) et d'Athènes (janvier 2004),* edited by Anne-Marie Guimier-Sorbets, Miltiade B. Hatzopoulos, and Yvette Morizot, pp. 63–88. Meletemata 45. Athens.

Cherpion, Corteggiani, and Gout 2007
Nadine Cherpion, Jean-Pierre Corteggiani, and Jean-François Gout. *Le tombeau de Pétosiris à Touna el-Gebel: Relevé photographique.* Institut Français d'Archéologie Orientale du Caire, Bibliothèque Générale 27. Cairo.

Chioffi 2004
Laura Chioffi. "Attalica e altre auratae vestes a Roma." In Alfaro, Wild, and Costa 2004, pp. 89–95.

Christie's London 2017
Christie's London. *Old Master and British Paintings.* March 29.

Ciancio 1980
Angela Ciancio. "I vetri alessandrini rinvenuti a Canosa." In Ada Riccardi, Angela Ciancio, and Marcella Chelotti, *Canosa,* vol. 1, pp. 31–56. Studi sull'Antico 3. Bari.

Cicero 2003
Marcus Tullius Cicero. *Philippics I–II.* Edited by John T. Ramsey. Cambridge Greek and Latin Classics. Cambridge, U.K.

Cima and Tomei 2012
Maddalena Cima and Maria Antonietta Tomei, eds. *Vetri a Roma.* Exh. cat. Milan.

Coarelli 1977
Filippo Coarelli. "Arti minori." In Bianchi Bandinelli 1977, pp. 514–35.

Coarelli 1983
Filippo Coarelli. "I santuari del Lazio e della Campania tra i Gracchi e le guerre civili." In *Les "Bourgeoisies" municipales italiennes aux IIe et Ier siècles av. J.-C.: Centre Jean Bérard, Institut Français de Naples 7–10 décembre 1981,* pp. 217–40. Colloques Internationaux du Centre National de la Recherche Scientifique 609; Collection du Centre Jean Bérard 6. Paris and Naples.

Coarelli 2013
Filippo Coarelli. "L'acrolito maschile di Nemi a Nottingham: Asklepios o Virbius?" In Braconi et al. 2013, pp. 643–47.

Coarelli 2014
Filippo Coarelli. *La gloria dei vinti: Pergamo, Atene, Roma.* Exh cat. Milan.

Cohen 2006a
Beth Cohen. "Added Clay and Gilding in Athenian VasePainting." In Cohen 2006b, pp. 106–17.

Cohen 2006b
Beth Cohen, ed. *The Colors of Clay: Special Techniques in Athenian Vases.* Los Angeles.

Connelly 2010
Joan Breton Connelly. *Portrait of a Priestess: Women and Ritual in Ancient Greece.* Princeton, N.J., and Oxford.

Conze 1913
Alexander Conze. *Stadt und Landschaft.* Pt. 2, *Die Stadt.* Königliche Museen zu Berlin, Altertümer von Pergamon 1, no. 2. Berlin.

B. Cook 1966
Brian F. Cook. *Inscribed Hadra Vases in The Metropolitan Museum of Art.* Papers 12. New York.

R. Cook 1996
Robert Manuel Cook. *Greek Painted Pottery.* 3rd ed. New York.

Costamagna 1999
Liliana Costamagna. "Il terrazzo di Varapodio." In *Oppido Mamertina, Calabria, Italia: Ricerche archeologiche nel territorio e in contrada Mella,* edited by Liliana Costamagna and Paolo Visonà, pp. 139–42. Rome.

Cristofani 1966
Mauro Cristofani. "La coppa di Tresilico." *Klearchos* 8, pp. 63–79.

D'Alessio 2006
Alessandro D'Alessio. "Il santuario della Magna Mater dalla fondazione all'età imperiale: Sviluppo architettonico, funzioni e paesaggio urbano." *Scienze dell'antichità* 13, pp. 429–54.

D'Alessio 2011
Alessandro D'Alessio. "Spazio, funzioni e paesaggio nei santuari a terrazze italici di età tardo-repubblicana: Note per un *approccio sistematico* al linguaggio di una grande architettura." In D'Alessio and La Rocca 2011, pp. 51–86.

D'Alessio and La Rocca 2011
Alessandro D'Alessio and Eugenio La Rocca, eds. *Tradizione e innovazione: L'elaborazione del linguaggio ellenistico nell'architettura romana e italica di età tardo-repubblicana.* Studi Miscellanei 35. Rome.

D'Andria 1970
Francesco D'Andria. *I bronzi romani di Veleia, Parma e del territorio parmense.* Contributi dell'Instituto di Archeologia 3; Pubblicazioni dell'Università Cattolica del Sacro Cuore, Contributi, ser. 3, Scienze Storiche 13. Milan.

D'Arms 1995
John H. D'Arms. "Heavy Drinking and Drunkenness in the Roman World: Four Questions for Historians." In *In Vino Veritas,* edited by Oswyn Murray and Manuela Tecuşan, pp. 304–17. London.

Daehner and Lapatin 2015
Jens M. Daehner and Kenneth Lapatin, eds. *Power and Pathos: Bronze Sculpture of the Hellenistic World.* Exh. cat. Los Angeles.

Dahmen 2007
Karsten Dahmen. *The Legend of Alexander the Great on Greek and Roman Coins.* London and New York.

Damaskos 2002
Dimitris Damaskos. "Ein kolossaler Herakleskopf aus Sparta." *Antike Plastik* 28, pp. 117–24.

Damaskos 2016
Dimitris Damaskos. "Die Statue der Artemis-Bendis aus Amphipolis: Ein frühhellenistisches Kultbild?" *Antike Plastik* 31, pp. 33–40.

Daszewski 1985
Wiktor A. Daszewski. *Corpus of Mosaics from Egypt.* Vol. 1, *Hellenistic and Early Roman Period.* Aegyptiaca Treverensia 3. Mainz am Rhein.

Daux 1963
Georges Daux. "La grande Démarchie: Un nouveau calendrier sacrificiel d'Attique (Erchia)."*Bulletin de correspondance héllenique* 87, no. 2, pp. 603–34.

Daux 1964
Georges Daux. "Notes de lecture." *Bulletin de correspondance héllenique* 88, no. 2, pp. 676–79.

Daux 1983
Georges Daux. "Le calendrier de Thorikos au musée J. Paul Getty." *L'antiquité classique* 52, pp. 150–74.

De Franciscis 1975
Alfonso De Franciscis. "La villa romana di Oplontis." In Andreae and Kyrieleis 1975, pp. 9–19.

De Juliis 1989
Ettore M. De Juliis. *Gli ori di Taranto in età ellenistica.* Exh. cat. Milan.

de Luca 1990
Gioia de Luca. "Hellenistische Kunst in Pergamon im Spiegel der Megarischen Becher: Ein Beitrag zur pergamenischen Ornamentik." *Istanbuler Mitteilungen* (Deutsches Archäologisches Institut, Abteilung Istanbul) 40, pp. 157–66.

de Luca 1997
Gioia de Luca. "Tradierung von Bildthemen in den Werkstätten megarischer Becher in Pergamon." In *D'epistimoniki synantisi gia tin hellinistiki keramiki: Chronologika problimata, kleista synola—Ergastiria* [Fourth scientific meeting for Hellenistic pottery: Chronological problems, closed deposits—workshops], pp. 367–68. Athens.

de Luca 2011
Gioia de Luca. "Reliefkeramik: Die Megarischen Becher." In Grüssinger, V. Kästner, and Scholl 2011, pp. 362–65.

de Luca and Radt 1999
Gioia de Luca and Wolfgang Radt. *Sondagen im Fundament des grossen Altars.* Pergamenische Forschungen 12. Berlin.

de Luca and Ziegenaus 1968
Gioia de Luca and Oskar Ziegenaus. *Das Asklepieion.* Vol. 1, *Der südliche Temenosbezirk in hellenistischer und frührömischer Zeit.* Altertümer von Pergamon 11, no. 1. Berlin.

De Vries 1980
Keith de Vries, ed. *From Athens to Gordion: The Papers of a Memorial Symposium for Rodney S. Young, Held at the University Museum, the Third of May, 1975.* University Museum Papers 1. Philadelphia.

Deininger 1965
Jürgen Deininger. *Die Provinziallandtage der römischen Kaiserzeit: Von Augustus bis zum Ende des 3. Jahrhunderts n. Chr.* Vestigia 6. Munich and Berlin.

Delange 2007
Elisabeth Delange. "The Complexity of Alloys: New Discoveries about Certain 'Bronzes' in the Louvre." In *Gifts for the Gods: Images from Egyptian Temples,* edited by Marsha Hill and Deborah Schorsch, pp. 38–49. New York and New Haven.

Delbrueck 1912
Richard Delbrueck. *Antike Porträts.* Tabulae in Usum Scholarum 6. Bonn.

Delbrueck 1914
Richard Delbrueck. "Archäologische Funde im Jahre 1913: Italien." *Archäologischer Anzeiger* 29, pp. 174–205.

Dench 1998
Emma Dench. "Austerity, Excess, Success, and Failure in Hellenistic and Early Imperial Italy." In *Parchments of Gender: Deciphering the Bodies of Antiquity,* edited by Maria Wyke, pp. 121–46. Oxford and New York.

Deonna 1925
Waldemar Deonna. "Bol en verre à décor doré." *Revue des études anciennes* 27, no. 1, pp. 15–21.

Dereboylu 2003
Emel Dereboylu. "Daskyleion kabartmalı kâseleri ve batı yamacı kapları: Kronoloji ve üretim yeri problemleri / Les bols à décor en relief et les vases 'West Slope' de Daskyleion: Problèmes de chronologie et de lieu de production." In Abadie-Reynal 2003, pp. 55–63, 220.

Descamps-Lequime 2005
Sophie Descamps-Lequime. "L'encrier de Vaison-la-Romaine et la patine volontaire des bronzes antiques." *Monuments et mémoires de la Fondation Eugène Piot* 84, pp. 5–30.

Despinis 1995
Giorgos Despinis. "Studien zur hellenistischen Plastik I: Zwei Künstlerfamilien aus Athen." *Jahrbuch des deutschen archäologischen Instituts* 110, pp. 321–72.

Despinis 2004
Giorgos I. Despinis. *Zu Akrolithstatuen griechischer und römischer Zeit.* Nachrichten der Akademie der Wissenschaften zu Göttingen 1; Philologisch-Historische Klasse 8. Göttingen.

Deterling 2013
Jörg Deterling. Review of Ina Altripp, *Athenastatuen der Spätklassik und des Hellenismus* (Cologne, 2010). *Göttingische gelehrte Anzeiger* 265, pp. 282–91.

Dohrn 1985
Tobias Dohrn. "Schwarzgefirnisste Plakettenvasen." *Mitteilungen des Deutschen Archäologischen Instituts, Römische Abteilung* 92, pp. 77–106.

Domăneanţu 2000
Catrinel Domăneanţu. *Les bols hellénistiques à décor en relief.* Histria 11. Bucharest.

Dow 1965
Sterling Dow. "The Greater Demarkhia of Erkhia." *Bulletin de correspondance héllenique* 89, no. 1, pp. 180–213.

Drougou and Touratsoglou 2012
Stella Drougou and Ioannis Touratsoglou, eds. *Topics on Hellenistic Pottery in Ancient Macedonia / Themata tes ellenistikes keramikes sten archaia Makedonia.* Athens.

Dwyer 1982
Eugene J. Dwyer. *Pompeian Domestic Sculpture: A Study of Five Pompeian Houses and Their Contents.* Archaeologica 28. Rome.

Edwards 1956
G. Roger Edwards. "Hellenistic Pottery." In *Small Objects from the Pnyx,* vol. 2, pp. 79–112. Hesperia: Supplement 10. Princeton, N.J.

Erskine 2003
Andrew Erskine, ed. *A Companion to the Hellenistic World.* Blackwell Companions to the Ancient World, Ancient History. Malden, Mass.

Erskine 2013
Andrew Erskine. "Hellenistic Parades and Roman Triumphs." In Spalinger and Armstrong 2013, pp. 37–55.

Eustace 1997
Katharine Eustace. "'Questa scabrosa missione': Canova in Paris and London in 1815." In *Canova: Ideal Heads,* edited by Katharine Eustace, pp. 9–38. Exh. cat. Oxford.

Faldi 1954
Italo Faldi. *Galleria Borghese: Le sculture dal secolo XVI al XIX.* Rome.

Fantuzzi 2009
Marco Fantuzzi. Review of Prioux 2008. *American Journal of Philology* 130, pp. 294–300.

Faraone 2013
Christopher A. Faraone. "Playing the Bear and the Fawn for Artemis: Female Initiation or Substitute Sacrifice?" In *Initiation in Ancient Greek Rituals and Narratives: New Critical Perspectives,* edited by David B. Dodd and Christopher A. Faraone, pp. 43–68. Hoboken.

Feuser n.d.
Stefan Feuser. "Skulpturenfragment mit Gewand (Sitz): Berlin, Staatliche Museen, Antikensammlung Berlin." *Arachne* [Central Object Database of the German Archaeological Institute (DAI) and the Archaeological Institute of the University of Cologne]. http://arachne.uni-koeln.de/item/objekt/200457.

Ficacci 2000
Luigi Ficacci. *Giovanni Battista Piranesi: The Complete Etchings / Giovanni Battista Piranesi: Gesamtkatalog der Kupferstiche / Giovanni Battista Piranesi: Catalogue raisonné des eaux-fortes.* Cologne.

Filippini 2000
Paola Filippini. "Gold Glasses from the Catacomb of Novatianus in Rome." In Association Internationale pour l'Histoire du Verre 2000, pp. 126–31.

Finkielsztejn 2001
Gérald Finkielsztejn. *Chronologie détaillée et révisée des éponymes amphoriques rhodiens, de 270 à 108 av. J.-C. environ: Premier bilan.* BAR (British Archaeological Reports) International 990. Oxford.

Fischer-Bossert 2006
Wolfgang Fischer-Bossert. Review of Osmund Bopearachchi and Philippe Flandrin, *Le portrait d'Alexandre le Grand: Histoire d'une découverte pour l'humanité* (Monaco, 2005). *ANS Magazine* 5, no. 2 (Summer), pp. 62–65.

Fittschen 1975
Klaus Fittschen. "Zum Figurenfries der Villa von Boscoreale." In Andreae and Kyrieleis 1975, pp. 93–100.

Fittschen 1991
Klaus Fittschen. "Zur Rekonstruktion griechischer Dichterstatuen. 1: Die Statue des Menander." *Mitteilungen des Deutschen Archäologischen Instituts, Athenische Abteilung* 106, pp. 243–79.

Fittschen 1992
Klaus Fittschen. "Über das Rekonstruieren griechischer Porträtstatuen." In *Ancient Portraiture: Image and Message*, edited by Tobias Fischer-Hansen et al., pp. 9–28. Acta Hyperborea 4. Copenhagen.

Fittschen 1993
Klaus Fittschen. "Zur Rekonstruktion griechischer Dichterstatuen, 2; Teil: Die Statuen des Poseidippos und des Ps.-Menander." *Mitteilungen des deutschen archäologischen Instituts: Athenische Abteilung* 107, pp. 229–71.

Fleischer 1967
Robert Fleischer. *Die römischen Bronzen aus Österreich.* Mainz am Rhein.

Fleischer 1991
Robert Fleischer. *Herrscherbildnisse.* Studien zur Seleukidischen Kunst 1. Mainz am Rhein.

Follmann-Schulz 1988
Anna-Barbara Follmann-Schulz. *Die römischen Gläser aus Bonn.* Beihefte der Bonner Jahrbücher 46. Cologne and Bonn.

Fontan and Le Meaux 2005
Elisabeth Fontan and Hélène Le Meaux. "De l'Égypte à la Perse: Figurines et amulettes." In Caubet and Pierrat-Bonnefois 2005, pp. 153–56.

B. Fowler 1989
Barbara Hughes Fowler. *The Hellenistic Aesthetic.* Wisconsin Studies in Classics. Madison, Wisc.

R. Fowler 1988
Robert L. Fowler. "ΑΙΓ—In Early Greek Language and Myth." *Phoenix* 42, no. 2 (Summer), pp. 95–113.

Foy and Nenna 2003
Danièle Foy and Marie-Dominique Nenna, eds. *Echanges et commerce du verre dans le monde antique: Actes du colloque de l'Association française pour l'archéologie du verre, Aix-en-Provence et Marseille, 7–9 juin 2001.* Monographies Instrumentum 24. Montagnac.

Franken 2002
Norbert Franken. "Zur Bedeutung der Anstückungstechnik bei hellenistischen und römischen Bronzestatuetten." In *From the Parts to the Whole: Acta of the 13th International Bronze Congress, Held at Cambridge, Massachusetts, May 28–June 1, 1996*, edited by Carol C. Mattusch, Amy Brauer and Sandra E. Knudsen, vol. 2, pp. 182–88. Journal of Roman Archaeology, Supplementary 39. Portsmith, R.I.

Freestone 2006
Ian C. Freestone. "Glass Production in Late Antiquity and the Early Islamic Period: A Geochemical Perspective." In *Geomaterials in Cultural Heritage*, edited by Marino Maggetti and Bruno Messiga, pp. 201–16. Geological Society Special Publication 257. London.

Friederichs and Wolters 1885
Karl Friederichs and Paul Wolters. *Die Gipsabgüsse antiker Bildwerke in historischer Folge erklärt: Bausteine zur Geschichte der griechisch-römischen plastik.* Berlin.

Friedman 1998
Florence D. Friedman, ed. *Gifts of the Nile: Ancient Egyptian Faience.* Exh. cat. London.

Froehner 1879
Wilhelm Froehner. *La verrerie antique: Déscription de la Collection Charvet.* Le Pecq, France.

Frova and Scarani 1965
Antonio Frova and Rento Scarani. *Parma: Museo nazionale di Antichità.* Parma.

Führer durch das Gypsmuseum 1893
Führer durch das Gypsmuseum in der Skulpturhalle zu Basel. Basel.

Fukai 1977
Shinji Fukai. *Persian Glass.* Translated by Edna B. Crawford. New York.

Fulińska 2012
Agnieszka Fulińska. "Arsinoe *Hoplismene*: Poseidippos 36, Arsinoe Philadelphos and the Cypriot Cult of Aphrodite," edited by Ewdoksia Papuci-Władyka. *Studies in Ancient Art and Civilization* 16, pp. 141–56.

Fürtwangler 1910
Adolf Fürtwangler. *Beschreibung der Glyptothek König Ludwig's I. zu München.* 2nd ed. Munich.

Gabelmann 1996
Hanns Gabelmann. "Pantherfellschabracken." *Bonner Jahrbücher* 196, pp. 11–39.

Gahtan and Pegazzano 2015
Maia Wellington Gahtan and Donatella Pegazzano, eds. *Museum Archetypes and Collecting in the Ancient World.* Monumenta Graeca et Romana 21. Leiden.

Galli 1937
Edoardo Galli. "Riflessi di pittura alessandrina in Calabria." *Rivista del Reale Istituto di archeologia e storia dell'arte* 6, nos. 1, 2, pp. 32–46.

Georgoula 1999
Elektra Georgoula, ed. *Greek Jewellery from the Benaki Museum Collections.* Athens.

Ghezelbash 2016
David Ghezelbash. *Archéologie*, no. 11. Paris.

Ghini 2000
Giuseppina Ghini. "Ricerche al santuario di Diana: risultati e progeti." In Brandt, Leander Touati, and Zahle 2000, pp. 54–64.

Giuliani 2004
Cairoli Fulvio Giuliani. *Tivoli: Il santuario di Ercole Vincitore.* 1st ed. Tivoli.

Giumlia-Mair 2000
Alessandra Giumlia-Mair. "*Pyropus, pinos* and *Graecanicus colos*: Surface Treatments on Copper Alloys in Roman Times." In *Antiken Bronzen* 2000, pp. 593–606.

Giumlia-Mair and Craddock 1993
Alessandra R. Giumlia-Mair and Paul T. Craddock. *Das schwarze Gold der Alchimisten: Corinthium aes.* Zaberns Bildbände zur Archäologie 11. Mainz am Rhein.

Gleba 2008
Margarita Gleba. "*Auratae vestes*: Gold Textiles in the Ancient Mediterranean." In Alfaro and Karali 2008, pp. 61–77.

Gleba and Pásztókai-Szeöke 2013
Margarita Gleba and Judit Pásztókai-Szeöke, eds. *Making Textiles in Pre-Roman and Roman Times: Peoples, Places, Identities.* Ancient Textiles Series 13. Oxford, U.K., and Oakville, Conn.

Govi 2006
Elisabetta Govi. "L'ultima' spina: Riflessioni sulla tarda etruscità adriatica." In *Rimini e l'Adriatico nell'età delle guerre puniche: Atti del Convegno internationale de studi Rimini, Musei comunali, 25–27 marzo 2004*, edited by Fiamma Lenzi, pp. 111–36. Archeologia dell'Adriatico 2. Bologna.

Gow and Page 1968
Andrew Sydenham Farrar Gow and Denys Lionel Page, eds. *The Greek Anthology: The Garland of Philip, and Some Contemporary Epigrams.* 2 vols. London.

Greenewalt and Majewski 1980
Crawford Hallock Greenewalt Jr. and Lawrence J. Majewski. "Lydian Textiles." In De Vries 1980, pp. 133–47.

Grimm 1975
Günter Grimm. *Kunst der Ptolemäer- und Römerzeit im Ägyptischen Museum Kairo.* Mainz.

Gros 1976
Pierre Gros. "Les premières générations d'architectes hellénistiques à Rome." In *L'Italie préromaine et la Rome républicaine: Mélanges offerts à Jacques Heurgon*, pp. 387–409. Collection de l'Ecole Française de Rome 27. Rome.

Gros 1996
Pierre Gros. *L'architecture romaine: Du début du IIIe siècle av. J.-C. à la fin du Haut-Empire.* Vol. 1, *Les monuments publics.* Les Manuels d'Art et d'Archéologie Antiques. Paris.

Grose 1981
David Frederick Grose. "The Hellenistic Glass Industry Reconsidered." In *Annales du 8e congrès de l'AIHV, Londres–Liverpool, 18–25 septembre 1979*, pp. 61–72. Liège.

Grose 1982
David Frederick Grose. "The Hellenistic and Early Roman Glass from Morgantina (Serra Orlando), Sicily." *Journal of Glass Studies* 24, pp. 20–29.

Grose 1989
David Frederick Grose. *Early Ancient Glass: Core-Formed, Rod-Formed, and Cast Vessels and Objects from the Late Bronze Age to the Early Roman Empire, 1600 B.C. to A.D. 50.* New York.

Grose 2012
David Frederick Grose. "The Pre-Hellenistic, Hellenistic, Roman, and Islamic Glass Vessels." In *Tel Anafa*, pt. 2, *The Hellenistic and Roman Pottery*, vol. 2, *Glass Vessels, Lamps, Objects of Metal, and Groundstone and Other Stone Tools and Vessels*, edited by Andrea Berlin and Sharon C. Herbert, pp. 1–98. Journal of Roman Archaeology, Supplementary 10. Ann Arbor, Mich.

Gruben 2001
Gottfried Gruben. *Griechische Tempel und Heiligtümer.* Rev. and expanded ed. of *Die Tempel der Griechen.* Munich.

Gruen 1993
Erich S. Gruen. *Culture and National Identity in Republican Rome.* London.

Grüssinger, V. Kästner, and Scholl 2011
Ralf Grüssinger, Volker Kästner, and Andreas Scholl, eds. *Pergamon: Panorama der antiken Metropole; Begleitbuch zur Ausstellung.* Exh. cat. Berlin and Petersberg.

Grüssinger et al. 2015
Ralf Grüssinger, Volker Kästner, Andreas Scholl, and Anja Küttner, eds. *Pergamon als Zentrum der hellenistischen Kunst: Bedeutung, Eigenheiten und Ausstrahlung; Internationales Kolloquium, Berlin, 26.–28. September 2012.* Petersberg.

Gudenrath 1991
William Gudenrath. "Techniques of Glassmaking and Decoration." In *Five Thousand Years of Glass*, edited by Hugh Tait, pp. 213–41. London.

Gullini 1983
Giorgio Gullini. "Terrazza, edificio, uso dello spazio: Note su architettura e società nel periodo medio e tardo repubblicano." In *Architecture et société: De l'archaïsme grec à la fin de la république romaine; Actes du Colloque international organisé par le Centre national de la recherche scientifique et l'Ecole française de Rome (Rome, 2–4 décembre 1980)*, pp. 119–89. Collection de l'Ecole Française de Rome 66. Paris and Rome.

Gutzwiller 1995
Kathryn J. Gutzwiller. "Cleopatra's Ring." *Greek, Roman, and Byzantine Studies* 36, no. 4, pp. 383–98.

Guzzo 2003
Pietro Giovanni Guzzo. "A Group of Hellenistic Silver Objects in the Metropolitan Museum." *Metropolitan Museum Journal* 38, pp. 45–94.

Habicht 1969
Christian Habicht. *Die Inschriften des Asklepieions.* Altertümer von Pergamon 8, no. 3. Berlin.

Habicht 1997
Christian Habicht. *Athens from Alexander to Antony.* Cambridge, Mass.

Haevernick 1981
Thea E. Haevernick. *Beiträge zur Glasforschung: Die wichtigsten Aufsätze von 1938 bis 1981.* Mainz am Rhein.

Hahland 1950
Walter Hahland. "Der Fries des Dionysostempels in Teos." *Jahreshefte des Österreichischen Archäologischen Instituts in Wien* 38, pp. 66–109.

Hamilton 1811
William Richard Hamilton. *Memorandum on the Subject of the Earl of Elgin's Pursuits in Greece.* London and Edinburgh. 2nd rev. ed., 1815.

Hänlein-Schäfer 1985
Heidi Hänlein-Schäfer. *Veneratio Augusti: Eine Studie zu den Tempeln des ersten römischen Kaisers.* Archaeologica 39. Rome.

Hansen 1971
Esther Violet Hansen. *The Attalids of Pergamon.* Cornell Studies in Classical Philology 36. Ithaca, N.Y., and London.

A. Harden 2013
Alastair Harden. "Animal-Skin Garments in Archaic Greek Art: Style and Iconography." DPhil diss., University of Reading, U.K.

D. Harden 1968
Donald Benjamin Harden. "The Canosa Group of Hellenistic Glasses in the British Museum." *Journal of Glass Studies* 10, pp. 21–47.

D. Harden 1981
Donald Benjamin Harden. *Catalogue of Greek and Roman Glass in the British Museum.* Vol. 1, *Core- and Rod-Formed Vessels and Pendants and Mycenaean Glass Objects.* London.

Harrell 2014
James A. Harrell. "Discovery of the Red Sea Source of Topazos (Ancient Gem Peridot) on Zabargad Island, Egypt." In Thoresen 2014, pp. 16–30.

Hauben and Meeus 2014
Hans Hauben and Alexander Meeus, eds. *The Age of the Successors and the Creation of the Hellenistic Kingdoms (323–276 B. C.).* Studia Hellenistica 53. Leuven.

Heesen 2011
Pieter Heesen. *Athenian Little-Master Cups.* 2 vols. Amsterdam.

Helbig 1869
Wolfgang Helbig. "Nike mit der Gorgonenmaske." *Rheinisches Museum für Philologie*, n.s., 24, pp. 303–5.

Helbig 1963–72
Wolfgang Helbig. *Führer durch die öffentlichen Sammlungen klassischer Altertümer in Rom.* Edited by Hermine Speier. 4 vols. 4th ed. Tübingen.

Hellenkemper Salies 1994
Gisela Hellenkemper Salies, ed. *Das Wrack: Der antike Schiffsfund von Mahdia.* 2 vols. Exh. cat. Kataloge des Rheinischen Landesmuseums Bonn 1. Bonn.

Hemingway 2004
Séan Hemingway. *The Horse and Jockey from Artemision: A Bronze Equestrian Monument of the Hellenistic Period.* Hellenistic Culture and Society 45. Berkeley, Calif.

Hemingway 2016a
Séan Hemingway. "Recent Acquisitions: A Selection, 2014–2016." *The Metropolitan Museum of Art Bulletin* 74, no. 2 (Fall), p. 10.

Hemingway 2016b
Séan Hemingway. "Seafaring, Shipwrecks, and the Art Market in the Hellenistic Age." In Picón and Hemingway 2016, pp. 85–91.

Hemingway, Milleker, and Evans 2004
Séan Hemingway, Elizabeth J. Milleker, and Jean Evans. "Ancient World." In "Recent Acquisitions: A Selection, 2003–2004." Special issue, *The Metropolitan Museum of Art Bulletin* 62, no. 2 (Fall), pp. 6–9.

Hemingway and Stone 2017
Séan Hemingway and Richard Stone. "The New York Sleeping Eros: A Hellenistic Statue and Its Ancient Restoration." *Technè* 41, pp. 46–63.

Henrichs 1990
Albert Henrichs. "Between Country and City: Cultic Dimensions of Dionysus in Athens and Attica." In *Cabinet of the Muses: Essays on Classical and Comparative Literature in Honor of Thomas G. Rosenmeyer*, edited by Mark Griffith and Donald J. Mastronarde, pp. 257–77. Homage Series. Atlanta, Ga.

Hepding 1952
Hugo Hepding. "Eine hellenistische Töpferwerkstatt in Pergamon." *Nachrichten der Giessener Hochschulgesellschaft* 21, pp. 49–60.

Herrmann 1993
Ariel Herrmann. "A Hellenistic Portrait Head." *Getty Museum Journal* 21, pp. 29–42.

Herrmann 2016
Ariel Herrmann. "Art in the Age of Alexander." In Picón and Hemingway 2016, pp. 9–20.

Hiebert and Cambon 2008
Fredrik Hiebert and Pierre Cambon, eds. *Afghanistan: Hidden Treasures from the National Museum, Kabul.* Exh. cat. Washington, D.C.

Higgins 1980
Reynold Alleyne Higgins. *Greek and Roman Gold Jewellery*. 2nd ed. London.

Hill 1900
George Francis Hill. *Catalogue of the Greek Coins of Lycaonia, Isauria, and Cilicia*. Catalogue of the Greek Coins in the British Museum 21. London.

Himmelmann 1983
Nikolaus Himmelmann. *Alexandria und der Realismus in der griechischen Kunst*. Tübingen.

Himmelmann 1986
Nikolaus Himmelmann. "Eine frühhellenistische Dionysos-Statuette aus Attika." In *Studien zur klassischen Archäologie: Friedrich Hiller zu seinem 60. Geburtstag am 12. März 1986*, edited by Karin Braun and Andreas Furtwängler, pp. 43–54. Saarbrücker Studien zur Archäologie und Alten Geschichte 1. Saarbrucken.

Himmelmann 1989
Nikolaus Himmelmann. Review of Smith 1988. *Bonner Jahrbuch* 189, pp. 581–85.

Hoepfner 1996
Wolfram Hoepfner. "L'architettura di Pergamo." In *L'altare di Pergamo* 1996, pp. 42–73.

Hoepfner and Brands 1996
Wolfram Hoepfner and Gunnar Brands, eds. *Basileia: Die Paläste der hellenistischen Könige; Internationales Symposion in Berlin vom 16.12. bis 20.12.1992*. Mainz am Rhein.

Hoff 2011
Ralf von den Hoff. "Bildnisse der Attaliden." In Grüssinger, V. Kästner, and Scholl 2011, pp. 122–30.

Hoff 2013
Ralf von den Hoff. "Überlebensgroßer Porträtkopf Eumenes II.? (sogenannter Attalos I.): Berlin, Staatliche Museen, Antikensammlung Berlin." *Arachne* [Central Object database of the German Archaeological Institute (DAI) and the Archaeological Institute of the University of Cologne]. http://arachne .uni-koeln.de/item/objekt/2145.

Hoff 2015
Ralf von den Hoff. "Die Clipei aus dem Mittelsaal H des Gymnasions von Pergamon." In Grüssinger et al. 2015, pp. 55–63.

Holt 2003
Frank L. Holt. *Alexander the Great and the Mystery of the Elephant Medallions*. Hellenistic Culture and Society 44. Berkeley, Calif.

Holt and Bopearachchi 2011
Frank L. Holt and Osmund Bopearachchi, eds. *The Alexander Medallion: Exploring the Origins of a Unique Artefact*. Rouqueyroux.

Hopp 1977
Joachim Hopp. *Untersuchungen zur Geschichte der letzten Attaliden*. Vestigia 25. Munich.

Horn 1994
Heinz Günther Horn. "Dionysos und Ariadne." In Hellenkemper Salies 1994, pp. 451–67.

Houghton, Lorber, and Hoover 2002
Arthur Houghton, Catherine C. Lorber, and Oliver Hoover. *Seleucid Coins: A Comprehensive Catalogue*. Part 1, *Seleucus I through Antiochus II*. With metrological tables by Brian Kritt. 2 vols. New York.

Howatson 2013
M. C. Howatson, ed. *Oxford Companion to Classical Literature*. Oxford.

Hughes 1991
Dennis D. Hughes. *Human Sacrifice in Ancient Greece*. London and New York.

Huguenot 2008
Caroline Huguenot. *La tombe aux Érotes et la tombe d'Amarynthos: Architecture funéraire et présence macédonienne en Grèce centrale*. 2 vols. Eretria 19. Gollion, Switzerland.

Ignatiadou 2000
Despina Ignatiadou. "Three Cast-Glass Vessels from a Macedonian Tomb in Pydna." In Association Internationale pour l'Histoire du Verre 2000, pp. 35–38.

Ignatiadou 2002a
Despina Ignatiadou. "Colorless Glass in Late Classical and Early Hellenistic Macedonia." *Journal of Glass Studies* 44, pp. 11–24.

Ignatiadou 2002b
Despina Ignatiadou. "Macedonian Glass-Working in the 4th C. BC." In Kordas 2002, pp. 63–70.

Ignatiadou 2012
Despina Ignatiadou. "Pottery, Metalware, and Glassware." [In Greek and English.] In Drougou and Touratsoglou 2012, pp. 214–46.

Ignatiadou 2013
Despina Ignatiadou. *Diaphanes hyalos gia -ten aristokrataia tes archaias Makedonias* [Colorless glass for the elite in ancient Macedonia]. Thessaloniki.

Ignatiadou and Lambrothanassi 2013
Despina Ignatiadou and Eleni Lambrothanassi. "A Glass Kotyle and a Faience Pyxis from Thessaloniki." *Journal of Glass Studies* 55, pp. 21–38.

Iossif and Lorber 2007
Panagiotis P. Iossif and Catharine C. Lorber. "Marduk and the Lion: A Hoard of Babylonian Lion Staters." In *Liber Amicorum Tony Hackens*, edited by Ghislaine Moucharte, Maria Beatriz Borba Florenzano, François de Callataÿ, Patrick Marchetti, Luc Smolderen, and Panayotis Yannopoulos, pp. 345–63. Numismatica Lovaniensia 20. Louvain-la-Neuve.

Iossif and Lorber 2010
Panagiotis P. Iossif and Catharine C. Lorber. "The Elephantarches Bronze of Seleucos I Nikator." *Syria* 87, pp. 147–64.

Jackson 2005
Caroline M. Jackson. "Making Colourless Glass in the Roman Period." *Archaeometry* 47, no. 4 (November), pp. 763–80.

Jackson 2017
Monica M. Jackson. *Hellenistic Gold Jewellery in the Benaki Museum, Athens*. Museio Benaki Parartima 10. Athens.

Jacobson 2007
David M. Jacobson. *The Hellenistic Paintings of Marisa*. Edited by Stanley A. Cook. Palestine Exploration Fund Annual 7. Leeds.

Jacobsthal 1908
Paul Jacobsthal. "Die Arbeiten zu Pergamon 1906–1907: III, Die Einzelfunde." *Mitteilungen des Deutschen Archäologischen Instituts, Athenische Abteilung* 33, no. 4, pp. 421–36.

Jacoby 1923–58
Félix Jacoby. *Die Fragmente der griechischen Historiker*. 3 vols. Berlin and Leyden.

Japp 2011
Sarah Japp. "Keramik aus Pergamon." In Grüssinger, V. Kästner, and Scholl 2011, pp. 356–61.

Johns 1998
Christopher M. S. Johns. *Antonio Canova and the Politics of Patronage in Revolutionary and Napoleonic Europe*. Berkeley.

C. Jones 1974
C. P. Jones. "Diodoros Pasparos and the Nikephoria of Pergamon." *Chiron: Mitteilungen der Kommission für Alte Geschichte und Epigraphik des Deutschen Archäologischen Instituts* 4, pp. 183–206.

F. Jones 1950
Frances Follin Jones. "The Pottery." In *Excavations at Gözlü Kule, Tarsus*, edited by Hetty Goldman, vol. 1, *The Hellenistic and Roman Periods*, pp. 149–246. Princeton, N.J.

J. Jones 2002
Janet D. Jones. "Glass Connections between Gordion and Rhodes: Core-formed and Cast Achaemenid Style Glass Vessels." In Kordas 2002, p. 61.

Kähler 1948
Heinz Kähler. *Der grosse Fries von Pergamon: Untersuchungen zur Kunstgeschichte und Geschichte Pergamons*. Berlin.

Kaiser and Shugar 2012
Bruce Kaiser and Aaron N. Shugar. "Glass Analysis Utilizing Handheld X-ray Fluorescence." In *Handheld XRF for Art and Archaeology*, edited by Aaron N. Shugar and Jennifer L. Mass, pp. 449–70. Studies in Archaeological Sciences 3. Leuven.

Kaltsas 2003
Nikolaos Kaltsas. *Sculpture in the National Archaeological Museum, Athens*. Los Angeles.

Karageorghis 2000
With Joan R. Mertens and Marice E. Rose. *Ancient Art from Cyprus: The Cesnola Collection in The Metropolitan Museum of Art.* New York.

Kaschnitz von Weinberg 1937
Guido Kaschnitz von Weinberg. *Sculture del Magazzino del Museo Vaticano.* Monumenti Vaticani di Archeologia e d'Arte 4. Vatican City.

U. Kästner 2014
Ursula Kästner. ""A Work So Grand and Magnificent . . . Had Been Restored to the World!' / (C. Humann 1880): History of the Excavations at Pergamon up to 1900 / O kadar yüce ve muhteşem bir eser ki . . . dünyaya bir kez daha bahşedilmiş gibi!' (C. Humann 1880): 1900 Yılına kadar Pergamon kazılarının tarihçesi." In Pirson and Scholl 2014, pp. 20–35.

Kaufmann-Heinimann 1977
Annemarie Kaufmann-Heinimann. *Augst und das Gebiet der Colonia Augusta Raurica.* Die Römischen Bronzen der Schweiz 1. Edited by Hans Jucker. Mainz am Rhein.

Kaufmann-Heinimann 1998
Annemarie Kaufmann-Heinimann. *Götter und Lararien aus Augusta Raurica: Herstellung, Fundzusammenhänge und sakrale Funktion figürlicher Bronzen in einer römischen Stadt.* Forschungen in Augst 26. Augst and Basel.

Kaufmann-Heinimann and Liebel 1994
Annemarie Kaufmann-Heinimann and Detlef Liebel. "Legierungen figürlicher Bronzen aus der Colonia Raurica." *Jahresberichte aus Augst und Kaiseraugst* 15, pp. 225–37.

Kelp 2011
Ute Kelp. "Die Nekropolen von Pergamon." In Grüssinger, V. Kästner, and Scholl 2011, pp. 289–96.

Kelp 2014
Ute Kelp. "The Necropoleis of Pergamon / Pergamon Nekropolleri." In Pirson and Scholl 2014, pp. 354–75.

Kenfield 1976
John F. Kenfield III. "A Bronze Herakles in the Metropolitan Museum: Drunkard or Wrestler?" *American Journal of Archaeology* 80, no. 4 (October), pp. 415–19.

Kisa 1908
Anton Kisa. *Das Glas im Altertume.* 3 vols. Hiersemanns Handbücher 3. Leipzig.

Kogioumtzi 2006
Dimitra Kogioumtzi. *Untersuchungen zur attisch rotfigurigen Keramikproduktion des 4. Jhs. v. Chr.: Die sog. Kertscher Vasen.* Premium 1177. Berlin.

Kondoleon and Segal 2011
Christine Kondoleon and Phoebe C. Segal, eds. *Aphrodite and the Gods of Love.* Exh. cat. Boston.

Kopcke 1964
Günter Kopcke. "Golddekorierte attische Schwarzfirniskeramik des vierten Jahrhunderts v. Chr." *Mitteilungen des Deutschen archäologischen Instituts: Athenische Abteilung* 79, pp. 22–84.

Kordas 2002
George Kordas, ed. *Hyalos / Vitrum / Glass: History, Technology and Conservation of Glass and Vitreous Materials in the Hellenic World.* Athens.

Kosmin 2014
Paul J. Kosmin. *The Land of the Elephant Kings: Space, Territory, and Ideology in the Seleucid Empire.* Cambridge, Mass.

Koutsoufakis and Simosi 2015
George Koutsoufakis and Angeliki Simosi. "Hellenistic Bronze Sculptures from the Aegean Sea: Recent Discoveries (1994–2009)." In Daehner and Lapatin 2015, pp. 72–81.

Kozloff and Mitten 1988
Arielle Kozloff and David Gordon Mitten, eds. *The Gods Delight: The Human Figure in Classical Bronze.* Exh. cat. Cleveland.

Kraay 1966
Colin M. Kraay. *Greek Coins.* Photographs by Max Hirmer. New York.

Kroll 2014
John H. Kroll. "The Emergence of Ruler Portraiture on Early Hellenistic Coins: The Importance of Being Divine." In Schultz and Hoff 2014, pp. 113–22.

Krug 1968
Anjte Krug. *Binden in der griechischen Kunst: Untersuchungen zur Typologie (6.–1. Jahrh. v. Chr.).* Hösel.

Kuchumov 1975
Anatolii Mikhailovich Kuchumov. *Pavlovsk Palace & Park.* translated from the Russian by V. Travlinsky and J. Hine. Leningrad.

Kunina 1997
Nina Kunina. *Ancient Glass in the Hermitage Collection.* Saint Petersburg.

Kuttner 2005
Ann L. Kuttner. "Cabinet Fit for a Queen: The Λιθικά [Lithika] as Posidippus' Gem Museum." In *The New Posidippus: A Hellenistic Poetry Book,* edited by Kathryn Gutzwiller, pp. 141–63. Oxford.

Kuttner 2015
Ann L. Kuttner. "Hellenistic Court Collecting from Alexandros to the Attalids." In Gahtan and Pegazzano 2015, pp. 45–53.

Kyrieleis 1975
Helmut Kyrieleis. *Bildnisse der Ptolemäer.* Archäologische Forschungen 2. Berlin.

Kyrieleis 2015
Helmut Kyrieleis. *Hellenistische Herrscherporträts auf Siegelabdrücken aus Paphos (Paphos IV B).* Archäologische Forschungen 34. Wiesbaden.

L'altare di Pergamo 1996
L'altare di Pergamo: Il fregio di Telefo. Exh. cat. Milan.

La Regina 1998
Adriano La Regina, ed. *Palazzo Massimo alle Terme.* With texts by Marina Sapelli. Milan and Rome.

La Rocca 1990
Eugenio La Rocca. "Linguaggio artistico e ideologia politica a Roma in età repubblicana." In *Roma e l'Italia: Radices imperii,* pp. 289–495. Antica Madre 13. Milan.

La Rocca 1996
Eugenio La Rocca. "Il Pantheon, Hiera e la gloria degli Attalidi nel Grande Altare." In *L'altare di Pergamo,* pp. 152–57.

La Rocca 2011
Eugenio La Rocca. "La forza della tradizione: L'architettura sacra a Roma tra II e I secolo a.C." In D'Alessio and La Rocca 2011, pp. 1–24.

La Rocca 2012
Eugenio La Rocca. "La pietrificazione della memoria: I templi a Roma in età medio-repubblicana." *Ostraka: Rivista di antichità,* vol. spec., pp. 37–88.

La Rocca and Parisi Presicce 2010
Eugenio La Rocca and Claudio Parisi Presicce, eds. *I giorni di Roma: L'età de la conquista.* Exh. cat. Milan.

Ladstätter and Scheibelreiter 2010
Sabine Ladstätter and Veronika Scheibelreiter, eds. *Städtisches Wohnen im östlichen Mittelmeerraum, 4. Jh. v. Chr.–1. Jh. n. Chr.: Akten des internationalen Kolloquiums vom 24.–27. Okt. 2007 an der österreichischen Akademie der Wissenschaften.* Denkschriften 397; Archäologische Forschungen 18. Vienna.

Lahusen and Formigli 2001
Götz Lahusen and Edilberto Formigli. *Römische Bildnisse aus Bronze: Kunst und Technik.* Munich.

Lambert 2001
S. D. Lambert. *The Phratries of Attica.* Rev. ed. Michigan Monographs in Classical Antiquity. Ann Arbor, Mich.

Lapatin 2006
Kenneth Lapatin. "Kerch-Style Vases: The Finale." In Cohen 2006b, pp. 318–26.

Lapatin 2015
Kenneth D. S. Lapatin. *Luxus: The Sumptuous Arts of Greece and Rome.* Los Angeles.

Lattanzi 1987
Elena Lattanzi, ed. *Il Museo Nazionale di Reggio Calabria.* Rome and Reggio Calabria.

Laumonier 1977
Alfred Laumonier. *La céramique hellénistique à reliefs.* Pt. 1, *Ateliers "ioniens."* Exploration Archéologique de Délos 31. Paris.

Lauter 1972
Hans Lauter. "Kunst und Landschaft: Ein Beitrag zum rhodischen Hellenismus." *Antike Kunst* 15, pp. 49–59.

Lauter 1986
Hans Lauter. *Die Architektur des Hellenismus.* Darmstadt.

Lauter 1987–88
Hans Lauter. "Zu Alexander der Grosse." In *Zu Alexander d. Gr.: Festschrift G. Wirth zum 60. Geburtstag am 9.12.86*, edited by Wolfgang Will, vol. 2, pp. 717–43. Amsterdam.

Lavagne 2003
Henri Lavagne, ed. *Nouvel Espérandieu: Recueil général des sculptures sur pierre de la Gaule.* Vol. 1, *Vienne (Isère).* Paris.

Le Glay 1976
Marcel Le Glay. "Hadrien et l'Asklépieion de Pergame." *Bulletin de correspondance hellénique* 100, no. 1, pp. 347–72.

Levante 1986
Edoardo Levante. *Sylloge Nummorum Graecorum Switzerland.* Vol. 1, *Levante-Cilicia.* Bern.

Leventi 2007
Iphigeneia Leventi. "The Mondragone Relief Revisited: Eleusinian Cult Iconography in Campania." *Hesperia* 76, pp. 107–41.

Levi 1947
Doro Levi. *Antioch Mosaic Pavements.* 2 vols. Publications of the Committee for the Excavation of Antioch and Its Vicinity 4. Princeton, N.J.

Lichtenberger et al. 2012
Achim Lichtenberger, Katharina Martin, Heinz-Helge Nieswandt, and Dieter Salzmann, eds. *Das Diadem der hellenistischen Herrscher: Übernahme, Transformation oder Neuschöpfung eines Herrschaftszeichens?; Kolloquium vom 30.–31. Januar 2009 in Münster.* Euros (Universität Münster, Forschungsstelle Antike Numismatik) 1. Bonn.

Lierke 1991
Rosemarie Lierke. "Glass Bowls Made on a Potter's Wheel." *Glastechnische Berichte* 64, pp. 310–17.

Lightfoot 1990
Christopher S. Lightfoot. "Three Cast Vessels from Anatolia." In *Annales du 11e congrès de l'Association internationale pour l'histoire du verre: Bâle 29 août–3 septembre 1988*, pp. 85–94. Amsterdam.

Lightfoot 2003
Christopher S. Lightfoot. "Ancient Glass at The Metropolitan Museum of Art: Two Recent Acquisitions." In *Annales du 15e congrès de l'Association Internationale pour l'Histoire du Verre: New York—Corning 2001*, edited by Jennifer Price, pp. 18–22. Nottingham.

Lightfoot 2016a
Christopher S. Lightfoot. "Fragments of Time: Ancient Glass in the Department of Greek and Roman Art." *Metropolitan Museum Journal* 51, pp. 30–41.

Lightfoot 2016b
Christopher S. Lightfoot. "Royal Patronage and the Luxury Arts." In Picón and Hemingway 2016, pp. 77–83.

Lightfoot 2016c
Christopher S. Lightfoot. *The Yunwai Lou Collection of Ancient Glass and Antiquities.* 2 vols. Hong Kong.

Lightfoot and Picón 2015
Christopher S. Lightfoot and Carlos A. Picón. "A Fragment of a Mold-Pressed Glass Bowl in The Metropolitan Museum of Art." *Journal of Glass Studies* 57, pp. 21–28.

LIMC 1984
Lexicon Iconographicum Mythologiae Classicae (LIMC). Vol. 2, pt. 2. Zurich.

LIMC 1986
Lexicon Iconographicum Mythologiae Classicae (LIMC). Vol. 3. Zurich.

LIMC 1988
Lexicon Iconographicum Mythologiae Classicae (LIMC). Vol. 4. Zurich.

LIMC 1997
Lexicon Iconographicum Mythologiae Classicae (LIMC). Vol. 8. Zurich.

LIMC: Supplementum 2009
Lexicon Iconographicum Mythologiae Classicae (LIMC): Supplementum. Vol. 1. Düsseldorf.

Lippold 1956
Georg Lippold. *Die Skulpturen des Vatikanischen Museums.* Vol. 3, pt. 2. Berlin.

Lippolis 1988–89
Enzo Lippolis. "Il santuario di *Athena* a Lindo." *Annuario della Scuola archeologica di Atene e delle missioni italiane in Oriente* 66–67, pp. 97–157.

Lissarrague 1999a
François Lissarrague. *Greek Vases: The Athenians and Their Images.* Translated by Kim Allen. New York.

Lissarrague 1999b
François Lissarrague. "Publicity and Performance: *Kalos* Inscriptions in Attic Vase-Painting." In *Performance Culture and Athenian Democracy*, edited by Simon Goldhill and Robin Osborne, pp. 359–73. Cambridge, U.K.

Livadiotti and Rocco 1996
Monica Livadiotti and Giorgio Rocco, eds. *La presenza italiana nel Dodecaneso tra il 1912 e il 1948: La ricerca archeologica, la conservazione, le scelte progettuali.* Exh. cat. Catania.

Lod Mosaic 2015
The Lod Mosaic: A Spectacular Roman Mosaic Floor. New York.

Lopez 1932
Michele Lopez. "Intorno un Ercole di bronzo del Museo di Parma." *Annali dell' Instituto di corrispondenza archeologica di Roma* 4, pp. 68–75.

Lucian 1961
Lucian of Samosata. *Lucian.* Vol. 7. Edited and translated by M. D. Macleod. Loeb Classical Library. London and Cambridge, Mass.

Lunsingh Scheurleer 1988
R. A. Lunsingh Schuerleer. "Eros Op de Gans." *Mededelingenblad* 43, pp. 18–21.

Ma 2003
John Ma. "Kings." In Erskine 2003, pp. 177–95.

Ma 2007
John Ma. "Mysians on the Çan Sarcophagus?: Ethnicity and Domination in Achaimenid Military Art." *Historia: Zeitschrift für Alte Geschichte* 57, no. 3, pp. 243–54.

Maas and Snyder 1989
Martha Maas and Jane McIntosh Snyder. *Stringed Instruments of Ancient Greece.* New Haven and London.

Mao 2000
Yunhui Mao. "Lead-Alkaline Glazed Egyptian Faience: Preliminary Technical Investigation of Ptolemaic Period Faience Vessels in the Collection of the Walters Art Gallery." *Journal of the American Institute for Conservation* 39, no. 2 (Summer), pp. 185–204.

Maish 2017
Jeffrey Maish. "The Getty Herm of Dionysos: Technical Observations, Review, and Interpretation." In *Artistry in Bronze: The Greeks and Their Legacy; XIXth International Congress on Ancient Bronzes*, edited by Jens M. Daehner, Kenneth Lapatin, and Ambra Spinelli, pp. 358–65. Los Angeles. http://www.getty.edu/publications/artistryinbronze.

Marshall 1907
Frederick H. Marshall. *Catalogue of the Finger Rings, Greek, Etruscan, and Roman, in the Departments of Antiquities, British Museum.* London.

Marzatico, Gebhard, and Gleirscher 2011
Franco Marzatico, Rupert Gebhard, and Paul Gleirscher, eds. *Le grandi vie delle civiltà: Relazioni e scambi fra Mediterraneo e il Centro Europa dalla preistoria alla romanità.* Exh. cat. Trent.

Massa-Pairault 2015
Françoise-Hélène Massa-Pairault. "Réalisme et allégorie—Retour sur un enchaînement des motifs de la Gigantomachie." In Grüssinger et al. 2015, pp. 78–85.

Matheson 1980
Susan B. Matheson. *Ancient Glass in the Yale University Art Gallery.* New Haven.

Mathys 2014
Marianne Mathys. *Architekturstiftungen und Ehrenstatuen: Untersuchungen zur visuellen Repräsentation der Oberschicht im späthellenistischen und kaiserzeitlichen Pergamon.* Pergamenische Forschungen 16. Darmstadt.

Mattusch 1996
Carol C. Mattusch. *The Fire of Hephaistos: Large Classical Bronzes from North American Collections.* Exh. cat. Cambridge, Mass.

Mattusch 2014
Carol C. Mattusch. *Enduring Bronze: Ancient Art, Modern Views.* Los Angeles.

Mattusch 2015
Carol Mattusch. "Repeated Images: Beauty with Economy." In Daehner and Lapatin 2015, pp. 110–25.

McGing 1986
Brian Charles McGing. *The Foreign Policy of Mithridates VI Eupator, King of Pontus.* Mnemosyne, Bibliotheca Classica Batava, Supplementum 89. Leiden.

Megow 1987
Wolf-Rüdiger Megow. *Kameen von Augustus bis Alexander Severus.* Antike Münzen und Geschnittene Steine 11. Berlin.

Meinecke 2016
Katharina Meinecke. "Antike Dornausziehergruppen*.*" *BABESCH: Annual Papers on Mediterranean Archaeology* 91, pp. 129–60.

Mellor 1981
Ronald Mellor. "The Goddess Roma." *Aufstieg und Niedergang der römischen Welt: Geschichte und Kultur Roms im Spiegel der neueren Forschun*, pt. 2, 17, no. 2, pp. 950–1030.

Menninger 1996
Michael Menninger. *Untersuchungen zu den Gläsern und Gipsabgüssen aus dem Fund von Begram (Afghanistan).* Würzburger Forschungen zur Altertumskunde 1. Würzburg.

Mercklin 1933
Eugen von Mercklin. "Wagenschmuck aus der römischen Kaiserzeit." *Jahrbuch des Deutschen archaologischen Instituts* 48, nos. 1, 2, pp. 84–176.

Mertens 1985
Joan R. Mertens. "Greek Bronzes in The Metropolitan Museum of Art." *The Metropolitan Museum of Art Bulletin*, n.s., 43, no. 2 (Fall).

Mertens 2010
Joan R. Mertens. *How to Read Greek Vases.* How to Read 2. New York and New Haven.

Mertens 2013
Joan R. Mertens. "Some Notes on the Metropolitan Museum's Pagenstecher Lekythos." in *Amilla: The Quest for Excellence: Studies Presented to Guenter Kopcke in Celebration of His 75th Birthday*, edited by Robert B. Koehl, pp. 415–21. Prehistory Monographs 43. Philadelphia.

Mertens 2016
Joan R. Mertens. "Earthy Arts: Vases, Terracottas, and Small Bronzes." In Picón and Hemingway 2016, pp. 55–61.

Meyboom 1995
Paul G. P. Meyboom. *The Nile Mosaic of Palestrina: Early Evidence of Egyptian Religion in Italy.* Religions in the Graeco-Roman World 121. Leiden and New York.

Meyer 2012
Kai Michael Meyer. "Die Binde des Dionysos als Vorbild für das Diadem." In Lichtenberger et al. 2012, pp. 163–79.

Michaelis 1882
Adolf Michaelis. *Ancient Marbles in Great Britain.* Translated by Charles Augustus Maude Fennell. Cambridge, U.K.

Michalowski 1932
Casimir Michalowski. *Les portraits hellénistiques et romains.* Exploration Archéologique de Délos 13. Paris.

Mildenberg 1999
Leo Mildenberg. "A Note on the Coinage of Hierapolis-Bambyce." In *Travaux de numismatique grecque offerts à Georges Le Rider*, edited by Michel Amandry and Silvia Hurter, pp. 277–84. London.

Miller 1979
Stella G. Miller. *Two Groups of Thessalian Gold.* University of California Publications, Classical Studies 18. Berkeley, Calif.

Milne 1916
Joseph Grafton Milne. "Ptolemaic Seal Impressions." *Journal of Hellenic Studies* 36, pp. 87–101.

Mingazzini 1958
Paolino Mingazzini, ed. *Corpus Vasorum Antiquorum: Italia.* Vol. 29. *Capua, Museo Campano.* Vol. 3. Rome.

Mingazzini 1969
Paolino Mingazzini, ed. *Corpus Vasorum Antiquorum*: *Italia.* Vol. 44. *Capua, Museo Campano.* Vol. 4. Rome.

Mitchell 2009
Alexandre Guillaume Mitchell. *Greek Vase-Painting and the Origins of Visual Humour.* Cambridge, U.K., and New York.

Moltesen 1995
Mette Moltesen. *Greece in the Classical Period: Catalogue, Ny Carlsberg Glyptotek.* Copenhagen.

Moltesen 2000
Mette Moltesen. "The Marbles from Nemi in Exile: Sculpture in Copenhagen, Nottingham, and Philadelphia." In Brandt, Leander Touati, and Zahle 2000, pp. 111–20.

Monaco 1940
Giorgio Monaco. *Il R. Museo di Antichità di Parma.* Itinerari dei Musei e Monumenti d'Italia 74. Rome.

Moormann 2007
Eric M. Moormann. "Villas Surrounding Pompeii and Herculaneum." In *The World of Pompeii*, edited by John J. Dobbins and Pedar W. Foss, pp. 435–54. London and New York.

Moraw 2012
Susanne Moraw. "Visual Differences: Dionysos in Ancient Art." In *A Different God?: Dionysos and Ancient Polytheism*, edited by Renate Schlesier, pp. 233–52. Berlin and Boston.

Moret 1984
Jean-Marc Moret. *Œdipe, la Sphinx et les thébains: Essai de mythologie iconographique.* Rome.

Moretti 1913
Giuseppe Moretti. "Antica tazza di vetro con figura e fregi d'oro." *Bollettino d'arte* 7, pp. 226–32.

Moysey 1986
Robert A. Moysey. "The Silver Stater Issues of Pharnabazos and Datames from the Mint of Tarsus in Cilicia." *American Numismatic Society Museum Notes* 31, pp. 7–61.

Nassioula 2009
Maria Nassioula. "Erotic Grammatika Vases." In *Eros: From Hesiod's Theogony to Late Antiquity,* edited by Nicholas Chr. Stampolidis and Yorgos Tassoulas, pp. 58–69. Athens.

Nassioula 2013
Maria Nassioula. "Potirion Grammatikon: Hellenistic Relief Vases with Inscribed Narrative Scenes." PhD diss., Aristotle University of Thessaloniki.

Nenna 1999
Marie-Dominique Nenna. *Les verres.* Exploration Archéologique de Délos 37. Athens.

Nenna 2002
Marie-Dominique Nenna. "New Research on Mosaic Glass: Preliminary Results." In Kordas 2002, pp. 153–58.

Nenna 2005
Marie-Dominique Nenna. "En Egypte sous les Ptolémées." In Caubet and Pierrat-Bonnefois 2005, pp. 165–73.

Nenna 2006
Marie-Dominique Nenna. "Les artisanats du verre et de la faïence: Tradition et renouvellement dans l'Égypte gréco-romaine." In *L'apport de l'Egypte à l'histoire des techniques: Méthodes, chronologie et comparaisons*, edited by Bernard Mathieu, Dimitri Meeks, and Myriam Wissa, pp. 185–206. Publications de l'Institut Français d'Archéologie Orientale 944; Institut Français d'Archéologie Bibliothèque d'Etude 142. Exh. cat. Cairo.

Nenna 2014
Marie-Dominque Nenna. "Bibliographie commentée des contributions sur la faïence gréco-romaine, 2000–2013." In *Alexandrina. 4: En l'honneur de Mervat Seif el-Din*, edited by Jean-Yves Empereur, pp. 341–63. Etudes Alexandrines 32. Alexandria.

Nenna and Seif El-Din 2000
Marie-Dominique Nenna and Merwatte Seif El-Din. *La vaisselle en faïence d'époque gréco-romaine: Catalogue du Musée gréco-romain d'Alexandrie.* Etudes Alexandrines 4. Cairo.

Neudecker 1988
Richard Neudecker. *Die Skulpturen-Ausstattung römischer Villen in Italien*. Mainz am Rhein.

Neugebauer 1951
Karl Anton Neugebauer, *Die griechischen Bronzen der klassischen Zeit und des Hellenismus*, Berlin.

Neumann 1977
Gerhard Neumann. "Zum Helioskopf von Rhodos." *Anzeiger des Deutschen Archäologischen Instituts*, pp. 86–90.

Neumann 1988
Gerhard Neumann. "Ein späthellenistisches Tondo-Bildnis." *Mitteilungen des Deutschen Archäologischen Instituts: Athenische Abteilung* 103, pp. 221–38.

Nicholls 1982
Richard V. Nicholls. "The Drunken Herakles: A New Angle on an Unstable Subject." *Hesperia: The Journal of the American School of Classical Studies at Athens* 51, no. 3 (July–September), pp. 321–28.

Nicholson 2013
Paul T. Nicholson. *Working in Memphis: The Production of Faience at Roman Period Kom Helul*. Excavation Memoir 105. London.

Nicolet-Pierre 1978
Hélène Nicolet-Pierre. "Monnaies 'à éléphant.'" *Bulletin de la Société française de numismatique* 33, no. 7, pp. 401–3.

Nicolet-Pierre 1999
Hélène Nicolet-Pierre. "Argent et or frappés en Babylonie entre 331 et 311 ou de Mazdai à Séleucos." In *Travaux de Numismatique grecque offerts à Georges Le Rider*, edited by Michel Amandry and Silvia Hurter, pp. 285–305. London.

Nielsen 1993
Anne Marie Nielsen. "The Mirage of Alexander—A Minimalist View." In *Alexander the Great: Reality and Myth*, edited by Jesper Carlsen, pp. 137–44. Analecta Romana Instituti Danici, Supplementum 20. Rome. Repr. ed., 1997.

Noël 1983
Daniel Noël. "Du vin pour Héraklès!" In *Image et céramique grecque: Actes du colloque de Rouen 25–26 novembre 1982*, edited by François Lissarrague and Françoise Thelamon, pp. 141–50. Publications de l'Université de Rouen 96. Rouen.

Nünnerich-Asmus 1993
Annette Nünnerich-Asmus, ed. *Denkmäler der Römerzeit*. Hispania Antiqua. Mainz am Rhein.

Oliver 1967
Andrew Oliver Jr. "Late Hellenistic Glass in the Metropolitan Museum." *Journal of Glass Studies* 9, pp. 13–33.

Oliver 1968
Andrew Oliver Jr. "Millefiori Glass in Classical Antiquity." *Journal of Glass Studies* 10, pp. 48–70.

Oliver 1969
Andrew Oliver Jr. "A Gold-Glass Fragment in The Metropolitan Museum of Art." *Journal of Glass Studies* 11, pp. 9–16.

Oliver 1970
Andrew Oliver Jr. "Persian Export Glass." *Journal of Glass Studies* 12, pp. 9–16.

Oliver 1977
Andrew Oliver Jr. *Silver for the Gods: 800 Years of Greek and Roman Silver*. Exh. cat. Toledo, Ohio.

Oliver 1996
Andrew Oliver Jr. "Honors to Romans: Bronze Portraits." In Mattusch 1996, pp. 138–160.

Onians 1979
John Onians. *Art and Thought in the Hellenistic Age: The Greek World View, 350–50 BC*. London.

Page 2006
Jutta-Annette Page. *The Art of Glass: Toledo Museum of Art*. Toledo, Ohio, and London.

Palagia 2003
Olga Palagia. "The Impact of *Ares Makedon* on Athenian Sculpture." In *The Macedonians in Athens, 322–229 B.C.: Proceedings of an International Conference Held at the University of Athens, May 24–26, 2001*, edited by Olga Palagia and Stephen V. Tracy, pp. 140–51. Oxford.

Palagia 2014a
Olga Palagia. "Berenike II in Athens." In Schultz and Hoff 2014, pp. 237–45.

Palagia 2014b
Olga Palagia. "The Frescoes from the Villa of P. Fannius Synistor in Boscoreale as Reflections of Macedonian Funerary Paintings of the Early Hellenistic Period." In Hauben and Meeus 2014, pp. 207–31.

Palagia 2017
Olga Palagia. "Alexander's Battles against Persians in the Art of the Successors." In *Ancient Historiography on War and Empire*, edited by Timothy Howe, Sabine Müller, and Richard Stoneman, pp. 177–87. Oxford and Havertown.

Palagia and Coulson 1998
Olga Palagia and William Coulson, eds. *Regional Schools in Hellenistic Sculpture: Proceedings of an International Conference Held at the American School of Classical Studies at Athens, March 15–17, 1996*. Oxbow Monograph 90. Oxford.

Pantermalis 1971
Dimitrios Pantermalis. "Zum Programm der Statuenausstattung in der Villa dei Papiri." *Mitteilungen des Deutschen Archäologischen Instituts, Athenische Abteilung* 86, pp. 173–209.

Pantermalis 2004
Dimitrios Pantermalis. *Alexander the Great: Treasures from an Epic Era of Hellenism*. Exh. cat. New York.

Pantos 1989
Pantos A. Pantos. "Echedemos: 'The Second Attic Phoibos.'" *Hesperia* 58, no. 3 (July–September), pp. 277–88.

Papini 2016
Massimiliano Papini. "Commemorations of Victory: Attalid Monuments to the Defeat of the Galatians." In Picón and Hemingway 2016, pp. 40–43.

Paribeni 1902
Roberto Paribeni. "Il borgo marinaro presso il Sarno." *Notizie degli scavi di antichità* 27, no. 11, pp. 568–78.

Parke 1994
Herbert William Parke. *Festivals of the Athenians*. Aspects of Greek and Roman Life. 3rd ed. Ithaca, N.Y.

Parker 1987
Robert R. Parker. "Festivals of the Attic Demes." In *Gifts to the Gods: Proceedings of the Uppsala Symposium, 1985*, edited by Tullia Linders and Gullög Nordquist, pp. 137–47. Acta Universitatis Upsaliensis, Boreas 15. Uppsala and Stockholm.

Parlasca 1976
Klaus Parlasca. "Zur Verbreitung ptolemäischer Fayencekeramik ausserhalb Ägyptens." *Jahrbuch des Deutschen Archäologischen Instituts* 91, pp. 135–56.

Patch 1998
Diana Craig Patch. "By Necessity or Design: Faience Use in Ancient Egypt." In Friedman 1998, pp. 32–45.

Paton 1916–18
William Roger Paton, transl. *The Greek Anthology*. 5 vols. Loeb Classical Library. London and New York.

Pensabene 2006
Patrizio Pensabene. "Architetture e spazio sacro sul Palatino: Il tempio della Vittoria e il santuario della Magna Mater." In *Roma: Memorie del sottosuolo; Ritrovamenti archeologici, 1980–2006*, edited by Maria Antonietta Tomei, pp. 43–51. Exh. cat. Milan.

Perdrizet 1911
Paul Perdrizet. *Bronzes grecs d'Égypte de la collection Fouquet*. Publications pour Faciliter les Etudes d'Art en France. Paris.

Perdu 2002
Olivier Perdu. "Le roi Roudamon en personne!" *Revue d'égyptologie* 53, pp. 157–70.

Pernice 1932
Erich Pernice. *Hellenistische Tische, Zisternenmündungen, Beckenuntersätze, Altäre und Truhen*. Die Hellenistische Kunst in Pompeji 5. Berlin and Leipzig.

Pescei and Freed 2004
Angelo Pescei and Lou Freed, eds. *In Stabiano: Exploring the Ancient Seaside Villas of the Roman Elite*. Exh. cat. Naples.

Petrova 2014
Aneta Petrova. "A Pontic Group of Hellenistic Mouldmade Bowls." In Bilde and Lawall 2014, pp. 215–31.

Pfrommer 1987
Michael Pfrommer. *Studien zu alexandrinischer und grossgriechischer Toreutik frühhellenistischer Zeit.* Archäologische Forschungen 16. Berlin.

Pfrommer 1990
Michael Pfrommer. *Untersuchungen zur Chronologie früh- und hochhellenistischen Goldschmucks.* Istanbuler Forschungen 37. Tübingen.

Pfrommer 2001
Michael Pfrommer. *Greek Gold from Hellenistic Egypt.* Los Angeles.

Pfrommer 2004
Michael Pfrommer. "Arsinoe II und ihr magnetischer Tempel." *Städel-Jahrbuch* 19, pp. 455–62.

Pickard-Cambridge 1968
Sir Arthur Wallace Pickard-Cambridge. *The Dramatic Festivals of Athens.* Revised by John Gould and David Malcolm Lewis. 2nd ed. Oxford.

Picón 2014
Carlos A. Picón. "An Ancient Plaster Cast in New York: A Ptolemaic Syncretistic Goddess." In *Approaching the Ancient Artifact: Representation, Narrative, and Function; A Festschrift in Honor of H. Alan Shapiro,* edited by Amalia Avramidou and Denise Demetriou, pp. 449–54. Berlin.

Picón 2016
Carlos A. Picón. "Introduction." In Picón and Hemingway 2016, pp. 1–7.

Picón and Hemingway 2016
Carlos A. Picón and Seán Hemingway, eds. *Pergamon and the Hellenistic Kingdoms of the Ancient World.* Exh. cat. New York.

Picón et al. 2007
Carlos A. Picón, Joan R. Mertens, Elizabeth J. Milleker, Christopher S. Lightfoot, and Seán Hemingway. *Art of the Classical World in The Metropolitan Museum of Art: Greece, Cyprus, Etruria, Rome.* New York.

Pierrat-Bonnefois 2005
Geneviève Pierrat-Bonnefois. "Flacons héritiers des formes de Grèce orientale." In Caubet and Pierrat-Bonnefois 2005, pp. 157–61.

Pinkwart 1965
Doris Pinkwart. *Das Relief von Archelaos von Priene und die "Musen des Philiskos."* Kallmünz über Regensburg.

Pinkwart and Stammnitz 1984
Doris Pinkwart and Wolf Stammnitz. *Peristylhaüser westlich der unteren Agora.* Altertümer von Pergamon 14. Berlin.

Piranesi 1778–80
Giovanni Battista Piranesi. *Vasi, candelabri, cippi, sarcofagi, tripodi Lucerne et ornamenti antichi.* 2 vols. Piranesi Opera 13, 14. Rome.

Pirson 2012
Felix Pirson, ed. *Manifestationen von Macht und Hierarchien in Stadtraum und Landschaft: Wissenschaftliches Netzwerk der Abteilung Istanbul im Rahmen des Forschungsclusters 3 "Politische Räume" des Deutschen Archäologischen Instituts.* Byzas 13. Istanbul.

Pirson 2014
Felix Pirson. "The City and Its Landscape: Tradition and Innovation in the Investigation of Pergamon / Kent ve çevresi: Gelenek ve yenilik arasında Pergamon araştırmaları." In Pirson and Scholl 2014, pp. 50–63.

Pirson and Scholl 2014
Felix Pirson and Andreas Scholl, eds. *Pergamon: A Hellenistic Capital in Anatolia / Pergamon: Anadolu'da Hellenistik bir başkent.* Anadolu Uygarlıkları Serisi 4. Istanbul.

Pirzio Biroli Stefanelli 1991
Lucia Pirzio Biroli Stefanelli. *L'argento dei Romani: Vasellame da tavola e d'apparato.* Metallo—Mito e Fortuna nel Mondo Antico 2. Rome.

Plantzos 1996
Dimitris Plantzos. "Hellenistic Cameos: Problems of Classification and Chronology." *Bulletin of the Institute of Classical Studies* 41, pp. 115–31.

Plantzos 1999
Dimitris Plantzos. *Hellenistic Engraved Gems.* Oxford Monographs on Classical Archaeology. Oxford and New York.

Platz-Horster 1995
Gertrude Platz-Horster. "Die Berliner Glasamphora aus Olbia." *Journal of Glass Studies* 37, pp. 35–49.

Platz-Horster 2001
Gertrud Platz-Horster. *Antiker Goldschmuck; Altes Museum; Eine Auswahl der ausgestellten Werke.* Mainz am Rhein and Berlin.

Pliny 1940–86
Pliny the Elder. *Natural History.* Translated by Harris Rackham. 10 vols. Cambridge, Mass., and London.

Polinskaya 2003
Irene Polinskaya. "Liminality as Metaphor: Initiation and the Frontiers of Ancient Athens." In *Initiation in Ancient Greek Rituals and Narratives: New Critical Perspectives,* edited by David B. Dodd and Christopher A. Faraone, pp. 85–106. London and New York.

Pollitt 1986
Jerome Jordan Pollitt. *Art in the Hellenistic Age.* Cambridge, U.K., and New York.

Poseidippos of Pella 2001
Poseidippos of Pella. *Epigrammi: P.Mil.Vogl. 8. 309.* Edited by Guido Bastianini and Claudio Gallazzi. Pubblicazioni della Facoltà di Lettere e Filosofia dell'Università di Milano 200; Papiri dell'Università degli Studi di Milano 8. Milan.

Price 1982
Martin Jessop Price. "The 'Porus' Coinage of Alexander the Great: A Symbol of Concord and Community." In *Studia Paulo Naster Oblata,* vol. 1, *Numismatica antiqua,* edited by Simone Scheers, pp. 75–85. Orientalia Lovaniensia Analecta 12. Leuven.

Price 1991a
Martin Jessop Price. "Circulation at Babylon in 323 b.c." In *Mnemata: Papers in Memory of Nancy M. Waggoner,* edited by William E. Metcalf, pp. 63–72. New York.

Price 1991b
Martin Jessop Price. *The Coinage in the Name of Alexander the Great and Philip Arrhidaeus: a British Museum Catalogue.* 2 vols. Zurich and London.

Price et al. 1975–2010
Martin Jessop Price, Ute Wartenberg, Kaelyn McGregor, and Andrew Meadows. *Coin Hoards.* 10 vols. Royal Numismatic Society, Great Britain, Special Publication 35. London and New York.

Prioux 2008
Evelyne Prioux. *Petits musées en vers: Epigramme et discours sur les collections antiques.* L'Art et l'Essai 5. Paris.

Prioux and Trinquier 2016
Evelyne Prioux and Jean Trinquier. "L'autruche d'Arsinoé et le lion de Bérénice: Des usages de la faune dans la représentation des premières reines lagides." In *D'Alexandre à Auguste: Dynamiques de la création dans les arts visuels et la poésie* [Colloque tenu à Paris, Institut national d'histoire de l'art, INHA, 10–12 mai 2012], edited by Pascale Linant de Bellefonds, Evelyne Prioux and Agnès Rouveret, pp. 31–56. Collection Archéologie et Culture. Rennes.

Prittwitz und Gaffron 1998
Hans-Hoyer von Prittwitz und Gaffron. "The Divine Circle: The Roundels of Mahdia." In Palagia and Coulson, 1998, pp. 69–73.

Protonotariou-Deilaki 1961–62
Evangelia Protonotariou-Deilaki. "Ἀνασκαφή Φενεοῦ 1958, 1959, 1961." *Archaiologikon Deltion* 17, pp. 57–61.

Pülz 1989
Stefan Pülz. *Untersuchungen zur kaiserzeitlichen Bauornamentik von Didyma.* Istanbuler Mitteilungen 35. Tübingen.

Quattrocchi 1956
Giovanna Quattrocchi. *Il Museo Archeologico Prenestino.* Rome.

Queyrel 2003
François Queyrel. *Les portraits des Attalides: Fonction et représentation.* Athens.

Queyrel 2015
François Queyrel. "Les sculpteurs de l'Autel de Pergame." In Grüssinger et al. 2015, pp. 70–77.

Radt 1988
Wolfgang Radt. "Pergamon: Vorbericht über die Kampagne 1986." *Archäologischer Anzeiger*, pp. 461–85.

Radt 1997
Wolfgang Radt. "Pergamon. Vorbericht über die Kampagne 1996." *Archäologischer Anzeiger*, pp. 415–29.

Radt 1999
Wolfgang Radt. *Pergamon: Geschichte und Bauten einer antiken Metropole.* Darmstadt. 2nd ed. 2011.

Raeck 1988
Wulf Raeck. "Zur hellenistischen Bebauung der Akropolis von Pergamon." *Istanbuler Mitteilungen* 38, pp. 201–30.

Reeder 1988
Ellen D. Reeder. *Hellenistic Art in the Walters Art Gallery.* Exh. cat. Baltimore and Princeton, N.J.

S. Reinach 1897
Salomon Reinach. *Sept mille statues antiques.* Vol. 2 of *Répertoire de la statuaire grecque et romaine.* Paris.

T. Reinach 1960
Théodore Reinach. *Mitridate Eupatore: Re del Ponto.* Cento Libri 10. Milan.

Reinsberg 1980
Carola Reinsberg. *Studien zur hellenistischen Toreutik: Die antiken Gipsabgüsse aus Memphis.* Hildesheimer Ägyptologische Beiträge 9. Hildesheim.

Rendeli 1989
Marco Rendeli. "Vasi attici da mensa in Etruria: Note sulle occorrenze e sulla distribuzione." *Mélanges de l'Ecole française de Rome, Antiquite* 101, no. 2, pp. 545–79.

Rice 1983
Ellen E. Rice. *The Grand Procession of Ptolemy Philadelphus.* Oxford.

Richter 1915
Gisela M. A. Richter. "A Bronze Statuette of Herakles." *Bulletin of The Metropolitan Museum of Art* 10, no. 11 (November), pp. 236–37.

Richter 1930
Gisela M. A. Richter. *Handbook of the Classical Collection* [The Metropolitan Museum of Art]. New York.

Richter 1931
Gisela M. A. Richter. "The Objects of Classical Art." *Bulletin of The Metropolitan Museum of Art* 26, no. 3 (March), sect. 2, *The Theodore M. Davis Bequest*, p. 13.

Richter 1950
Gisela M. A. Richter. *The Sculpture and Sculptors of the Greeks* [The Metropolitan Museum of Art, New York]. Rev. edition. New Haven.

Richter 1953
Gisela M. A. Richter. *Handbook of the Greek Collection* [The Metropolitan Museum of Art, New York]. Cambridge, Mass.

Richter 1954
Gisela M. A. Richter. *Catalogue of Greek Sculptures* [The Metropolitan Museum of Art, New York]. Cambridge, Mass.

Ridder 1911
André de Ridder. *Collection de Clercq: Catalogue méthodique et raisonné; Antiquités assyriennes, cylindres orientaux, cachets, briques, bronzes, bas-reliefs, etc.* Vol. 7, pt 1, *Les bijoux.* Paris.

Ridgway 1990–2002
Brunilde Sismondo Ridgway. *Hellenistic Sculpture.* 3 vols. Bristol, U.K., and Madison, Wisc.

Ridgway 1997
Brunilde Sismondo Ridgway. *Fourth-Century Styles in Greek Sculpture.* Wisconsin Studies in Classics. Madison, Wisc.

Ridgway 2015
Brunilde Sismondo Ridgway. Review of Daehner and Lapatin 2015. *Bryn Mawr Classical Review*, Blog, 2015.09.02. http://bmcr.brynmawr.edu/2015/2015-09-02.html.

Ridgway 2016
Brunilde Sismondo Ridgway. Response: Ridgway on Barr-Sharrar on Ridgway on Daehner and Lapatin 2015. *Bryn Mawr Classical Review* open access online journal, 2016.02.47. http://bmcr.brynmawr.edu/2016/2016-02-47.html.

Ritter 1965
Hans Werner Ritter. *Diadem und Königsherrschaft: Untersuchungen zu Zeremonien und Rechtsgrundlagen des Herrschaftsantritts bei den Persern, bei Alexander dem Grossen und im Hellenismus.* Vestigia 7. Munich.

Rogl 1996
Christine Rogl. "Hellenistische Reliefbecher aus der Stadt Elis." *Jahreshefte des österreichischen archäologischen Institutes in Wien* 65, pp. 113–58.

Rogl 2008
Christine Rogl. *Die hellenistischen Reliefbecher aus Lousoi: Material aus den Grabungen im Bereich Phournoi, 1983–1994.* Ergänzungshefte zu den Jahresheften des Österreichischen Archäologischen Institutes in Wien 10. Vienna.

Rogl 2014
Christine Rogl. "Moldmade Relief Bowls from Ephesos—The Current State of Research." In Bilde and Lawall 2014, pp. 113–39.

Rolley 1979
Claude Rolley. "Les bronzes antiques: Objets d'art ou documents historiques?" In *Bronzes hellénistiques et romains: Tradition et renouveau; Actes du Ve Colloque international sur les bronzes antiques, Lausanne, 8–13 mai 1978*, pp. 13–20. Cahiers d'Archéologie Romande de la Bibliothèque Historique Vaudoise 17. Lausanne.

Rolley 1983
Claude Rolley. *Les bronzes grecs.* Fribourg. German ed., *Die griechischen Bronzen.* Munich, 1984.

Romano 2006
Irene Bald Romano. *Classical Sculpture: Catalogue of the Cypriot, Greek and Roman Stone Sculpture in the University of Pennsylvania Museum of Archaeology and Anthropology.* University Museum Monograph 125. Philadelphia.

Rostovtzeff 1941
Michael Ivanovitch Rostovtzeff. *The Social and Economic History of the Hellenistic World.* 3 vols. Oxford.

Rostovtzeff 1980
Michael Ivanovitch Rostovtzeff. *Storia economica e sociale mondo ellenistico.* Vol. 3. Translated by Manfredo Liberanome and Giovanni Santa. Il Pensiero Storico 42. Florence.

Rotroff 1982a
Susan I. Rotroff. *Hellenistic Pottery: Athenian and Imported Moldmade Bowls.* Athenian Agora 22. Princeton, N.J.

Rotroff 1982b
Susan I. Rotroff. "Silver, Glass, and Clay: Evidence for the Dating of Hellenistic Luxury Tableware." *Hesperia* 51, pp. 329–37.

Rotroff 1986
Susan I. Rotroff. Review Sinn 1979. *Gnomon* 58, no. 5, pp. 472–75.

Rotroff 1991
Susan I. Rotroff. "Attic West Slope Vase Painting." *Hesperia* 60, no. 1 (January–March), pp. 59–102.

Rotroff 1996
Susan I. Rotroff. *The Missing Krater and the Hellenistic Symposium: Drinking in the Age of Alexander the Great.* Christchurch, New Zealand.

Rotroff 1997
Susan I. Rotroff. *Hellenistic Pottery: Athenian and Imported Wheelmade Table Ware and Related Material.* 2 vols. Athenian Agora 29, nos. 1, 2. Princeton, N.J.

Rotroff 2006
Susan I. Rotroff. "The Introduction of the Moldmade Bowl Revisited: Tracking a Hellenistic Innovation." *Hesperia* 75, no. 3 (July–September), pp. 357–78.

Rotroff 2009
Susan I. Rotroff. "Material Culture." In *The Cambridge Companion to the Hellenistic World*, edited by Glenn Richard Bugh, pp. 136–57. Cambridge, U.K.

Rotroff 2013
Susan I. Rotroff. "Bion International: Branch Pottery Workshops in the Hellenistic Aegean." In *Networks in the Hellenistic World: According to the Pottery in the Eastern Mediterranean and Beyond*, edited by Nina Fenn and Christiane Römer-Strehl, pp. 15–23. BAR (British Archaeological Reports) International Series 2539. Oxford.

Rotroff and Oliver 2003
Susan I. Rotroff and Andrew Oliver Jr. *The Hellenistic Pottery from Sardis: The Finds through 1994*. Monograph (Archaeological Exploration of Sardis) 12. Cambridge, Mass.

Roussel 1915–16
Pierre Roussel. *Les cultes égyptiens à Délos du IIIe au Ier siècle av. J.-C.* Paris and Nancy.

Rumscheid 2006
Frank Rumscheid. *Die Figürlichen Terrakotten von Priene: Fundkontexte, Ikonographie und Funktion in Wohnhäusern und Heiligtümern im Licht antiker Parallelbefunde*. Archäologische Forschungen 22; Priene 1. Wiesbaden.

Saldern 1959
Axel von Saldern. *Antikes Glas*. Handbuch der Archäologie 7. Munich.

Saldern 2004
Axel von Saldern. *Antikes Glas*. Handbuch der Archäologie 7. Munich.

Salvetti 2013
Carla Salvetti. *I mosaici antichi pavimentali e parietali e i "sectilia pavimenta" di Roma nelle collezioni Capitoline*. Musiva & Sectilia 6. Pisa and Rome.

Salzmann 2012
Dieter Salzmann. "Anmerkungen zur Typologie des hellenistischen Königsdiadems und zu de anderen herrscherlichen Kopfbinden." In Lichtenberger et al. 2012, pp. 337–83.

Sapelli Ragni 2009
Marina Sapelli Ragni, ed. *Anzio e Nerone: Tesori dal British Museum e dai Musei Capitolini*. Exh. cat. Rome.

Sapouna-Sakellaraki 1995
Efi Sapouna-Sakellaraki. *Chalkis: History, Topography and Museum*. Translated by W. Phelps. Athens.

Sassatelli 2010
Giuseppe Sassatelli. "Atene e l'Etruria Padana." In "Dal Mediterraneo all'Europa: Conversazioni adriatiche," edited by Elisabetta Govi. Special issue, *Hesperia* 25, pp. 153–71.

Sayre 1963
Edward V. Sayre. "The Intentional Use of Antimony and Manganese in Ancient Glasses." In *Advances in Glass Technology: Part 2, History Papers and Discussions of the Technical Papers*, edited by Frederick R. Matson and Guy E. Rindone, pp. 263–82. New York.

Sayre and R. W. Smith 1961
Edward V. Sayre and Ray W. Smith. "Compositional Categories of Ancient Glass." *Science*, n.s., 133, no. 3467 (June 9), pp. 1824–26.

Sayre and R. W. Smith 1967
Edward V. Sayre and Ray W. Smith. "Some Materials of Glass Manufacturing in Antiquity." In *Archaeological Chemistry: A Symposium*, edited by Martin Levey, pp. 279–311. Philadelphia.

Scarisbrick 2004
Diana Scarisbrick. *Historic Rings: Four Thousand Years of Craftsmanship*. Tokyo and New York.

Schäfer 1968
Jörg Schäfer. *Hellenistische Keramik aus Pergamon*. Pergamenische Forschungen 2. Berlin.

Schalles 1985
Hans-Joachim Schalles. *Untersuchungen zur Kulturpolitik der pergamenischen Herrscher im dritten Jahrhundert vor Christus*. Istanbuler Forschungen 36. Tübingen.

Schalles 2011
Hans-Joachim Schalles. "'Wohltaten und Geschenke'— Die Kulturpolitik der pergamenischen Herrscher." In Grüssinger, V. Kästner, and Scholl 2011, pp. 118–21.

Schede 1964
Martin Schede. *Die Ruinen von Priene: Kurze Beschreibung*. 2nd ed. Berlin.

Schnitzler 1995
Bernadette Schnitzler. *Bronzes antiques d'Alsace: Musée archéologique de Strasbourg, Musées de Biesheim, Colmar, Haguenau, Mulhouse, Niederbronn, Wissembourgh*. Inventaire des Collections Publiques Françaises 37. Paris.

Schüler 1966
Irmgard Schüler. "A Note on Jewish Gold Glasses." *Journal of Glass Studies* 8, pp. 48–61.

Schultz and Hoff 2014
Peter Schultz and Ralf von den Hoff, eds. *Early Hellenistic Portraiture: Image, Style, Context*. Cambridge, U.K.

Schwarzer and Rehren 2015
Holger Schwarzer and Thilo Rehren. "Antikes Glas aus Pergamon—Ergebnisse archäologischer und naturwissenschaftlicher Untersuchungen." In Grüssinger et al. 2015, pp. 106–34.

Schwarzmaier 1997
Agnes Schwarzmaier. *Griechische Klappspiegel: Untersuchungen zu Typologie und Stil*. Mitteilungen der Deutschen Archäologischen Instituts, Athenische Abteilung 18. Berlin.

Schwarzmaier 2011
Agnes Schwarzmaier. "Der Grabfund aus Tumulus II." In Grüssinger, V. Kästner, and Scholl 2011, pp. 297–99.

***Search for Alexander* 1980**
The Search for Alexander: An Exhibition. With contributions by Nicholas Yalouris, Manolis Andronikos, Katerina Rhomiopoulou, Ariel Herrmann, and Cornelius C. Vermeule. Exh. cat. Boston.

***SEG* 1965**
Supplementum epigraphicum graecum (SEG). Vol. 21. Amsterdam.

Segall 1938
Berta Segall. *Museum Benaki, Athens: Katalog der Goldschmiede-Arbeiten*. Athens.

Seif El-Din and Nenna 1994
Mervat Seif El-Din and Marie-Dominique Nenna. "La petite plastique en faïence du Musée gréco-romain d'Alexandrie." *Bulletin de correspondance hellénique* 118, no. 2, pp. 291–320.

Sevinç et al. 2001
Nurten Sevinç, Reyhan Körpe, Musa Tombul, Charles Brian Rose, Donna Strahan, Henrike Keisewetter, and John Wallrodt. "A New Painted Graeco-Persian Sarcophagus from Çan." *Studia troica* 11, pp. 383–420.

Seyrig 1971
Henri Seyrig. "Monnaies hellénistiques; XIX: Le monnayage de Hiérapolis de Syrie à l'époque d'Alexandre." *Revue numismatique*, ser. 6, 13, pp. 11–21.

Shaw and Jameson 1993
Ian Shaw and Robert Jameson. "Amethyst Mining in the Eastern Desert: A Preliminary Survey at Wadi el-Hudi." *Journal of Egyptian Archaeology* 79, pp. 81–97.

Shortland and Schroeder 2009
Andrew J. Shortland and Hannes Schroeder. "Analysis of First Millenium BC Glass Vessels and Beads from the Pichvnari Necropolis, Georgia." *Archaeometry* 51, no. 6 (January), pp. 947–65.

Shortland et al. 2006
Andrew J. Shortland, Lukas Schachner, Ian C. Freestone, and Michael Tite. "Natron as a Flux in the Early Vitreous Materials Industry: Sources, Beginnings and Reasons for Decline." *Journal of Archaeological Science* 33, no. 4 (April), pp. 521–30.

Siebert 1978
Gérard Siebert. *Recherches sur les ateliers de bols à reliefs du Péloponnèse à l'époque hellénistique*. Bibliothèque des l'Ecoles Françaises d'Athènes et de Rome 233. Athens and Paris.

Siedentopf 1968
Heinrich Siedentopf. *Das hellenistische Reiterdenkmal*. Bayern.

Siegler 1966
Karl Georg Siegler. "Die Einzelnen Gragungs objekte, Traianeum." *Archäologischer Anzeiger* 4, pp. 430–34.

Simon 1983
Erika Simon. *Festivals of Attica: An Archaeological Commentary*. Wisconsin Studies in Classics. Madison, Wisc.

Simpson 2005
St. John Simpson. "The Royal Table." In *Forgotten Empire: The World of Ancient Persia*, edited by John E. Curtis and Nigel Tallis, pp. 104–31. Exh. cat. Berkeley, Calif.

Sinn 1979
Ulrich Sinn. *Die homerischen Becher: Hellenistische Reliefkeramik aus Makedonien*. Mitteilungen des Deutschen Archäologischen Instituts, Athenische Abteilung, Beiheft 7. Berlin.

A. Smith 1904
Arthur Hamilton Smith. *A Catalogue of the Sculpture in the Department of Greek and Roman Antiquities, British Museum*. Vol. 3. London.

R. R. Smith 1988
Roland R. R. Smith. *Hellenistic Royal Portraits*. Oxford.

R. R. Smith 1991
Roland R. R. Smith. *Hellenistic Sculpture: A Handbook*. World of Art. New York.

R. R. Smith 1994
Roland R. R. Smith. "Spear-Won Land at Boscoreale: On the Royal Paintings of a Roman Villa." *Journal of Roman Archaeology* 7, pp. 100–128.

R. R. Smith 2006
Roland R. R. Smith. *Roman Portrait Statuary from Aphrodisias*. Aphrodisias 2. Mainz am Rhein.

Snowden 1976
Frank M. Snowden Jr. "Témoignages iconographiques sur les populations noires dans l'Antiquité gréco-romaine." In Vercoutter et al. 1976, pp. 133–245.

Sommella and Parisi Presicce 1997
Anna Mura Sommella and Claudio Parisi Presicce, eds. *Il Marco Aurelio e la sua copia*. Rome.

Sommerey 2008
Kai Michael Sommerey. "Die Chora von Pergamon. Studien zu Grenzen, Siedlungsstruktur und Wirtschaft." *Istanbuler Mitteilungen* 58, pp. 135–70.

Sorabella 2007
Jean Sorabella. "Eros and the Lizard: Children, Animals, and Roman Funerary Sculpture." In *Constructions of Childhood in Ancient Greece and Italy*, edited by Ada Cohen and Jeremy B. Rutter, pp. 353–70. Hesperia, Supplement 41. Princeton, N.J.

Sotheby's London 2011
Sotheby's London. *European Sculpture and Works of Art: Medieval to Modern*. December 6.

Sotheby's New York 1999
Sotheby's New York. *Antiquities and Islamic Works of Art*. December 10.

Sourvinou-Inwood 2003
Christiane Sourvinou-Inwood. *Tragedy and Athenian Religion*. Lanham, Md.

Spaer 2001
Maud Spaer. *Ancient Glass in the Israel Museum: Beads and Other Small Objects*. Katalog 447. Jerusalem.

Spalinger and Armstrong 2013
Anthony Spalinger and Jeremy Armstrong, eds. *Rituals of Triumph in the Mediterranean World*. Leiden.

Specimens 1835
Specimens of Antient Sculpture, Aegyptian, Etruscan, Greek, and Roman: Selected from Different Collections in Great Britain by the Society of Dilettanti. Vol. 2. London.

Spier 1989
Jeffrey Spier. "A Group of Ptolemaic Engraved Garnets." *Journal of the Walters Art Gallery* 47, pp. 21–38.

Spier 1992
Jeffrey Spier. *Ancient Gems and Finger Rings: Catalogue of the Collection* [J. Paul Getty Museum]. Malibu.

Spier and Ogden 2015
Jeffrey Spier and Jack Ogden. *Rings of the Ancient World: Egyptian, Near Eastern, Greek, and Roman Rings from the Slava Yevdayev Collection*. Wiesbaden.

St. Clair 1967
William L. St. Clair. *Lord Elgin and the Marbles*. Oxford.

Stähli 1999
Adrian Stähli. *Die Verweigerung der Lüste: Erotische Gruppen in der antiken Plastik*. Berlin.

Stamper 2005
John W. Stamper. *The Architecture of Roman Temples: The Republic to the Middle Empire*. Cambridge, U.K.

Stampolidis and Tasoulas 2014
Nicholas Chr. Stampolidis and Giorgos Tasoulas, eds. *Hygieia: Health, Illness, Treatment from Homer to Galen*. Exh. cat. Athens.

Steiger 1967
Ruth Steiger. "Drei römische Bronzen aus Augst." In *Gestalt und Geschichte, Festschrift Karl Schefold zu seinem 60. Geburtstag am 26. Januar 1965*, edited by Martha Rohde-Liegle, Herbert Adolph Cahn, and Hans Christoph Ackermann, pp. 186–95. Beiheft zur Halbjahresschrift Antike Kunst 4. Bern.

Stemmer 1978
Klaus Stemmer. *Untersuchungen zur Typologie, Chronologie und Ikonographie der Panzerstatuen*. Archäologische Forschungen 4. Berlin.

Stern 1994
Eva Marianne Stern. "Ein Fund hellenistischen Luxusglases." In Stern and Schlick-Nolte 1994, pp. 97–115.

Stern 1999
Eva Marianne Stern. "Ancient Glass in Athenian Temple Treasures." *Journal of Glass Studies* 41, pp. 19–50.

Stern 2002
Eva Marianne Stern. "Glass for the Gods." In Kordas 2002, pp. 353–65.

Stern 2007
Eva Marianne Stern. "Ancient Glass in a Philological Context." *Mnemosyne*, ser. 4, 60, no. 3, pp. 341–406.

Stern and Schlick-Nolte 1994
Eva Marianne Stern and Birgit Schlick-Nolte. *Early Glass of the Ancient World, 1600 B.C.–A.D. 50: Ernesto Wolf Collection*. Ostfildern-Ruit.

Stewart 1990
Andrew F. Stewart. *Greek Sculpture: An Exploration*. 2 vols. New Haven.

Stewart 1993
Andrew F. Stewart. *Faces of Power: Alexander's Image and Hellenistic Politics*. Berkeley, Calif.

Stewart 2004
Andrew F. Stewart. *Attalos, Athens, and the Akropolis: The Pergamene "Little Barbarians" and Their Roman and Renaissance Legacy*. Cambridge, U.K.

Stewart 2014
Andrew F. Stewart. *Art in the Hellenistic World: An Introduction*. Cambridge, U.K.

Stewart 2017
Andrew F. Stewart. "Hellenistic Freestanding Sculpture from the Athenian Agora, Part 3." *Hesperia* 86, pp. 83–127.

Stiller 1895
Hermann Stiller. *Das Traianeum*. Altertümer von Pergamon 5, no. 2. Berlin.

Strabo 1903
Strabo. *Geography*. Vol. 1. Translated by Hans Claude Hamilton and W. Falconer. Bohn's Classical Library. London and New York.

Strocka 2012
Volker Michael Strocka. "Bauphasen des kaiserzeitlichen Asklepieions von Pergamon." *Istanbuler Mitteilungen* 62, pp. 199–287.

Strong 1966
Donald Emrys Strong. *Greek and Roman Gold and Silver Plate*. Methuen's Handbooks of Archeology. London.

Stuart Jones 1926
Henry Stuart Jones, ed. *Catalogue of the Ancient Sculptures Preserved in the Municipal Collections of Rome*. [Vol. 2], *The Sculptures of the Palazzo dei Conservatori*. Oxford. Reprint ed., Rome, 1968.

Syme 1988
Ronald Syme. "Journeys of Hadrian." *Zeitschrift für Papyrologie und Epigraphik* 73, pp. 159–70.

Tasia 1993
Anastasia Tasia. "Isostiki anaskaphi tis 16' Ephorias stin Plateia Dioikitiriou (Rescue excavation by the 16th Ephoria in Plateia Dioikitiriou)." In *To archaiologiko ergo stin Makedonia kai Thraki* 7, pp. 329–41. Thessaloniki.

Tatton-Brown 2002
Veronica Tatton-Brown. "Hellenistic Glass in the British Museum." In Kordas 2002, pp. 91–99.

Taylor 2008
Rabun M. Taylor. *The Moral Mirror of Roman Art*. Cambridge, U.K.

Theocritus 2015
Theocritus. *Moschus, Bion*. Edited and translated by Neil Hopkinson. Loeb Classical Library 28. Cambridge, Mass.

Theophrastos 1956
Theophrastos. *On Stones: Introduction, Greek Text, English Translation, and Commentary*. Edited and translated by Earle Radcliffe Caley and John F. C. Richards. Columbus.

Theophrastos 1965
Theophrastos. *De lapidibus*. Edited by D. E. Eichholz. Oxford.

Thomas 2017a
Ross Thomas. "Egyptian Late Period Figures in Terracotta and Limestone." *Naukratis: Greeks in Egypt*. http://www.britishmuseum.org/research /online_research_catalogues/ng/naukratis_greeks_in _egypt/material_culture_of_naukratis/late_period _figures.aspx.

Thomas 2017b
Ross Thomas. "Stone and Terracotta Figures: An Introduction." *Naukratis: Greeks in Egypt*. http://www .britishmuseum.org/research/online_research _catalogues/ng/naukratis_greeks_in_egypt/material _culture_of_naukratis/figures_introduction.aspx.

Thompson 1973
Dorothy Burr Thompson. *Ptolemaic Oinochoai and Portraits in Faience: Aspects of the Ruler-Cult*. Oxford Monographs on Classical Archaeology. Oxford.

Thonemann 2015
Peter Thonemann. *The Hellenistic World: Using Coins as Sources*. Guides to the Coinage of the Ancient World. Cambridge, U.K.

Thoresen 2014
Lisbet Thoresen, ed. *Twelfth Annual Sinkankas Symposium: Peridot and Uncommon Green Gem Minerals*. Fallbrook, Calif.

Thoresen 2017
Lisbet Thoresen. "Archaeogemmology and Ancient Literary Sources on Gems and their Origins." *Römisch-Germanisches Zentralmuseum-Tagungen* 30, pp. 155–217.

Thoresen and Harrell 2014
Lisbet Thoresen and James A. Harrell. "Archaeogemology of Peridot." In Thoresen 2014, pp. 31–51.

Toynbee 1973
Jocelyn M. C. Toynbee. *Animals in Roman Life and Art*. London.

Triantafyllidis 2000a
Pavlos Triantafyllidis. Ροδιακη Υαλουργια. Vol. 1. Athens.

Triantafyllidis 2000b
Pavlos Triantafyllidis. "New Evidence of Glass Manufacture in Classical and Hellenistic Rhodes." In Association Internationale pour l'Histoire du Verre 2000, pp. 30–34.

Triantafyllidis 2003a
Pavlos Triantafyllidis. "Achaemenian Glass Production." In *Annales du 15e congrès de l'Association Internationale pour l'Histoire du Verre: New York—Corning 2001*, edited by Jennifer Price, pp. 13–17. Nottingham.

Triantafyllidis 2003b
Pavlos Triantafyllidis. "Classical and Hellenistic Glass Workshops from Rhodes." In Foy and Nenna 2003, pp. 131–38.

Triantafyllidis 2006a
Pavlos Triantafyllidis. "Late Hellenistic Glass from Kos, Dodecanese, Greece." *Journal of Glass Studies* 48, pp. 145–61.

Triantafyllidis 2006b
Pavlos Triantafyllidis. "A Unique Late Hellenistic Glass Bowl from Kalymnos (Dodecanese, Greece)." *Journal of Glass Studies* 48, pp. 325–27.

Triantafyllidis 2011
Pavlos Triantafyllidis. "A Unique Glass Psykter from Lithovouni in Aetolia, Greece." *Journal of Glass Studies* 53, pp. 45–57.

Triantafyllidis 2015
Pavlos Triantafyllidis. "Classical Colorless Glass Stands from Rhodes, Dodecanese, Greece." *Journal of Glass Studies* 57, pp. 285–87.

Troxell 1997
Hyla A. Troxell. *Studies in the Macedonian Coinage of Alexander the Great*. Numismatic Studies 21. New York.

True 2006
Marion True. "Plastic Vases and Vases with Plastic Additions." In Cohen 2006b, pp. 240–49.

Tsiafaki 1998
Despina S. Tsiafaki. *I thraki stin attiki eikonografia tou 5ou aiona p.Ch: Prosegiseis stis scheseis Athinas kai Thrakis*. Komotini.

Turner 1956
W. E. S. Turner. "Studies in Ancient Glasses and Glassmaking Processes: Part IV, The Chemical Composition of Ancient Glasses." *Journal of the Society of Glass Technology* 40, pp. 162T–186T.

Tzanavari 2011
Katerina Tzanavari. "H latreia tou Dionysou." In *The Gift of Dionysos: Mythology of Wine in Central Italy (Molise) and Northern Greece (Macedonia) / Il dono di Dioniso: Mitologia del vino nell'Italia centrale (Molise) e nella Grecia del Nord (Macedonia) / To dōro tou Dionysou: mythologia tou krasiou stin kentriki Italia (Molise) kai tē boreia Hellada (Makedonia)*, edited by Polyxeni Adam-Veleni, Eurydiki Kephalidu, and Euaneglia Stephani, pp. 104–17. Exh. cat. Ekdosi 8. Thessaloniki.

van Alfen 2000
Peter G. van Alfen. "The 'Owls' from the 1973 Iraq Hoard." *American Journal of Numismatics*, ser. 2, 12, pp. 9–58.

Van Straten 1995
Folkert T. Van Straten. *Hierà kalá: Images of Animal Sacrifice in Archaic and Classical Greece*. Religions in the Graeco-Roman World 127. Leiden.

Vassilika 2006
Eleni Vassilika. *Trésors d'art du Museo Egizio: Guide en français*. Turin.

Veyne 1979
Paul Veyne. "L'hellènisation de Rome et la problèmatique des acculturations." *Diogène* 106, pp. 3–29.

Vercoutter et al. 1976
Jean Vercoutter, Jean Leclant, Frank M. Snowden Jr., and Jehan Desanges. *L'image du noir dans l'art occidental*. Edited by Ladislas Bugner. Vol. 1, *Des pharaons à la chute de l'empire Romain*. Fribourg.

Vidal-Naquet 1998
Pierre Vidal-Naquet. *The Black Hunter: Forms of Thought and Forms of Society in the Greek World*. Translated by Andrew Szegedy-Maszak. Baltimore.

Villing 2017
Alexandra Villing. *Naukratis: Greeks in Egypt*. http:// www.britishmuseum.org/research/online_research _catalogues/ng/naukratis_greeks_in_egypt.aspx.

Virgilio 1985
Biagio Virgilio. "Punti di vista sugli Attalidi di Pergamo." In *Studi in onore di Edda Bresciani*, edited by Sandro Filippo Bondì, Sergio Pernigotti, F. Serra, and Angelo Vivian, pp. 547–65. Pisa.

Virgilio 1994a
Biagio Virgilio. "Fama, eredità e memoria degli attalidi di Pergamo." In *Aspetti e problemi dell'ellenismo: Atti del convegno di studi, Pisa 6–7 novembre 1992*, edited by Biagio Virgilio, pp. 137–71. Studi Ellenistici 4; Biblioteca di Studi Antichi 73. Pisa.

Virgilio 1994b
Biagio Virgilio. "La città ellenistica e i suoi 'benefattori': Pergamo e Diodoro Pasparos." *Athenaeum: Studi di letteratura e storia dell'antichità* 82, pp. 299–314.

Virgilio 2003
Biagio Virgilio. *Lancia, diadema e porpora: Il re e la regalità ellenistica*. 2nd rev. and enlarged ed. Studi Ellenistici 14. Pisa.

Vokotopoulou 1996
Ioulia Vokotopoulou. *Guide to the Archaeological Museum of Thessalonike*. Athens.

Vokotopoulou 1997
Ioulia Vokotopoulou. *Argyra kai chalkina erga technis stin archaiotita* [Silver and bronze works of art in antiquity]. Athens.

Vokotopoulou and Koukouli-Chryssanthaki 1996
Ioulia Vokotopoulou and Haïdo Koukouli-Chryssanthaki. *Macedonians: The Northern Greeks*. Exh. cat. Athens.

von Bothmer 1961
Dietrich von Bothmer. "Etruscan, Greek, and Roman: Sculptures in the Recent Accessions Room." *The Metropolitan Museum of Art Bulletin* 19, no. 6 (February), pp. 181–82.

Voretzsch 1957
Ernst Adalbert Voretzsch. "Ein römisches Porträt-Medaillon in Afghanistan." *Mitteilungen des Deutschen Archäologischen Instituts, Römische Abteilung* 64, pp. 8–45.

Vorster 2007
Christiane Vorster. ""Die Plastik des späten Hellenismus: Porträts und rundplastische Gruppen." In Bol 2007, pp. 273–331, 405–16.

Wachter 2003
Rudolf Wachter. "Drinking Inscriptions on Little-Master Cups: A Catalogue (*AVI 3*)." *Kadmos* 42, pp. 141–89.

Wachter 2016
Rudolf Wachter, ed. *Potters–Painters–Scribes: Inscriptions on Attic Vases / Töpfer–Maler–Schreiber: Inschriften auf attischen Vasen / Potiers–peintres–scribes: Inscriptions sur vases attiques.* Akanthus Proceedings 4. Kilchberg and Zurich.

Walker 1996
Alan S. Walker, ed. *A Peaceable Kingdom: Animals in Ancient Art from the Leo Mildenberg Collection.* Mainz am Rhein.

Walker and Higgs 2001
Susan Walker and Peter Higgs, eds. *Cleopatra of Egypt: From History to Myth.* Exh. cat. London.

Wallace-Hadrill 2008
Andrew Wallace-Hadrill. *Rome's Cultural Revolution.* Cambridge, U.K., and New York.

Walsh 2008
David Walsh. *Distorted Ideals in Greek Vase-Painting: The World of Mythological Burlesque.* Cambridge, U.K.

Walter-Karydi 1998
Elena Walter-Karydi. "Dangerous is Beautiful: The Elemental Quality of a Hellenistic Scylla." In Palagia and Coulson 1998, pp. 271–79.

Weinberg 1961
Gladys Davidson Weinberg. "Hellenistic Glass Vessels from the Athenian Agora." *Hesperia* 30, no. 4 (October–December), pp. 380–92.

Weinberg 1969
Gladys Davidson Weinberg. "Glass Manufacture in Hellenistic Rhodes." *Archaiologikon Deltion* 24, pp. 143–51.

Weinberg 1992
Gladys Davidson Weinberg. *Glass Vessels in Ancient Greece: Their History Illustrated from the Collection of the National Archaeological Museum, Athens.* Publications of the Archaeologikon Deltion 47. Athens.

Welc 2014
Fabian Welc. *Tell Atrib, 1985–1995.* Vol. 4, *Faience Objects.* Polish Archaeology in the Mediterranean 5. Warsaw.

Whitehouse 2000
David Whitehouse. "Ancient Glass: Some Recent Developments." In Association Internationale pour l'Histoire du Verre 2000, pp. 1–5.

Widdows 2006
Daniella Louise Widdows. "Removing the Body: Representations of Animal Skins on Greek Vases." PhD diss., University of Southern California, Los Angeles.

Willer 1994
Frank Willer. "Fragen sur intentionellen Schwarzpatina an den Mahdiabronzen." In Hellenkemper Salies 1994, vol. 2, pp. 1023–31.

Winnefeld 1910
Hermann Winnefeld. *Die Friese des grossen Altars.* Altertümer von Pergamon 3, no. 2. Berlin.

Winter 1908
Franz Winter. *Die Skulpturen mit Ausnahme der Altarreliefs.* Altertümer von Pergamon 7, no. 1. Berlin.

Wroth 1889
Warwick Wroth. *A Catalogue of the Greek Coins in the British Museum: Pontus, Paphlagonia, Bithynia, and the Kingdom of Bosporus.* Edited by Reginald Stuart Poole. London.

Wuilleumier 1930
Pierre Wuilleumier. *Le Trésor de Tarente: Collection Edmond de Rothschild.* Paris.

Wypyski 1998
Mark T. Wypyski. "Appendix." In Friedman 1998, p. 265.

Yatromanolakis 2016
Dimitrios Yatromanolakis, ed. *Epigraphy of Art: Ancient Greek Vase-Inscriptions and Vase-Paintings.* Oxford.

Yoon 2012
David Yoon. Review of Holt and Bopearachchi 2011. *ANS Magazine* 11, no. 2 (Summer), pp. 54–55.

Zanker 1989
Paul Zanker. *Die trunkene Alte: Das Lachen der Verhöhnten.* Frankfurt am Main.

Zanker 2016
Paul Zanker. *Roman Portraits: Sculptures in Stone and Bronze the Collection of The Metropolitan Museum of Art.* New York.

Zervoudaki 1968
Ios A. Zervoudaki. "Attische polychrome Reliefkeramik des späten 5. und des 4. Jahrhunderts v. Chr." *Mitteilungen des Deutschen Archäologischen Instituts, Athenische Abteilung* 83, pp. 1–88.

Zervoudaki 2002–3
Ios A. Zervoudaki. "Krokodeilos sto Palaiokastro tes Karditsas" [A crocodile at Palaiokastro, Karditsa]. *Mouseion* 3, pp. 55–68.

Zevi 1999
Fausto Zevi. "Considerazioni vecchie e nuove sul santuario della Fortuna Primigenia: L'organizzazione del santuario, i Mucii Scaevolae e l'architettura mariana." In *Le Fortune dell'età arcaica nel Lazio ed in Italia e loro posterità: Atti del 3o Convegno di studi archeologici, Palestrina, 15–16 ottobre 1994*, pp. 137–83. Palestrina.

G. Zimmer 1996
Gerhard Zimmer. "Prunkgeschirr hellenistischer Herrscher." In Hoepfner and Brands 1996, pp. 130–35.

T. Zimmer 2010
Torsten Zimmer. "Repräsentatives Wohnen am Beispiel der Palastanlagen von Pergamon." In Ladstätter and Scheibelreiter 2010, pp. 155–66.

T. Zimmer 2011
Torsten Zimmer. "Die Basileia: Der Palastbezirk von Pergamon." In Grüssinger, V. Kästner, and Scholl 2011, pp. 144–47.

T. Zimmer 2012
Torsten Zimmer. "Zur Lage und Funktion der Basileia in Pergamon." In Pirson 2012, pp. 251–59.

PHOTOGRAPH AND ILLUSTRATION CREDITS

Introduction
Seán Hemingway
Image © The Metropolitan Museum of Art, photograph by Bruce Schwarz: figs. 1, 3, 10
Image © The Metropolitan Museum of Art, photograph by Heather Johnson: fig. 2
Manuel Cohen/ Art Resource, NY: fig. 4
Image © The Metropolitan Museum of Art: figs. 5–9

Early Portraits of Alexander the Great: The Numismatic Evidence
Ute Wartenberg
Courtesy Bibliothèque Nationale de France, Paris: fig. 1
Numismatica Ars Classica NAC AG, Auction 59, lot 658: fig. 2
Courtesy American Numismatic Society: figs. 3, 5–12
Courtesy Private Collection: fig. 4

Precious Gems and Poetry in the Hellenistic Royal Courts
Jeffrey Spier
Image © Ashmolean Museum, University of Oxford: fig. 1
The Walters Art Museum, Baltimore: figs. 2, 7
Digital image courtesy of the Getty's Open Content Program: figs. 3, 6
Image © Metropolitan Museum of Art, photo by Heather Johnson: fig. 4
© 2018 Museum of Fine Arts, Boston: fig. 5

Visual Riddles and Wordplay in Hellenistic Art
Christine Kondoleon
Courtesy of the Baltimore Museum of Art, photograph by Mitro Hood: fig. 1
© 2018 Museum of Fine Arts, Boston: fig. 2
Courtesy Private Collection: fig. 3
© The al-Sabah Collection, Dar al-Athar al-Islamiyyah, Kuwait: fig. 4
© Trustees of the British Museum: fig. 5

Monumental, Impressive, Unique: Hellenistic Art and Architecture in the Restored Pergamon Museum
Andreas Scholl
© Antikensammlung, Staatliche Museen zu Berlin, Photographic archive: figs. 1, 2, 9
© SPK / ART + COM 2015: figs. 1, 6. 10–13
© Jürgen Liepe, Antikensammlung, Staatliche Museen zu Berlin: figs. 7–8

The Moldmade Bowls of Pergamon: Origin and Influence
Susan I. Rotroff
© Antikensammlung, Staatliche Museen zu Berlin: photograph by Ingrid Geske: fig. 1
Photograph by the author: fig. 2
© Agora Excavations: fig. 4
Drawing by author, after Conze 1913, Beibl. 40:1: fig. 5A

© Archeological Exploration of Sardis/ President and Fellows of Harvard College: figs. 5B, 6B, 7B
Drawing by the author, after de Luca and Ziegenaus 1968, no. 359, pl. 54: fig. 6A
Drawing by the author, after Conze 1913, p. 274:6: fig. 7A

Luxury Goods from Hellenistic Pergamon: The Archaeological Influence
Agnes Schwarzmaier
Antikensammlung, Staatliche Museen zu Berlin, photograph by Ingrid Geske: figs. 1, 6, 8
CoDArchLab, www.arachne.uni-koeln.de, photograph by Gisela Geng/Philipp Groß: fig. 2
Antikensammlung, Staatliche Museen zu Berlin, photograph by Johannes Laurentius: figs. 3, 7
Drawing by M. da Fonseca, after Wuilleumier 1930, pl. 11: fig. 4
Antikenmuseum Basel und Sammlung Ludwig, photograph by Ruedi Habegger: fig. 5

Diadems, Royal Hairstyles, and the Berlin Attalos
R. R. R. Smith
© Ashmolean Museum, University of Oxford: figs. 2A–B
Photograph by David Gowers: figs. 3A–6A, 7a, 8A–B
Drawing by Sasha Wehm: figs. 6B, 7B

Pergamene Reflections in the Sanctuary of Diana at Nemi
Olga Palagia
© Nick Dunmur 2018: fig. 1
Photograph by Hans R. Goette: figs. 2–4
Photograph by Ole Haupt: figs. 5–6
Courtesy of Penn Museum, image #141409: fig. 7
Courtesy Athens, National Museum: fig. 8
Photograph by Annewies van den Hoek: fig. 9
Photograph by Olga Palagia: fig. 10

From Pergamon to Rome and from Rome to Pergamon: A Very Fruitful Archaeological Gift
Alessandro Viscogliosi
Drawing by Andrea Gallo: figs. 1–3
Photograph by the author: figs. 4–5, 7
Photograph by Vatican Museums: fig. 6

An Early Hellenistic Votive Statuette in The Metropolitan Museum of Art: Dionysos Melanaigis?
Kiki Karoglou
Image © The Metropolitan Museum of Art: figs. 1–2, 4, 7
© Hellenic Ministry of Culture and Sports, photograph by Maria Karoglou: fig. 3
© Hellenic Ministry of Culture and Sports, photograph by Giorgos Vitsaropoulos: fig. 5

Photograph © RMN-Grand Palais / Art Resource, NY Photograph: Hervé Lewandowski: fig. 6
Photograph © 2018 Museum of Fine Arts, Boston: fig. 8
Image © The Metropolitan Museum of Art, photograph by Heather Johnson: fig. 9

Falling Hero: A Drunken Herakles in The Metropolitan Museum of Art
Lillian Bartlett Stoner
Image © The Metropolitan Museum of Art: figs. 1A–D
Scala/Ministero per i Beni e le Attivita culturali / Art Resource, NY: fig. 2
Courtesy Museo Archeologico Nazionale di Firenze: fig. 3
Archaeologisches Institut der Universitat Goettingen, photograph by Stephan Eckardt: fig. 5
Erich Lessing/ Art Resource, NY: fig. 6
Alinari / Art Resource, NY: fig. 7

Hellenistic and Roman Victory Monuments: A Bronze Torso in The Metropolitan Museum of Art
Seán Hemingway, Dorothy H. Abramitis, and Karen Stamm
Image © The Metropolitan Museum of Art: fig. 1
Photograph by Federico Carò: figs. 10A–B

The Hellenistic Legacy of Metallic Polychromy: Roman Statuettes of an African Boy in the Pose of an Orator
Sophie Descamps-Lequime and Dominique Robcis
© Boston, Museum of Fine Arts: fig. 1
Photograph by Susanne Schenker, Augusta Raurica, Switzerland: fig. 2
© RMN-Grand Palais / Art Resource, NY. Photo: Franck Raux: figs. 3–4
© Daniel Roger: fig. 5
© C2RMF/Elsa Lambert: fig. 6
© C2RMF/Dominique Robcis: figs. 7–8
© Musée du Louvre, Dist. RMN-Grand Palais / Patrick Lebaube / Art Resource, NY: fig. 9

The Hamilton Fragment and the Bronze Roundel from Thessaloniki: Athena with the Gorgoneion Helmet
Ariel Hermann
© Hellenic Ministry of Culture & Sports / Archaeological Receipts Fund: fig. 1
Photograph Rudolf Habegger, courtesy of the Antikenmuseum Basel und Sammlung Ludwig: fig. 3
Photograph Vatican Museums: figs. 4–5, 9
© Roma, Superintendence Capitoline ai Beni Culturali, photograph by Alfredo Valeriani: fig. 6
Photograph Courtesy of Sotheby's, Inc. © 1989: fig. 7

Photograph Jörg Deterling: fig. 8
Photograph: Maggie Nimkin: fig. 10

Innovation in Hellenistic Athenian Pottery: the Evolution from Painted to Relief Wares
Joan R. Mertens
Photograph Johannes Laurentius: fig. 1
Image © The Metropolitan Museum of Art: figs. 2–4, 6–10, 11–13
© Hellenic Ministry of Culture & Sports / Archaeological Receipts Fund: fig. 5
© SMB/Antikensammlung, Staatliche Museen zu Berlin, photograph by Ingrid Gaske: fig. 14

Regarding *Kallainopoioi*: Notes on Hellenistic Faience
Marsha Hill
Image © The Metropolitan Museum of Art: figs. 1, 3, 5
Digital image courtesy of the Getty's Open Content Program: fig. 2
The Walters Art Museum, Baltimore: fig. 6
© Musée du Louvre, Dist. RMN-Grand Palais / Gorges Poncet / Art Resource, NY: fig. 7
Drawing by Sara Chen: fig. 8

Hellenistic Glass: All That Glitters Is Not Gold
Christopher S. Lightfoot
Image © The Metropolitan Museum of Art: figs. 1, 3–7
Image © The Metropolitan Museum of Art, photograph by Paul Lachenauer: fig. 2

The Tresilico Sandwich Gold Glass Bowl
Christopher S. Lightfoot and Carmelo Malacrino
Image © The Metropolitan Museum of Art: figs. 1, 4, 6, 8
Courtesy Pushkin State Museum of Fine Arts, Moscow: fig. 2
Courtesy of LVR-Landesmuseum, Bonn: fig. 3
© Hellenic Ministry of Culture & Sports / Archaeological Receipts Fund. Photograph by Orestis Kourakis: fig. 5
Image © The Metropolitan Museum of Art, photograph by Heather Johnson: fig. 7

The Frescoes from the Villa of Publius Fannius Synistor at Boscoreale in The Metropolitan Museum of Art
Paul Zanker
© James Stanton-Abbott at www.computer-render.com: figs. 1–2, 4–5, 7, 12
© James Stanton-Abbott at www.computer-render.com. Image © The Metropolitan Museum of Art, photograph by Heather Johnson: figs. 3, 6, 8–9
Image © The Metropolitan Museum of Art: figs. 10–11, 13–18

This volume is published by The Metropolitan Museum of Art, New York.

This publication is made possible by The BIN Charitable Foundation, Inc., The Adelaide Milton de Groot Fund, in memory of the de Groot and Hawley families, and Mary Jaharis.

Published by The Metropolitan Museum of Art, New York
Mark Polizzotti, Publisher and Editor in Chief
Gwen Roginsky, Associate Publisher and General Manager of Publications
Peter Antony, Chief Production Manager
Michael Sittenfeld, Senior Managing Editor

Edited by Barbara Cavaliere
Designed by Rita Jules, Miko McGinty Inc.
Production by Peter Antony, Sally VanDevanter, and Nicole Jordan
Bibliography and notes edited by Amelia Kutschbach
Image acquisitions and permissions by Jennifer Sherman and Josephine Rodriguez-Massop
Map by Pamlyn Smith

Photographs of works in The Metropolitan Museum of Art's collection are by the Imaging Department, The Metropolitan Museum of Art, unless otherwise noted. Additional photography credits appear on page 223.

Typeset in Baskerville 10 and Retina by Tina Henderson
Printed on 128 gsm Neo Morrim
Separations by Alta Graphics, New York
Printed by Midas, Huizhou, Guangdong, China

Jacket illustrations: front: detail of figure 7 on page 72; back: detail of figure 9 left panel on page 196; inside cover: Detail of the left side of the Acropolis of Pergamon, Friedrich (von) Thiersch (1882–1921), 1882, pen and ink with watercolor on canvas, 78 in. x 11 ft. 5¾ in. (198 x 350 cm). Antikensammlung, Staatliche Museen zu Berlin (Archiv. Rep. 1, Abt. B, Inv. Graph 91)
Frontispiece: Athena winning against a giant and crowned by the Victory, Great Frieze of the Pergamon Altar, east side, 2nd quarter of the 2nd century B.C. Antikensammlung, Staatliche Museen zu Berlin. Adam Eastland / Alamy Stock Photograph
Page 6: detail of figure 1 on page 178
Page 8: Portrait head of Attalos 1 from Pegamon, Greek (Pergamene), Hellenistic, ca. 200–170 B.C. Marble, Pergamon Museum, Berlin (AvP VII 130). Photograph by Johannes Laurentius
Page 22: detail of figure 1 on page 32
Page 46: detail of figure 8 on page 73
Page 98: detail of figure 1 on page 100
Page 136: figure 18 on page 203

The Metropolitan Museum of Art endeavors to respect copyright in a manner consistent with its nonprofit educational mission. If you believe any material has been included in this publication improperly, please contact the Publications and Editorial Department.

The Metropolitan Museum of Art
1000 Fifth Avenue
New York, New York 10028
metmuseum.org

Distributed by Yale University Press, New Haven and London
yalebooks.com/art
yalebooks.co.uk

Cataloguing-in-Publication Data is available from the Library of Congress.

ISBN 978-1-58839-658-7
The Metropolitan Museum of Art